Drawings of Rembrandt

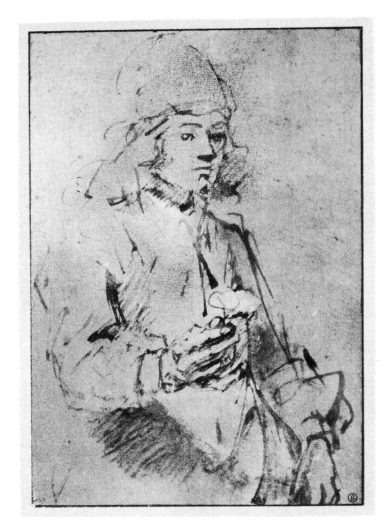

DRAWINGS OF REMBRANDT

With a Selection of Drawings by His Pupils and Followers

With an Introduction, Commentary, and Supplementary Material
by Seymour Slive
Professor of Fine Arts, Harvard University

Based on the Facsimile Series Edited by
F. Lippmann, C. Hofstede de Groot, and Others

In Two Volumes Volume Two

Dover Publications, Inc., New York

Published in Canada by General Publishing Company, Ltd., 30 Lesmill Road, Don Mills, Toronto, Ontario.
Published in the United Kingdom by Constable and Company Limited

This Dover edition, first published in 1965, contains all the drawings from *Original Drawings by Rembrandt Harmensz van Rijn*, edited by F. Lippmann, C. Hofstede de Groot, and others, first published in four series from 1888 to 1911 (full bibliographical information is given on p. xi of the Introduction to this Dover edition). The Introduction, Commentary on the Plates, Biographical Notes, Key to Abbreviations and Bibliography, Lists of Plates, Concordances, and Indexes are entirely new, having been prepared especially for this Dover edition by Seymour Slive.

International Standard Book Number: 0-486-21486-9
Library of Congress Catalog Card Number: 65-12555

Manufactured in the United States of America

Dover Publications, Inc.
180 Varick Street
New York, N. Y. 10014

CONTENTS

List of Plates xi

PLATES 301—550

Concordance Between the Numbers of the Present Edition and Those of the Catalogues of
Benesch, Valentiner, and Hofstede de Groot xxi

General Concordance Between the Numbers of the Catalogues of Benesch, Valentiner, and
Hofstede de Groot and Those of the Present Edition xxix

Index of Collections xxxix

Index of Subjects xlv

Index of Rembrandt's Pupils and Followers li

List of Plates

LIST OF PLATES

301 A Boy Lighting His Pipe at a Candle (II, 71).* Rijksprentenkabinet, Amsterdam.

302 Standing Beggar Turned to the Right (II, 72). Rijksprentenkabinet, Amsterdam.

303 Standing Beggar with a Leather Bag (II, 73). Rijksprentenkabinet, Amsterdam.

304 Landscape with an Inn, and a Sailboat on the Right (II, 74). Rijksprentenkabinet, Amsterdam.

305 The Incredulity of St. Thomas (II, 75). Rijksprentenkabinet, Amsterdam.

306 St. Jerome Praying (II, 76a). Rijksprentenkabinet, Amsterdam.

307 Two Old Men, One Seated in an Armchair, the Other with a Globe (II, 76b). Rijksprentenkabinet, Amsterdam.

308 Esther Fainting Before Ahasuerus (II, 77). Rijksprentenkabinet, Amsterdam.

309 The Unmerciful Servant (Matthew 18, 32) (II, 78). Rijksprentenkabinet, Amsterdam.

310 A City Gate (perhaps Rhenen) (II, 79). Rijksprentenkabinet, Amsterdam.

311 An Old Man Standing (II, 80a). Rijksprentenkabinet, Amsterdam.

312 Young Woman with a Large Hat and a Walking Stick (II, 80b). Rijksprentenkabinet, Amsterdam.

313 The Angel in the House of Tobit (II, 81). Rijksprentenkabinet, Amsterdam.

314 Departure of the Young Tobias (II, 82). Rijksprentenkabinet, Amsterdam.

315 Two Women with a Child Learning to Walk (II, 83). Rijksprentenkabinet, Amsterdam.

316 A Woman Holding a Child, Her Left Foot on a Stair (II, 84). Rijksprentenkabinet, Amsterdam.

317 View Over the Amstel from the Blauwbrug in Amsterdam (II, 85). Rijksprentenkabinet, Amsterdam.

318 The Pancake Woman (II, 86). Rijksprentenkabinet, Amsterdam.

319 Standing Female Nude (II, 87). Rijksprentenkabinet, Amsterdam.

320 Raguel Welcomes Tobias (II, 88). Rijksprentenkabinet, Amsterdam.

321 The Annunciation to the Shepherds (II, 89). Rijksprentenkabinet, Amsterdam.

322 Winter Landscape with a Farm (II, 90). Rijksprentenkabinet, Amsterdam.

323 A Woman in a Faint, Supported by Two Figures (II, 91). Rijksprentenkabinet, Amsterdam.

324 The Virgin Showing the Infant Christ to One of the Magi (II, 92). Rijksprentenkabinet, Amsterdam.

325 Standing Man with His Right Hand Raised and a Whip(?) in His Left (II, 93). Rijksprentenkabinet, Amsterdam.

326 God Appearing to Abraham (II, 94). Rijksprentenkabinet, Amsterdam.

*The numbers which appear in parentheses in this List of Plates and throughout the present volumes are the numbers assigned to the facsimiles in the four series of the original edition of this work.

327 THE ANGEL APPEARING TO JOSEPH IN A DREAM (II, 95). Rijksprentenkabinet, Amsterdam.

328 SASKIA'S LYING-IN ROOM (II, 96). Rijksprentenkabinet, Amsterdam.

329 JOB AND HIS FRIENDS(?) (II, 97). Rijksprentenkabinet, Amsterdam.

330 CHRIST HEALING A LEPER (II, 98). Rijksprentenkabinet, Amsterdam.

331 CHRIST APPEARING AS A GARDENER TO MARY MAGDALEN (II, 99). Rijksprentenkabinet, Amsterdam.

332 THE MESSENGER WITH THE CROWN OF SAUL BEFORE DAVID (II, 100). Rijksprentenkabinet, Amsterdam.

333 PORTRAIT OF A MAN (III, 1). Louvre, Paris.

334 PORTRAIT OF A MAN (III, 2). Louvre, Paris.

335 THE NAMING OF ST. JOHN THE BAPTIST (III, 3). Louvre, Paris.

336 FEMALE NUDE SEATED ON A STOOL, TURNED TO THE LEFT (III, 4). Louvre, Paris.

337 TWO STUDIES OF A BEGGING WOMAN SEATED WITH TWO CHILDREN (III, 5). Louvre, Paris.

338 CHRIST APPEARING AS A GARDENER TO MARY MAGDALEN (III, 6). Louvre, Paris.

339 HOUSES AMIDST TREES AND SHRUBS (III, 7). Louvre, Paris.

340 AN AVENUE LINED WITH TREES (DIEMERMEER?) (III, 8). Louvre, Paris.

341 CHRIST WASHING THE DISCIPLES' FEET (III, 9). Louvre, Paris.

342 YOUNG MAN HOLDING A FLOWER (TITUS?) (III, 10). Louvre, Paris.

343 LANDSCAPE WITH A POND (III, 11). Louvre, Paris.

344 HEAD OF AN ORIENTAL IN A TURBAN, TURNED TO THE RIGHT (III, 12). Louvre, Paris.

345 THE GOOD SAMARITAN ARRIVING AT THE INN WITH THE WOUNDED MAN (III, 13). Louvre, Paris.

346 JUDITH'S SERVANT PUTS HOLOFERNES' HEAD INTO A SACK (III, 14). Louvre, Paris.

347 THE PANCAKE WOMAN (III, 15). Louvre, Paris.

348 THE JUDGMENT OF SOLOMON (III, 16). Louvre, Paris.

349 PORTRAIT OF CORNELIS CLAESZ ANSLO (III, 17). Louvre, Paris.

350 A POLLARD WILLOW AT THE WATERSIDE (III, 18). Musée, Bayonne.

351 THREE WOMEN LOOKING OUT FROM AN OPEN DOOR (III, 19). French private collection.

352 THE HOLY FAMILY IN THE CARPENTER'S WORKSHOP (III, 20). Musée, Bayonne.

353 THE MOCKING OF CHRIST (III, 21). Formerly Léon Bonnat Collection, Paris.

354 A STANDING BOY IN A LONG ROBE (III, 22). Musée, Bayonne.

355 THE EASTERN GATE AT RHENEN (OOSTPOORT) (III, 23). Musée, Bayonne.

356 SARAH COMPLAINING OF HAGAR TO ABRAHAM (III, 24). Musée, Bayonne.

357 THREE PIGS OUTSIDE THEIR STY (III, 25). Musée, Bayonne.

358 THE ADORATION OF THE SHEPHERDS (III, 26). Musée, Bayonne.

359 A WOMAN SEATED IN A CHAIR BEFORE A MIRROR PUTTING ON AN EARRING (III, 27). Musée des Beaux-Arts, Brussels.

360 INTERIOR OF A HOUSE WITH A WINDING STAIRCASE (III, 28). Kobberstiksamling, Copenhagen.

361 THE ANGEL DISAPPEARING BEFORE MANOAH AND HIS WIFE (III, 29). Kupferstichkabinett, Dresden.

362 A WOMAN HANGING ON A GIBBET SEEN FROM THE FRONT (III, 30a). Fogg Art Museum, Harvard University, Cambridge, Massachusetts.

363 A WOMAN HANGING ON A GIBBET IN THREE-QUARTER PROFILE TO THE LEFT (III, 30b). Robert Lehman Collection, New York.

364 THE PRESENTATION IN THE TEMPLE (III, 31). Formerly Paul Mathey Collection, Paris.

365 A STANDING MAN, WITH A TWO-HANDED SWORD IN HIS RIGHT HAND (III, 32). Robert Lehman Collection, New York.

366 A STUDY OF A WOMAN SEATED AND OF A MAN STANDING IN FRONT OF HER, AND FOUR STUDIES OF THE HEAD OF A YOUNG WOMAN (III, 33). Formerly E. Wauters Collection, Paris.

367 DAVID TAKING LEAVE OF JONATHAN (III, 34). Rijksprentenkabinet, Amsterdam.

368 A PAINTER BEFORE HIS EASEL, ON THE RIGHT A VISITOR (III, 35). Formerly P. Mathey Collection, Paris.

369 A SCENE FROM THE OLD TESTAMENT(?) (III, 36). Count Antoine Seilern Collection, London.

370 TOBIAS CLEANING THE FISH (III, 37). Rijksprentenkabinet, Amsterdam.

371 JOSEPH DIVESTED OF HIS MULTICOLORED COAT (III, 38). Rijksprentenkabinet, Amsterdam.

372 THE LIBERATION OF ST. PETER FROM PRISON (III, 39). Rijksprentenkabinet, Amsterdam.

373 THE FINDING OF MOSES (III, 40). Rijksprentenkabinet, Amsterdam.

374 PORTRAIT STUDY OF A YOUNG LADY (III, 41). Rijksprentenkabinet, Amsterdam.

375 DAVID TAKING LEAVE OF JONATHAN (III, 42). Rijksprentenkabinet, Amsterdam.

376 TWO STUDIES OF A WOMAN WITH A BABY IN HER ARMS (III, 43). Rijksprentenkabinet, Amsterdam.

377 A YOUNG WOMAN SEATED BY A WINDOW (III, 44). Rijksprentenkabinet, Amsterdam.

378 THE ANNUNCIATION TO THE SHEPHERDS (III, 45). Rijksprentenkabinet, Amsterdam.

379 DANIEL IN THE LIONS' DEN (III, 46). Rijksprentenkabinet, Amsterdam.

380 AN OLD WOMAN SEATED IN A LOW WICKER BED WITH A BABY (III, 47). Boymans-van Beuningen Museum, Rotterdam.

381 AN OLD MAN ASLEEP IN HIS CHAIR (III, 48). Boymans-van Beuningen Museum, Rotterdam.

382 ABRAHAM KNEELING BEFORE GOD THE FATHER AND TWO ANGELS (III, 49). Boymans-van Beuningen Museum, Rotterdam.

383 THE GOOD SAMARITAN BRINGING THE WOUNDED MAN INTO THE INN (III, 50). Boymans-van Beuningen Museum, Rotterdam.

384 THE ANNUNCIATION (III, 51). Louvre, Paris.

385 A MAN SEATED IN A STUDY (III, 52). Louvre, Paris.

386 JUPITER AND ANTIOPE (III, 53). Louvre, Paris.

387 LARGE TREE ON A DIKE (III, 54). Louvre, Paris.

388 MERCURY AND ARGUS IN A LANDSCAPE (III, 55). Louvre, Paris.

389 TWO STANDING ORIENTALS (III, 56). Louvre, Paris.

390 THE SUPPER AT EMMAUS (III, 57). Formerly Walter Gay Collection, Paris.

391 THE ANGEL APPEARING TO ELIJAH IN THE DESERT (III, 58). Formerly Henry Oppenheimer Collection, London.

392 THE MEETING OF JACOB AND LABAN (III, 59). Kobberstiksamling, Copenhagen.

393 STUDY OF TWO MEN AND TWO CHILDREN (ONE OF THE LATTER IN A LITTLE CHAIR) (III, 60a). Louvre, Paris.

394 AN OLD MAN WITH HIS HANDS LEANING ON A BOOK AND A STUDY OF A MAN WEARING A TURBAN (III, 60b). Formerly Henry Oppenheimer Collection, London.

395 FOUR FIGURES IN AN INTERIOR AROUND A WOMAN LYING ON THE FLOOR (III, 61). Louvre, Paris.

396 COTTAGES BESIDE A ROAD (III, 62). Louvre, Paris.

397 THE MIRACULOUS DRAUGHT OF FISHES (III, 63). Louvre, Paris.

398 THE DISMISSAL OF HAGAR AT THE DOOR OF ABRAHAM'S HOUSE (III, 64). Louvre, Paris.

399 MUCIUS SCAEVOLA HOLDING HIS HAND IN FIRE BEFORE KING PORSENNA (III, 65). Louvre, Paris.

400 THE LAST SUPPER (III, 66). Louvre, Paris.

401 FARMSTEAD WITH A HAYRICK AND WEIRS (III, 67). Frits Lugt Collection, Paris.

402 DELILAH CALLS THE PHILISTINES (III, 68). Musée, Bayonne.

403 JUDAH AND TAMAR (III, 69). Boymans-van Beuningen Museum, Rotterdam.

404 THE STREET MUSICIAN (III, 70). Chr. P. van Eeghen Collection, Amsterdam.

405 CHRIST WALKING ON THE WAVES (III, 71). British Museum, London.

406 TWO STUDIES OF A CHILD PULLING OFF THE CAP OF AN OLD MAN, AND OTHER SKETCHES OF THE SAME GROUP (III, 72). British Museum, London.

407 WOMAN SEATED IN AN ARMCHAIR WITH HER HEAD RESTING ON HER LEFT HAND (III, 73). British Museum, London.

408 A WOMAN TEACHING A CHILD TO STAND (III, 74a). British Museum, London.

409 TWO WOMEN TEACHING A CHILD TO WALK (III, 74b). British Museum, London.

410 HOUSE BESIDE A ROAD LINED WITH TREES (III, 75). Frits Lugt Collection, Paris.

411 THE HOLY FAMILY IN THE CARPENTER'S WORKSHOP (III, 76). Boymans-van Beuningen Museum, Rotterdam.

412 THE KISS OF JUDAS (III, 77). Boymans-van Beuningen Museum, Rotterdam.

413 THE RAISING OF LAZARUS (III, 78). Boymans-van Beuningen Museum, Rotterdam.

414 STUDY OF A MAN SEATED AT A TABLE (III, 79). Boymans-van Beuningen Museum, Rotterdam.

415 COMPOSITIONAL SKETCH OF HORSEMEN (III, 80a). Boymans-van Beuningen Museum, Rotterdam.

416 A WOMAN LYING ASLEEP IN A LANDSCAPE (III, 80b). Boymans-van Beuningen Museum, Rotterdam.

417 TWO JEWS AND SOME DUTCH PEOPLE ON A STREET (III, 81). Teyler Museum, Haarlem.

418 MARS AND VENUS CAUGHT IN A NET AND EXPOSED BY VULCAN TO THE ASSEMBLED GODS (III, 82). Fodor Museum, Amsterdam.

419 THE HEALING OF TOBIT (III, 83). Fodor Museum, Amsterdam.

420 THE PRESENTATION IN THE TEMPLE (III, 84). Fodor Museum, Amsterdam.

421 NINE PEOPLE IN A SYNAGOGUE(?) BEHIND A LOW WALL (III, 85a). Fodor Museum, Amsterdam.

422 CHRIST SURROUNDED BY A GROUP OF FIGURES (III, 85b). Fodor Museum, Amsterdam.

423 TOWER OF THE WESTERKERK AT AMSTERDAM (III, 86). Fodor Museum, Amsterdam.

424 ESAU SELLING HIS BIRTHRIGHT TO JACOB (III, 87). Fodor Museum, Amsterdam.

425 THE ELEVATION OF THE CROSS (III, 88). Boymans-van Beuningen Museum, Rotterdam.

426 SHEET OF STUDIES WITH FOUR HEADS OF MEN (III, 89). Colnaghi's, London.

427 THE RUINS OF THE CHURCH OF MUIDERBERG (III, 90). V. de Stuers Collection, The Hague.

428 VIEW OF DIEMEN (III, 91a). V. de Stuers Collection, The Hague.

429 LANDSCAPE WITH A FARMER'S HOUSE AND A HAYRICK (III, 91b). Rijksprentenkabinet, Amsterdam.

430 LIFE STUDY OF A YOUTH PULLING AT A ROPE (III, 92). Rijksprentenkabinet, Amsterdam.

431 BOAZ POURS SIX MEASURES OF BARLEY INTO RUTH'S VEIL (III, 93). Rijksprentenkabinet, Amsterdam.

432 DAVID RECEIVING THE NEWS OF URIAH'S DEATH (III, 94). Rijksprentenkabinet, Amsterdam.

433 SEATED FEMALE NUDE WITH HER ARMS RAISED, SUPPORTED BY A SLING (III, 95). Rijksprentenkabinet, Amsterdam.

434 AHASUERUS SEATED AT A TABLE (III, 96). Rijksprentenkabinet, Amsterdam.

435 RECUMBENT LION SCRATCHING HIS MUZZLE (III, 97). Rijksprentenkabinet, Amsterdam.

436 COW STANDING IN A SHED (III, 98). Rijksprentenkabinet, Amsterdam.

437 JAEL DRIVING A NAIL INTO THE HEAD OF SISERA (III, 99). Rijksprentenkabinet, Amsterdam.

438 THE MIRACLE OF ELISHA MAKING A PIECE OF IRON FLOAT ON WATER (III, 100). Bredius Museum, The Hague.

439 A MAN SEATED BY A WINDOW, READING (IV, 1). Staatliche Graphische Sammlung, Munich.

440 THE VISION OF ST. PETER (IV, 2). Staatliche Graphische Sammlung, Munich.

441 SASKIA SITTING UP IN BED (IV, 3). Staatliche Graphische Sammlung, Munich.

442 CHRIST AND THE WOMAN TAKEN IN ADULTERY (IV, 4). Staatliche Graphische Sammlung, Munich.

443 SASKIA LYING IN BED, A WOMAN SITTING AT HER FEET (IV, 5). Staatliche Graphische Sammlung, Munich.

444 TWO STUDIES OF A BABY WITH A BOTTLE (IV, 6a). Staatliche Graphische Sammlung, Munich.

445 FOUR STUDIES OF A BABY (IV, 6b). Staatliche Graphische Sammlung, Munich.

446 RECLINING FEMALE NUDE, RESTING HER HEAD ON HER LEFT HAND (IV, 7). Staatliche Graphische Sammlung, Munich.

447 FEMALE NUDE SEATED ON A CHAIR SEEN FROM BEHIND (IV, 8). Staatliche Graphische Sammlung, Munich.

448 A YOUNG WOMAN SEATED (IV, 9). Staatliche Graphische Sammlung, Munich.

449 THE CONSPIRACY OF JULIUS CIVILIS (IV, 10a). Staatliche Graphische Sammlung, Munich.

450 THE CONSPIRACY OF JULIUS CIVILIS (IV, 10b). Staatliche Graphische Sammlung, Munich.

451 THE LAMENTATION FOR ABEL (IV, 11). Staatliche Graphische Sammlung, Munich.

452 RUINS OF CASTLE HONINGEN, NEAR ROTTERDAM (IV, 12a). Staatliche Graphische Sammlung, Munich.

453 THE RUINS OF CASTLE HONINGEN (IV, 12b). Staatliche Graphische Sammlung, Munich.

454 A MAN PULLING A ROPE (IV, 13). Staatliche Graphische Sammlung, Munich.

455 STUDY OF AN ARCHER (IV, 14). Staatliche Graphische Sammlung, Munich.

456 STUDY OF AN ARCHER (IV, 15). Kupferstichkabinett, Dresden.

457 A SLEEPING CHILD (IV, 16a). Kupferstichkabinett, Dresden.

458 A SLEEPING WOMAN, HER HEAD SUPPORTED ON HER RIGHT HAND (IV, 16b). Kupferstichkabinett, Dresden.

459 WOMAN WITH A PISSING CHILD (IV, 17a). Kupferstichkabinett, Dresden.

460 A GIRL LEANING ON A WINDOW FRAME (IV, 17b). Kupferstichkabinett, Dresden.

461 A VIEW OF THE FRONT OF THE CASTLE OF KOSTVERLOREN (IV, 18). Kupferstichkabinett, Dresden.

462 A BOY DRAWING AT A DESK (TITUS?) (IV, 19). Kupferstichkabinett, Dresden.

463 PORTRAIT STUDIES OF TWO WOMEN (IV, 20). Kupferstichkabinett, Dresden.

464 FARM BUILDINGS AT THE "DIJK" (IV, 21). Museum of Art, Rhode Island School of Design, Providence, Rhode Island.

465 A QUACK ADDRESSING A CROWD AT A FAIR (IV, 22). Count Antoine Seilern Collection, London.

466 THE RUINS OF KOSTVERLOREN CASTLE (IV, 23). The Art Institute of Chicago, Chicago, Illinois.

467 BEARDED MAN IN PROFILE (IV, 24a). Friedrich August II Collection, Dresden.

468 PORTRAIT OF THE PREACHER JAN CORNELISZ SYLVIUS (IV, 24b). Friedrich August II Collection, Dresden.

469 A GIRL LEANING ON THE SILL OF A WINDOW (IV, 25a). Count Antoine Seilern Collection, London.

470 TWO STANDING JEWS, BETWEEN THEIR FEET THE INVERTED HEAD OF A THIRD (IV, 25b). Formerly Friedrich August II Collection, Dresden.

471 THE SACRIFICE OF ABRAHAM (IV, 26). Kupferstichkabinett, Berlin.

472 A VIEW OF THE AMSTEL WITH A MAN BATHING; IN THE BACKGROUND AMSTERDAM (IV, 27). Kupferstichkabinett, Berlin.

473 THE HOLY FAMILY (IV, 28). Kupferstichkabinett, Berlin.

474 THE RETURN OF YOUNG TOBIAS (IV, 29). Kupferstichkabinett, Berlin.

475 A VIEW OF THE AMSTEL (IV, 30). Kupferstichkabinett, Berlin.

476 A ROAD WITH HOUSES ON EACH SIDE (IV, 31). Kupferstichkabinett, Berlin.

477 FARMHOUSES WITH TREES ON THE RIGHT (IV, 32). Kupferstichkabinett, Berlin.

478 Landscape with Cottages at the Left Side of a Road (IV, 33). Kupferstichkabinett, Berlin.

479 Jonah Ejected by the Whale (IV, 34). Kupferstichkabinett, Berlin.

480 Half-Figure of an Oriental Turned to the Left, superimposed upon a compositional study of a Girl at a Window (IV, 35). Kupferstichkabinett, Berlin.

481 The Dismissal of Hagar (IV, 36). Kupferstichkabinett, Berlin.

482 The Good Samaritan Paying the Host (IV, 37). Kupferstichkabinett, Berlin.

483 A Bearded Man Seated at a Desk Covered with Books (IV, 38). Kupferstichkabinett, Berlin.

484 Christ Healing a Leper (IV, 39). Kupferstichkabinett, Berlin.

485 Young Samuel Finds the High Priest Eli Asleep in the Temple (IV, 40). Kupferstichkabinett, Berlin.

486 Four Women Mourning the Death of a Young Man (IV, 41). Kupferstichkabinett, Berlin.

487 An Avenue of Trees Leading into the Distance (IV, 42). Kupferstichkabinett, Berlin.

488 The Discovery of Abel's Body (IV, 43). Kupferstichkabinett, Berlin.

489 Esau at the Well(?) (IV, 44). Formerly F. Koenigs Collection, Rotterdam.

490 A Shepherd Watering His Flock (IV, 45). Boymans-van Beuningen Museum, Rotterdam.

491 A Lion Resting, in Profile to the Left (IV, 46). Boymans-van Beuningen Museum, Rotterdam.

492 Isaac Refusing to Bless Esau (IV, 47). Formerly E. Wauters Collection, Paris.

493 The Departure of Tobias(?) (IV, 48). Frits Lugt Collection, Paris.

494 Two Studies of a Man Seated in a Chair (IV, 49). Boymans-van Beuningen Museum, Rotterdam.

495 Farmhouse (IV, 50a). Formerly H. Véver Collection, Paris.

496 A Woman Picking the Pocket of a Sleeping Man (IV, 50b). Formerly H. Véver Collection, Paris.

497 A Man (Jan Six?) Writing (IV, 51). Louvre, Paris.

498 The Flight into Egypt (IV, 52). Formerly E. Moreau-Nélaton Collection, Paris.

499 Lot Defending the Angels (IV, 53). P. Thureau-Dangin Collection, Paris.

500 Noli Me Tangere (IV, 54). Van der Waals Collection, Heemstede.

501 The Healing of Tobit (IV, 55). Mme. Pierre Goujon Collection, Paris.

502 View in Gelderland (IV, 56). Comtesse de Béhague Collection, Paris.

503 Saul and His Servants with the Witch of Endor (IV, 57). Bredius Museum, The Hague.

504 Two Studies of Old Men Facing Each Other (IV, 58a). Comtesse de Béhague Collection, Paris.

505 A Farmhouse with a Haystack Between Trees (IV, 58b). Boymans-van Beuningen Museum, Rotterdam.

506 Abraham Before God and the Two Angels (IV, 59). British Museum, London.

507 Abraham Before God and the Two Angels (IV, 60). British Museum, London.

508 Lioness Eating a Bird (IV, 61). British Museum, London.

509 Study of a Chained Lioness Lying Down to the Right (IV, 62). British Museum, London.

510 Four Studies of Lions (IV, 63). British Museum, London.

511 The Holy Family in the Carpenter's Workshop (IV, 64). British Museum, London.

512 Study after Leonardo's "Last Supper" (IV, 65). British Museum, London.

513 Judith Returning in Triumph with the Head of Holofernes (IV, 66). British Museum, London.

514 Houses Among Trees on the Bank of a River (IV, 67). British Museum, London.

515 Village Street Beside a Canal (IV, 68). British Museum, London.

516 Landscape with a Thatched Cottage (IV, 69a). British Museum, London.

517 Farm Buildings near a Canal (IV, 69b). British Museum, London.

518 Landscape with a Cottage, Canal and Trees (IV, 70a). British Museum, London.

519 Cottages with Trees Beside Water and a Hay Barn (IV, 70b). British Museum, London.

520 Four Orientals Seated Beneath a Tree (IV, 71). British Museum, London.

521 Landscape with Cottages, Meadows and a Distant Windmill (IV, 72). British Museum, London.

522 View from near the Anthoniespoort (IV, 73). British Museum, London.

523 The Holy Family (IV, 74). British Museum, London.

524 Diana at Her Bath (IV, 75). British Museum, London.

525 A Woman Sleeping (Hendrickje?) (IV, 76). British Museum, London.

526 A Woman Standing, with a Candle (IV, 77). British Museum, London.

527 Angels Leading Lot and His Family Out of Sodom (IV, 78). British Museum, London.

528 Children Dancing and Making Music Before a Street Door (IV, 79). British Museum, London.

529 ST. PAUL PREACHING AT ATHENS (IV, 80). British Museum, London.

530 THE SACRIFICE OF ABRAHAM (IV, 81). British Museum, London.

531 CHRIST WALKING ON THE WAVES (IV, 82). British Museum, London.

532 STUDIES FOR A BEHEADING OF ST. JOHN THE BAPTIST (IV, 83). British Museum, London.

533 STUDY OF AN ORIENTAL STANDING (IV, 84). British Museum, London.

534 FEMALE NUDE SEATED AND BENDING FORWARD (IV, 85). British Museum, London.

535 LIFE STUDY OF A MAN LYING ON HIS BACK WITH HIS HANDS IN A PRAYING GESTURE (IV, 86). British Museum, London.

536 STUDY OF A YOUNG MAN ASLEEP (IV, 87). British Museum, London.

537 PORTRAIT OF A LADY HOLDING A FAN (IV, 88). British Museum, London.

538 WOMAN WEARING A COSTUME OF NORTH HOLLAND (IV, 89a). British Museum, London.

539 VIEW OVER THE AMSTEL FROM THE RAMPART (IV, 89b), Rosenwald Collection, National Gallery of Art. Washington, D.C.

540 THE DEPARTURE OF BENJAMIN FOR EGYPT (IV, 90). Teyler Museum, Haarlem.

541 ESAU SELLING HIS BIRTHRIGHT TO JACOB (IV, 91). Rembrandt Huis, Amsterdam.

542 VIEW OF THE GARDENS OF THE PAUW FAMILY ON THE AMSTEL (IV, 92). Rijksprentenkabinet, Amsterdam.

543 THE LORD APPEARING TO JOSHUA (JOSHUA 5, 13) (IV, 93). Rijksprentenkabinet, Amsterdam.

544 STUDY FOR AN "ECCE HOMO" (IV, 94). Rijksprentenkabinet, Amsterdam.

545 THE "KLOVENIERSDOELEN" AND THE TOWER "SWIJGHT UTRECHT" AT AMSTERDAM (IV, 95). A. Boerlage-Koenigs Collection, Amsterdam.

546 THE DAUGHTERS OF CECROPS DISCOVER ERICHTHONIUS (IV, 96). Museum, Groningen.

547 THE DISMISSAL OF HAGAR (IV, 97). Rijksprentenkabinet, Amsterdam.

548 STUDIES OF THREE FIGURES (IV, 98). Museum, Groningen.

549 THE ANGEL APPEARING TO HAGAR IN THE WILDERNESS (IV, 99). Rijksprentenkabinet, Amsterdam.

550 DANIEL IN THE LIONS' DEN (IV, 100). Museum, Groningen.

The Plates

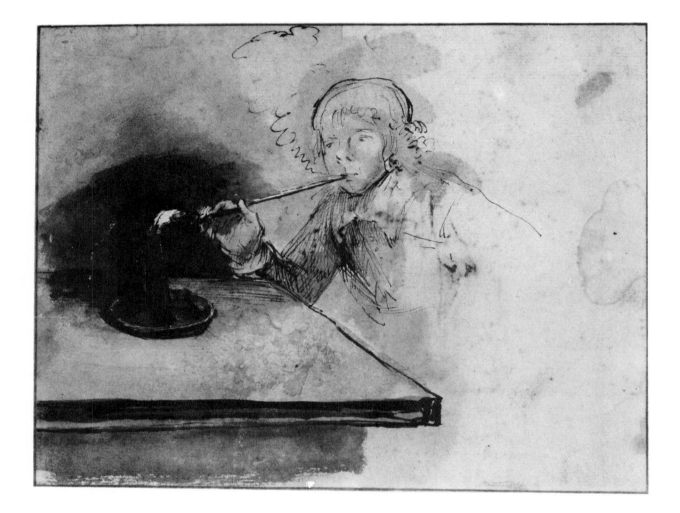

301 (*II, 71*). *A Boy Lighting His Pipe at a Candle.* (*Rijksprentenkabinet, Amsterdam*)
Pen and wash in bistre, grey wash: 131 × 170 mm.
Too feeble to be considered authentic. Henkel (1943, no. 86) concludes it is a school piece made around 1635.

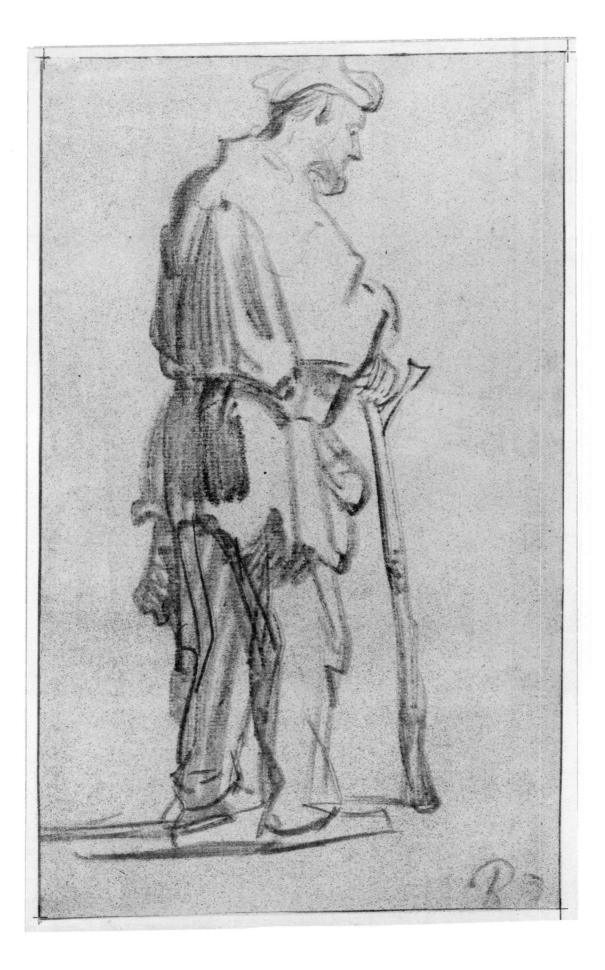

302 (*II, 72*). *Standing Beggar Turned to the Right.* (*Rijksprentenkabinet, Amsterdam*)
Black chalk: 292 × 170 mm. Initial in lower right corner: R.
About 1628–29. On the verso, a drawing of the back of a man. Probably from the same sketchbook as the following drawing.

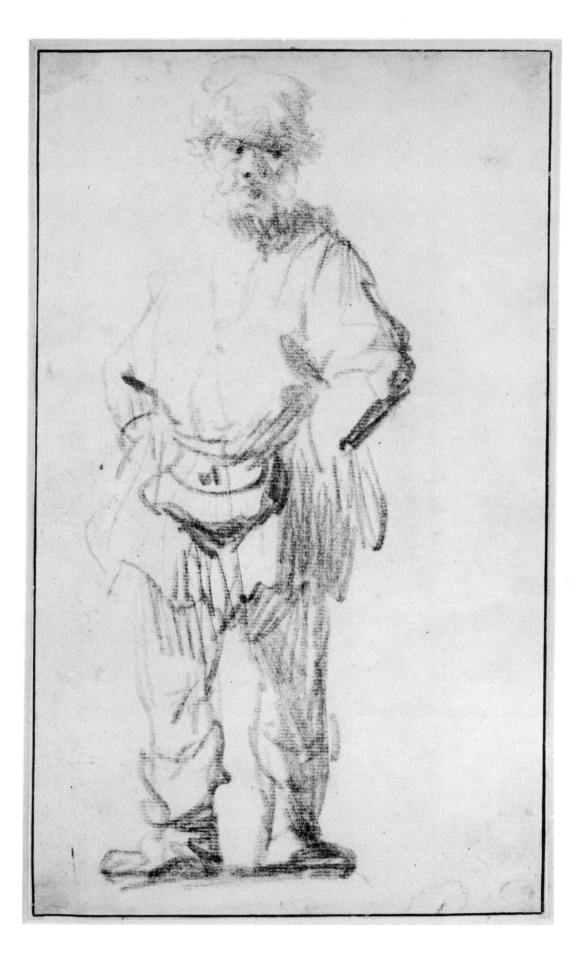

303 (*II, 73*). *Standing Beggar with a Leather Bag.* (*Rijksprentenkabinet, Amsterdam*)
Black chalk: 290 × 169 mm. Initial in lower right corner: R.
About 1628–29. Probably from the same sketchbook as the preceding drawing.

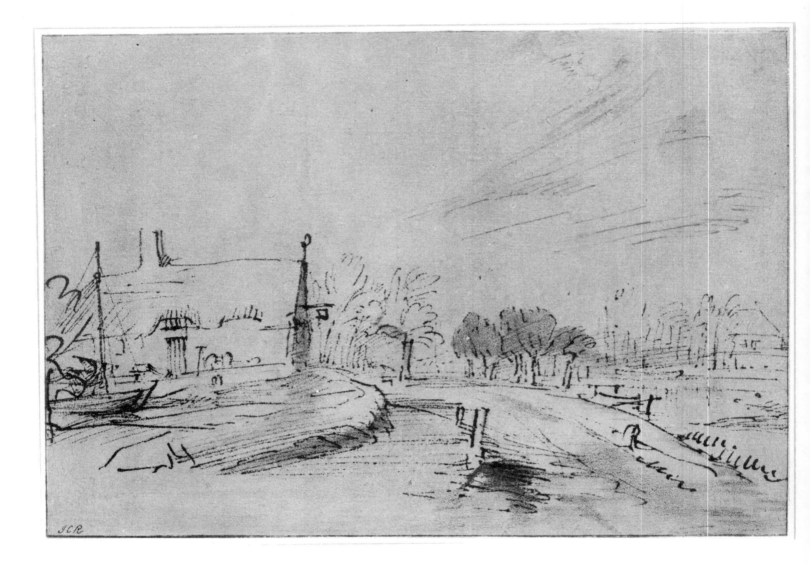

304 (*II, 74*). *Landscape with an Inn, and a Sailboat on the Right.* (*Rijksprentenkabinet, Amsterdam*)
Pen and bistre, wash with Indian ink, on brownish paper: 140 × 190 mm.
About 1650. The grey washes and lines in the sky are later additions.

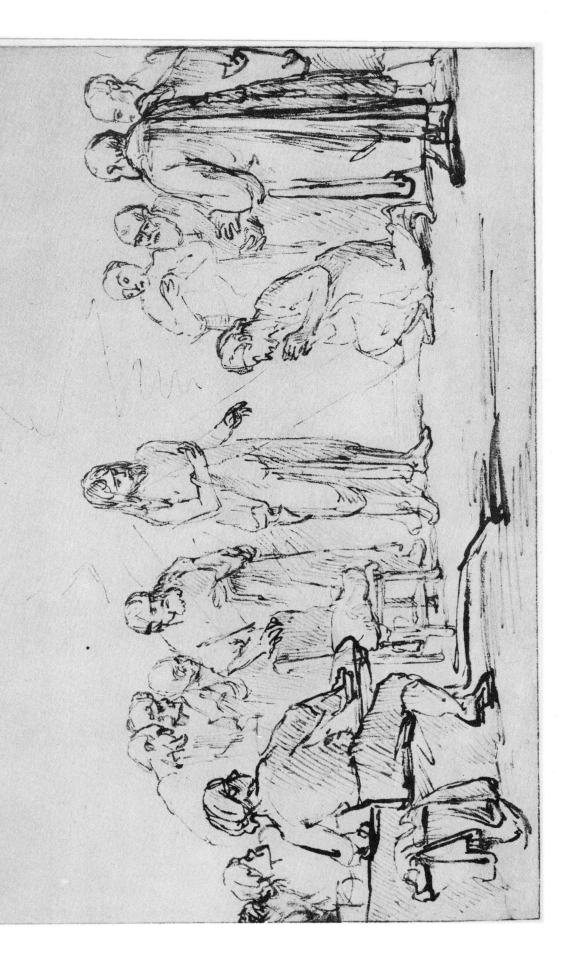

305 (II, 75). *The Incredulity of St. Thomas.* (Rijksprentenkabinet, Amsterdam)
Reed pen and bistre: 175 × 270 mm.

About 1650. Some hatchings in sepia by another hand. The drawing's stiff and awkward passages lead Lugt (1933, no. 1142) and Henkel (1943, p. 97, no. 10) to attribute the sheet tentatively to Nicolaes Maes. Benesch (869) defends the old attribution to Rembrandt. He notes that the later additions and the use of a delicately handled reed pen—an instrument Rembrandt only begins to use at this time and which he has not yet completely mastered—account for the wooden quality of the figures. Werner Sumowski, "Zwei Rembrandt—Originale," Pantheon, 22, 1964, pp. 22 ff., calls it a copy after another version in a Dutch private collection. He ascribes the latter to Rembrandt and dates it in the late 'forties.

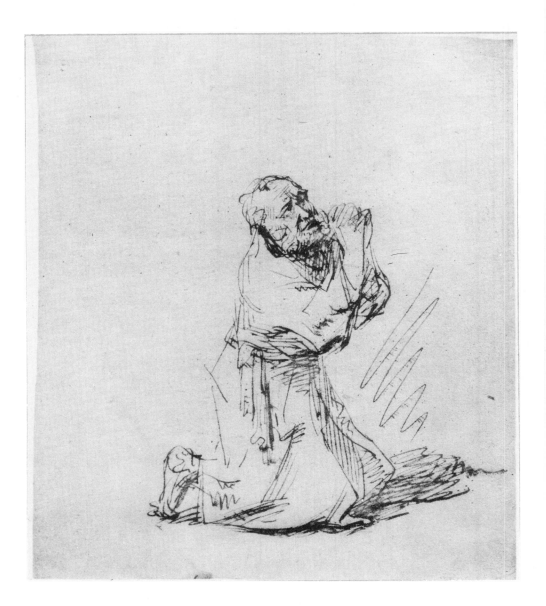

306 (*II, 76a*). *St. Jerome Praying.* (*Rijksprentenkabinet, Amsterdam*)
Pen and bistre: 152 × 130 mm.
Preliminary study in reverse for the figure of St. Jerome in the 1632 etching (Bartsch 101).

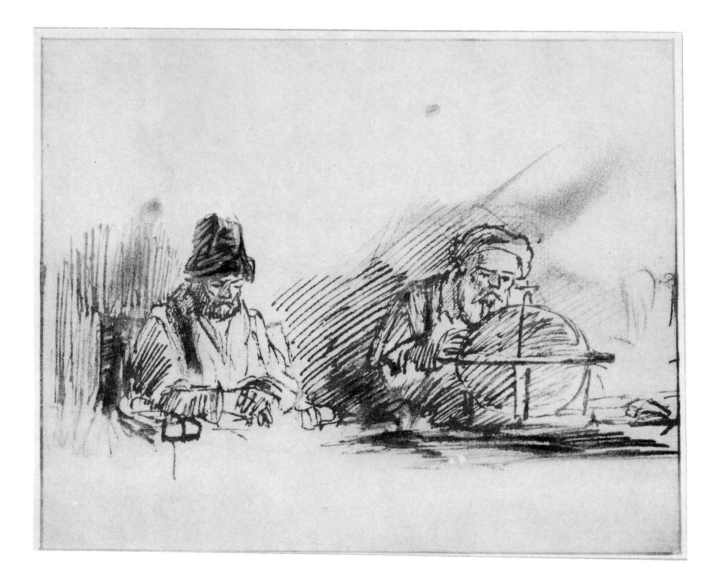

307 (*II, 76b*). *Two Old Men, One Seated in an Armchair, the Other with a Globe. (Rijksprentenkabinet, Amsterdam)*

Reed pen and wash in bistre: 145 × 175 mm.

About 1652. Henkel (1943, no. 29) endorses the suggestion that the men are the Greek philosophers Democritus and Heraclitus, but neither the expressions nor attitudes of these old men suggest the philosopher who mocked the folly of the world and the one who cried at its misery. Though the figures do not appear to be conceived as two independent studies, they do not form a cohesive group—a rare note in Rembrandt's authentic drawings.

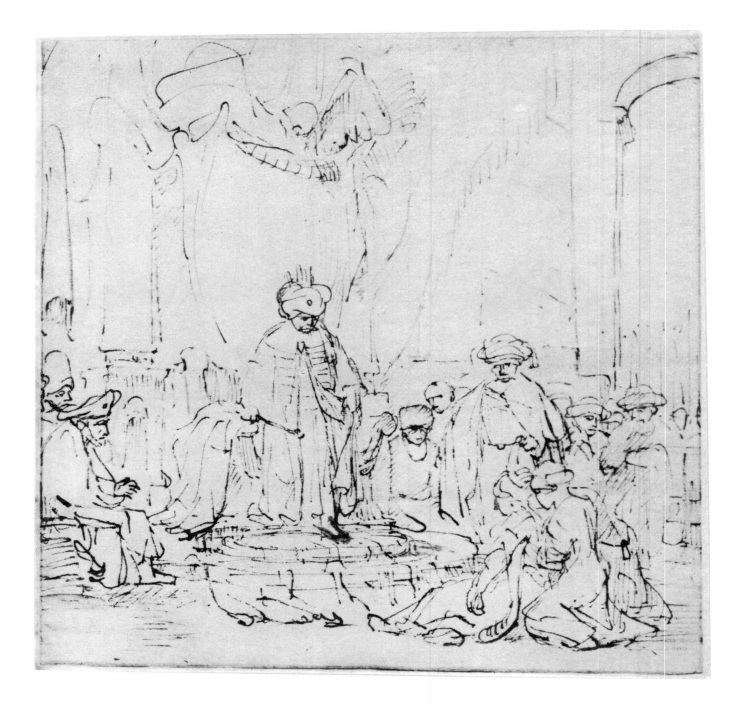

308 (*II, 77*). *Esther Fainting Before Ahasuerus.* (*Rijksprentenkabinet, Amsterdam*)

Pen and bistre: 175 × 177 mm.

About 1645–50. A copy (sale Frankfurt-am-Main, 17 June 1911, no. 415) shows that the drawing has been cropped at the top and on the left.

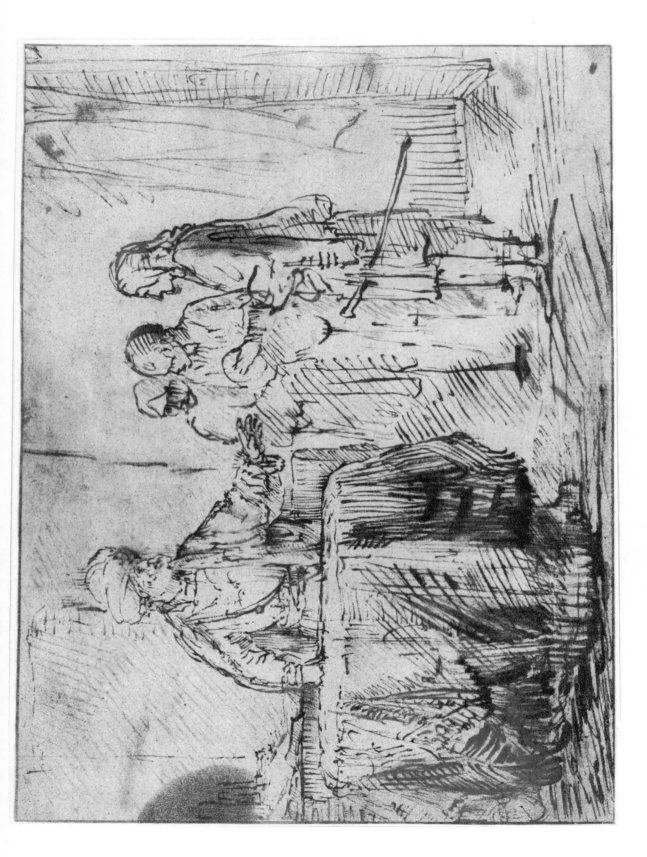

309 (II, 78). *The Unmerciful Servant (Matthew 18, 32). (Rijksprentenkabinet, Amsterdam)*

Pen and wash in bistre: 162 × 218 mm.

Related to the painting attributed to Rembrandt in the Wallace Collection called The Centurion Cornelius (Acts 10, 1–8).
Both the painting and drawing have been ascribed to Barent Fabritius (see Henkel, 1943, p. 80, no. 2). D. Pont (Barent Fabritius,
The Hague, 1958, p. 21, note 2, and p. 154) suggests the drawing may represent Joseph Threatened by His Brothers, and that Carel
Fabritius, not Barent, was its author.

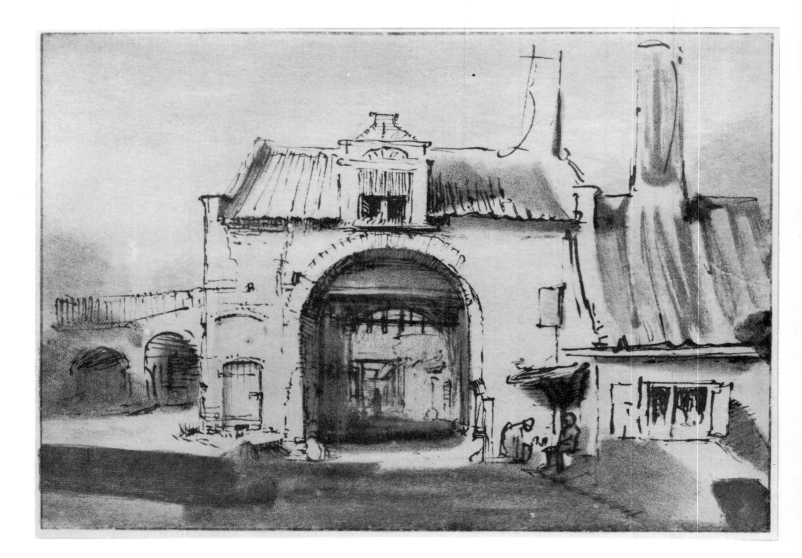

310 (*II, 79*). *A City Gate* (*perhaps Rhenen*). (*Rijksprentenkabinet, Amsterdam*)

Pen and washes in bistre, Indian ink washes: 139 × 197 mm.

*About 1644–48. Van Regteren Altena (Catalogue, Rome, 1951, Mostra . . . di Rembrandt, no. 77) suggests
that the drawing was made in 1644; it also can be related to the group cited 72 (I, 72).*

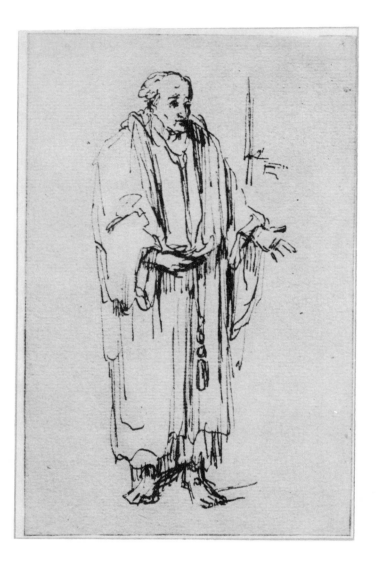

311 (*II, 80a*). *An Old Man Standing.* (*Rijksprentenkabinet, Amsterdam*)

Pen and bistre: 140 × 88 mm.

Erroneously listed by Hofstede de Groot as a companion piece to the following sheet. The drawing is not by Rembrandt, but a typical work by Philips Koninck (see Gerson, 1936, p. 158, Zeichnung 206).

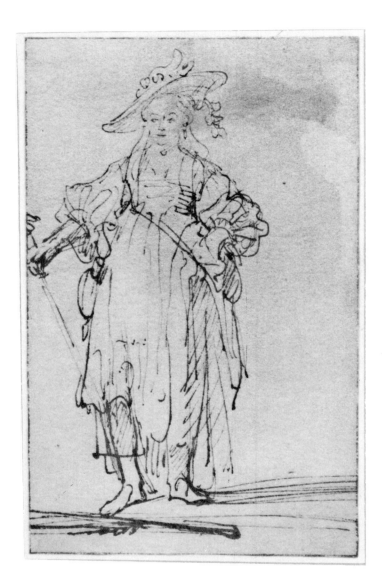

312 (*II, 80b*). *Young Woman with a Large Hat and a Walking Stick.* (*Rijksprentenkabinet, Amsterdam*)

Pen and bistre: 144 × 88 mm.

In spite of a slackness of the line in some passages the quality appears to be too high for a pupil's work. Probably a study for a Flora *made around 1633–35. Also related to the drawings of actors made in the mid–1630's. Henkel (1943, no. 12) defends the attribution to Rembrandt. Not listed by Benesch.*

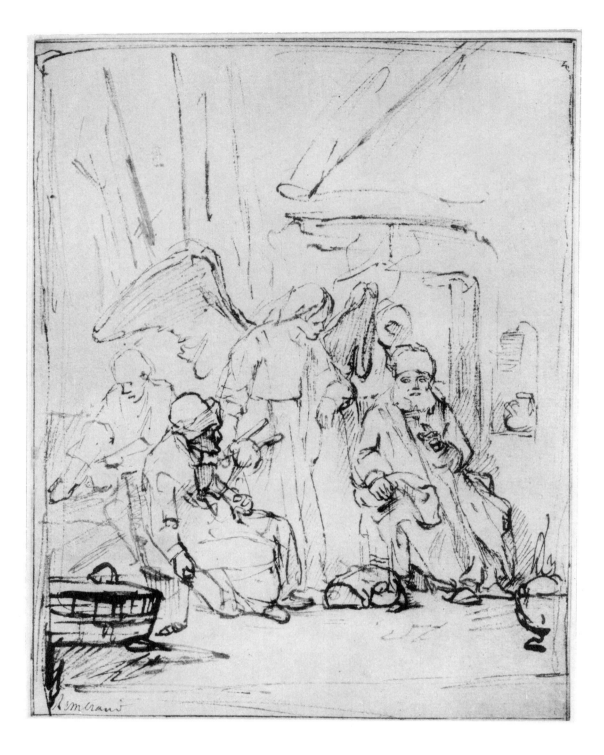

313 (*II, 81*). *The Angel in the House of Tobit.* (*Rijksprentenkabinet, Amsterdam*)

Reed pen and bistre: 184 × 142 mm. Inscribed by a later hand: Rembrand.

This sheet shows the style of the early 'fifties. Another version, in the Boymans-van Beuningen Museum,
Rotterdam, has been published as the original by Werner Sumowski, "Zwei Rembrandt—Originale,"
Pantheon, *22, 1964, pp. 29 ff.*

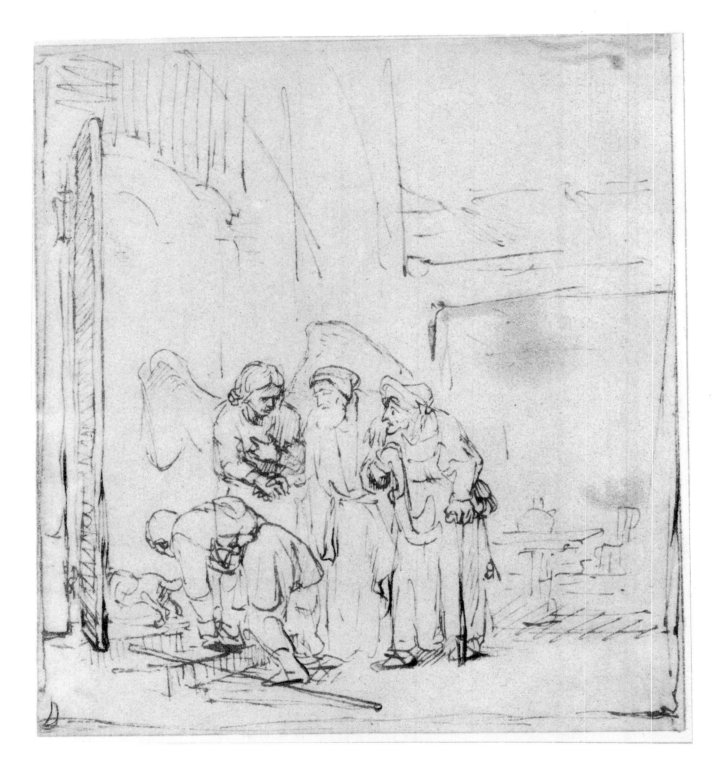

314 (*II, 82*). *Departure of the Young Tobias.* (*Rijksprentenkabinet, Amsterdam*)

Pen and bistre: 191 × 170 mm.

Benesch (C45) was the first to recognize that this is a copy after an unknown original which he dates about 1646–47. The weakness of the drawing of the furniture in the background gives the copyist away.

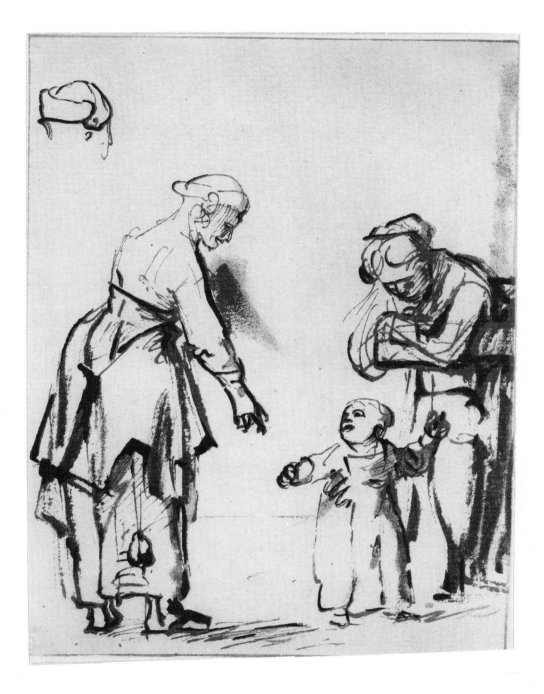

315 (*II, 83*). *Two Women with a Child Learning to Walk.* (*Rijksprentenkabinet, Amsterdam*)

Pen and bistre: 168 × 127 mm. Grey washes added later.

About 1635–40. The drawing has been called a companion piece to the following sheet; both are virtually the same size.

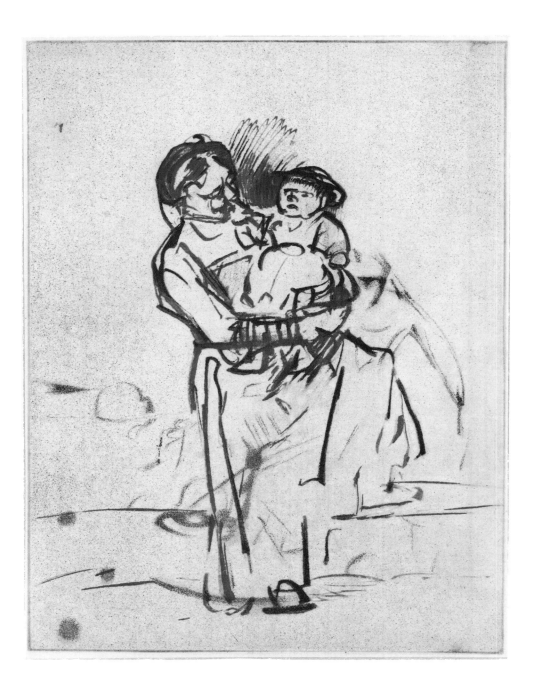

316 (*II, 84*). *A Woman Holding a Child, Her Left Foot on a Stair.* (*Rijksprentenkabinet, Amsterdam*)
Pen and bistre: 168 × 126 mm.

About 1635–40. A quick sketch similar to two drawings in Stockholm (135 [I, 131] and 234 [II, 17]); also see
315 (II, 83) and 337 (III, 5). On the verso, a study for a composition of Mordecai Kneeling Before Esther and
Ahasuerus. *For the argument that neither the recto nor verso of this sheet is by Rembrandt see Benesch (A63).*

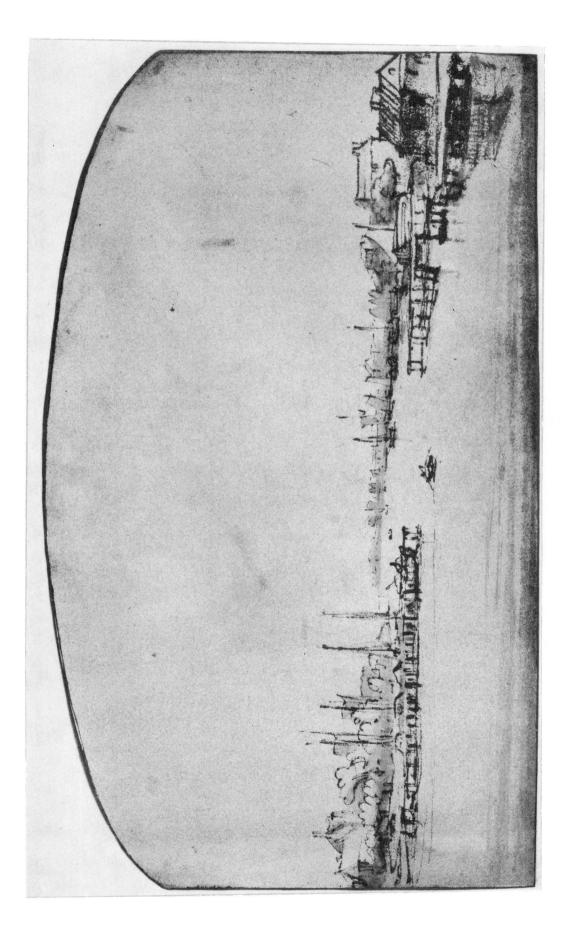

317 (II, 85). *View Over the Anstel from the Blauwbrug in Amsterdam. (Rijksprentenkabinet, Amsterdam)*

Pen and wash on vellum: 132 × 232 mm.

About 1648–50. A fine example of the space, light and fresh air which fill Rembrandt's mature landscape drawings.

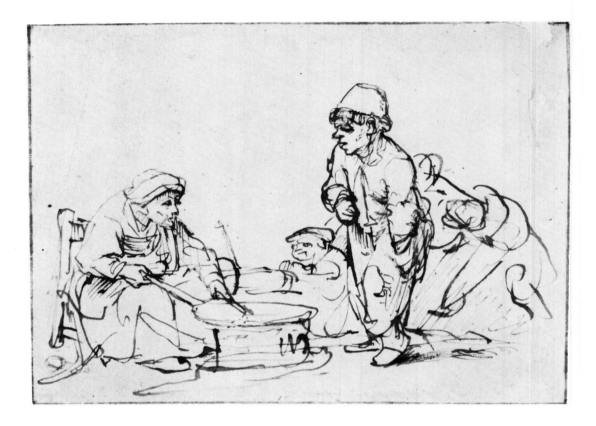

318 (*II, 86*). *The Pancake Woman. (Rijksprentenkabinet, Amsterdam)*

Pen and bistre: 107 × 142 mm.

About 1635. Related to the etching of the same year (Bartsch 124). Another drawing of the same subject is at the Louvre, Paris (347 [III, 15]).

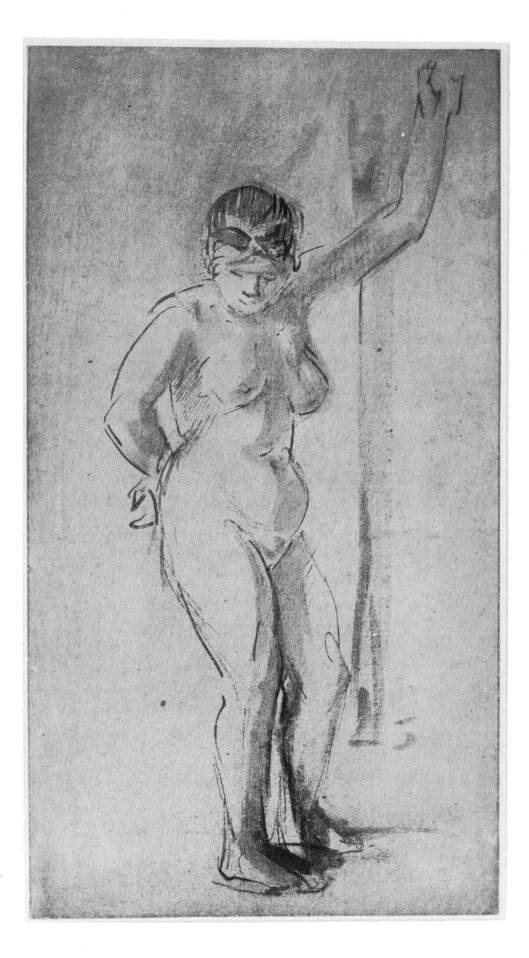

319 (*II, 87*). *Standing Female Nude.* (*Rijksprentenkabinet, Amsterdam*)
Pen and wash in bistre: 270 × 140 mm.
About 1655.

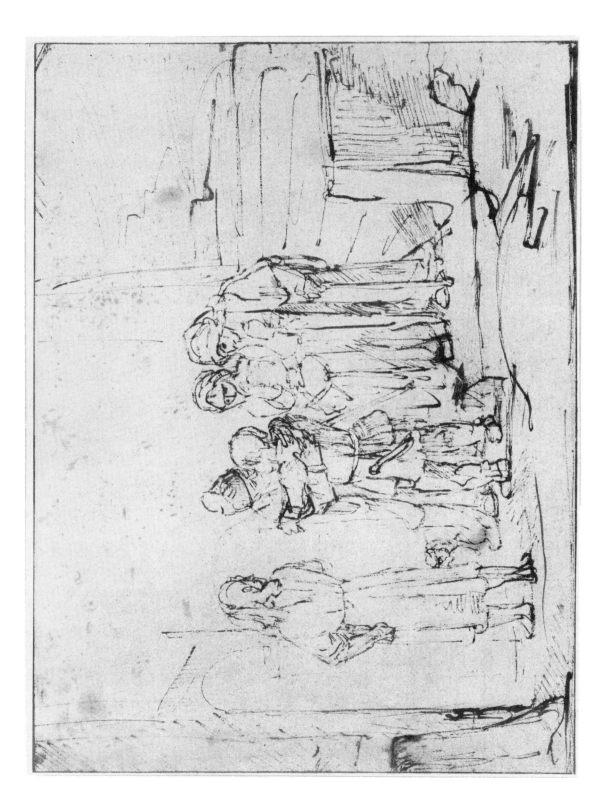

320 (II, 88). *Raguel Welcomes Tobias.* (Rijksprentenkabinet, Amsterdam)

Reed pen and bistre: 192 × 271 mm.

About 1650–52. See Henkel (1943, p. 31, no. 62) for convincing support of the argument first put forth in Wickhoff's *Seminarstudien* (Innsbruck, 1906, p. 22) that the drawing represents old Raguel greeting his nephew Tobias, watched by his wife and daughter, as related in Tobit 7, 1–8. Benesch (871) also accepts this interpretation. Hans Martin Rotermund ("Unidentifizierte bzw. missverstandene Zeichnungen Rembrandts zu biblischen Szenen," *Wallraf-Richartz-Jahrbuch,* XXI, 1959, p. 194) suggests it shows Tobias' departure from Raguel, and not his arrival, because of the sad mien of the women. Rotermund argues that according to the story when Tobias arrived he was received gladly. However, in support of the interpretation accepted here it should be noted that Tobias' arrival was not recorded as an event of pure joy. When Tobias arrived at Raguel's house he was told of his father's blindness, and when Raguel "heard that Tobit was blind, he was sorrowful, and wept. And likewise Edna his wife and Sara his daughter wept." Only after this exchange did his hosts receive him gladly and kill a ram of the flock, and set store of meat before them.

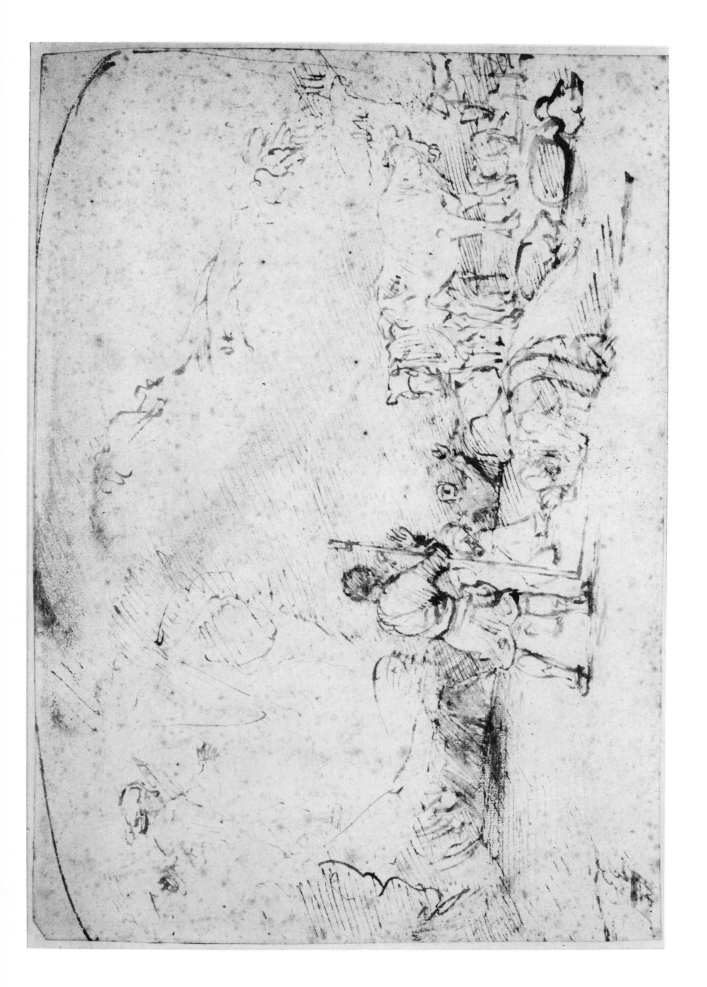

321 (II, 89). *The Annunciation to the Shepherds.* (*Rijksprentenkabinet, Amsterdam*)
Pen and wash in bistre: 188 × 280 mm.

About 1655.

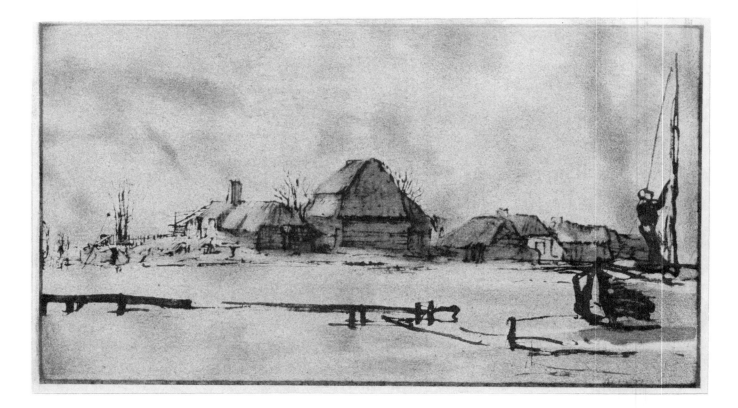

322 (*II, 90*). *Winter Landscape with a Farm.* (*Rijksprentenkabinet, Amsterdam*)
Pen and washes in bistre, Indian ink: 103 × 180 mm. Inscribed by a later hand: Rembrand.
About 1648–50.

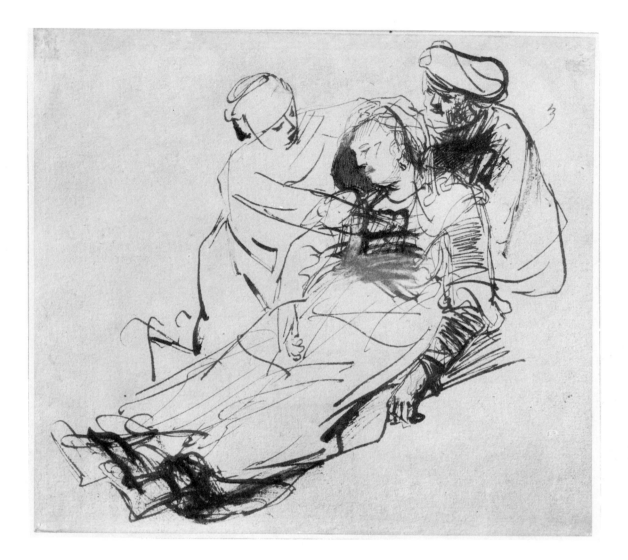

323 (*II, 91*). *A Woman in a Faint, Supported by Two Figures.* (*Rijksprentenkabinet, Amsterdam*)
Pen in bistre, white body color: 141 × 151 mm.

About 1635. Valentiner (Jahrbuch für Kunstwissenschaft, *1* [*1923*], *p. 277*), *calls it a study of a woman in labor and connects it with Rembrandt's numerous studies of the life of women. The drawing has also been associated with a study for a Death of Lucretia and a Mary at the Foot of the Cross (see Henkel, 1943, no. 11). For the view that it is not authentic, but the work of a pupil based on Rembrandt's drawing of a Crucifixion of about 1647, see Benesch (C22).*

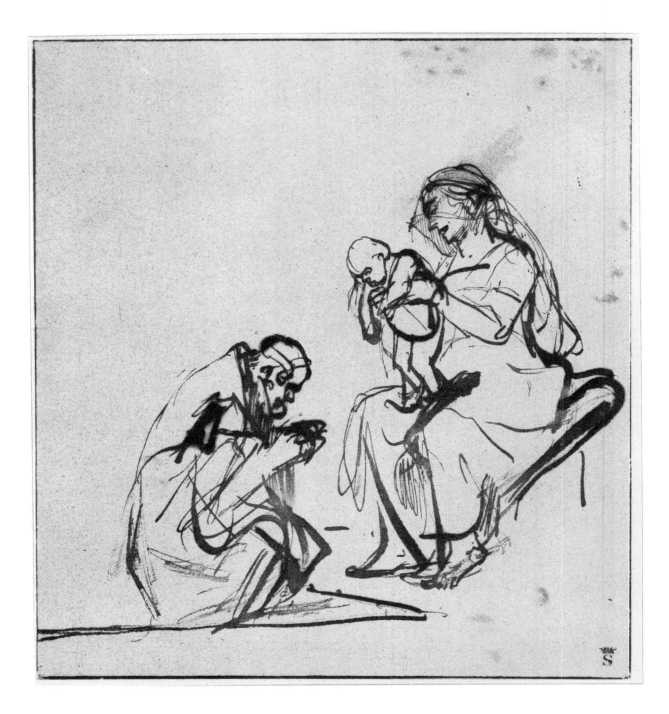

324 (*II, 92*). *The Virgin Showing the Infant Christ to One of the Magi.* (*Rijksprentenkabinet, Amsterdam*)
Pen and bistre: 178 × 160 mm.
About 1635. Related to 116 (I, 114) and 202 (I, 188a).

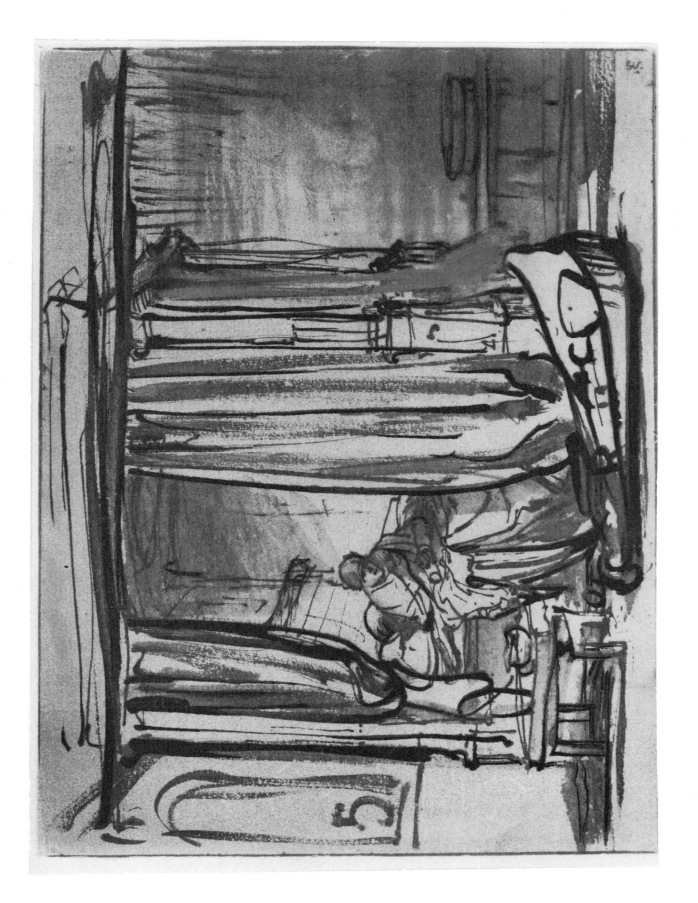

328 (II, 96). Saskia's Lying-in Room. (Rijksprentenkabinet, Amsterdam)

Pen and brush in bistre, washes, white body color: 177 × 240 mm.

About 1636-39. Valentiner wrote that the drawing and one now in the Fogg Art Museum, Harvard University, Cambridge, Massachusetts (Benesch 413), were done in Rembrandt's house in the Nieuwe Doelenstraat before the artist moved to his great house in the Jodenbreestraat in 1639 (cf. W. R. Valentiner, "Aus Rembrandts Häuslichkeit," Jahrbuch für Kunstwissenschaft, 1 [1923]).

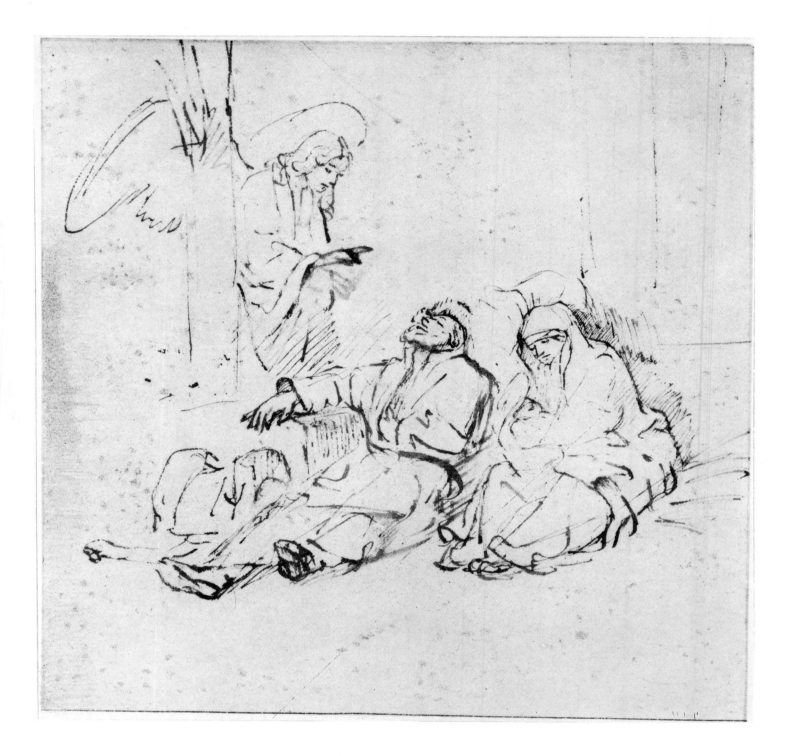

327 (*II, 95*). *The Angel Appearing to Joseph in a Dream.* (*Rijksprentenkabinet, Amsterdam*)
Pen and bistre: 179 × 181 mm.
About 1652.

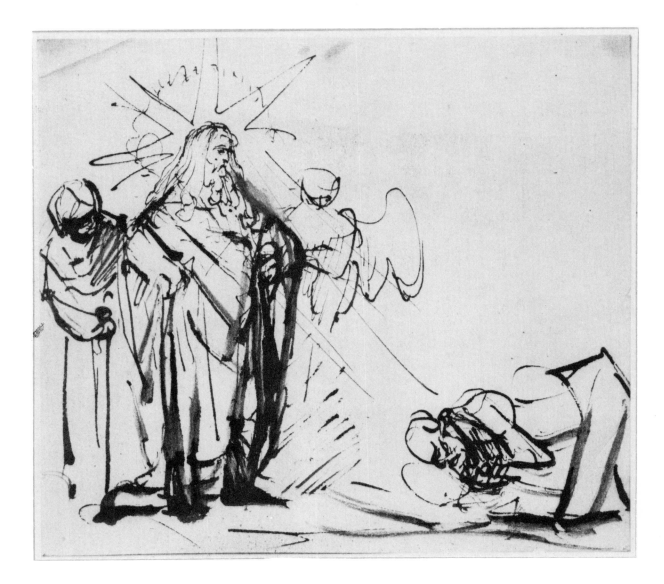

326 (*II, 94*). *God Appearing to Abraham.* (*Rijksprentenkabinet, Amsterdam*)

Pen and bistre: 154 × 159 mm.

About 1647–50. The subject, attribution and date have been the subject of controversy (see Henkel, 1943, no. 53),
but there is nothing in the style or execution that is inconsistent with Rembrandt's drawings of the late 'forties.
Not listed in Benesch, but he refers to it as a school piece (see his note to 1056).

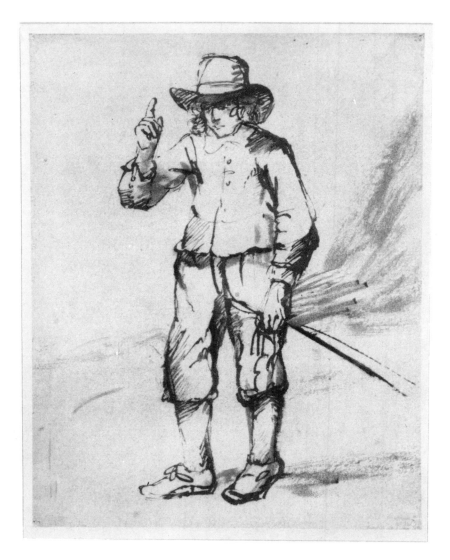

325 (*II, 93*). *Standing Man with His Right Hand Raised and a Whip(?) in His Left. (Rijksprentenkabinet, Amsterdam)*

Pen and bistre: 135 × 100 mm.

The work of a pupil or follower working in Rembrandt's style of about 1650. Not listed in Benesch.

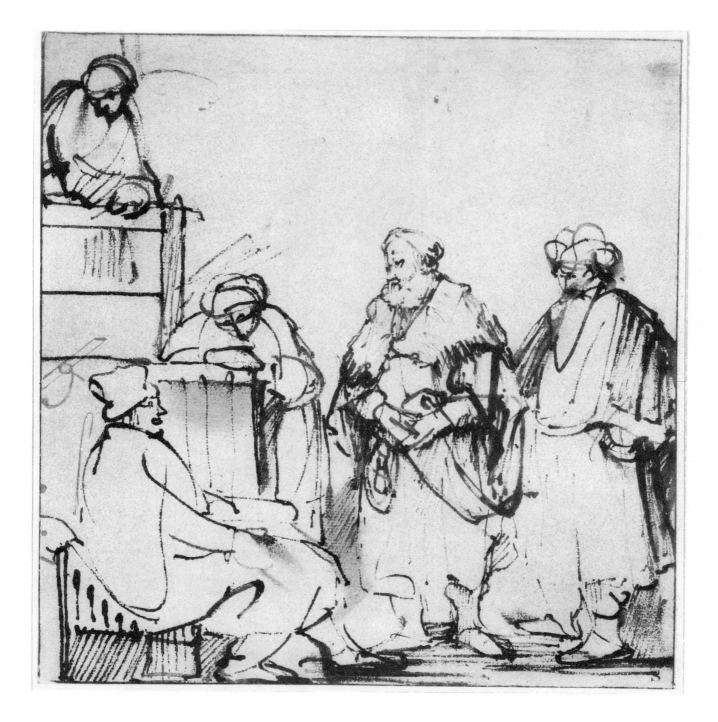

329 (II, 97). *Job and His Friends*(?). (*Rijksprentenkabinet, Amsterdam*)

Pen in bistre, on the left a few traces of red crayon: 178 × 166 mm.

Henkel (1943, p. 85, no. 3) discusses the difficulties of determining the subject and author of this school drawing.

His conclusion that it is a work by Arent de Gelder is not entirely satisfactory.

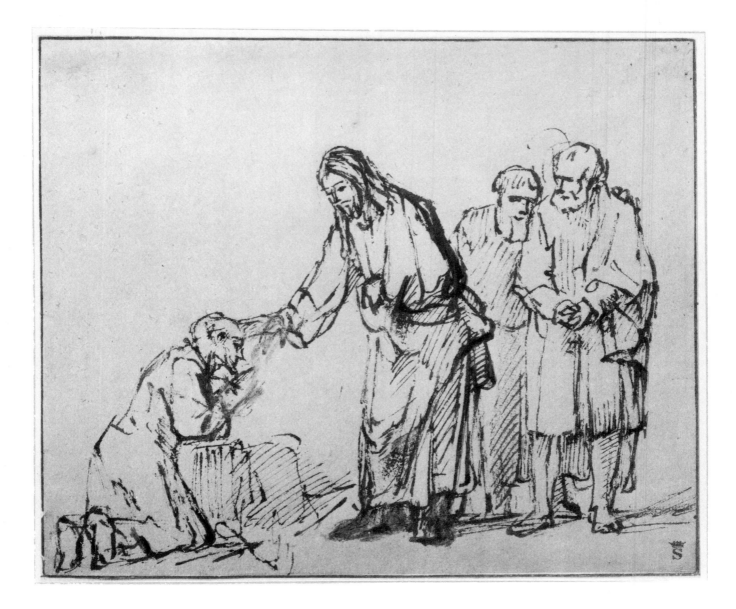

330 (*II, 98*). *Christ Healing a Leper.* (*Rijksprentenkabinet, Amsterdam*)

Pen and bistre, white body color: 147 × 172 mm.

About 1657–60. Christ's hand was originally grasped by the sick man's hand. Rembrandt changed this in favor of showing Christ's hand upon the leper's forehead. The change clarified the scene: the laying on of His hand heals.

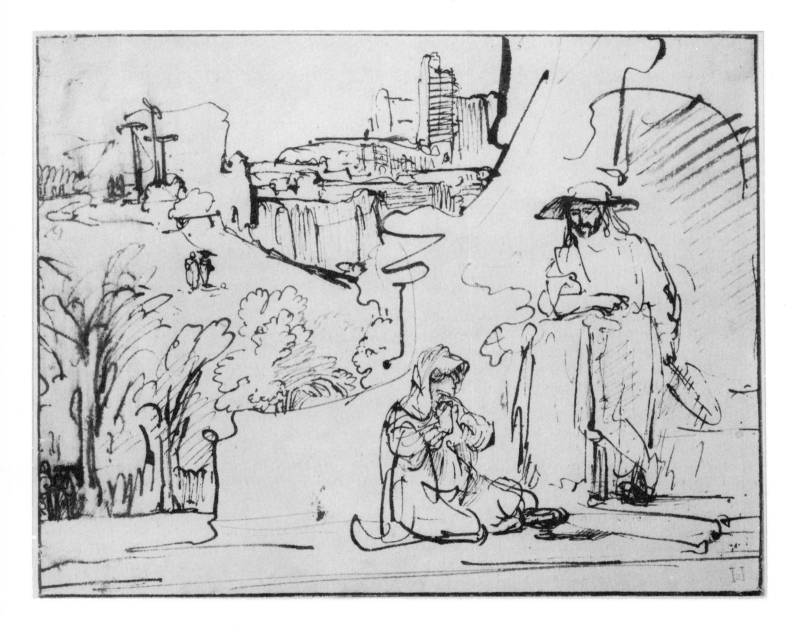

331 (*II, 99*). *Christ Appearing as a Gardener to Mary Magdalen.* (*Rijksprentenkabinet, Amsterdam*)
Pen and bistre: 152 × 190 mm.

Related by some Rembrandt students to the painting of 1638 at Buckingham Palace (Bredius 559). However, Benesch dates it about 1643, and Rosenberg (1959) agrees that it must be later than 1638 because of the broader composition and the relaxation of the baroque features characteristic of the late 1630's.

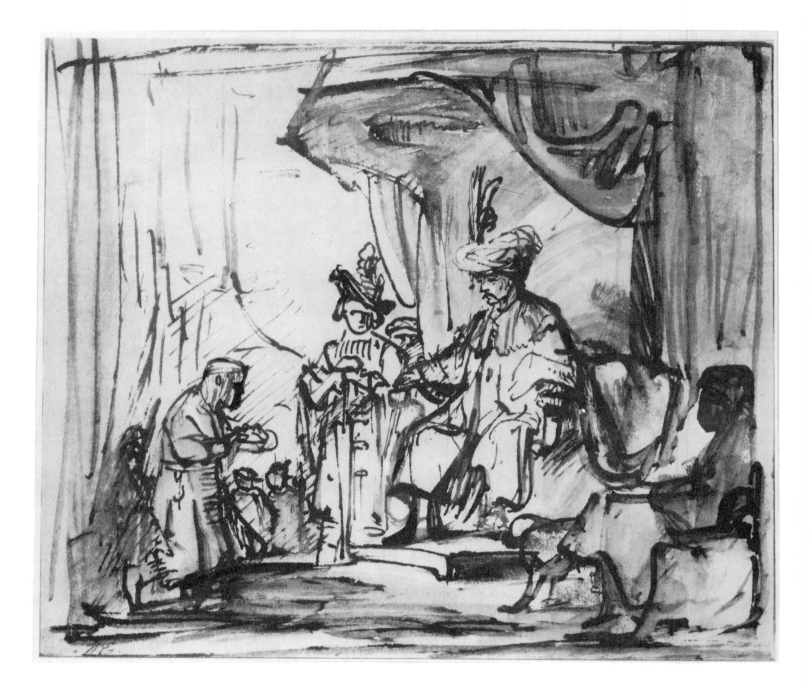

332 (*II, 100*). *The Messenger with the Crown of Saul Before David.* (*Rijksprentenkabinet, Amsterdam*)
Pen and brush in bistre, wash: 169 × 194 mm.

About 1640–43. The drawing has also been interpreted as Ahasuerus Orders Haman to Honour Mordecai in
Public (*Valentiner 199*) *but the crown in the kneeling figure's hands supports the view that the drawing shows the
passage, II Samuel 1, 10, when the messenger proclaims himself to David as the man who slew Saul because he was
sure that Saul "could not live after that he was fallen: and I took the crown that was upon his head, and the
bracelet that was on his arm, and have brought them hither unto my lord."*

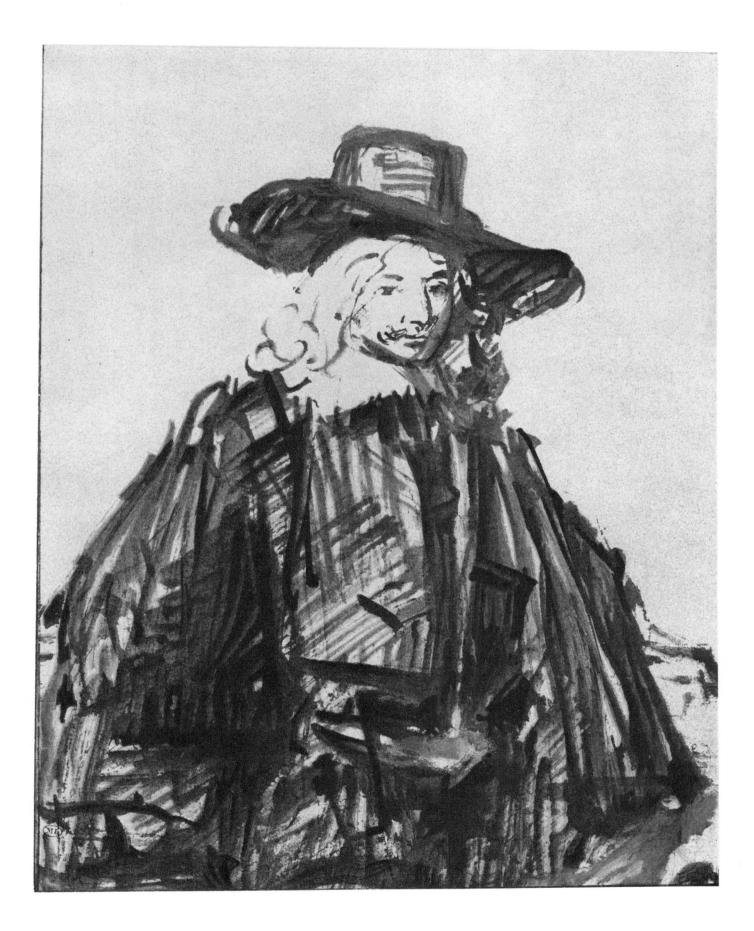

333 (III, 1). *Portrait of a Man.* (Louvre, Paris)

Reed pen and bistre, white body color: 247 × 192 mm.

About 1660–65. This beautiful late drawing shows Rembrandt's reed pen at its boldest. Extraordinary is the contrast between the large dark areas of the body and hat, and the few touches of the blunt pen which suggest light glowing on the sitter's face, blond hair and white collar. See 334 (III, 2) for the verso.

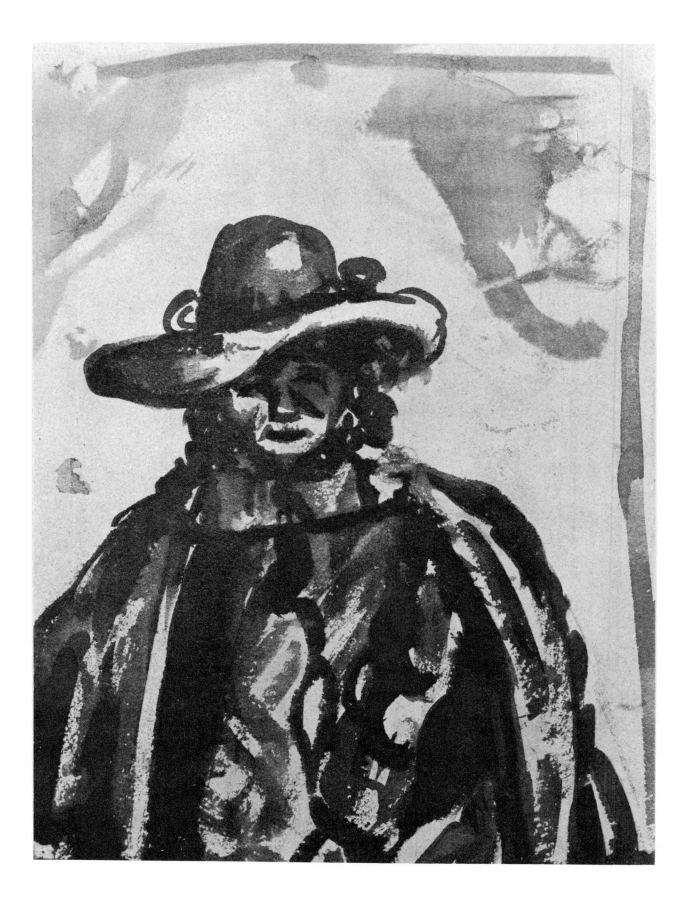

334 (III, 2). *Portrait of a Man.* (*Louvre, Paris*)
Brush and ink: 247 × 192 mm.
Verso of 333 (III, 1). A miserable imitation of Rembrandt's late style.

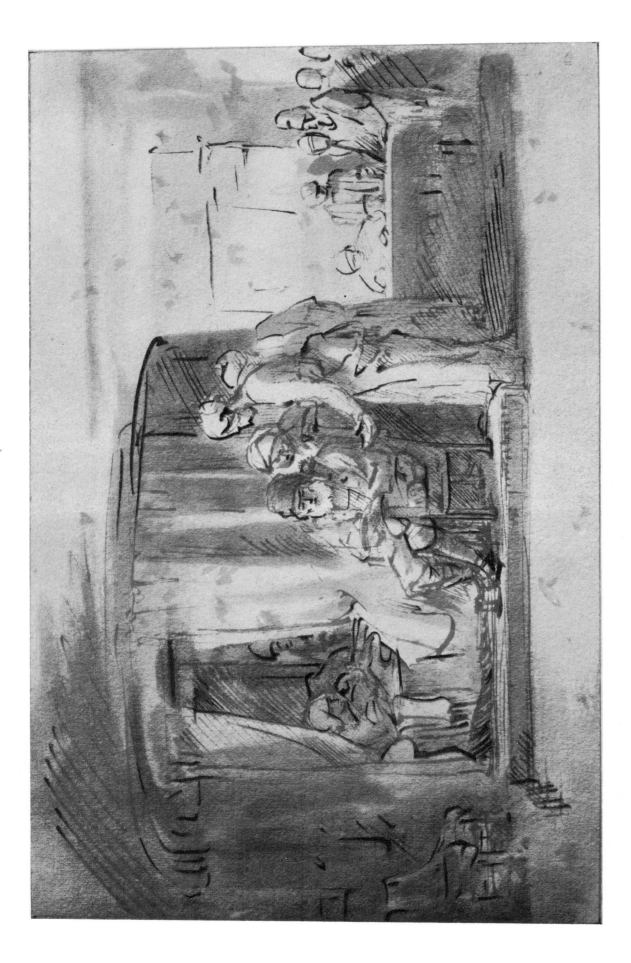

335 (III, 3). *The Naming of St. John the Baptist. (Louvre, Paris)*

Pen and wash in bistre and Indian ink: 199 × 314 mm. Inscribed by a later hand: Rembrant.

About 1655. The monumental composition recalls the drawings made of Saskia in bed during the late 1630's; it is noteworthy that Hendrickje gave birth to a daughter Cornelia in 1654. The chiaroscuro effect is softer and more vibrant than in earlier drawings of scenes in an interior.

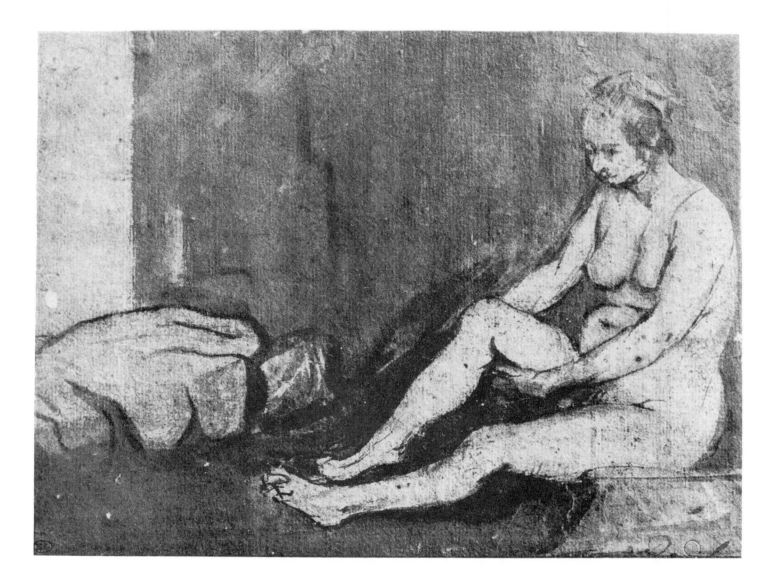

336 (*III, 4*). *Female Nude Seated on a Stool, Turned to the Left.* (*Louvre, Paris*)

Pen and wash in bistre: 145 × 190 mm.

It is difficult to distinguish Rembrandt's touch in this drawing which has been disfigured by a later hand. However, both Lugt (1933, no. 1189) and Benesch (1129), who note that the drawing has been reworked, accept the sheet.

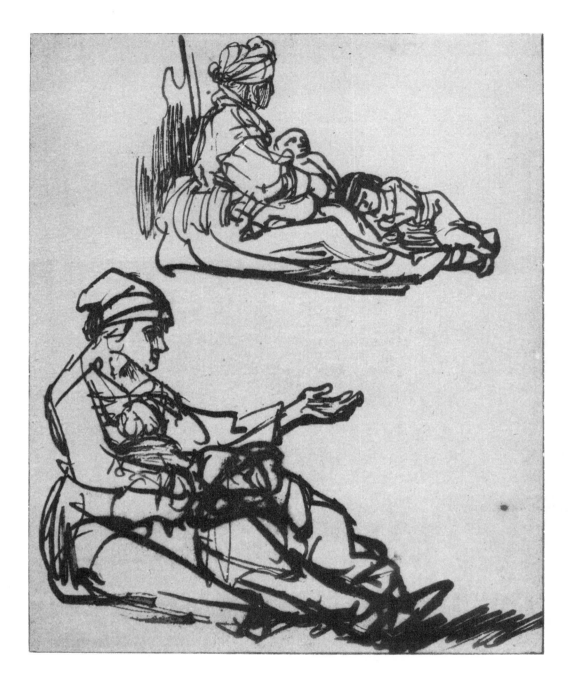

337 (III, 5). *Two Studies of a Begging Woman Seated with Two Children. (Louvre, Paris)*
Pen and ink: 175 × 140 mm.
About 1635–40. Related to 135 (I, 131); 234 (II, 17); 316 (II, 84).

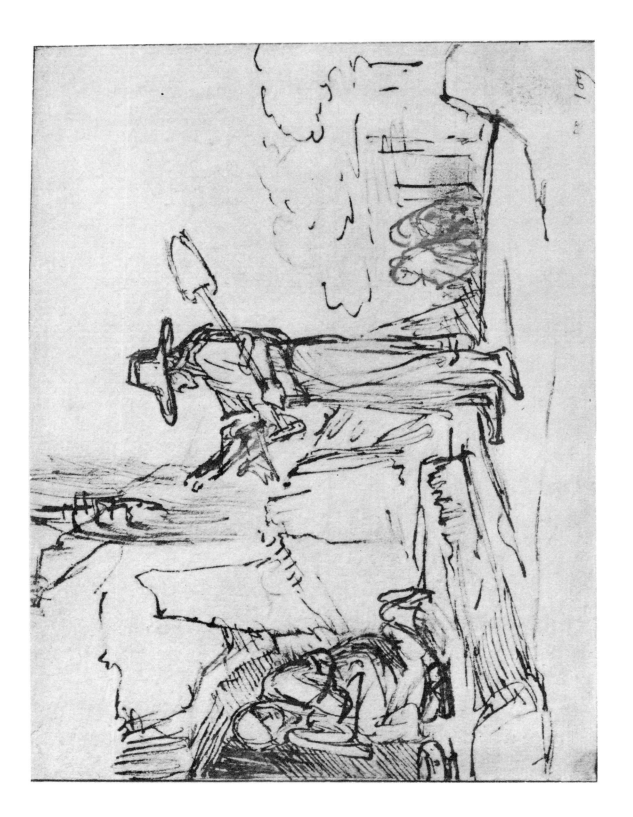

338 (III, 6). *Christ Appearing as a Gardener to Mary Magdalen. (Louvre, Paris)*

Pen and bistre, white body color: 155 × 210 mm.

About 1650. Hofstede de Groot, in the first edition of this work, erroneously considered this drawing a sketch for the 1638 painting now at Buckingham Palace (Bredius 559).

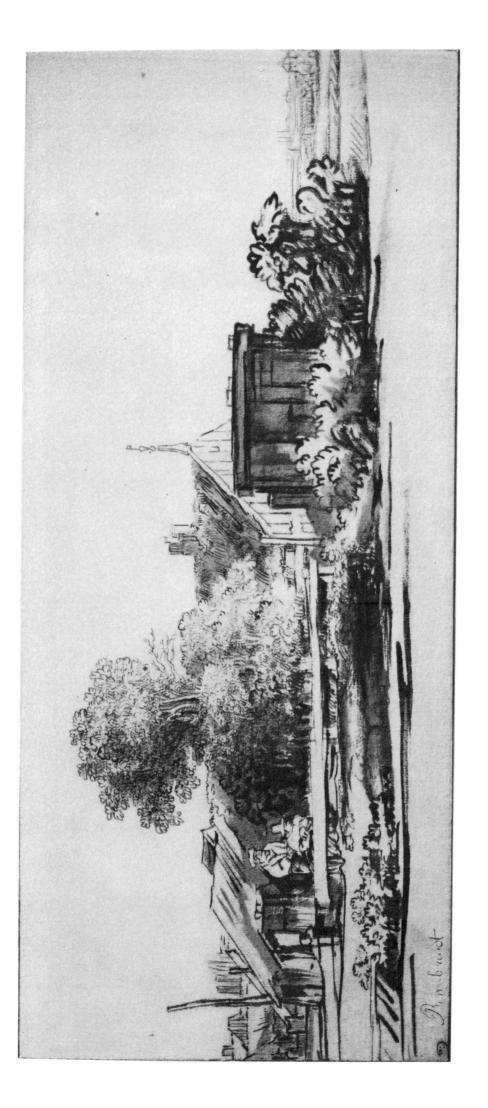

339 (III, 7). *Houses Amidst Trees and Shrubs.* (*Louvre, Paris*)

Pen and wash in bistre, white body color: 141 × 342 mm.

Not by Rembrandt. Both Philips Koninck and his brother Jacob made drawings in this manner; see Lugt (1933, no. 1345) and H. Gerson (1936, p. 146, Zeichnung 74).

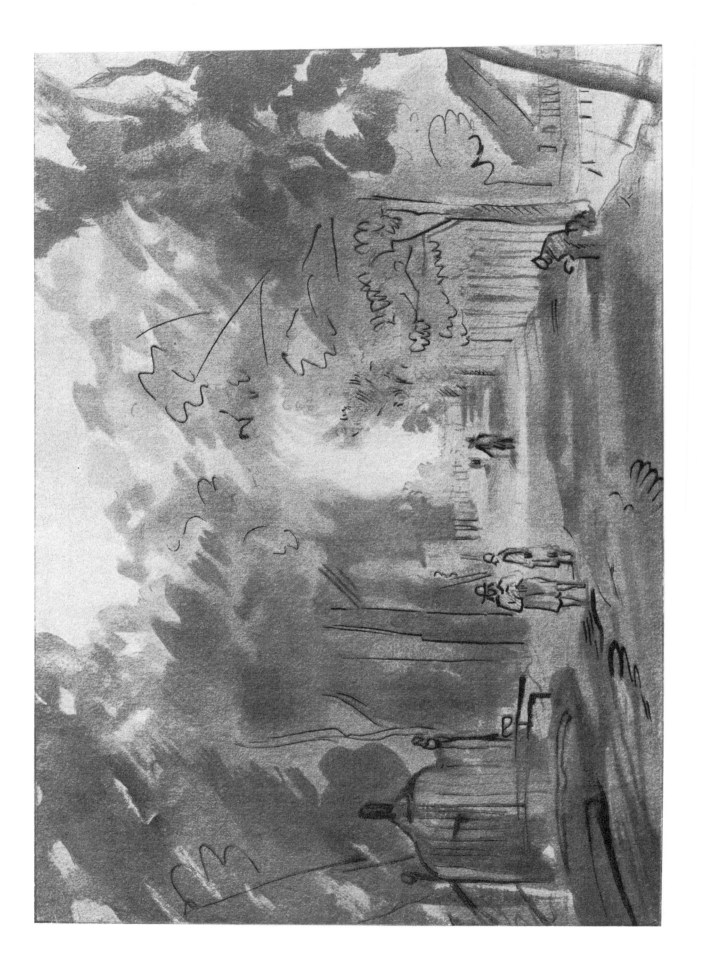

340 (III, 8). *An Avenue Lined with Trees (Diemermeer?). (Louvre, Paris)*
Pen and wash in bistre: 184 × 265 mm.

Lugt (1933, no. 1339) suggests that the drawing vaguely recalls the manner of Jan Leupenius and notes that the site is probably in the Diemermeer near Amsterdam.

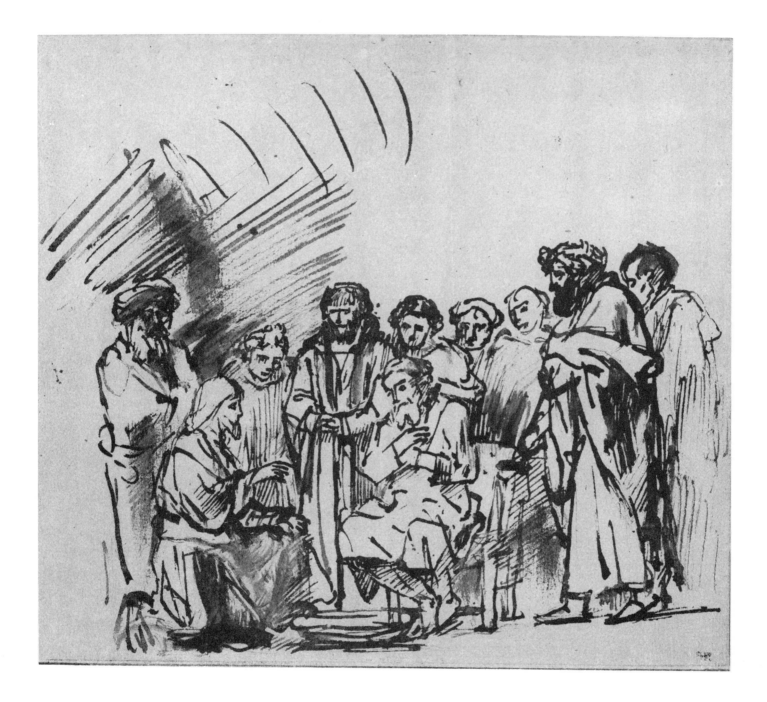

341 (*III, 9*). *Christ Washing the Disciples' Feet. (Louvre, Paris)*

Pen and wash in bistre, white body color: 175 × 187 mm.

About 1655–60. Lugt (1933, no. 1271) writes that the drawing may be a copy after a lost Rembrandt and cites another copy formerly in the Marsden J. Perry Collection, Providence, Rhode Island. Benesch (A110) calls it a copy after a pupil's work.

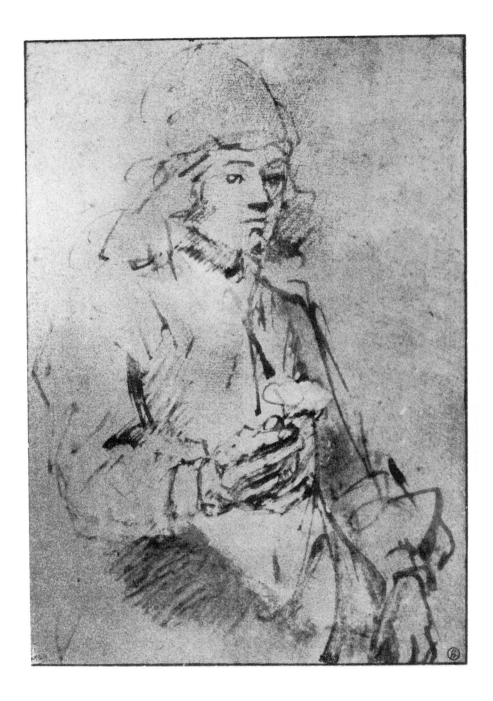

342 *(III, 10). Young Man Holding a Flower (Titus?). (Louvre, Paris)*

Pen and bistre: 175 × 118 mm.

About 1658–60. The drawing probably represents Rembrandt's son Titus. The identification is supported by the etching of Titus made around 1656 (Bartsch 261). Benesch (1184) dates it 1665–69.

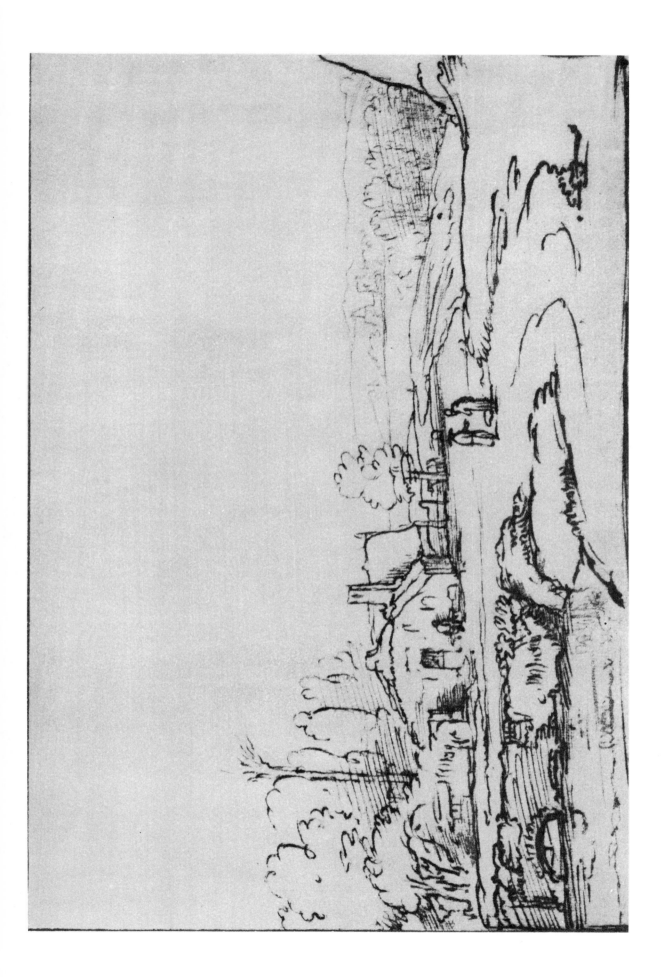

343 (III, 11). *Landscape with a Pond.* (*Louvre, Paris*)

Pen and bistre: 171 × 257 *mm.*

About 1645–48. Copy after a lost original (see Lugt, 1933, no. 1347).

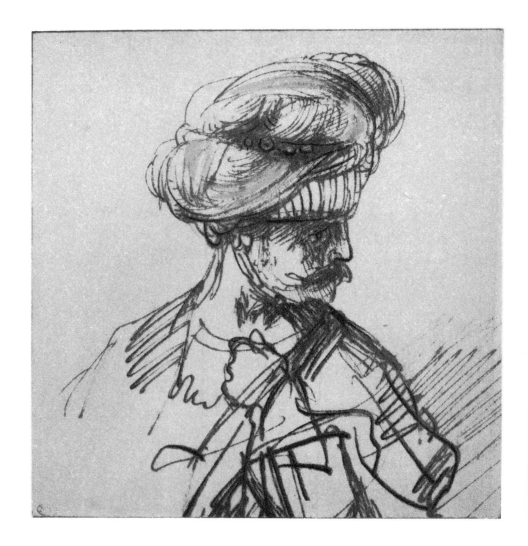

344 *(III, 12). Head of an Oriental in a Turban, Turned to the Right. (Louvre, Paris)*
Pen and bistre, white body color: 136 × 127 mm.
About 1633–35. One of the studies of picturesque Oriental types made during the artist's first years in Amsterdam.

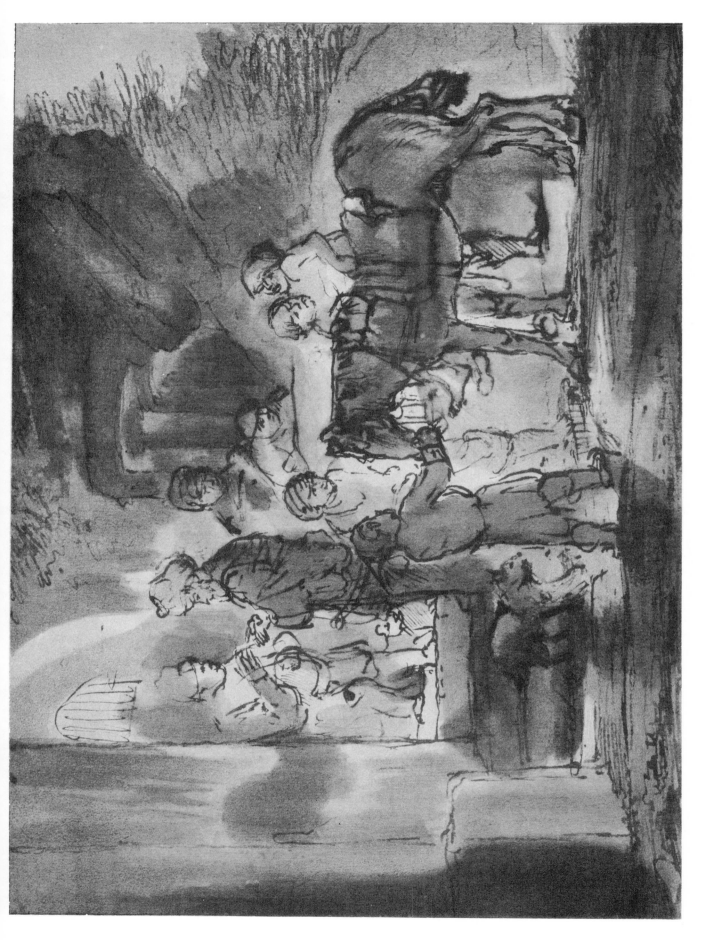

345 (III, 13). *The Good Samaritan Arriving at the Inn with the Wounded Man.* (Louvre, Paris)

Pen and wash in bistre: 180 × 249 mm.

Perhaps a copy after a lost drawing made around 1642–45 (see Lugt, 1933, no. 1268).

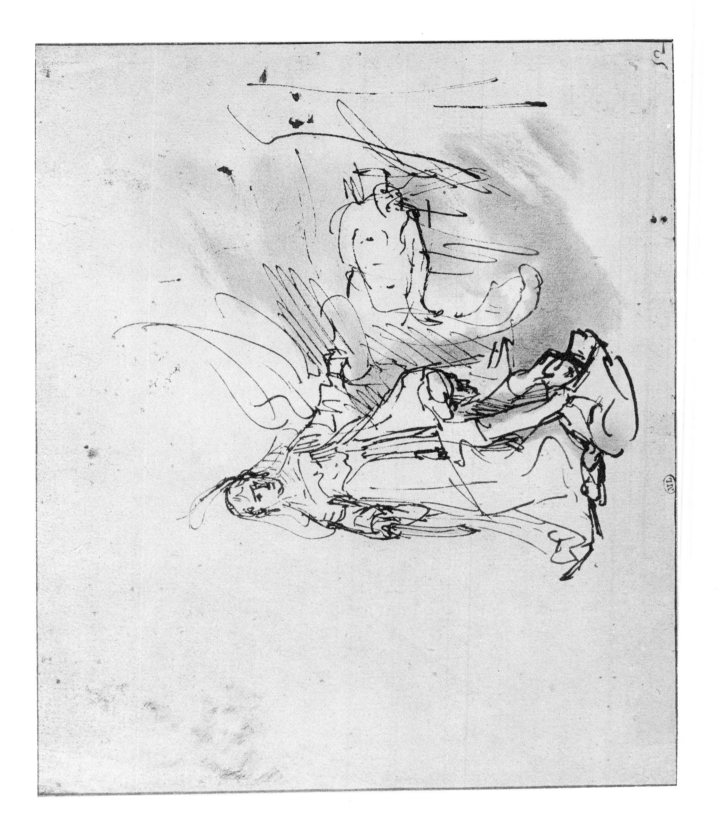

346 (III, 14). *Judith's Servant Puts Holofernes' Head into a Sack. (Louvre, Paris)*

Pen and ink: 178 × 212 mm.

About 1632–34. A rapid pen sketch made shortly after Rembrandt moved to Amsterdam. It is still closely related to the historical compositions made during the last years in Leiden.

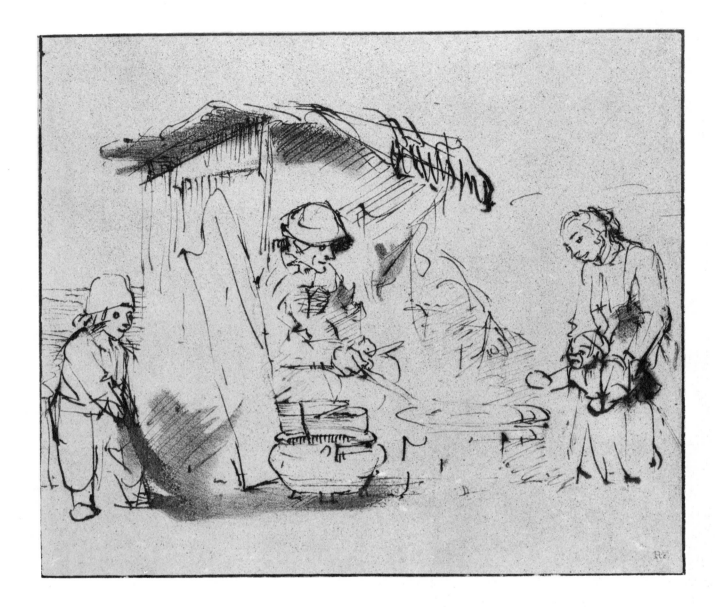

347 (III, 15). *The Pancake Woman.* (*Louvre, Paris*)

Pen and wash in bistre: 149 × 170 mm.

In the older literature the drawing was related to Rembrandt's 1635 etching (Bartsch 124) of the same subject.
Begemann (1961, p. 14) was the first to observe that it probably should be placed in the early 'forties. Not listed
in Benesch's corpus.

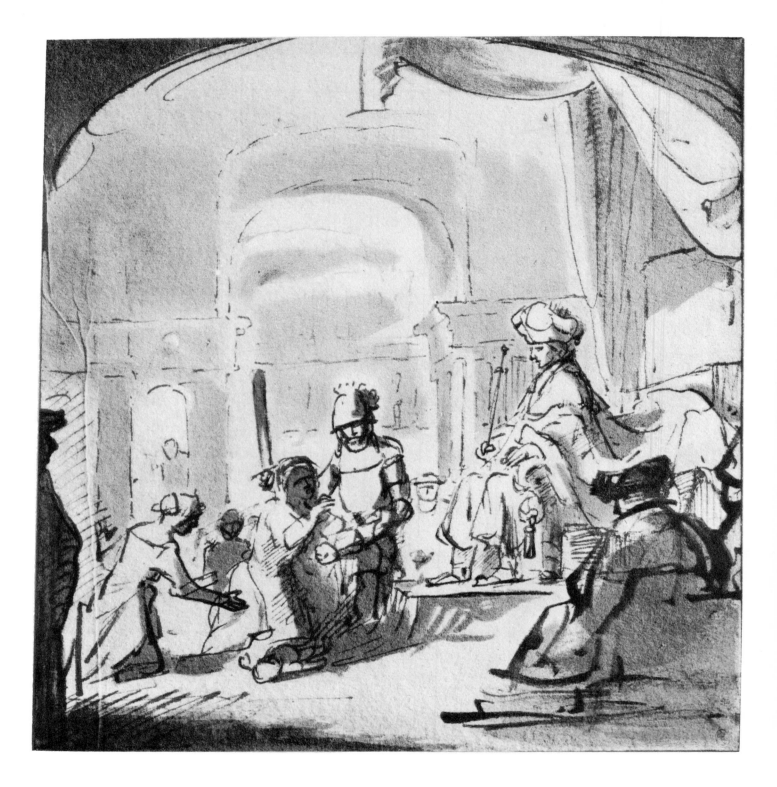

348 (*III, 16*). *The Judgment of Solomon.* (*Louvre, Paris*)

Pen and wash: 200 ×·189 mm.

Accepted by Valentiner (176) without reservation; relegated to the school with good reason by Lugt (1933, no.
1243). The execution is too feeble and hesitant for Rembrandt.

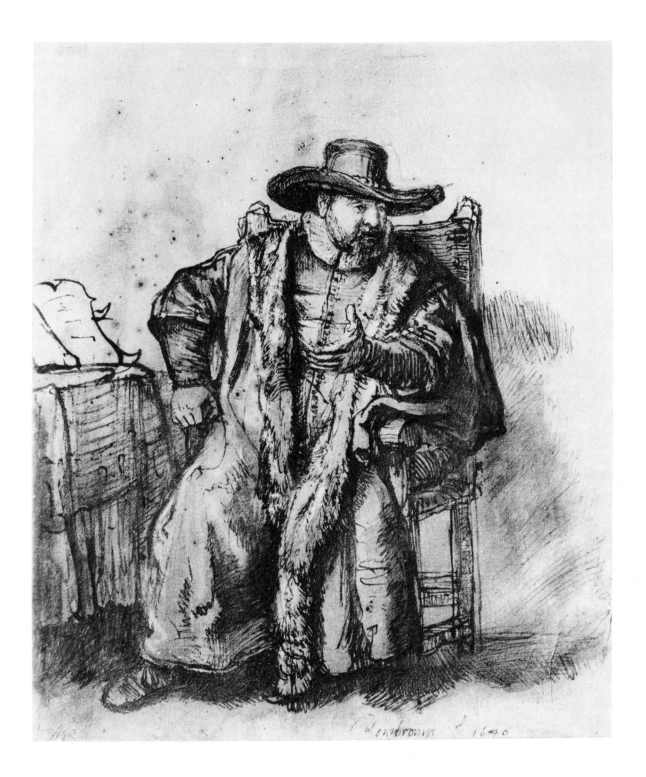

349 (III, 17). *Portrait of Cornelis Claesz Anslo. (Louvre, Paris)*
Red chalk, pen and wash in bistre, Indian ink, white body color: 246 × 201 mm. Signed and dated: Rembrandt f.
1640.
Study for the painting of 1641 of Anslo with a Woman at Berlin–Dahlem (Bredius 409). See 122 (I, 120) for
another portrait of Anslo made in 1640.

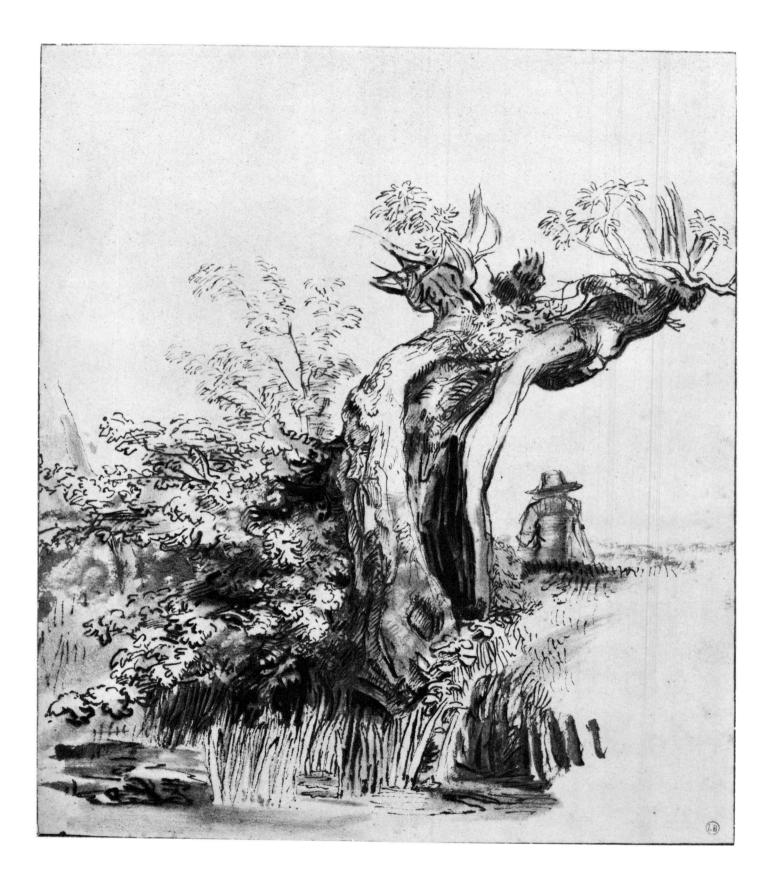

350 (*III, 18*). *A Pollard Willow at the Waterside.* (*Musée, Bayonne*)

Pen and wash in bistre: 224 × 190 mm.

Benesch (A25a) presents convincing reasons for not accepting this as an authentic work by Rembrandt. The spatial relations are unclear and the clumsy and heavy quality of the line and wash deprives the foliage and water of the luminosity found in genuine, carefully worked out landscape drawings by the master.

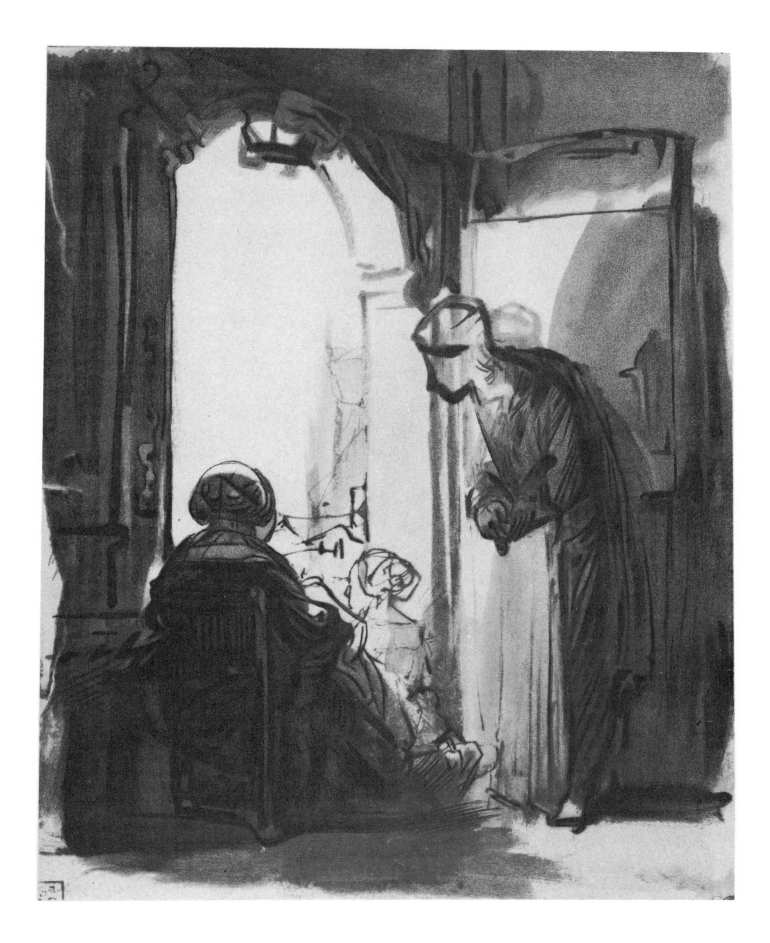

351 (III, 19). *Three Women Looking Out from an Open Door.* (French private collection)

Brush, pen and wash: 250 × 190 mm.

About 1635–45. A study of the contrast between the dark shadows of an interior and brilliant outdoor light. The figures in 242 (II, 25) appear to be in the same setting, but are seen from the outside of the doorway.

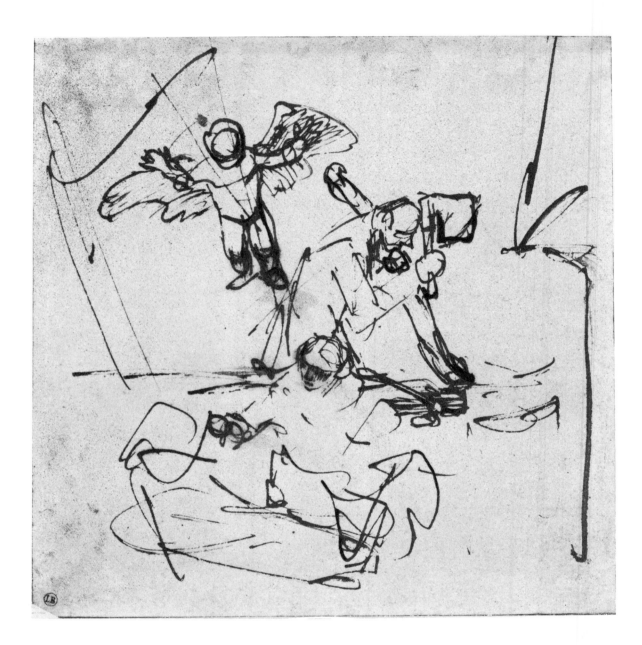

352 (*III, 20*). *The Holy Family in the Carpenter's Workshop.* (*Musée, Bayonne*)

Pen and bistre: 161 × 158 mm.

Preliminary study for the painting of 1645 at Leningrad (Bredius 570). This rapid drawing, which merely gives the roughest suggestion of the picture and yet presents all its essential elements, is one of the rare compositional studies for a known painting.

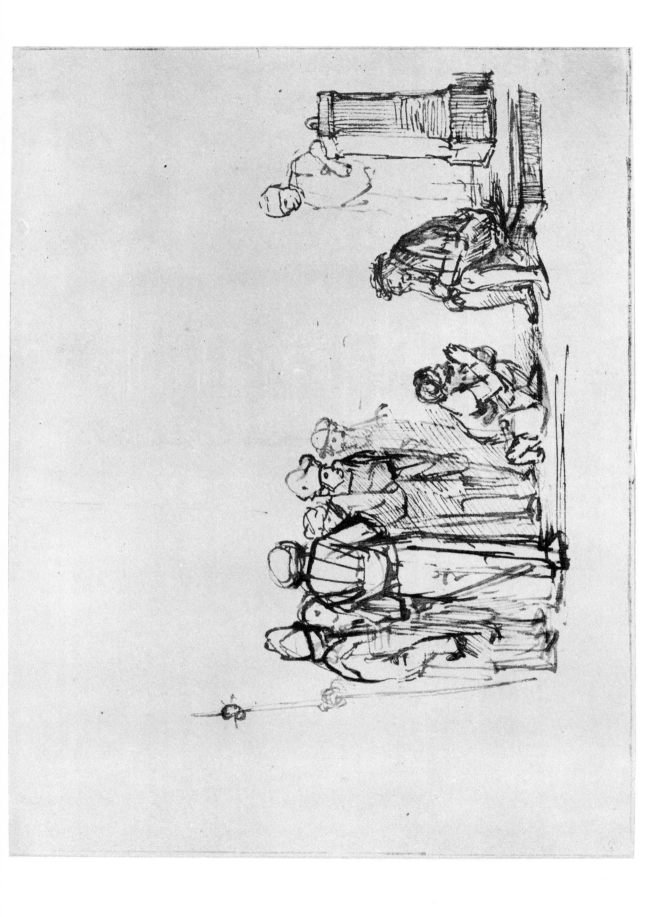

353 (III, 21). *The Mocking of Christ. (Formerly Léon Bonnat Collection, Paris)*
Pen and bistre: 181 × 245 mm.

About 1655. One of Rembrandt's most original and touching conceptions. The isolation of Christ has been subtly emphasized by the way the figures on the left are crowded together into a firm group, and by the significant interval between Jesus and the man on the extreme right. It is not in the Collection Bonnat at the Musée, Bayonne, as stated in the recent literature, and it was not included in the Bonnat bequest to the Cabinet des Dessins of the Louvre, Paris.) (The whereabouts of this important sheet is unknown.

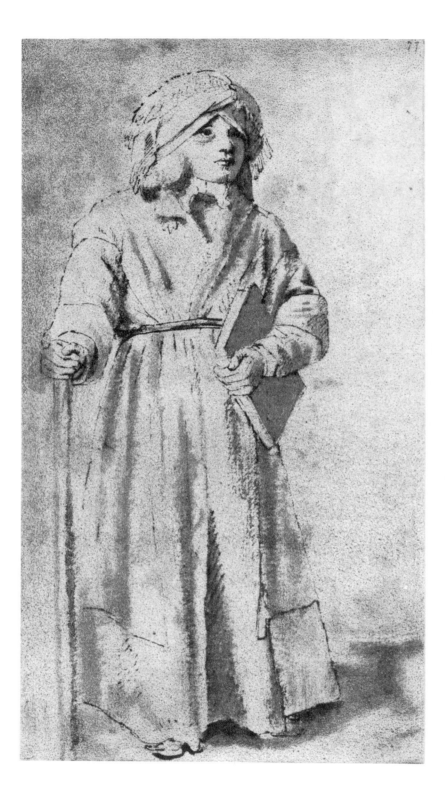

354 (*III, 22*). *A Standing Boy in a Long Robe.* (*Musée, Bayonne*)

Pen and wash in bistre: 205 × 110 mm.

Neumann (1919, note to no. 7) remarked that there is something odd about the hard outlines of the figure and noted that its authenticity is contested. Probably a school drawing made around 1650. There is a similar study, in the British Museum, which Hind (1915, no. 120) related to Eeckhout, and Valentiner (1924, pp. 51–52) ascribed to Maes. Not listed in Benesch.

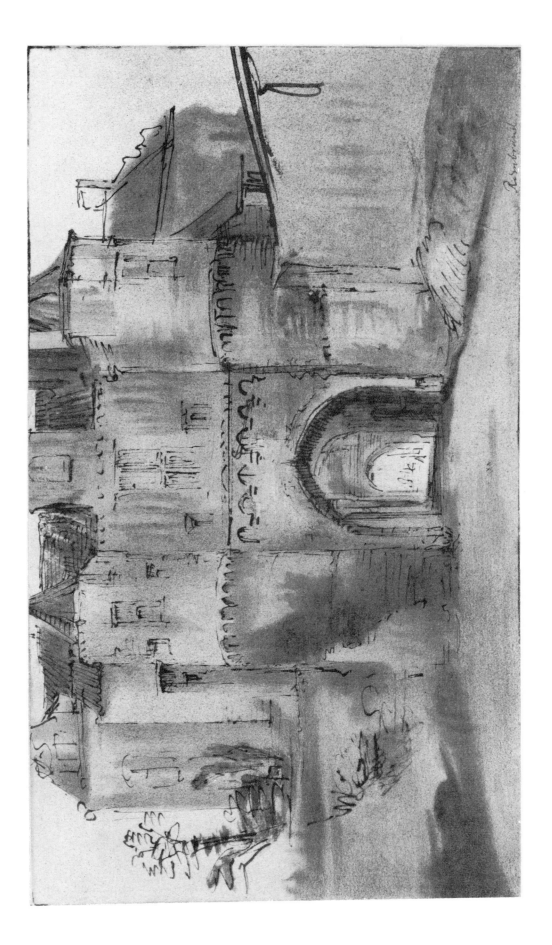

355 (III, 23). *The Eastern Gate at Rhenen (Oostpoort)* (*Musée, Bayonne*)

Pen and wash in bistre: 130 × 235 mm.

48. See the comment to 72 (I, 72).

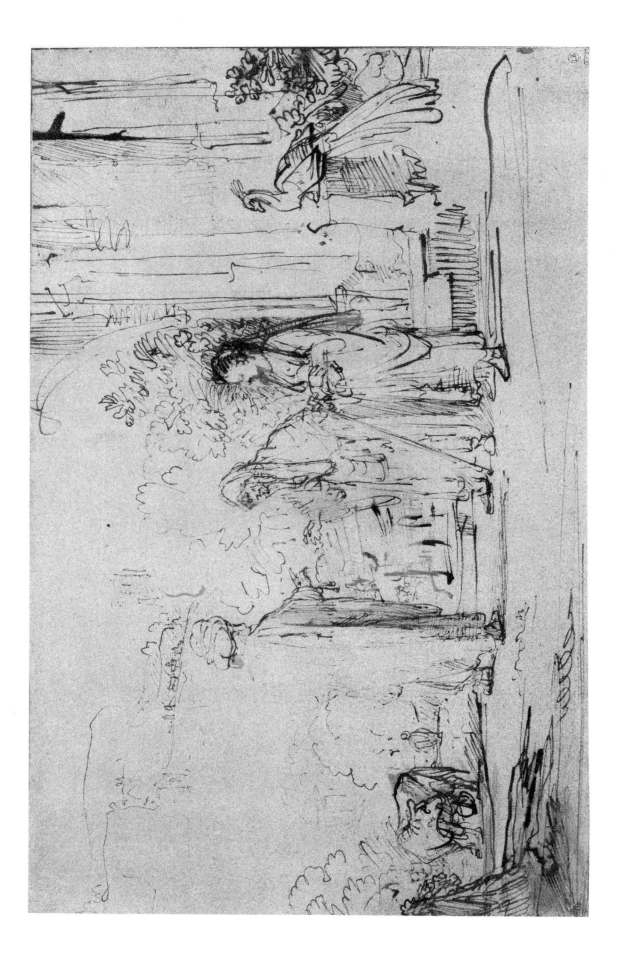

356 (III, 24). *Sarah Complaining of Hagar to Abraham.* (*Musée, Bayonne*)
Pen and bistre, white body color: 189 × 303 mm.
About 1640–43.

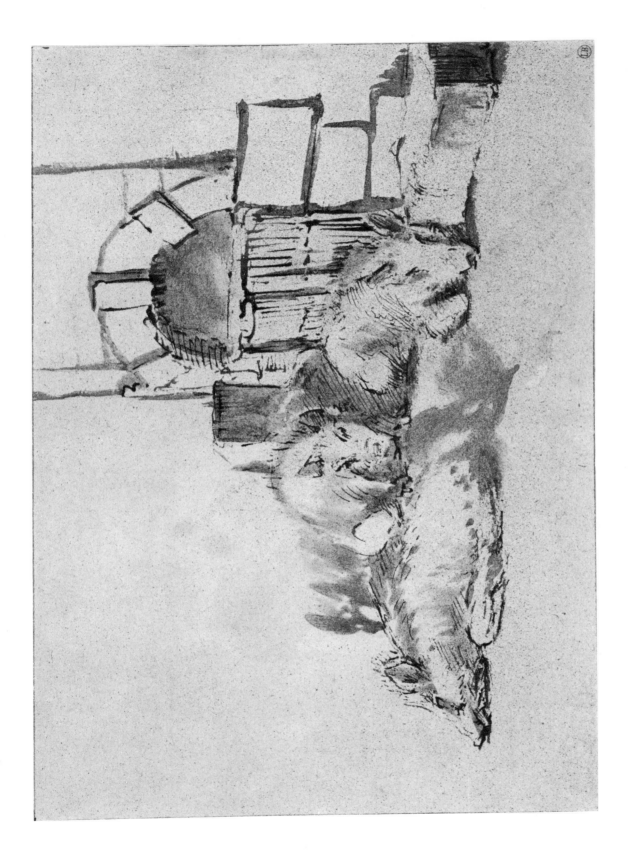

357 (III, 25). *Three Pigs Outside Their Sty.* (*Musée, Bayonne*)
Pen and brush in bistre, wash: 160 × 220 mm.

The attribution to Rembrandt was not questioned by Hind (1915, no. 41) or Lugt (1933, no. 1194); not listed by Benesch. The timid penwork and the ineffective use of the wash make it difficult to accept this drawing as an original. One of the artist's unquestioned drawings of pigs, now at the Louvre, Paris, is reproduced 193 (I, 180b).

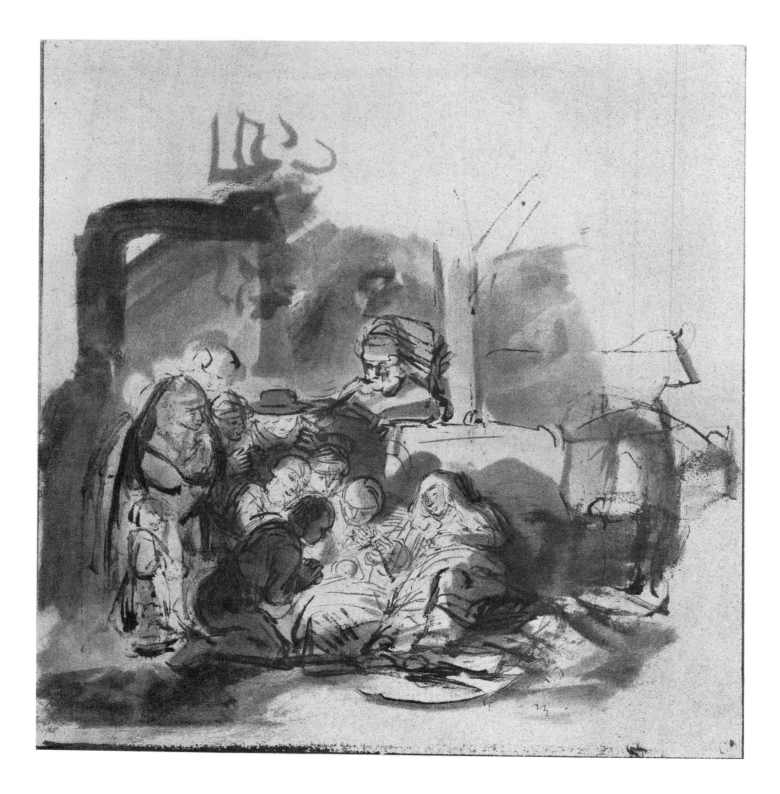

358 (*III, 26*). *The Adoration of the Shepherds.* (*Musée, Bayonne*)

Pen and wash in bistre, red chalk: 203 × 195 mm.

A convincing ascription to Nicolaes Maes was published by Valentiner (1924, p. 37). Young Maes was inspired by Rembrandt's 1646 painting now at Munich (Bredius 574).

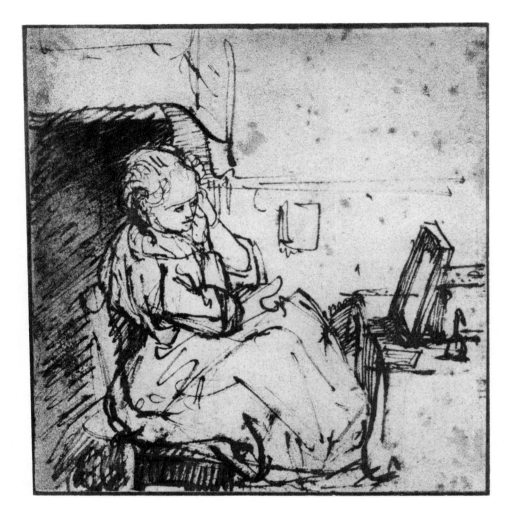

359 (*III, 27*). *A Woman Seated in a Chair Before a Mirror Putting on an Earring.* (*Musée des Beaux-Arts,*
Brussels)

Pen and wash in bistre: 130 × 122 mm.

About 1640–45. Rembrandt used the same theme in a painting dated 1654 at The Hermitage, Leningrad (Bredius
387).

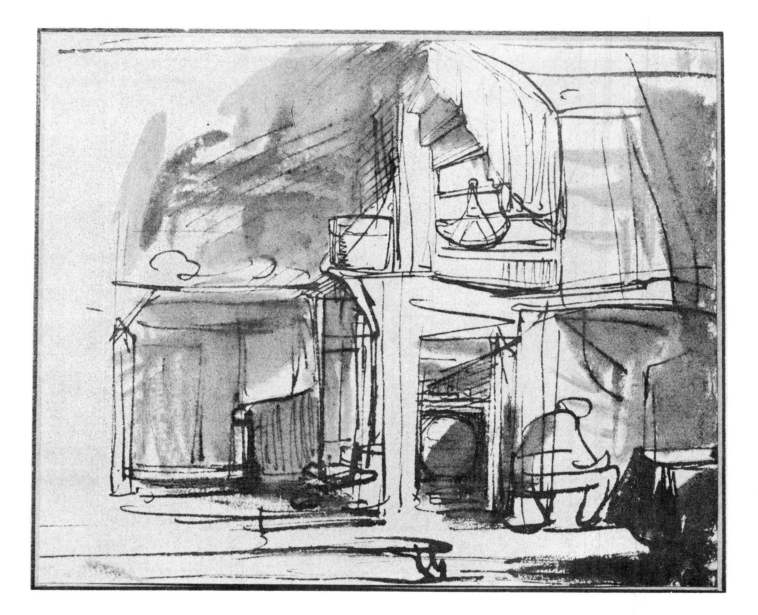

360 (*III, 28*). *Interior of a House with a Winding Staircase.* (*Kobberstiksamling, Copenhagen*)
Pen and wash in bistre: 153 × 180 mm.

About 1633. Rembrandt painted similar stairs in some of his pictures (see The Scholar in His Study, *Louvre,
Paris, 1633, Bredius 431). Contemporary handbooks on perspective gave elaborate instructions on how to draw
a spiral staircase. Their directions make even more impressive the ease with which Rembrandt renders the
complicated problem.*

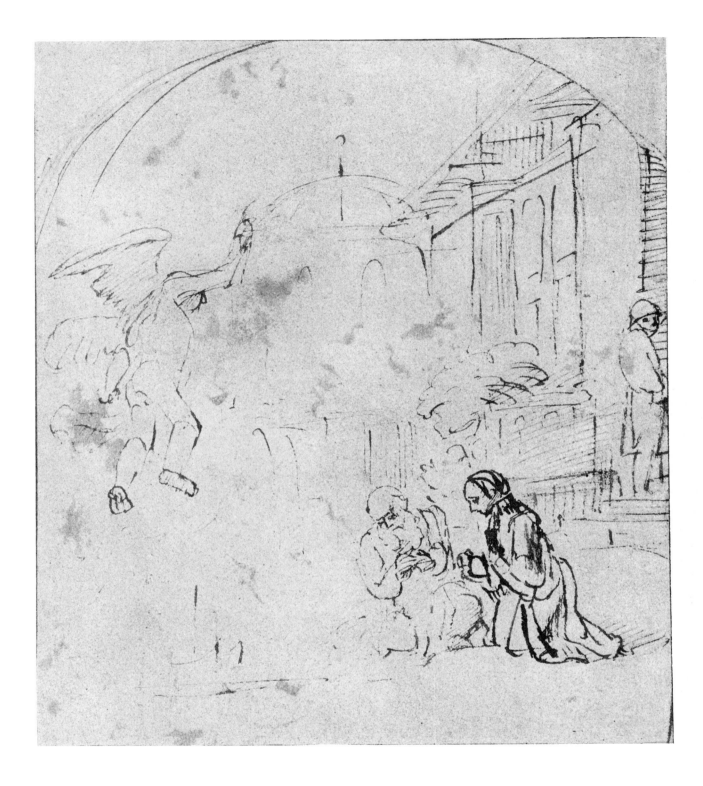

361 (*III, 29*). *The Angel Disappearing Before Manoah and His Wife.* (*Kupferstichkabinett, Dresden*)
Reed pen and bistre: 193 × 156 mm.

About 1655. Study for a modification, or for a new version, of Rembrandt's painting dated 1641 of the same
subject at the Gemäldegalerie, Dresden (Bredius 509); see F. Saxl, Rembrandt's Sacrifice of Manoah, Studies
of the Warburg Institute, 9, London, 1939. 132 (I, 128) is another study for this project.

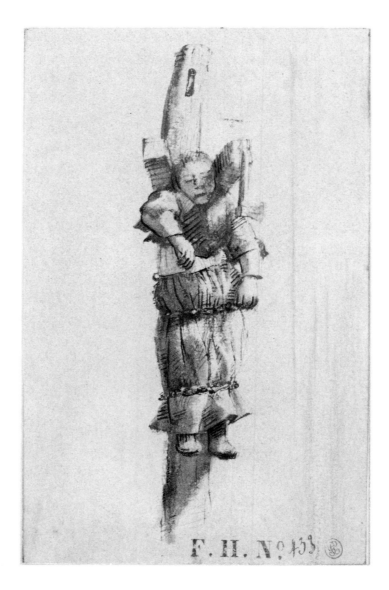

362 (*III, 30a*). *A Woman Hanging on a Gibbet Seen from the Front.* (*Fogg Art Museum, Harvard University, Cambridge, Massachusetts*)

Pen and wash in bistre: 153 × 93 mm.

A copy of a drawing by Rembrandt at the Metropolitan Museum of Art, New York (Benesch 1105). See 363 (III, 30b).

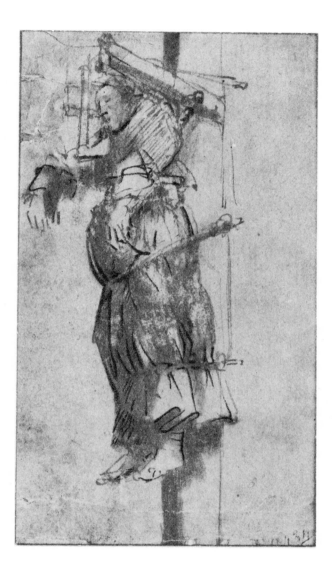

363 (*III, 30b*). *A Woman Hanging on a Gibbet in Three-quarter Profile to the Left.* (*Robert Lehman Collection, New York*)

Pen and wash in bistre: 142 × 81 mm.

About 1655. Rembrandt, who frequently depicted death, made more than one study of this executed criminal. The same woman is represented in the preceding drawing. Probably the weapon of her crime is the axe dangling from the projecting arm of the gibbet.

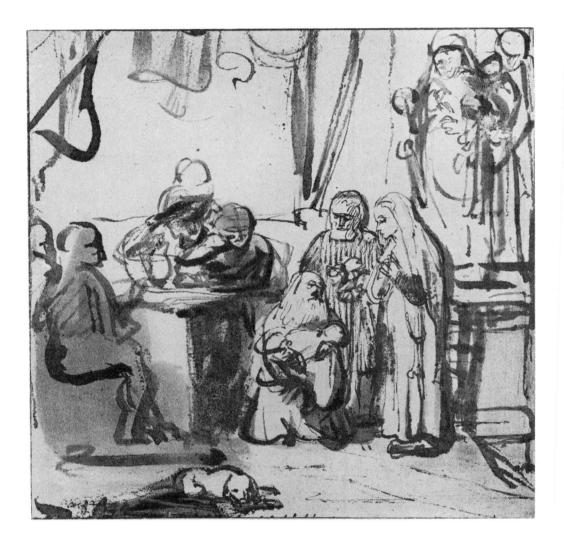

364 (*III, 31*). *The Presentation in the Temple.* (*Formerly Paul Mathey Collection, Paris*)
Pen and wash in bistre: 140 × 137 mm.
Identified as an early work of Nicolaes Maes by Valentiner (1924, p. 36).

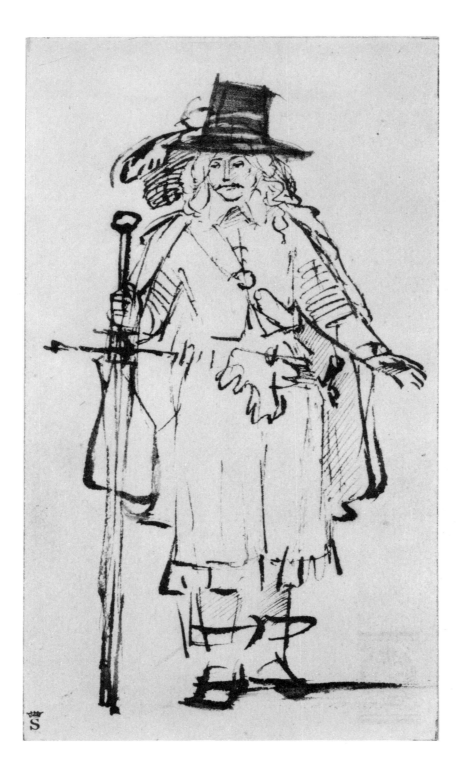

365 (*III, 32*). *A Standing Man, with a Two-handed Sword in His Right Hand.* (*Robert Lehman Collection, New York*)

Pen in bistre: 201 × 115 mm.

The drawing shows similarities to an original full-length portrait of an Old Man, published by L. Münz, Alte und Neue Kunst, I (1952), p. 152, now in Count Antoine Seilern's Collection, London (see Paintings and Drawings of Continental Schools other than Flemish and Italian at 56 Princes Gate, London, 1961, Vol. 3, no. 197, plate XXII), but it is a little weaker and may be by a good pupil's hand. A comparison with the authentic drawing of Two Jews and Some Dutch People on a Street, Teyler Museum, Haarlem (417 [III, 81]), also points up the drawing's weaknesses. Though the graphic vocabulary is quite close to the one Rembrandt used around 1650–55, the summary strokes lack the rich pictorial glow characteristic of the master's drawings of this phase.

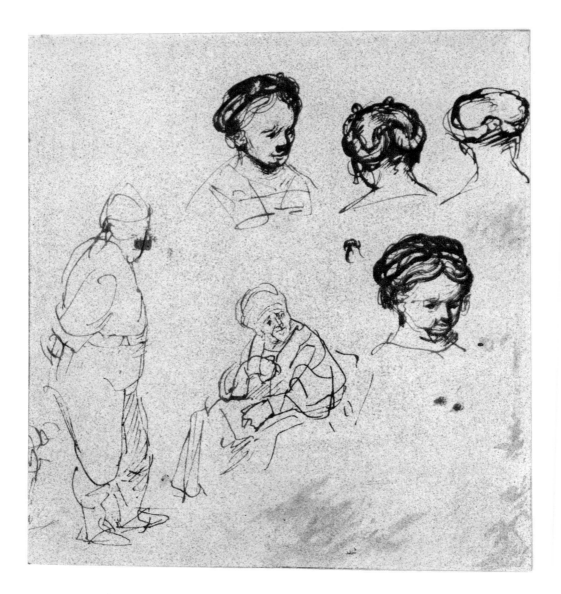

366 (*III, 33*). *A Study of a Woman Seated and of a Man Standing in Front of Her, and Four Studies of the Head of a Young Woman.* (*Formerly E. Wauters Collection, Paris*)

Pen and bistre: 147 × 133 mm.

About 1638–40. Rembrandt was interested in the young woman's hair-do and sketched different views of it. More elaborate studies of the coiffure of a girl were made a few years earlier on a sheet now at the Fogg Art Museum (see Catalogue, Rembrandt Drawings from American Collections, Pierpont Morgan Library, New York, and Fogg Art Museum, Cambridge, Massachusetts, 1960, no. 21, plate 17).

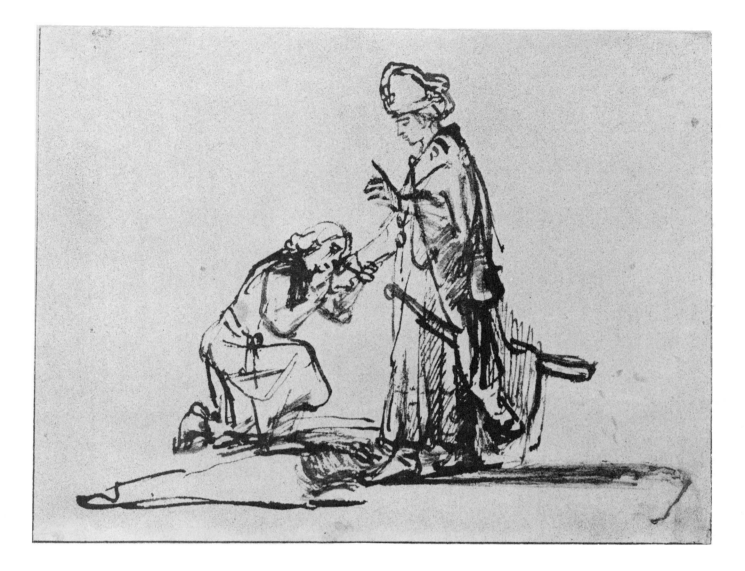

367 (III, 34). *David Taking Leave of Jonathan. (Rijksprentenkabinet, Amsterdam)*
Pen and bistre: 143 × 183 mm.
About 1655–58.

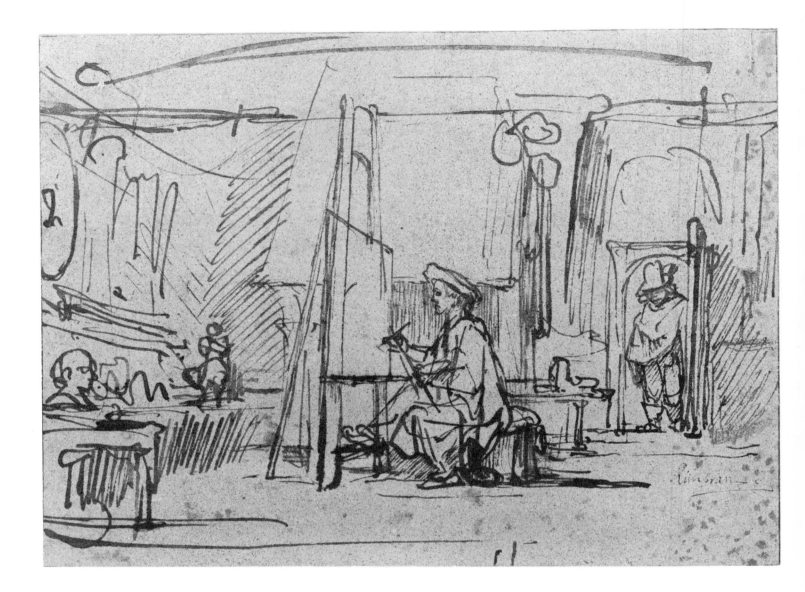

368 (*III, 35*). *A Painter Before His Easel, on the Right a Visitor.* (*Formerly P. Mathey Collection, Paris*)
Pen and bistre: 150 × 199 mm. Signed by another hand: Rimbran.
Perhaps a copy after a lost original made around 1640.

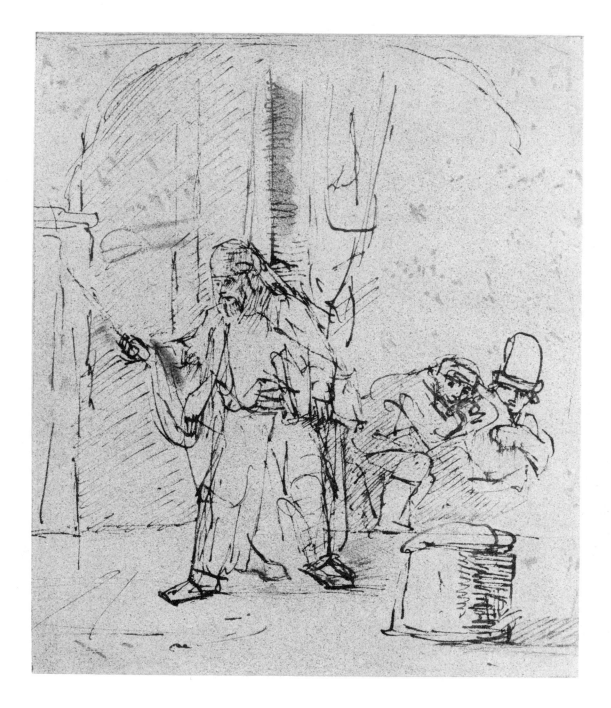

369 (*III, 36*). *A Scene from the Old Testament*(?). (*Count Antoine Seilern Collection, London*)

Pen and bistre, wash: 179 × 143 mm.

About 1650. The subject is a puzzling one. An old inscription on the mount reads: la fureur de Saul, *a reference to I Samuel 16, 14–15; this accounts for Benesch's (650) identification "The Madness of Saul" (with a question mark). Valentiner (393) suggested it represents Christ driving the money-changers from the Temple. He wrote that the men in the background are making off with a sack of money. However, the principal figure does not resemble Rembrandt's Christ type. The subject remains unidentified. The title used here is taken from the catalogue of Paintings and Drawings of Continental Schools other than Flemish and Italian at 56 Princes Gate, London, 1961, Vol. 3, p. 33.*

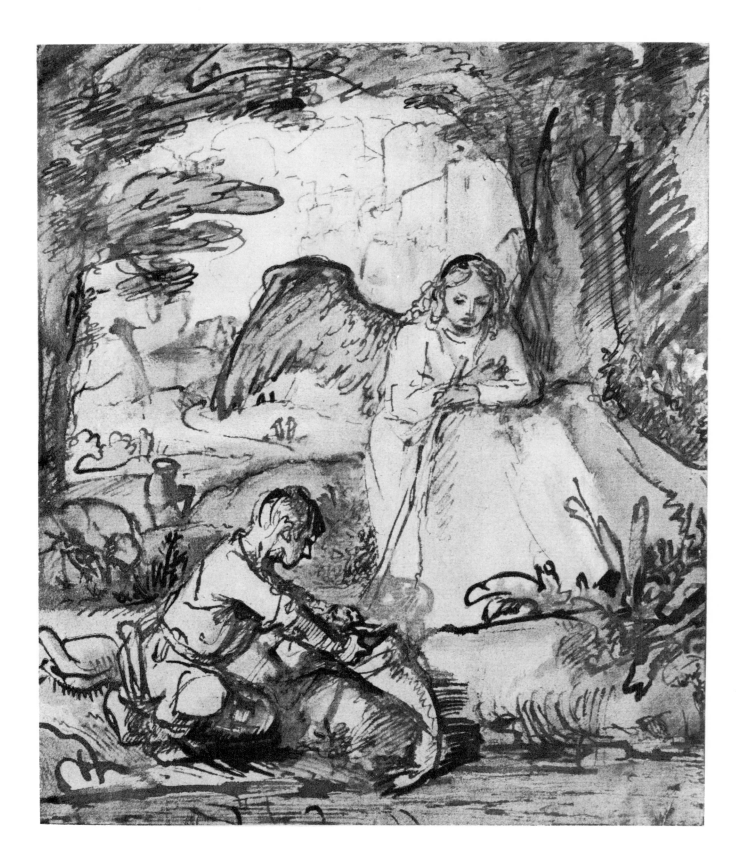

370 (*III, 37*). *Tobias Cleaning the Fish.* (*Rijksprentenkabinet, Amsterdam*)

Pen and wash: 219 × 181 mm.

By an imitator of Rembrandt's style of the early 1640's; the names of Philips Koninck and Govert Flinck have both been suggested (see Henkel, 1943, no. 108). The penwork is too rough and careless to be considered the master's, and the author of the sheet fails to integrate his flat dark washes with the strokes of his pen. Some corrections—particularly on the figure of Tobias—are visible; possibly these are Rembrandt's.

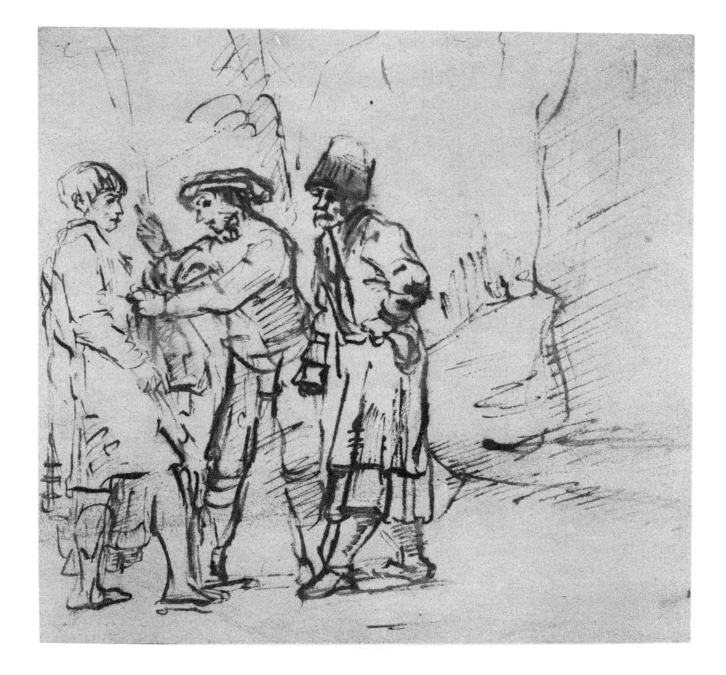

371 (*III, 38*). *Joseph Divested of His Multicolored Coat.* (*Rijksprentenkabinet, Amsterdam*)
Pen and bistre: 160 × 166 mm.
A copy after a lost original made around 1655.

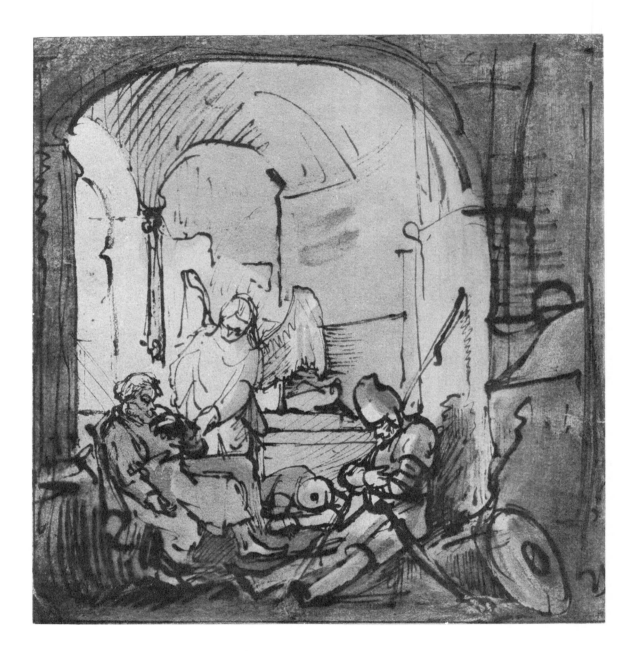

372 (III, 39). *The Liberation of St. Peter from Prison. (Rijksprentenkabinet, Amsterdam)*

Pen and wash: 165 × 155 mm.

Probably made by a pupil or follower familiar with Rembrandt's style of 1635–40; compare, for example, the drawing of Saskia's lying-in room, 328 (II, 96). The artist, however, fails to differentiate the position of figures in space or to realize the potential of Rembrandt's chiaroscuro. By the use of light and shadow Rembrandt could give a humdrum scene of women at a doorway (see 351 [III, 19]) more excitement than this artist was able to lend to the miracle of the Deliverance of Peter.

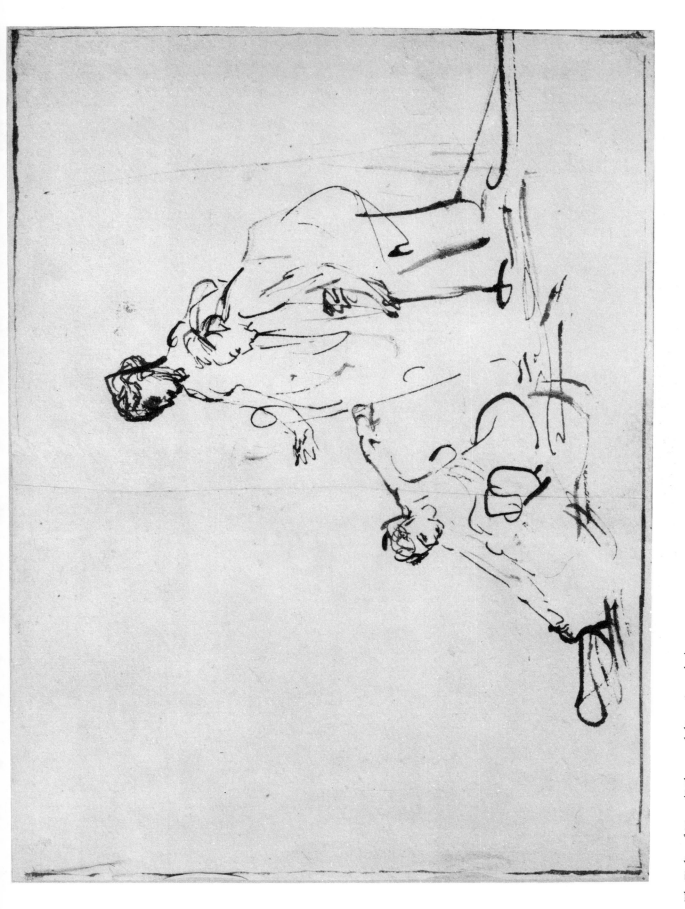

373 (III, 40). *The Finding of Moses.* (Rijksprentenkabinet, Amsterdam)

Pen and bistre: 170 × 232 mm. Cut in two vertically and pasted together.

An energetic charge seems to follow through every line of this masterful drawing made around 1635. Ferdinand Bol used this study by his teacher for his own painting now in the Palace of Peace at The Hague. For the view that the drawing is, in fact, by Bol with a single correction by Rembrandt (the head of the standing Pharaoh's daughter) see Benesch 435.

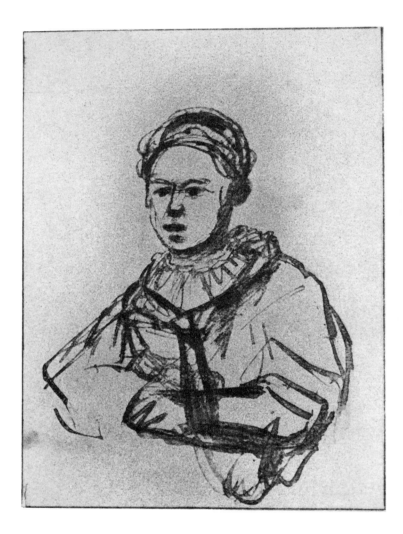

374 (III, 41). *Portrait Study of a Young Lady. (Rijksprentenkabinet, Amsterdam)*
Pen and bistre: 135 × 99 mm.
About 1635–40. Valentiner (673) suggests it may represent Saskia.

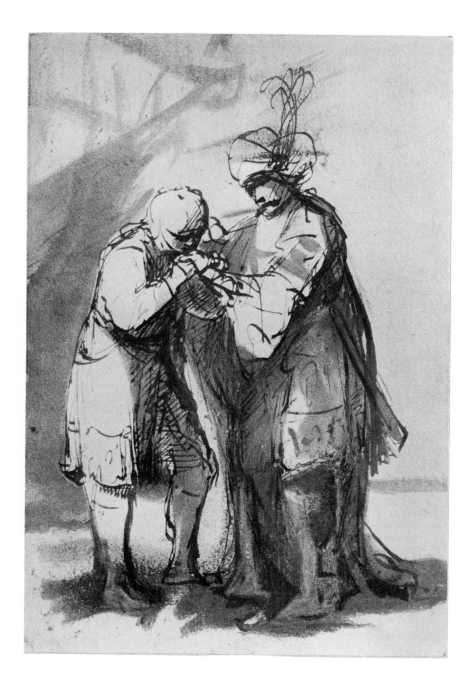

375 (III, 42). *David Taking Leave of Jonathan. (Rijksprentenkabinet, Amsterdam)*
Pen and wash: 169 × 112 mm.

*Also interpreted as the Reconciliation of David and Absalom. The drawing is the work of a pupil. Kruse offered
the name of Philips Koninck, Lugt suggested Ferdinand Bol, and Valentiner attributed it to Gerrit Willemsz Horst.
See Henkel (1943, p. 88, no. 1) for a discussion of the various interpretations and attributions of the sheet.*

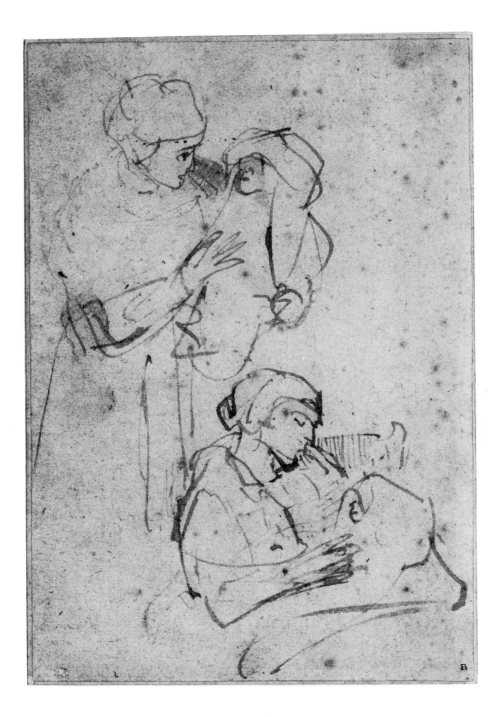

376 (III, 43). *Two Studies of a Woman with a Baby in Her Arms. (Rijksprentenkabinet, Amsterdam)*

Pen and bistre: 175 × 119 mm.

About 1636–40.

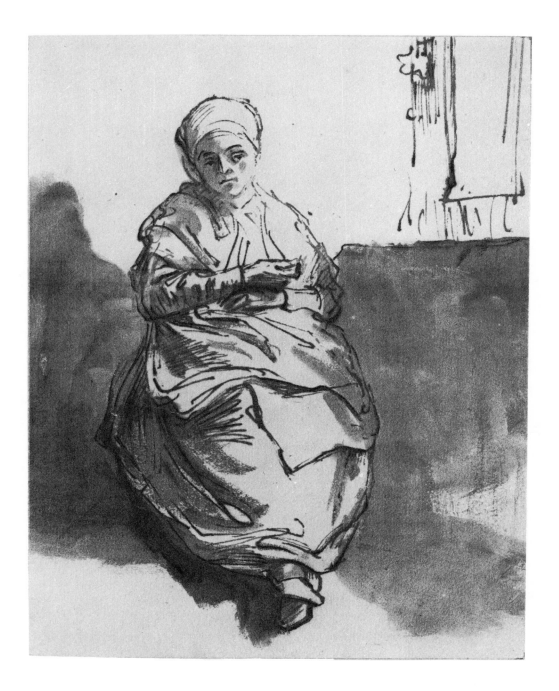

377 (III, 44). *A Young Woman Seated by a Window.* (Rijksprentenkabinet, Amsterdam)
Pen and brush in bistre, wash: 175 × 135 mm.

*The drawing has been attributed to a Rembrandt pupil by some specialists (see Benesch A3). There are, indeed,
weaknesses in the sheet, particularly the washes which fail to integrate with the penwork. It is, however, possible
that the clumsy washes were added by another hand to an original drawing made by the master around 1635.*

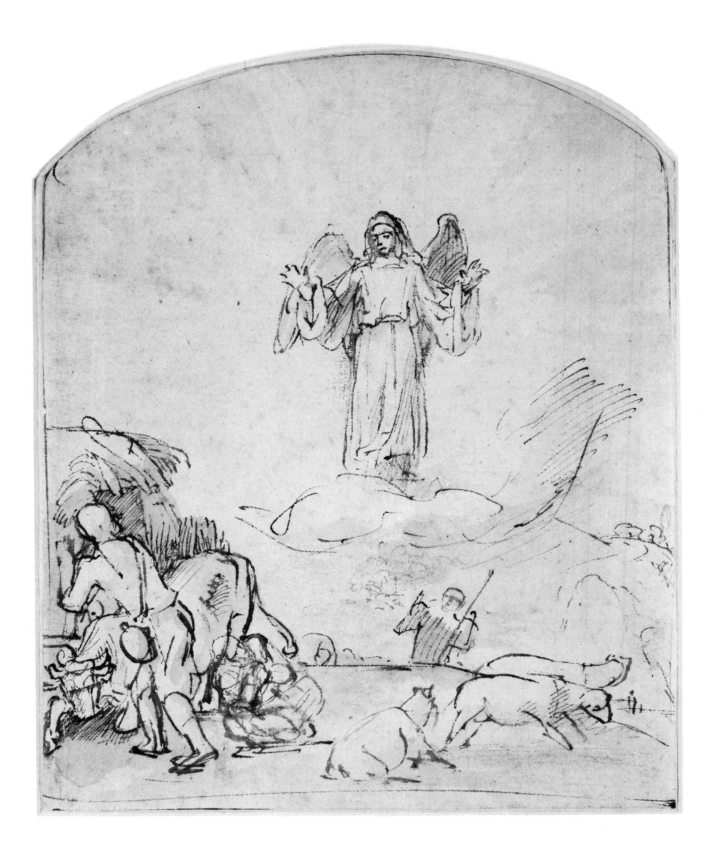

378 (III, 45). *The Annunciation to the Shepherds.* (Rijksprentenkabinet, Amsterdam)
Pen and bistre, grey wash added by a later hand: 219 × 180 mm.
About 1655.

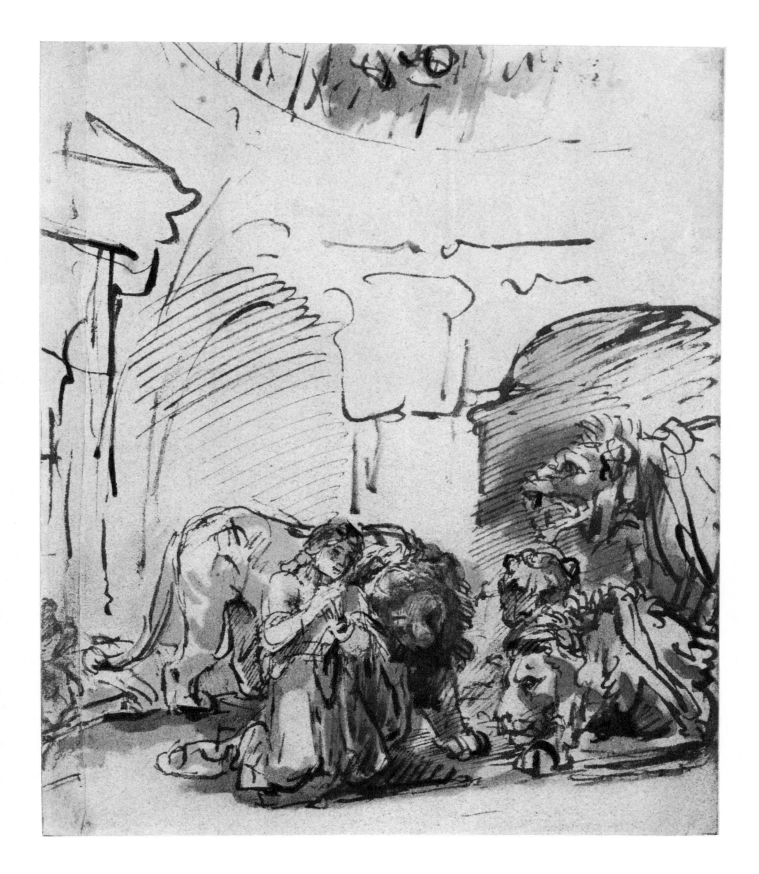

379 (III, 46). *Daniel in the Lions' Den. (Rijksprentenkabinet, Amsterdam)*
Reed pen and bistre, wash, white body color: 222 × 185 mm.
About 1652. In this composition Rembrandt incorporates the life studies he made of lions.

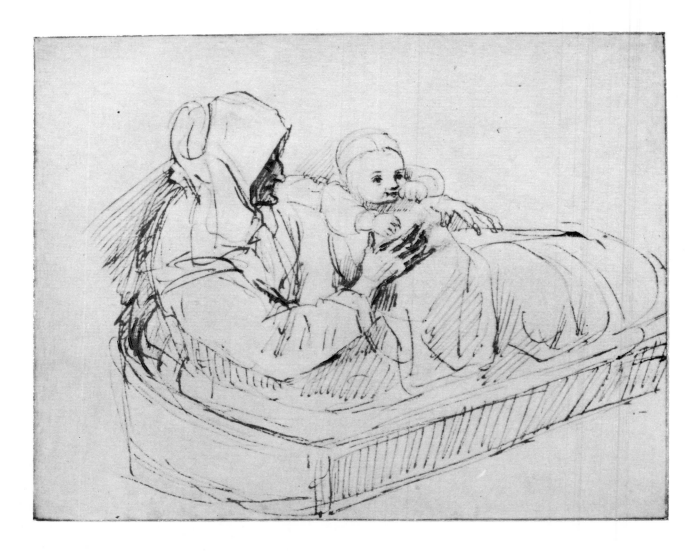

380 (*III, 47*). *An Old Woman Seated in a Low Wicker Bed with a Baby.* (*Boymans-van Beuningen Museum, Rotterdam*)

Pen in bistre: 135 × 170 mm.

The subject is one which would have appealed to Rembrandt, but the brittle pen line, the lack of clarity of the forms and the shaky perspective cannot be ascribed to him. The drawing was probably made by a pupil or follower around 1635. A wicker bed or basket of the type shown here was frequently used by mothers and wet nurses in seventeenth-century Holland. There was one in Rembrandt's household; it can be seen in the foreground of the master's drawing of Saskia's lying-in room (see 328 [II, 96]).

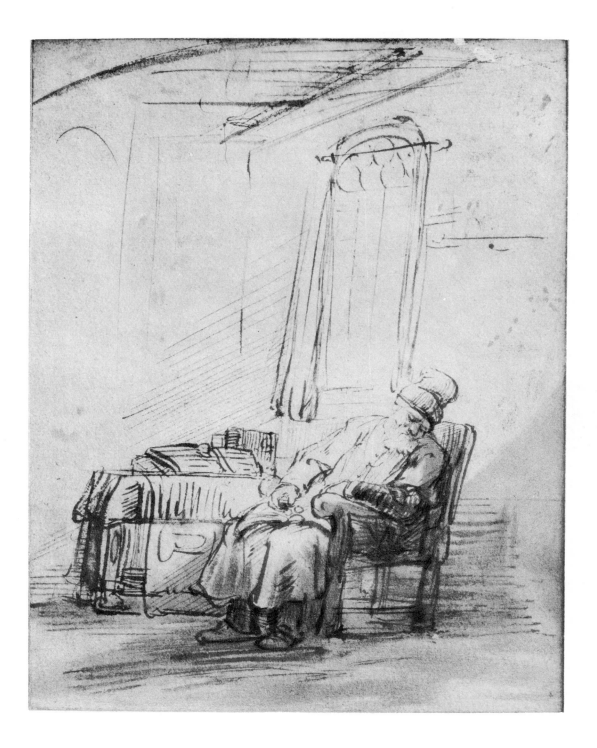

381 (*III, 48*). *An Old Man Asleep in His Chair.* (*Boymans-van Beuningen Museum, Rotterdam*)
Pen and brush in bistre, wash: 187 × 143 mm.
The work of a pupil or imitator which combines a common motif of the early 1630's with the style of the 1640's.

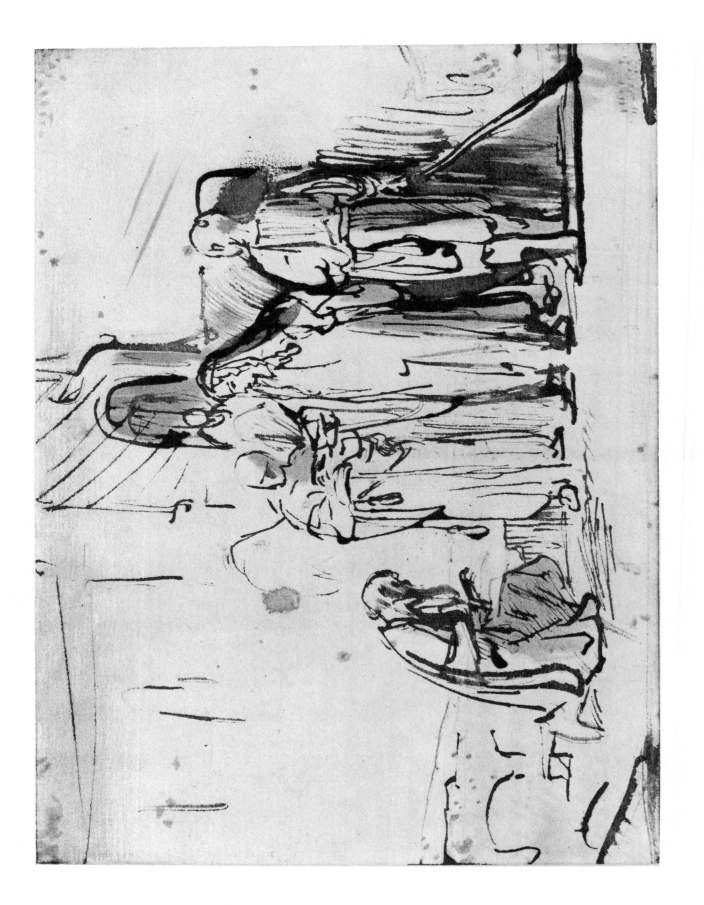

382 (III, 49). *Abraham Kneeling Before God the Father and Two Angels. (Boymans–van Beuningen Museum, Rotterdam)*
Pen and wash in bistre: 170 × 230 mm.
Probably a copy after a lost original made in the 1650's.

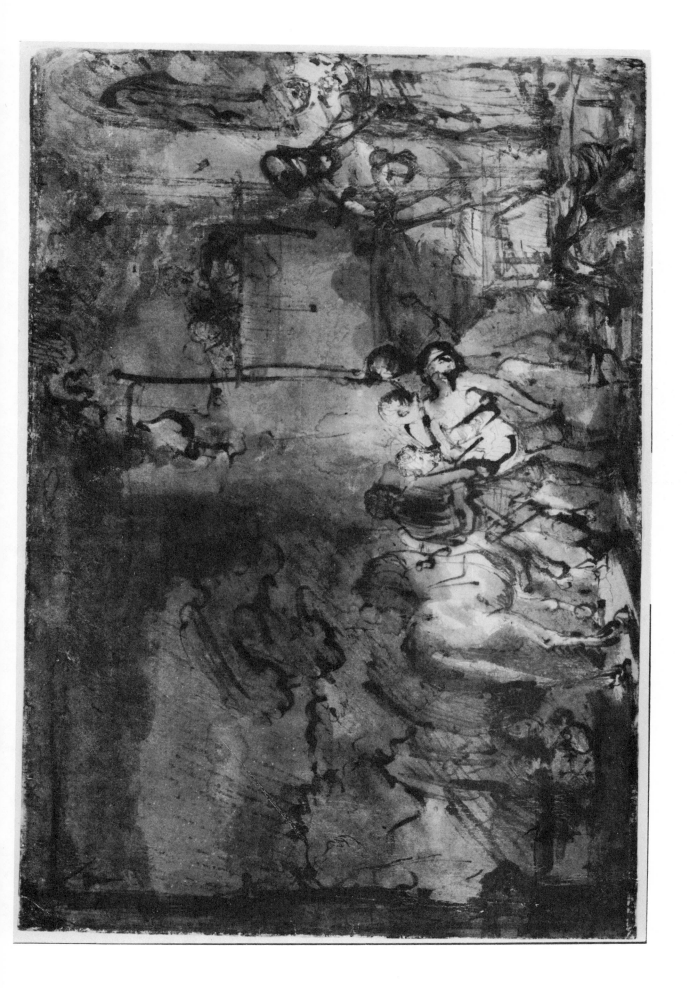

383 (III, 50). *The Good Samaritan Bringing the Wounded Man into the Inn. (Boymans-van Beuningen Museum, Rotterdam)*

Pen and wash in bistre, white body color: 209 × 310 mm.

About 1641–43. See the comment to 206 (I, 190).

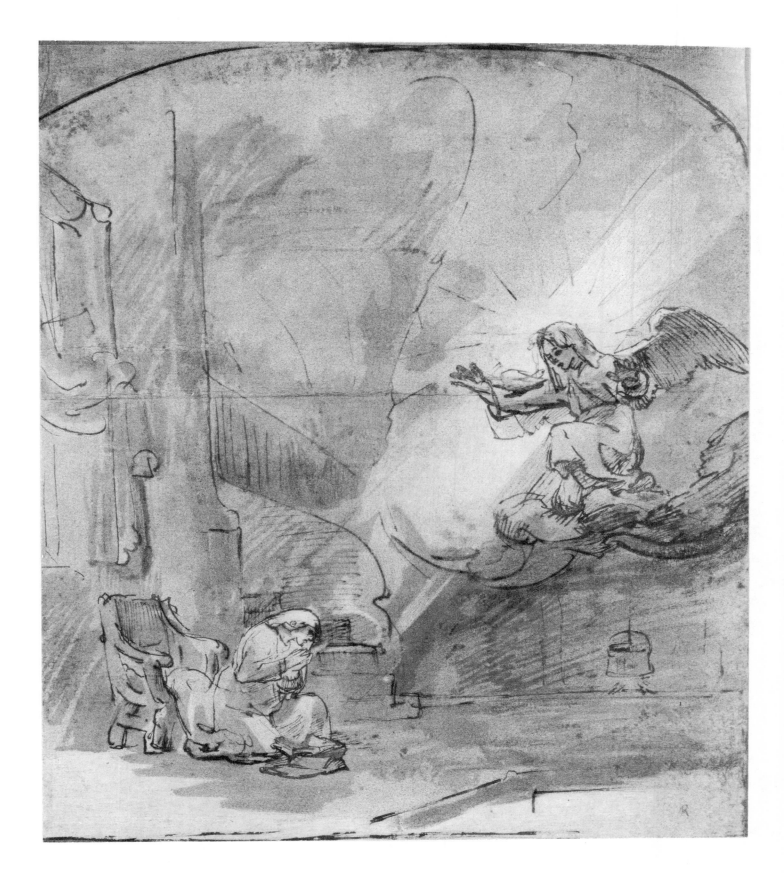

384 (*III, 51*). *The Annunciation.* (*Louvre, Paris*)

Pen and wash in bistre: 319 × 275 mm.

A copy of a drawing, now at the Albertina, Vienna (Benesch 1371), by an unidentified pupil who worked with Rembrandt around 1650. The pupil's drawing was corrected by Rembrandt and the copyist faithfully copied the master's changes. The sheet in Vienna has been cut down; this copy shows the original format.

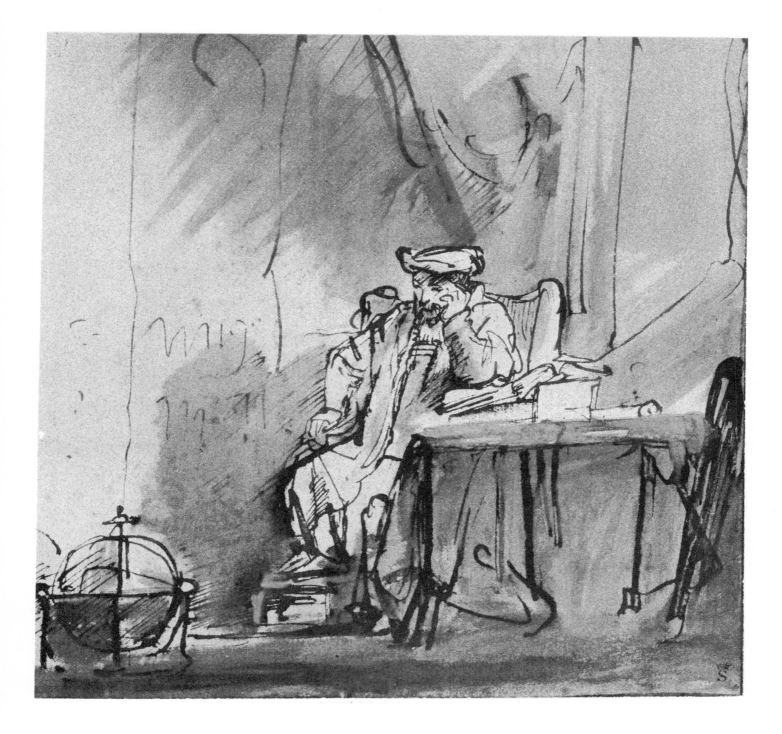

385 (*III, 52*). *A Man Seated in a Study.* (*Louvre, Paris*)

Pen and wash in bistre: 181 × 188 mm.

The motif of a man alone with his thoughts occupied Rembrandt from the beginning until the end of his career.
This drawing of the theme must have been made by Rembrandt around 1640–45. Not listed in Benesch.

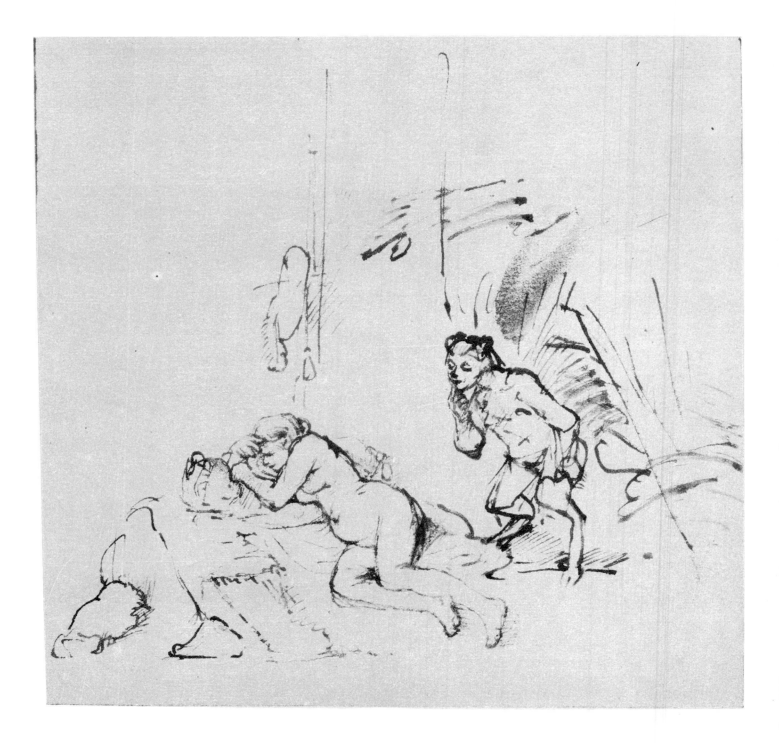

386 (III, 53). *Jupiter and Antiope. (Louvre, Paris)*

Pen and bistre, wash: 189 × 191 mm.

About 1655–60. On the verso (reproduced Benesch, figure 1257) another study of Antiope. Rembrandt treated the subject in an etching of 1659 (Bartsch 203) and these drawings were probably made around the same time. It has been noted that Rembrandt was probably familiar with Annibale Carracci's etching of this episode of the Antiope story (Bartsch 17), and a drawing or print of Correggio's painting, now at the Louvre.

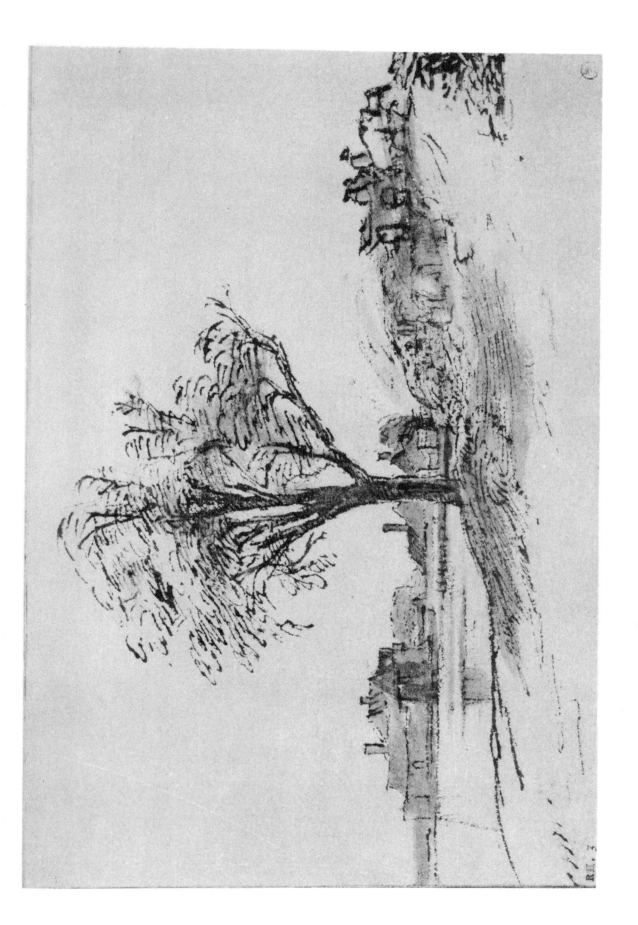

387 (III, 54). *Large Tree on a Dike. (Louvre, Paris)*
Reed pen and wash in bistre: 150 × 231 mm.
About 1652–55. Lugt (1920) writes that the site is probably by the Diemerdijk in the vicinity of Jaaphannes.

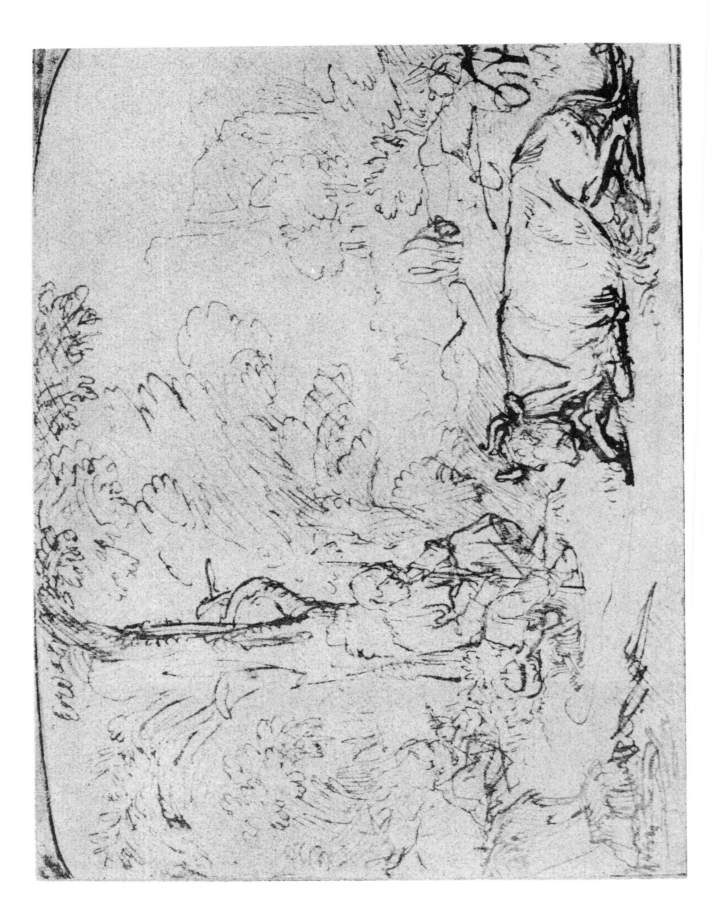

388 (III, 55). *Mercury and Argus in a Landscape.* (Louvre, Paris)

Pen in bistre: 175 × 238 mm.

An exceptionally fine composition made around 1650. Valentiner (593) rightly praises the way the figures have been integrated into the landscape. Not listed in Benesch.

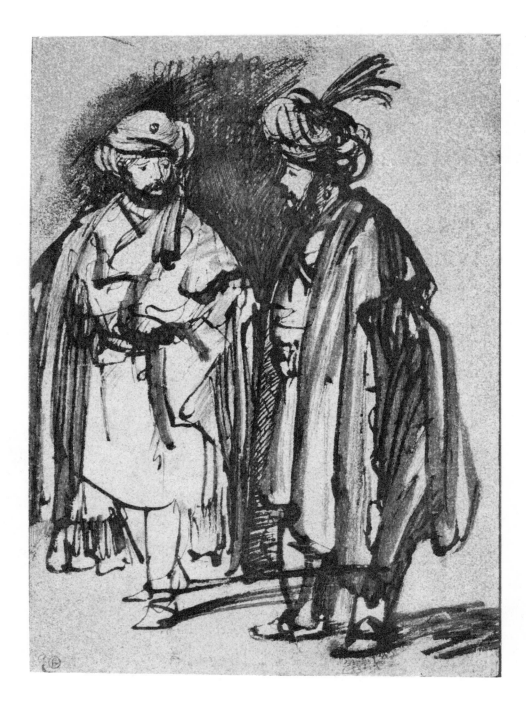

389 (*III, 56*). *Two Standing Orientals*. (*Louvre, Paris*)

Pen and brush in bistre, washes over red chalk: 180 × 126 mm.

The luminous and rich tonality suggests a date in the late 'forties; Benesch (212) dates the work about 1632–33.

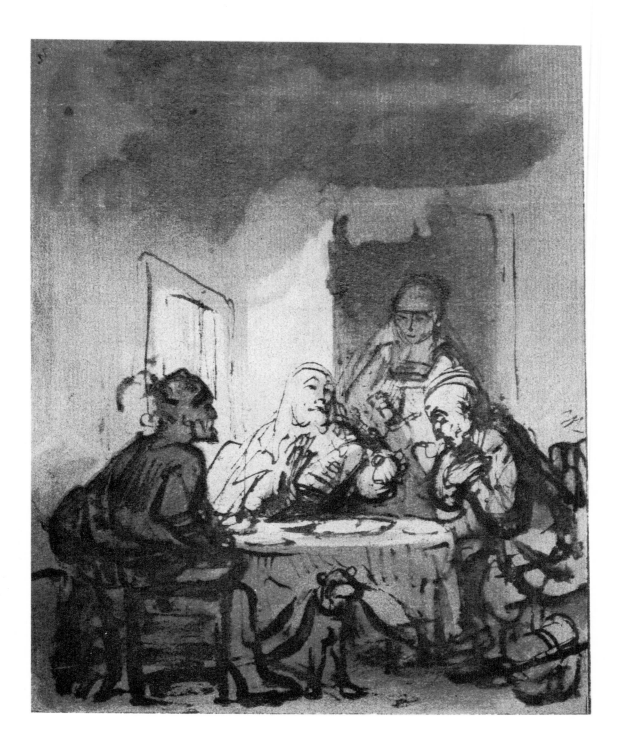

390 (*III, 57*). *The Supper at Emmaus. (Formerly Walter Gay Collection, Paris)*
Pen and wash in bistre: 188 × 150 mm.
A school drawing close to the group Valentiner (1924) attributed to Maes.

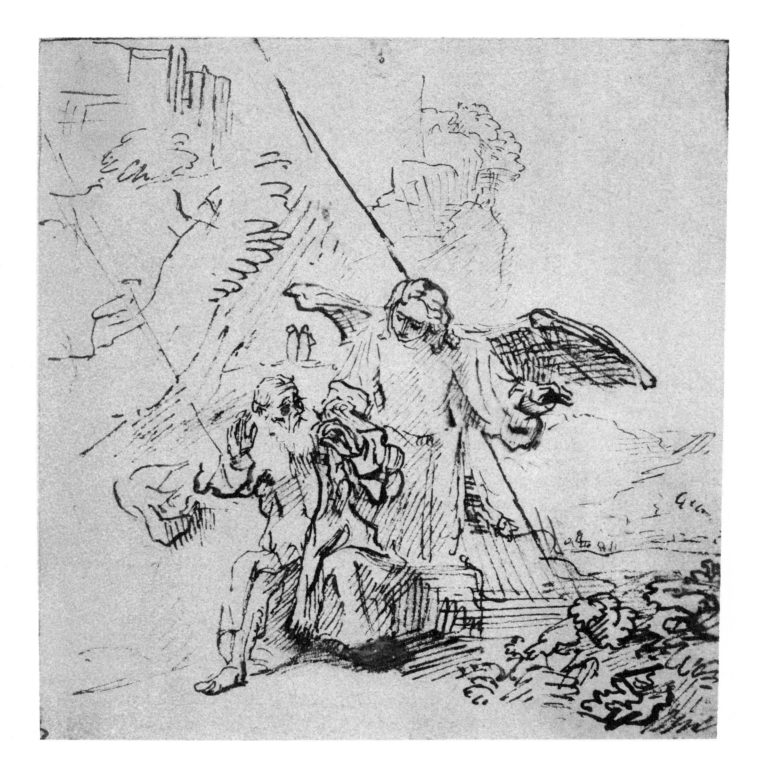

391 (III, 58). *The Angel Appearing to Elijah in the Desert. (Formerly Henry Oppenheimer Collection, London)*
Pen and bistre: 181 × 108 mm.

Until Benesch published the original made by Rembrandt around 1652 (Benesch 907, now in the Frits Lugt
Collection, Paris), this copy was considered an authentic work. Even the reproduction shows that the copyist was
unable to imitate Rembrandt's delicate hatching in the shadows. His hatched lines have none of the vibrancy of
Rembrandt's and fail to suggest the positions of the forms in space.

392 (III, 59). *The Meeting of Jacob and Laban.* (Kobberstiksamling, Copenhagen)

Pen and wash in bistre and Indian ink: 169 × 215 mm.

About 1652–55. "And it came to pass, when Laban heard the tidings of Jacob his sister's son, that he ran to meet him, and embraced him, and kissed him, and brought him to his house" (Genesis 29, 13).

393 (III, 60a). *Study of Two Men and Two Children (One of the Latter in a Little Chair). (Louvre, Paris)*
Pen and ink: 152 × 115 mm.
About 1637–40.

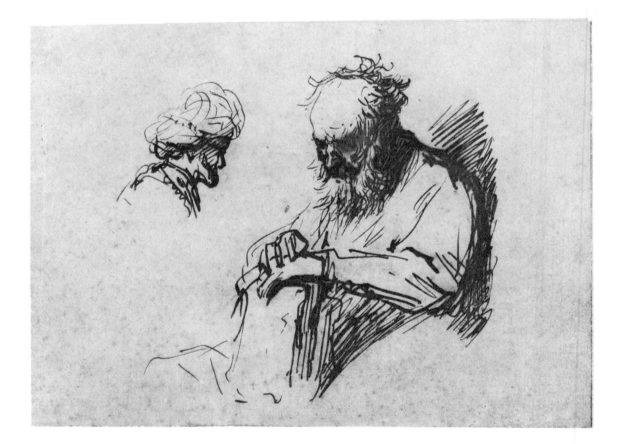

394 (*III, 60b*). *An Old Man with His Hands Leaning on a Book and a Study of a Man Wearing a Turban.*
(*Formerly Henry Oppenheimer Collection, London*)

Pen and bistre: 116 × 156 mm.

About 1631. The old man appears to be the same model Rembrandt used for chalk studies around 1630–31 (see 10 [I, 10]; 171 [I, 162a]; 201 [I, 187b]). Comparison with the preceding sheet shows the difference between Rembrandt's pen drawings of the early and late 1630's. The fine network of sharp lines gives way to more simplified and blocky outlines, and the playful, ornamental quality seen in the treatment of the hair of the old man has been replaced by a greater concentration upon essentials.

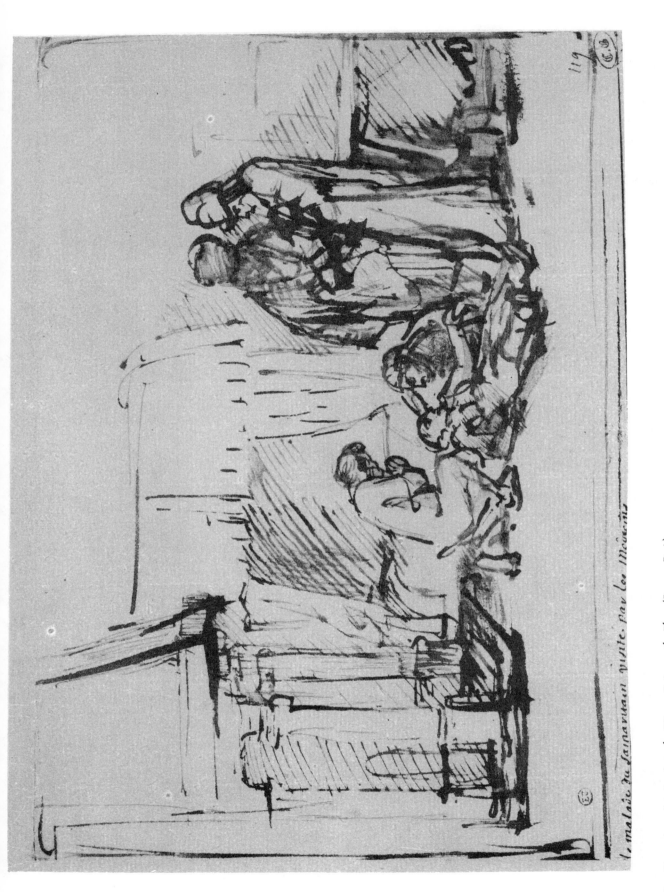

395 (III, 61). *Four Figures in an Interior Around a Woman Lying on the Floor.* (Louvre, Paris)

Pen and wash in bistre, white body color: 157 × 230 mm. A later inscription in the lower left reads: le malade du Samaritain visité par les Médecins.

About 1655. The subject is difficult to interpret. Benesch (1016) rightly notes that the French inscription ignores the fact that the figure on the floor is a woman. He suggests that The Death of Sapphira (Acts 5, 1–10) is the probable subject, but agrees it is not an entirely satisfactory interpretation. Valentiner (575) interprets it as The Death of Lucretia and calls the standing figures on the right Publius and Lucius Brutus.

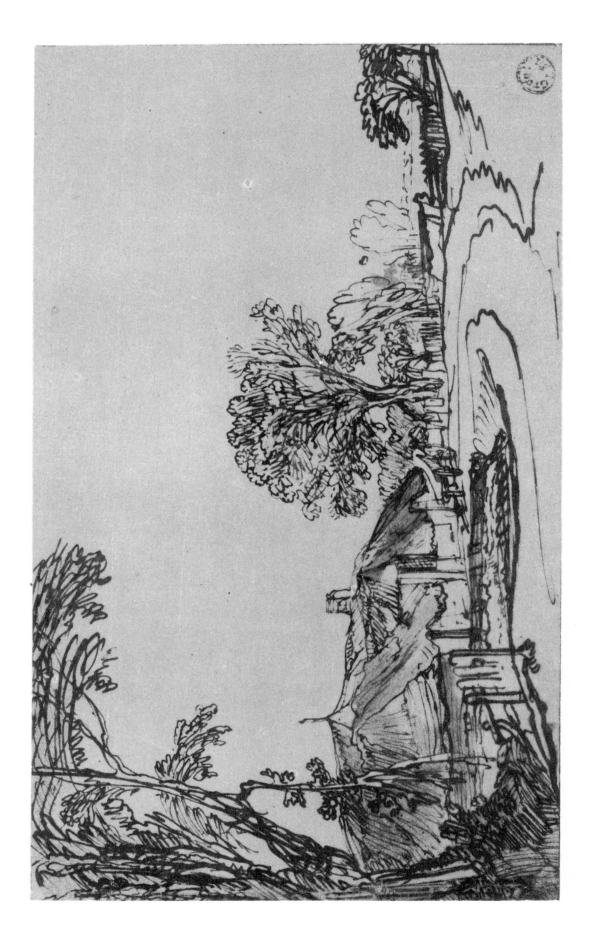

396 (III, 62). *Cottages Beside a Road. (Louvre, Paris)*
Pen and wash in bistre: 141 × 237 mm.

About 1640. Rembrandt only began to concentrate upon landscape studies in the late 1630's. Thus this study can be classified as a relatively early one. In it the large tree in the foreground and the diagonals which lead the eye back to the horizon help create the illusion of space. Rembrandt soon found ways to achieve the same effect without employing these stock devices and was able to suggest the great spaciousness of the Dutch countryside by less obvious and more economic means, with a few sensitive touches of the pen and an ingenious use of white paper.

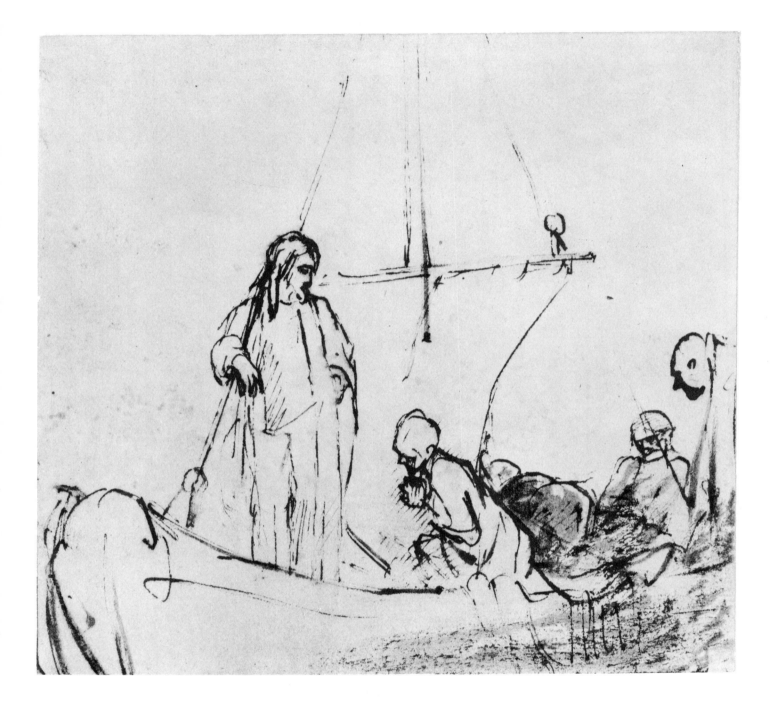

397 (*III, 63*). *The Miraculous Draught of Fishes.* (*Louvre, Paris*)·

Reed pen and wash in bistre: 180 × 192 mm.

About 1655. A copy of the drawing, which is in the British Museum (Hind, 1915, no. 130), shows that this sheet was cut on the right.

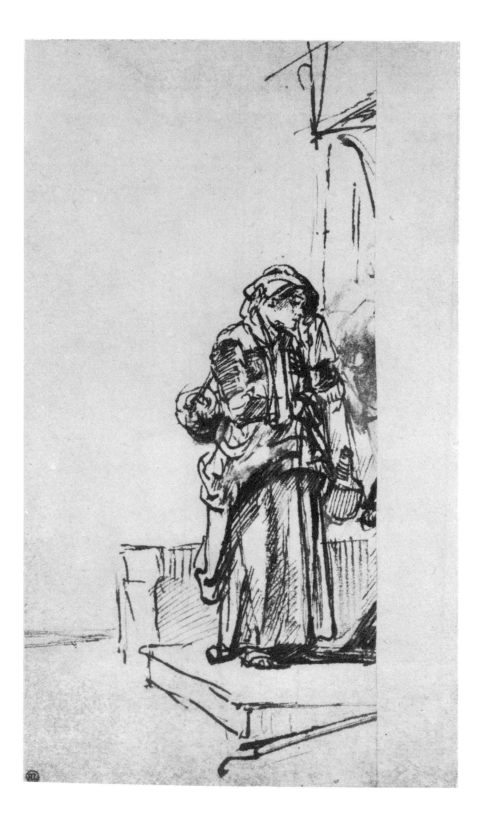

398 (*III, 64*). *The Dismissal of Hagar at the Door of Abraham's House. (Louvre, Paris)*
Pen and bistre, wash, white body color: 206 × 116 mm.
About 1645–48. The drawing is clearly a fragment which has been cut on the right.

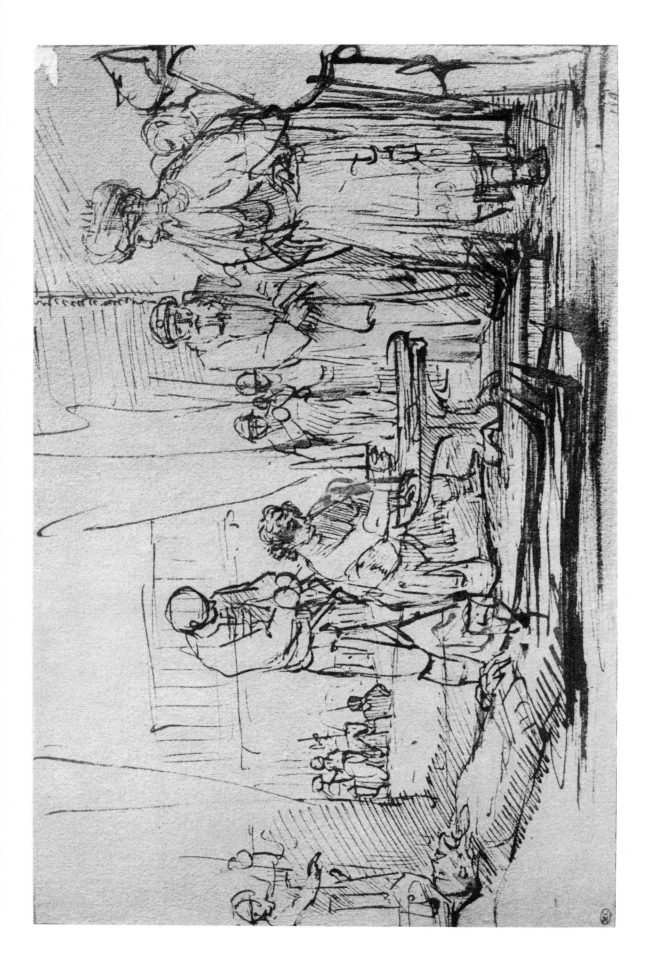

399 (III, 65). *Mucius Scaevola Holding His Hand in Fire Before King Porsenna.* (Louvre, Paris)

Pen and brush in bistre, white body color: 200 × 312 mm.

A school drawing probably made in the late 1650's or early 1660's when Rembrandt himself worked on paintings of scenes from Roman history for Amsterdam's New Town Hall.

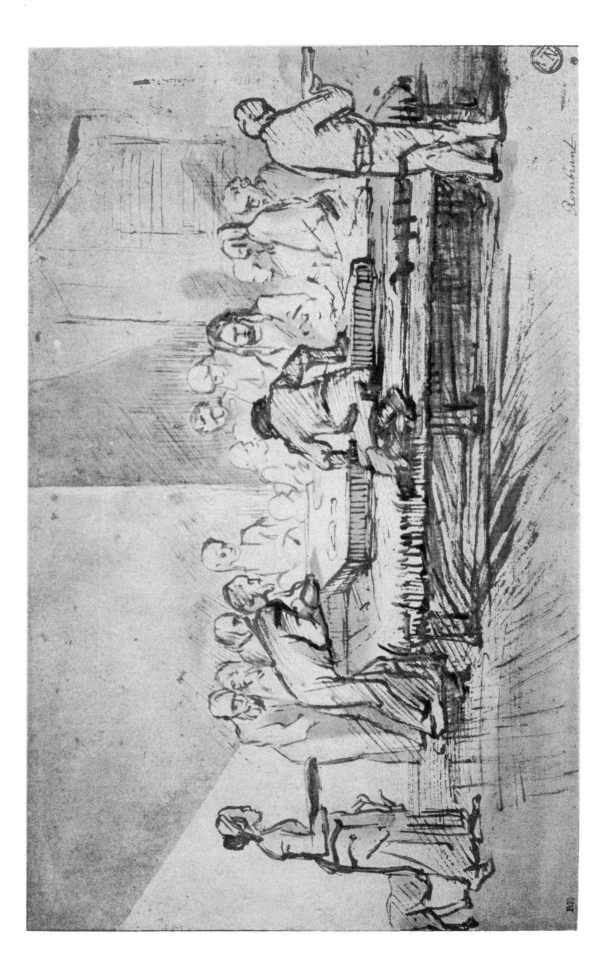

400 (III, 66). *The Last Supper.* (Louvre, Paris)

Pen and wash in bistre: 180 × 297 mm.

The drawing is not worthy of the master. Lugt (1933, no. 1272) calls it a copy after a work by a pupil. Valentiner (441) also labels it a copy, but maintains that the original was made by Rembrandt himself around 1655.

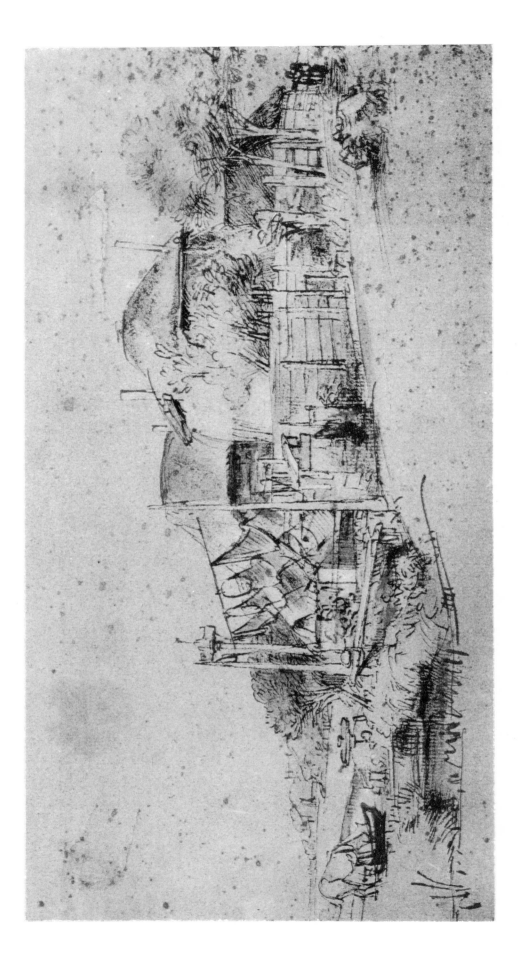

401 (III, 67). *Farmstead with a Hayrick and Weirs. (Frits Lugt Collection, Paris)*

Pen and wash in bistre: 120 × 226 mm.

About 1652. 69 (I, 69) shows the farm from almost the same angle. Also see 70 (I, 70).

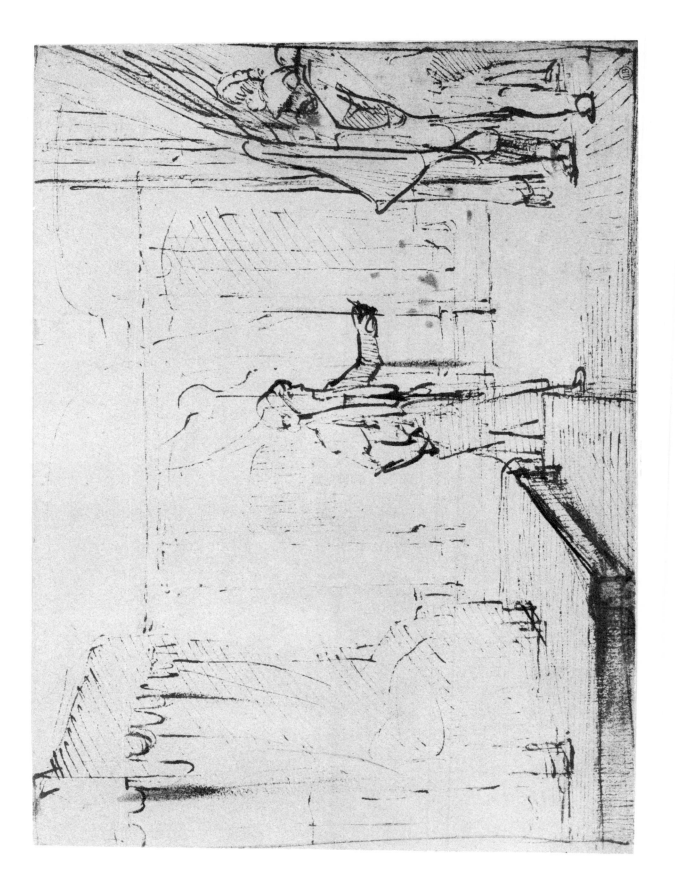

402 (III, 68). *Delilah Calls the Philistines. (Musée, Bayonne)*
Pen and brush in bistre: 165 × 227 mm.

About 1655.

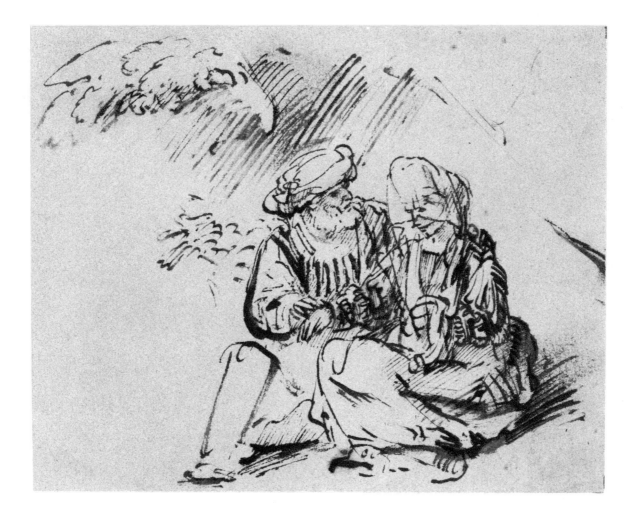

403 (*III, 69*). *Judah and Tamar.* (*Boymans–van Beuningen Museum, Rotterdam*)

Pen and wash in bistre: 128 × 155 mm.

About 1655–60. The subtle psychological grasp of the characters of old Judah and his wily daughter-in-law as they approach a crucial moment in their relationship (Genesis, 38), and the sure and sensitive handling of the pen in the background as well as the figures, place the sheet among Rembrandt's authentic works. See Benesch (A113) for the view it is by a pupil.

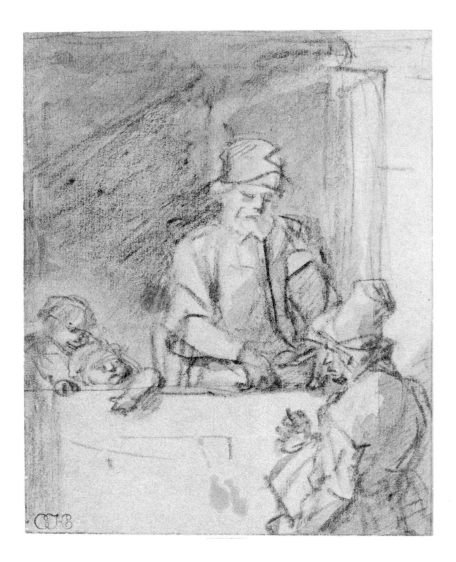

404 (*III, 70*). *The Street Musician.* (*Chr. P. van Eeghen Collection, Amsterdam*)

Black chalk; wash in Indian ink added by another hand: 144 × 110 mm.

About 1645. Used for a painting made by a member of Rembrandt's circle which has been attributed to Arent de Gelder (see K. Lilienfeld, Arent de Gelder, *1914, p. 184, no. 142).*

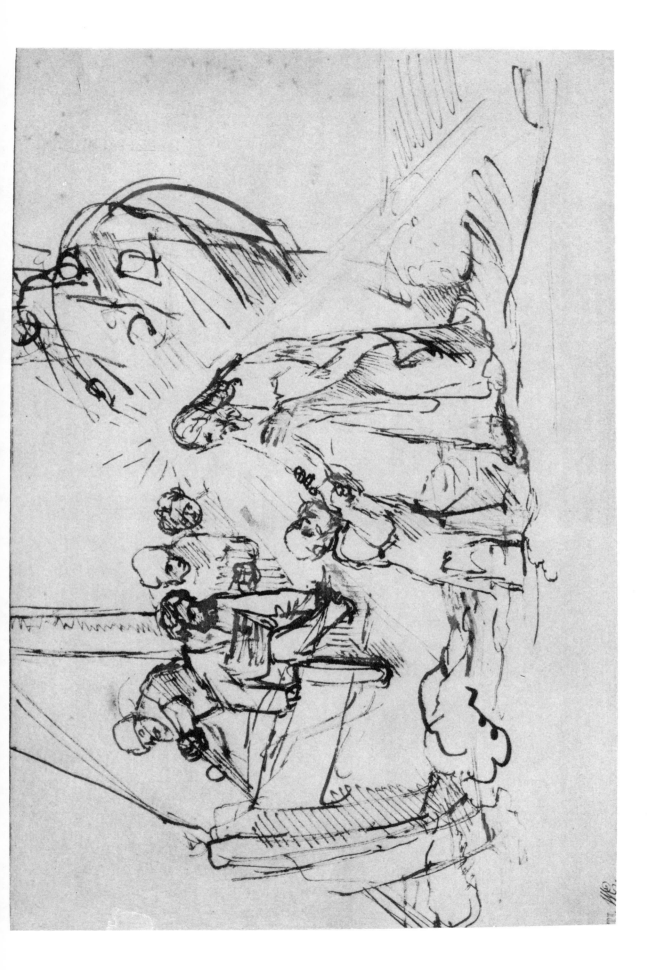

405 (III, 71). *Christ Walking on the Waves.* (*British Museum, London*)

Reed pen and bistre: 191 × 295 mm.

About 1658–60. Comparison with the drawing of the same subject made around 1633 (531 [IV, 82]) is instructive. In the early work, a baroque composition and an energetic quill pen emphasize the dramatic aspects of the story. Here the composition has become more static and Rembrandt's late abbreviated style and richer touch, as well as the dazzling supernatural light which radiates from Christ, suppress unessential detail.

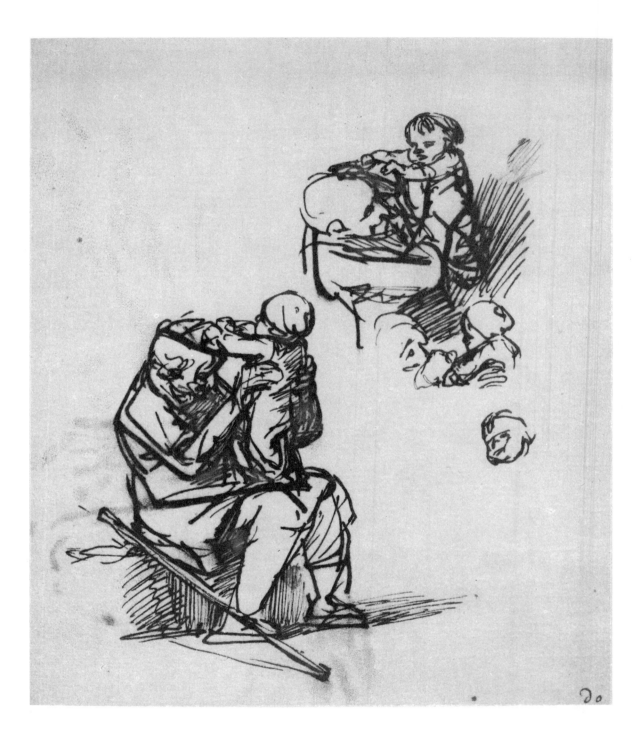

406 (*III, 72*). *Two Studies of a Child Pulling Off the Cap of an Old Man, and Other Sketches of the Same Group*. (*British Museum, London*)

Pen and bistre: 189 × 158 mm.

About 1635–40. Rembrandt was one of the few master draughtsmen who made drawings which show that men as well as women enjoy playing with children.

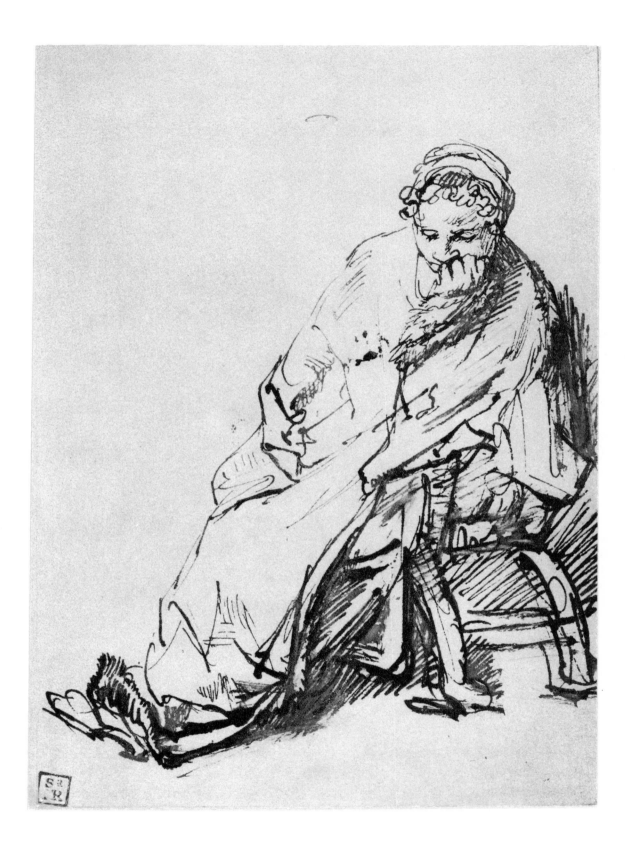

407 (III, 73). *Woman Seated in an Armchair with Her Head Resting on Her Left Hand.* (British Museum, London)

Pen and bistre: 217 × 153 mm.

About 1637–40. With good reason Hind (1915, no. 29) called this one of Rembrandt's finest studies of his earlier period. For the opinion that it is an outstanding school piece see Benesch (A12).

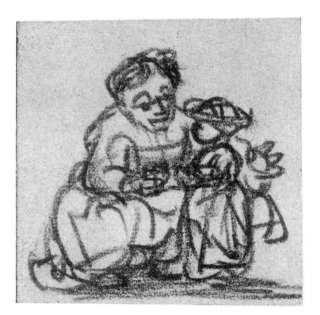

408 (*III, 74a*). *A Woman Teaching a Child to Stand*. (*British Museum, London*)
Red chalk: 78 × 75 mm.
About 1640.

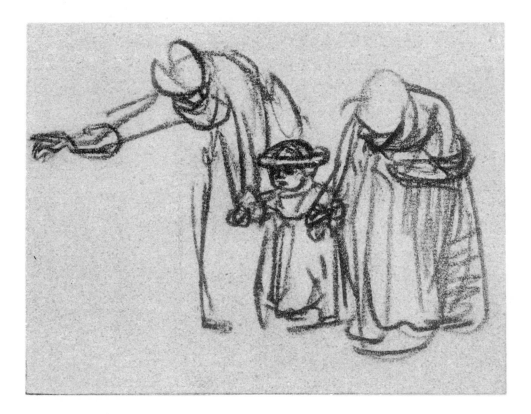

409 (*III, 74b*). *Two Women Teaching a Child to Walk.* (*British Museum, London*)
Red chalk: 103 × 128 mm.
About 1640. Made at the same time as the preceding sheet. Both show Rembrandt's warm humanity and the uncanny power of his suggestive line. The padded hat the child wears protected it from its inevitable falls.

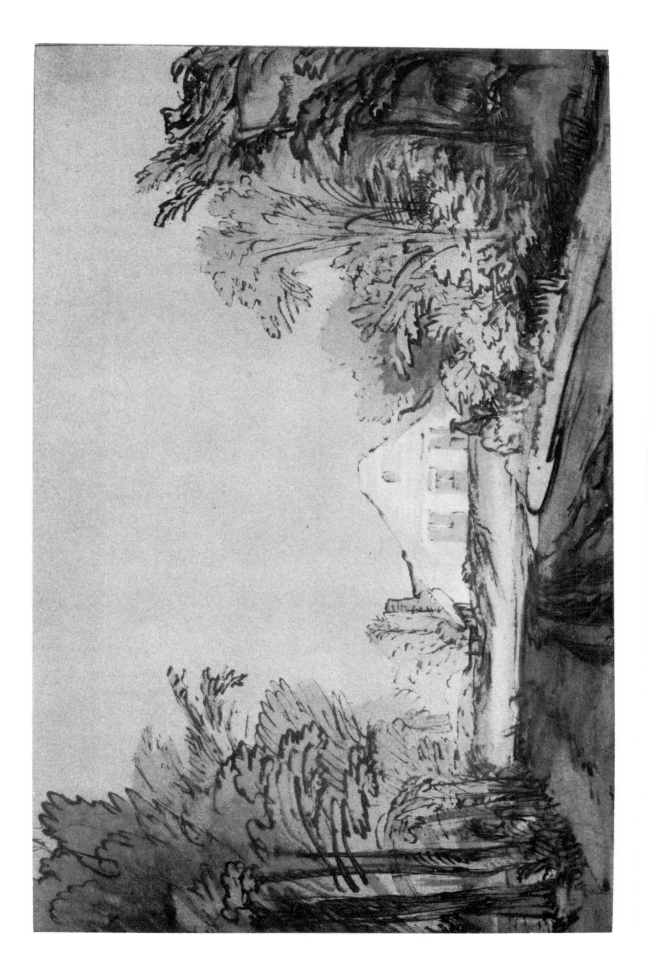

410 (III, 75). *House Beside a Road Lined with Trees. (Frits Lugt Collection, Paris)*

Reed pen and wash in bistre: 210 × 330 mm.

About 1657–60. This drawing and one in Berlin (see 12 [I, 12]) are among Rembrandt's latest landscape studies.

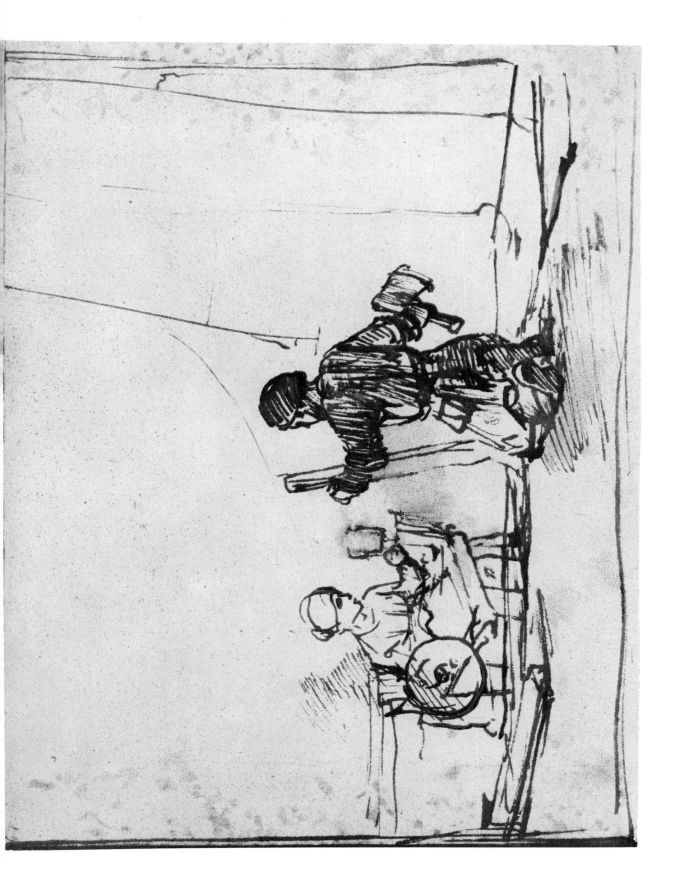

411 (III, 76). *The Holy Family in the Carpenter's Workshop. (Boymans-van Beuningen Museum, Rotterdam)*

Pen and bistre: 173 × 227 mm.

About 1645. After the tragic death of Saskia in 1642, Rembrandt frequently depicted the peaceful home life of the Holy Family. The mood of this scene of the Virgin spinning and of St. Joseph at work can be related to the calm which permeates paintings of the Holy Family at Cassel (Bredius 572) and Downton Castle (Bredius 568).

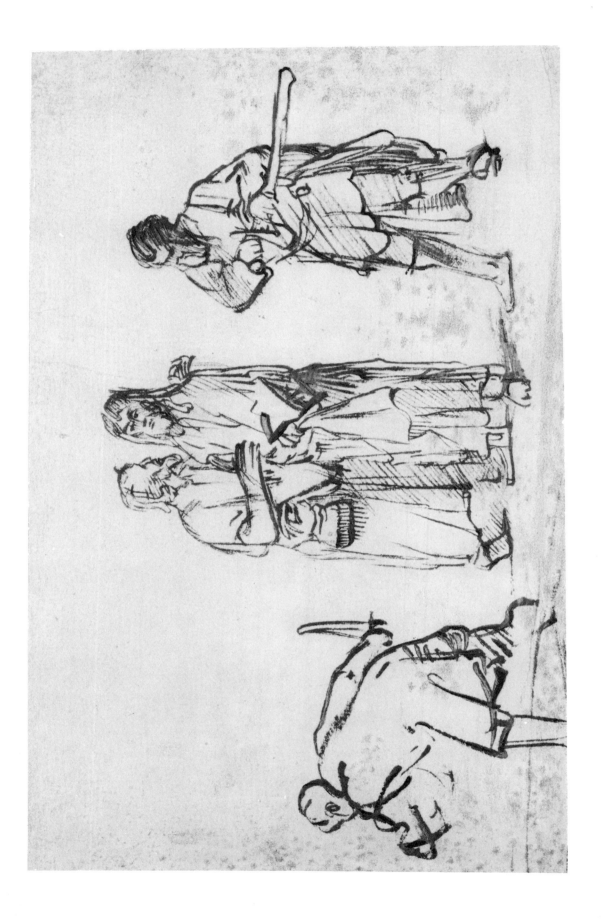

412 (III, 77). *The Kiss of Judas. (Boymans–van Beuningen Museum, Rotterdam)*

Pen and bistre: 160 × 236 mm.

A copy of an original by Rembrandt made around the mid-1650's. The graphic vocabulary used for the figure on the left, St. Peter cutting off the ear of Malchus, is good proof that the original was by Rembrandt and not the invention of an excellent pupil, but some awkward passages—for example, the hands and feet—and a rather insensitive line betray the copyist.

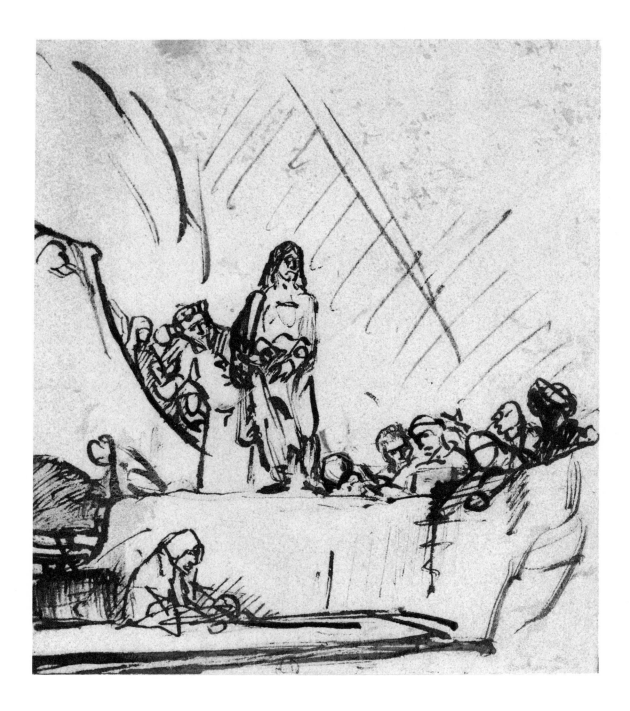

413 (III, 78). *The Raising of Lazarus.* (*Boymans–van Beuningen Museum, Rotterdam*)

Pen and bistre: 182 × 157 mm.

The drawing has been assigned to three different periods. Hofstede de Groot (1352) and Valentiner (421) dated it in the early 1630's and related it to the early etching of the subject (Bartsch 73). Saxl (Oud Holland, 41 [1923–24], pp. 156–7) placed it at the end of the 1650's. Benesch's (518) date of 1641–42 is most acceptable. The bold pen stroke can be related to drawings at the beginning of the middle period, and the emphasis on vertical and horizontal elements supports that date. It is also noteworthy that a black chalk drawing of a Seated Woman on the verso (reproduced Benesch, figure 645) can be dated in the early 1640's.

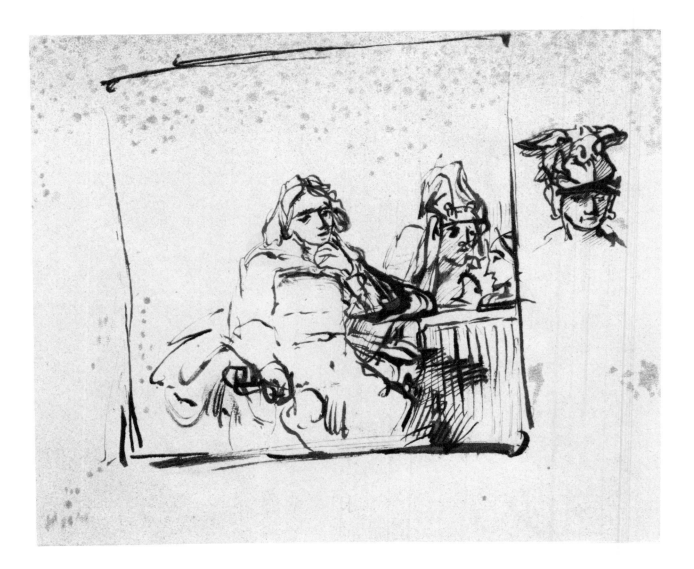

414 (*III, 79*). *Study of a Man Seated at a Table.* (*Boymans-van Beuningen Museum, Rotterdam*)
Pen in bistre: 150 × 175 mm.

Another version of this drawing is now in the Frits Lugt Collection, Paris (formerly in the Liechtenstein Collection, Vienna). Hofstede de Groot called the Rotterdam sheet the original and entitled it a portrait of a sculptor.
Benesch (Old Master Drawings, 2 [1928], pp. 25–26) wrote that it is a preliminary study by Rembrandt's German pupil Johann Ulrich Mair for a self-portrait painted in 1648 and stated that the version now in the Lugt Collection is a copy of Mair's drawing. Valentiner (740) agrees that Mair based his self-portrait on the drawing, but he rightly argues that the painting is so weak that it is difficult to believe that Rembrandt's mediocre pupil was capable of making the drawing. Moreover, Valentiner maintains that the Lugt version is the original, and that the one reproduced here is a copy. Valentiner suggests that the drawing may be related to the commissions Rembrandt executed for his Sicilian patron Don Antonio Ruffo.

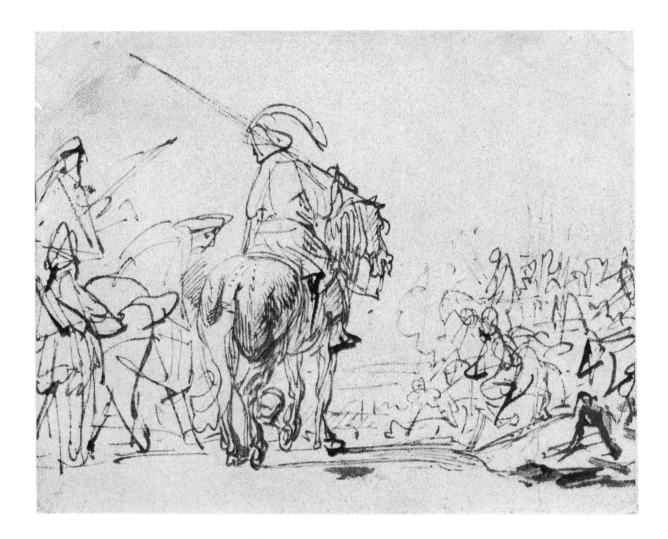

415 (*III, 80a*). *Compositional Sketch of Horsemen.* (*Boymans-van Beuningen Museum, Rotterdam*)
Pen and bistre: 132 × 165 mm.

About 1630–32. The study, which is based on a print by Tempesta, appears to have been used for the small etching of a Soldier on Horseback (*Bartsch 139*) *made around the same time. See Benesch (151) for the argument that the drawing was made about 1636–37.*

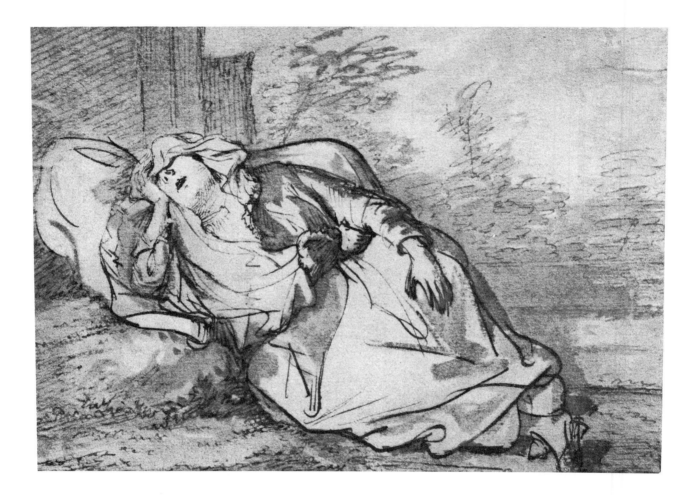

416 (III, 80b). *A Woman Lying Asleep in a Landscape.* (*Boymans–van Beuningen Museum, Rotterdam*)

Pen and wash: 128 × 175 mm.

About 1635. The drawing originally represented a figure (Saskia?) asleep in an interior. A later hand added the landscape detail.

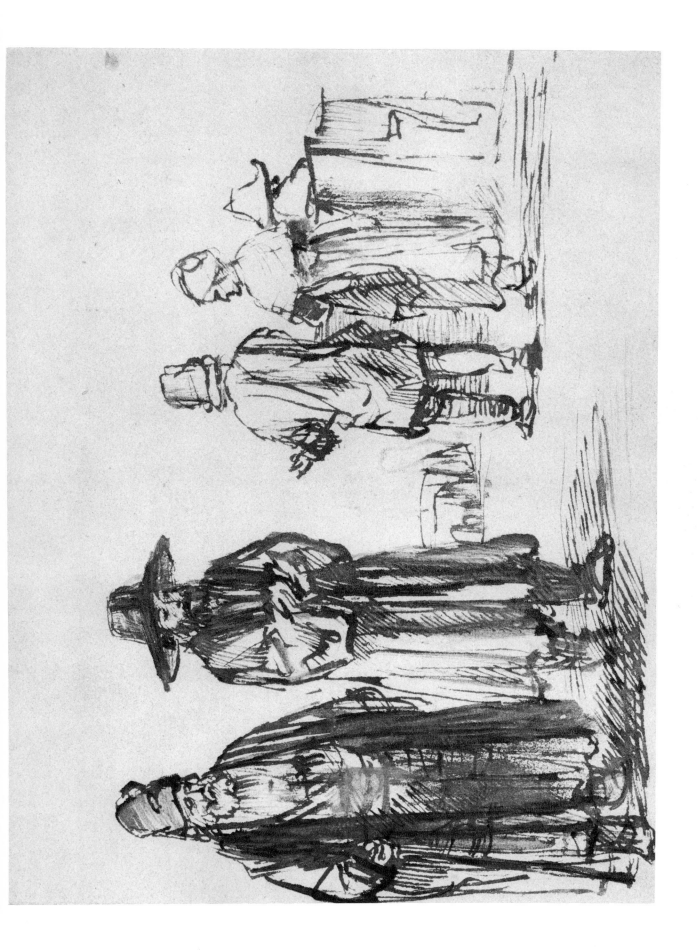

417 (III, 81). *Two Jews and Some Dutch People on a Street.* (*Teyler Museum, Haarlem*)
Pen and wash in bistre: 175 × 237 mm.

About 1655.

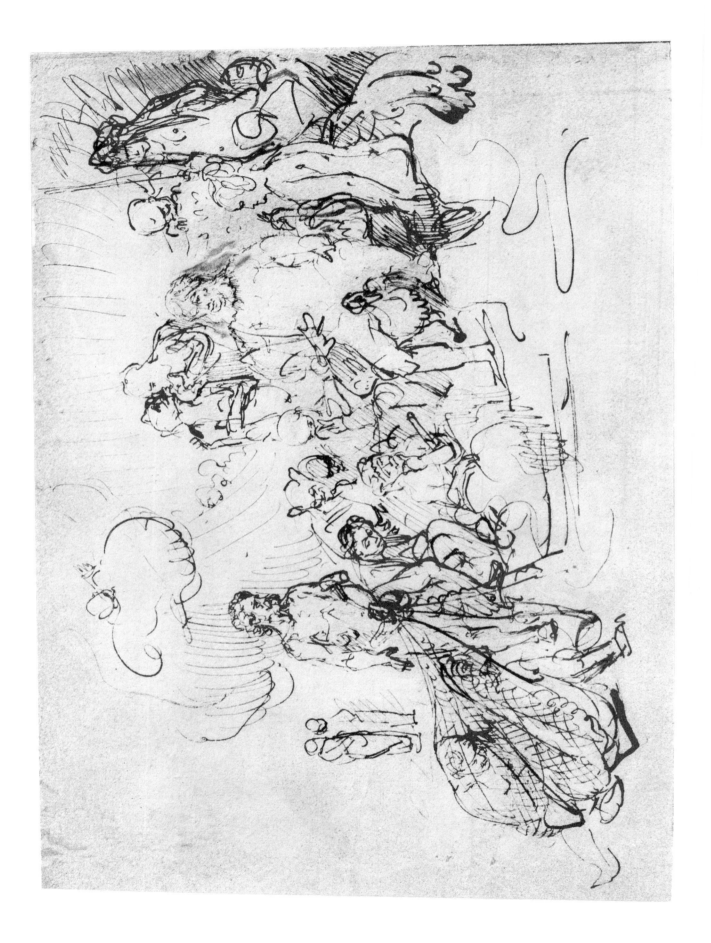

418 (III, 82). *Mars and Venus Caught in a Net and Exposed by Vulcan to the Assembled Gods.* (Fodor Museum, Amsterdam)

Pen and bistre, wash: 210 × 288 mm.

About 1638. Critics who believed that great artists must idealize the ancient gods and treat them with respect had works similar to this one in mind when they called Rembrandt the foremost heretic who broke the rules of art.

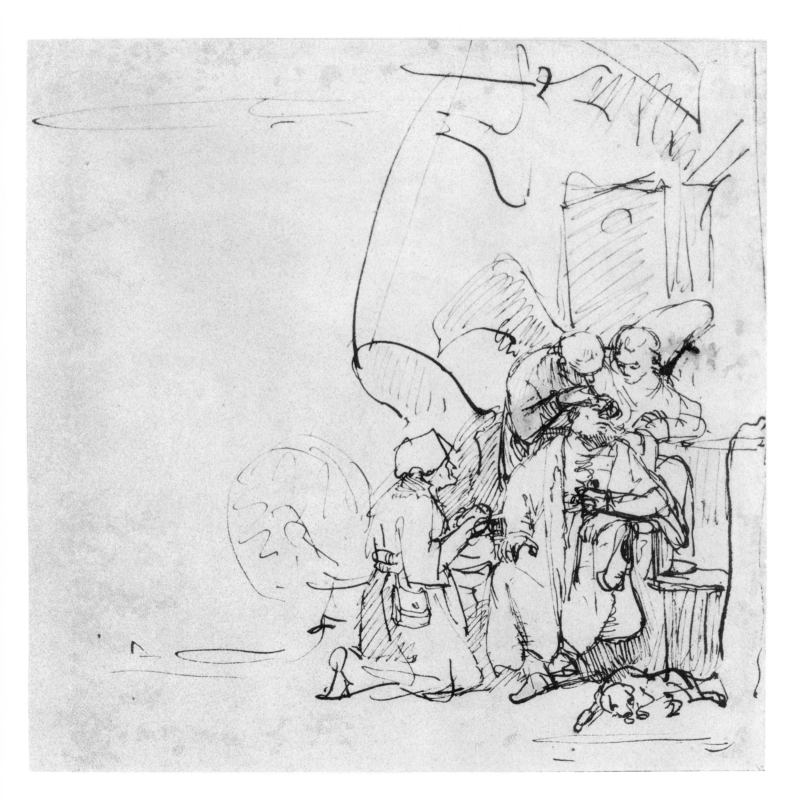

419 (III, 83). *The Healing of Tobit. (Fodor Museum, Amsterdam)*
Pen and bistre: 207 × 200 mm.
About 1640.

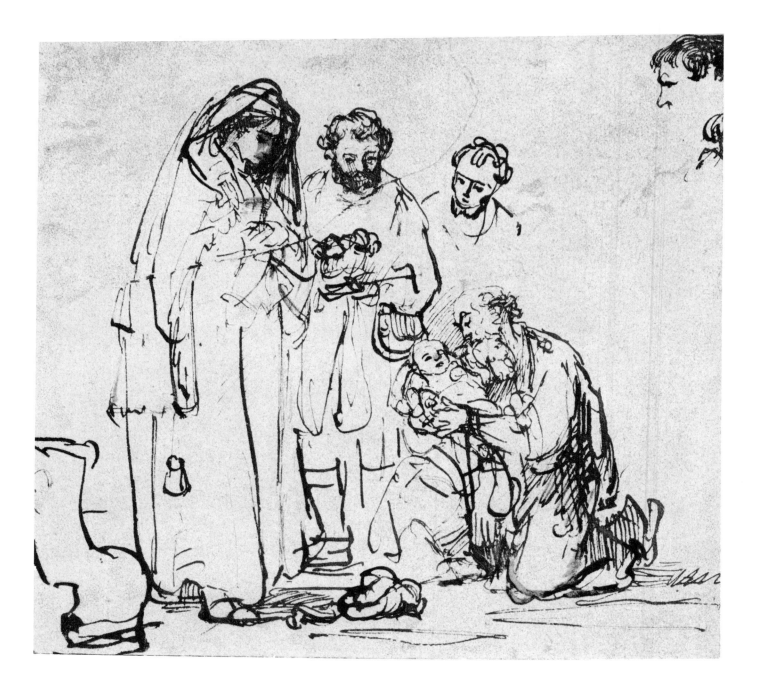

420 (*III, 84*). *The Presentation in the Temple.* (*Fodor Museum, Amsterdam*)

Pen and bistre: 180 × 190 *mm.*

About 1640. A large part of the upper left of the sheet was torn away. It seems that this section was repaired by Rembrandt himself.

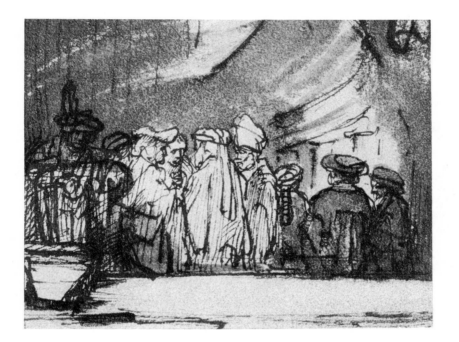

421 (*III, 85a*). *Nine People in a Synagogue(?) Behind a Low Wall.* (*Fodor Museum, Amsterdam*)

Pen and wash in bistre: 87 × 111 mm.

Vaguely related to the etching of 1648, Jews in a Synagogue (Bartsch 126). The weak character of the figures and the failure of the line and wash to suggest tonal gradations in this small sketch raise doubts about the attribution to Rembrandt. Not listed in Benesch.

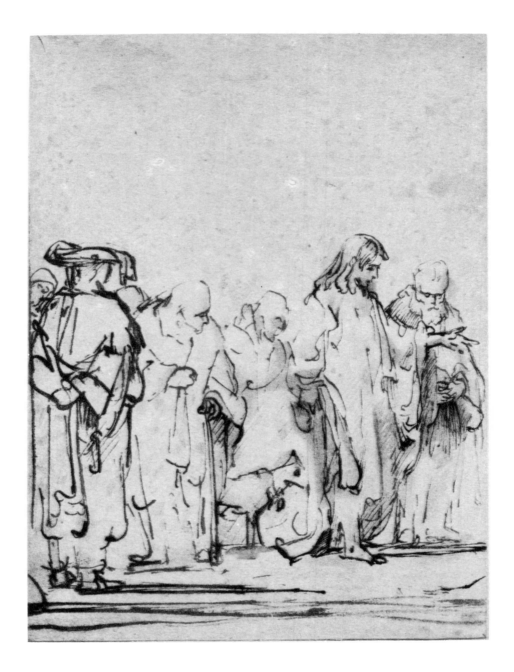

422 *(III, 85b). Christ Surrounded by a Group of Figures. (Fodor Museum, Amsterdam)*

Pen and some wash: 172 × 125 mm.

Probably a copy after an original made around the early 1640's. A conclusion about the subject is difficult to reach because the composition has been cut on the right.

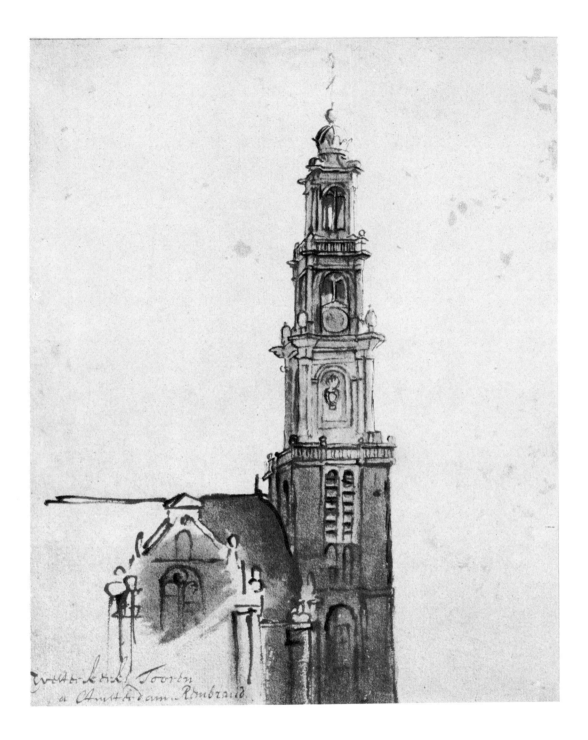

423 (*III, 86*). *Tower of the Westerkerk at Amsterdam.* (*Fodor Museum, Amsterdam*)

Pen and bistre, wash: 190 × 148 mm. A later inscription in the lower left corner reads: Westerkerks Tooren/ a Amsterdam; *and in another hand:* Rembrand.

About 1650–52. Comparison with the drawing of The Old Town Hall at Amsterdam After Its Destruction by Fire in 1652, *38 (I, 38) indicates that Rembrandt drew both around the same time. Rembrandt was buried at the foot of the tower on 8 October 1669. See Benesch (A62) for the view that this is a pupil's work.*

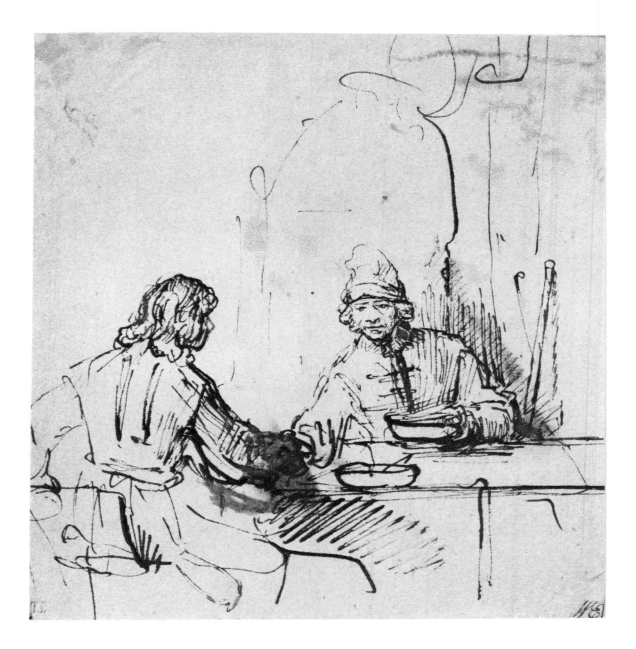

424 (III, 87). *Esau Selling His Birthright to Jacob. (Fodor Museum, Amsterdam)*
Pen and bistre: 155 × 148 mm.
About 1645. A copy of the drawing, now at the British Museum, is reproduced 108 (I, 106).

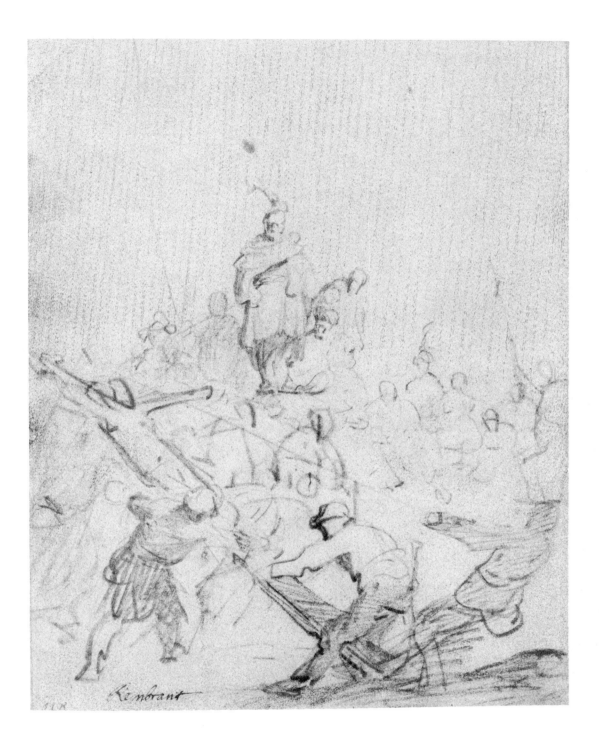

425 (III, 88). *The Elevation of the Cross.* (*Boymans-van Beuningen Museum, Rotterdam*)

Black chalk: 193 × 148 mm.

Benesch established the date of about 1627–28 for this drawing. It is, however, difficult to see the relationship he notes (see Benesch 6) between this early compositional study and Callot's etching (Lieure 548) of the same subject. On the verso a drawing of two figures seated in armchairs.

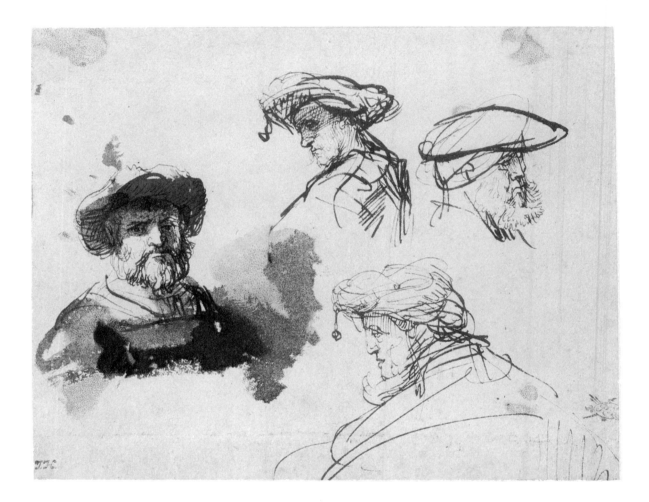

426 (*III, 89*). *Sheet of Studies with Four Heads of Men.* (*Colnaghi's, London*)

Pen and bistre, wash: 126 × 158 mm.

About 1635. Münz (1952, no. 204) wrote that the studies may have been used for Rembrandt's etching Christ
Before Pilate (*Bartsch 77*) *of 1635.*

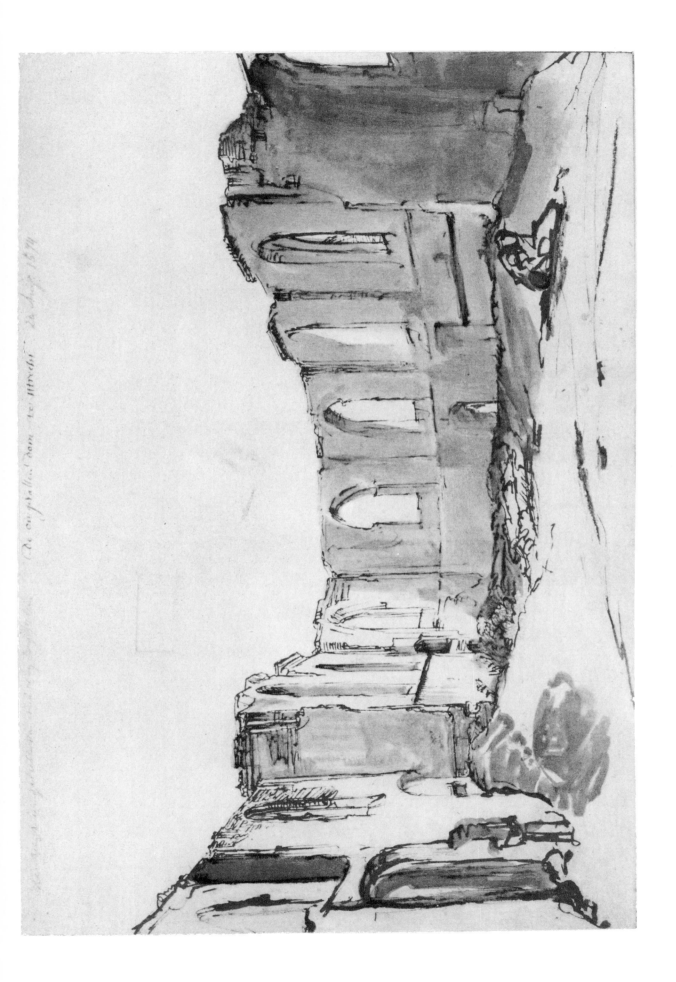

427 (III, 90). *The Ruins of the Church of Muiderberg.* (*V. de Stuers Collection, The Hague*)

Pen and wash in bistre: 185 × 272 mm.

About 1648. The inscription by two different hands, at the top of the imposing sheet, is only partially legible. The part which can be read erroneously identifies the drawing as "the collapsed cathedral of Utrecht 20 August 1674" (De omgevallen dom te Utrecht 20. Aug. 1674). Lugt (1920) identified the subject as the church at Muiderberg.

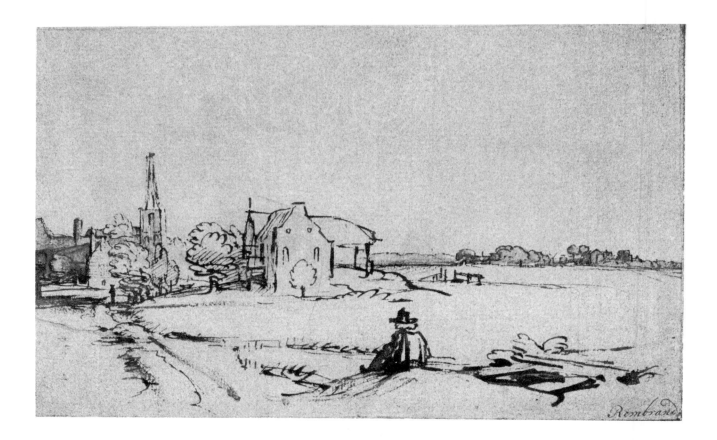

428 (*III, 91a*). *View of Diemen.* (*V. de Stuers Collection, The Hague*)

Pen and bistre, wash: 112 × 175 mm. Signed by a later hand: Rembrand.

About 1648. The artist seated in the foreground can, in a way, be considered a self-portrait. This was a site Rembrandt often visited.

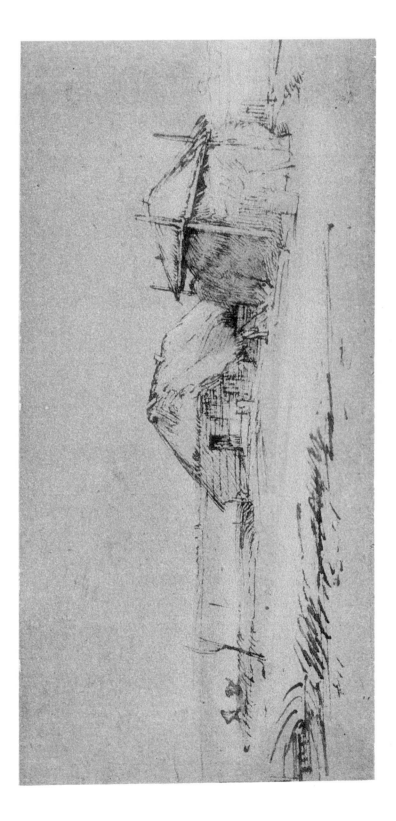

429 (III, 91b). *Landscape with a Farmer's House and a Hayrick.* (Rijksprentenkabinet, Amsterdam)

Pen and bistre: 98 × 208 mm.

About 1650.

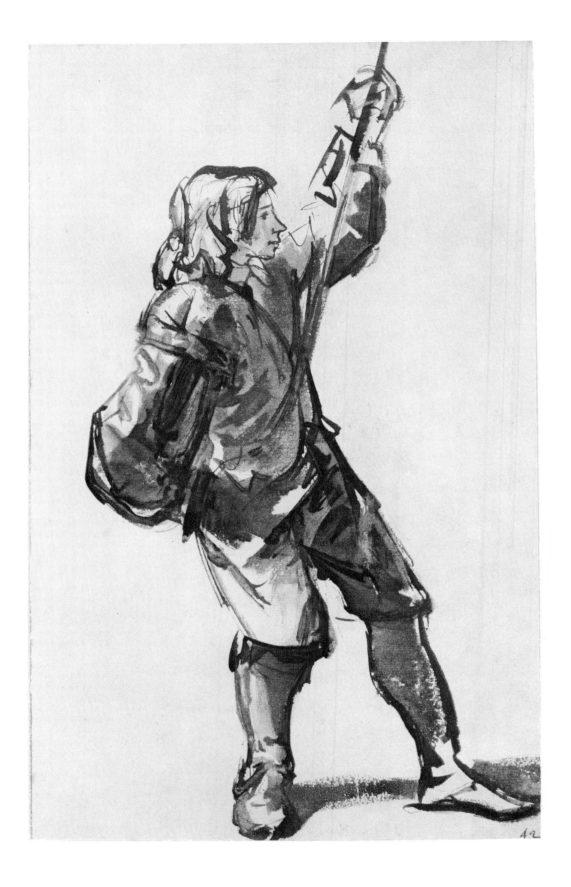

430 (III, 92). *Life Study of a Youth Pulling at a Rope.* (*Rijksprentenkabinet, Amsterdam*)

Brush, quill and reed pen, wash, heightened with white: 290 × 178 mm.

About 1656–58. Rembrandt's close and constant study of nature continued to produce masterworks until the end. This drawing from life was made as a preliminary study for the painting at Darmstadt of Christ at the Column, *1658 (Bredius 593). A similar rich tonal effect achieved without the use of the pen, but with the same bold brush, luminous washes, and an uncanny use of white paper can be seen in* A Woman Sleeping *(525 [IV, 76]) at the British Museum, London. For the suggestion that the drawing must be dated around 1636 and that the Darmstadt painting is the work of a pupil, see Benesch 311.*

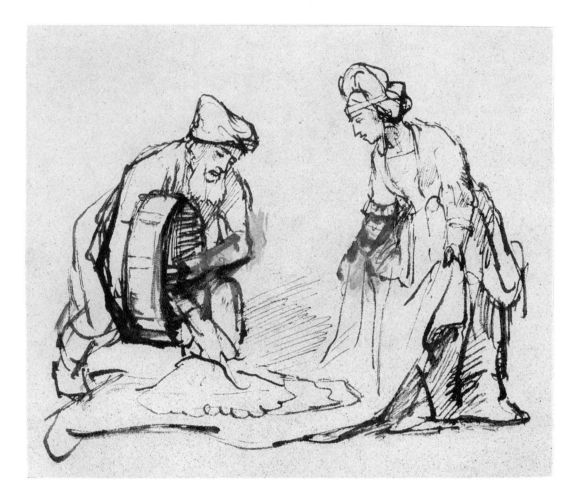

431 (*III, 93*). *Boaz Pours Six Measures of Barley into Ruth's Veil.* (*Rijksprentenkabinet, Amsterdam*)
Pen and bistre, white body color: 126 × 143 mm.
About 1648–50.

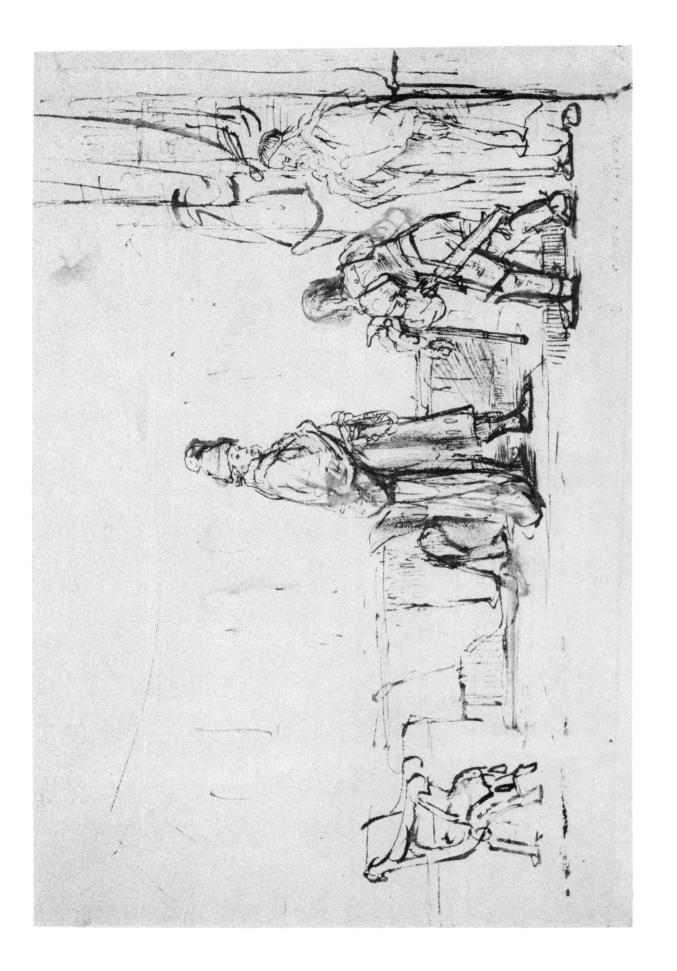

432 (III, 94). *David Receiving the News of Uriah's Death.* (*Rijksprentenkabinet, Amsterdam*)

Pen and bistre, white body color: 195 × 290 mm. Two signatures, both added later.

About 1650–52. The drawing combines two scenes of the story told in different chapters (11 and 12) of II Samuel: David receiving word that Uriah is dead, and the prophet Nathan's visit to David. Everything heightens the drama here: the crowding of the dramatic action on the right; the attitude of guilty David; solemn Nathan who will admonish the man who sent Uriah to his death; even the detail, which Rembrandt invented, of showing the messenger with the dead Uriah's weapons.

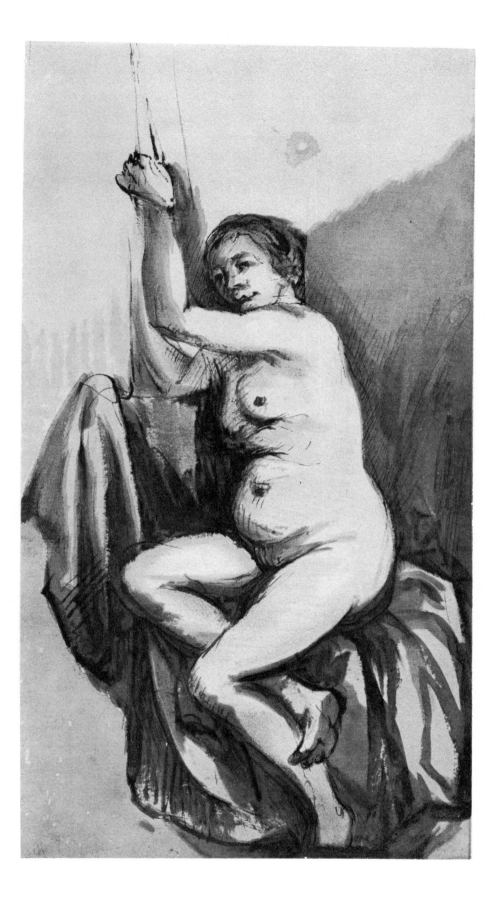

433 (*III, 95*). *Seated Female Nude with Her Arms Raised, Supported by a Sling.* (*Rijksprentenkabinet, Amsterdam*)

Pen, brush and wash in bistre: 292 × 155 mm.

About 1660–61. Closely related to the drawing which served as a preliminary study for the etching The Woman with an Arrow *of 1661 (see 125 [I, 123]). The model's legs are in the same position, but here both of her hands grasp the sling and her breasts and belly are emphasized. For the etching Rembrandt chose a more decorous view of the nude.*

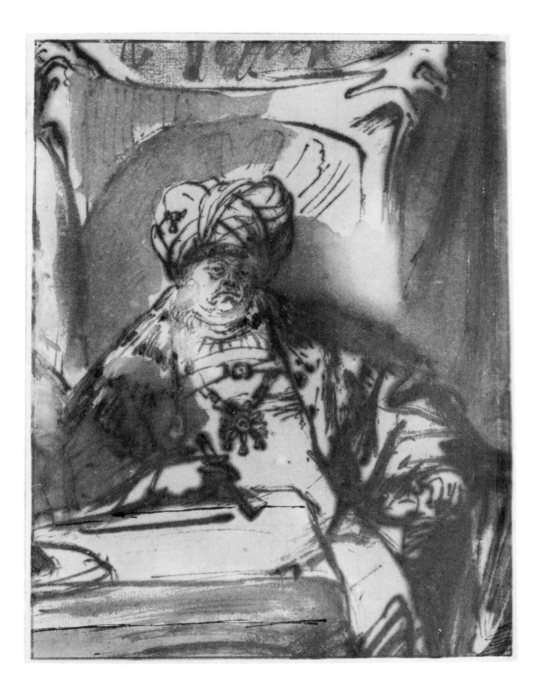

434 (*III, 96*). *Ahasuerus Seated at a Table.* (*Rijksprentenkabinet, Amsterdam*)

Pen and wash in bistre, Indian ink wash: 177 × 130 mm.

About 1632–35. Probably a fragment of a Banquet of Esther, one of the Biblical themes Rembrandt depicted from the very beginning until the end of his career.

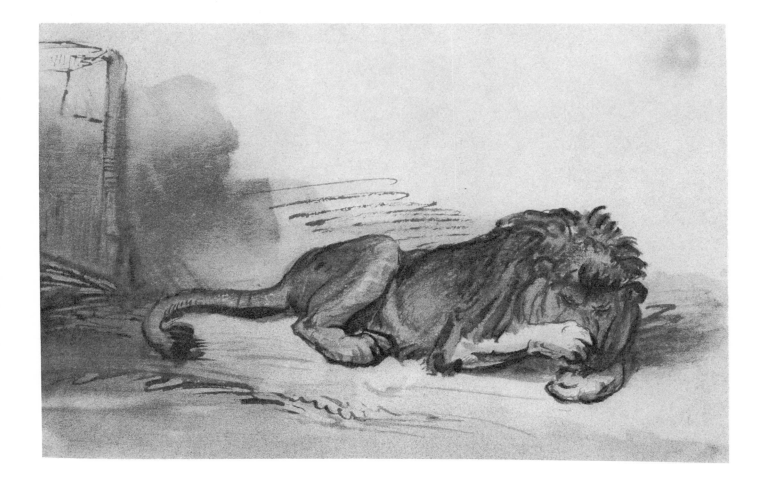

435 (*III, 97*). *Recumbent Lion Scratching His Muzzle.* (*Rijksprentenkabinet, Amsterdam*)
Pen, brush and wash in bistre: 124 × 186 mm.
Contemporary copy after an unknown original of about 1650. (See Henkel, 1943, no. 105.)

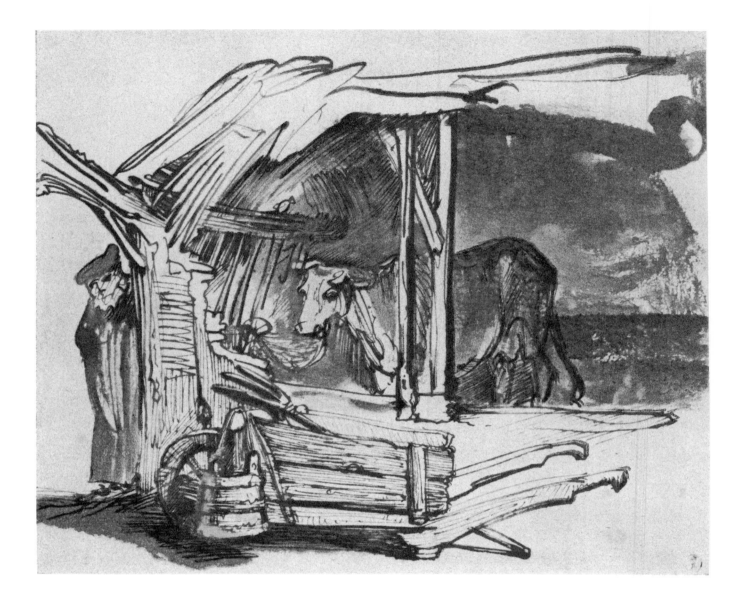

436 (*III, 98*). *Cow Standing in a Shed*. (*Rijksprentenkabinet, Amsterdam*)

Pen and wash in bistre, white body color: 153 × 183 mm.

The subject is an unusual one in Rembrandt's œuvre. This led Henkel (1943, no. 111) to doubt its authenticity.
Benesch (no. 393) rightly argues that it is genuine and dates the study about 1633 by noting its close relation to
the drawing of a Cottage with a Draw Well (*Benesch 462*) *at the Kunsthalle, Hamburg.*

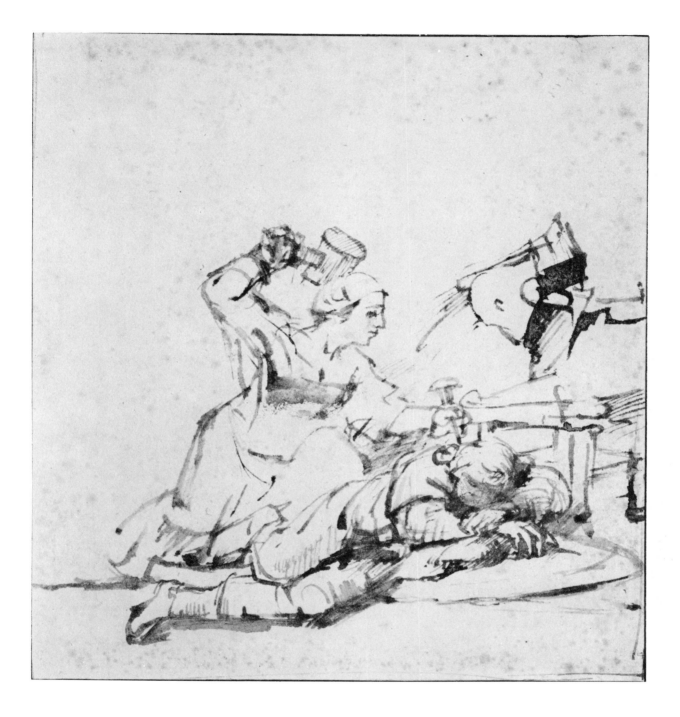

437 (*III, 99*). *Jael Driving a Nail into the Head of Sisera.* (*Rijksprentenkabinet, Amsterdam*)

Pen and bistre, white body color: 190 × 172 mm.

About 1657–60. Old copies are at The Print Room, Brunswick, and the Louvre, Paris—an indication that this monumental composition of the passage, Judges 4, 21, was as much admired in earlier times as it is today.

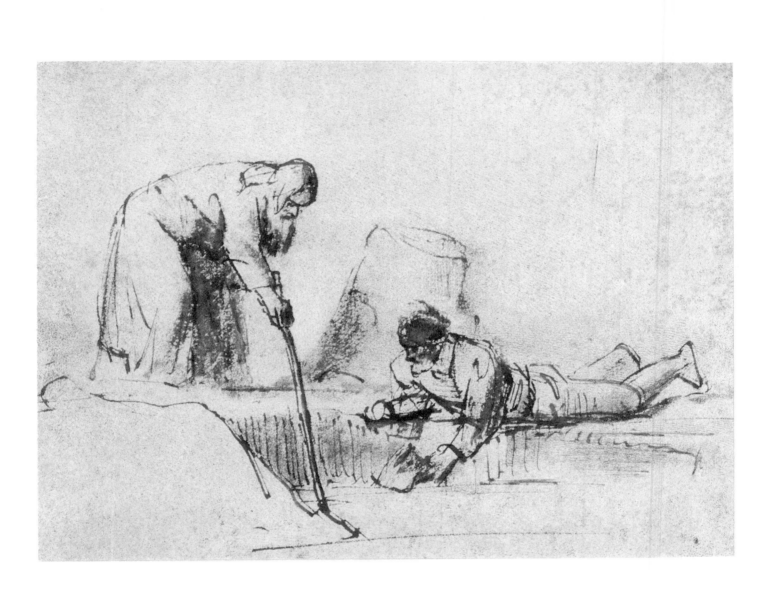

438 (*III, 100*). *The Miracle of Elisha Making a Piece of Iron Float on Water.* (*Bredius Museum, The Hague*)
Pen and bistre, wash: 140 × 188 mm.
About 1650–53. Wash rubbed with the finger, a technique which Rembrandt frequently used in his mature phase,
is especially evident here.

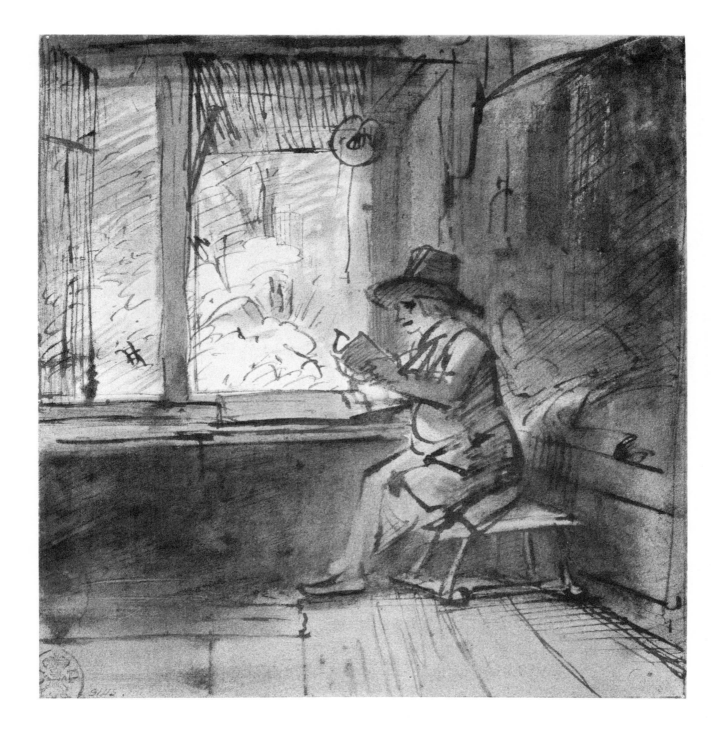

439 (*IV, 1*). *A Man Seated by a Window, Reading. (Staatliche Graphische Sammlung, Munich)*
Pen and bistre, wash: 181 × 171 mm.

About 1650–53. The attribution has occasionally been contested, but the work has the quality of an original and can be related in conception and execution to the drawing of A Man (Jan Six?) Writing (*see 497* [*IV, 51*]).

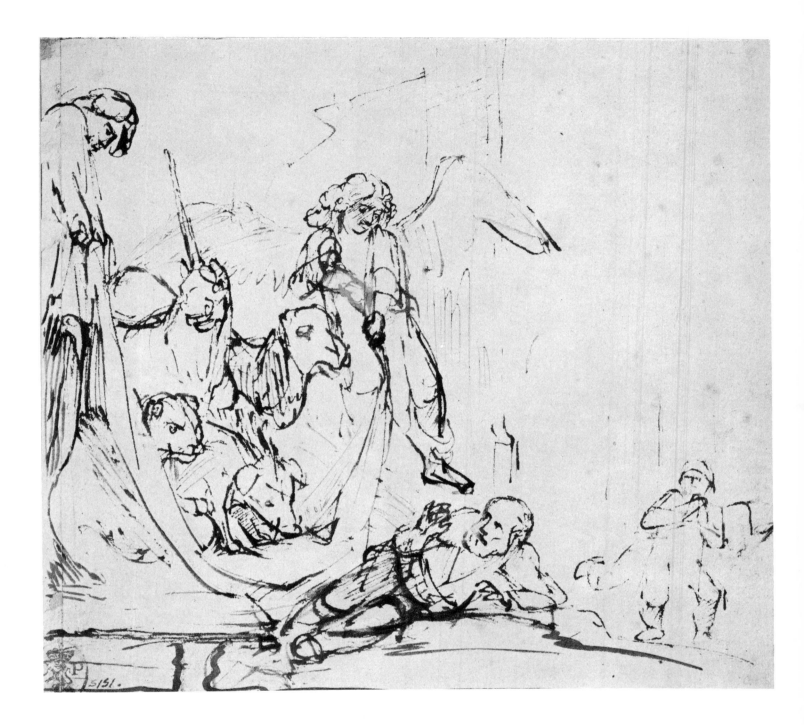

440 (*IV, 2*). *The Vision of St. Peter.* (*Staatliche Graphische Sammlung, Munich*)

Pen and bistre: 179 × 193 mm.

About 1660. The heavy clumsy lines in the lower left corner are not by the master. Rembrandt's pupil Samuel van Hoogstraten made a water color variant (now in Stockholm) of this unusual subject from Acts 10, in which the heavens open and a great sheet is let down, "Wherein were all manner of fourfooted beasts of the earth, and wild beasts, and creeping things, and fowls of the air."

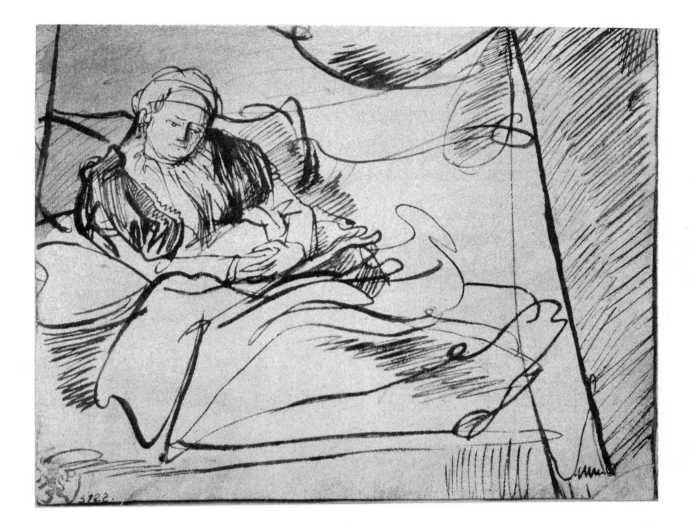

441 (*IV, 3*). *Saskia Sitting Up in Bed.* (*Staatliche Graphische Sammlung, Munich*)

Pen and bistre, wash: 131 × 165 mm.

About 1635. Rembrandt is responsible for the figure of Saskia; another hand added the mechanical hatching and the scribbles meant to suggest the curtain and the blanket.

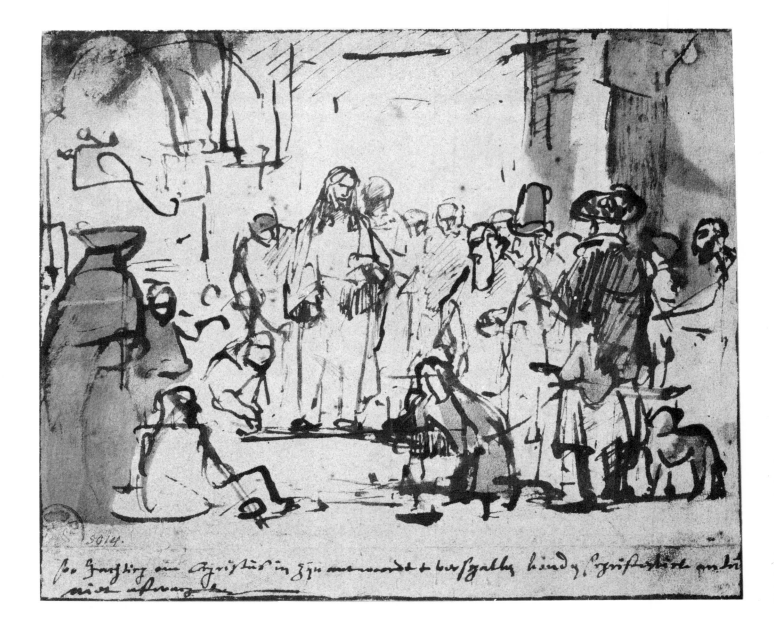

442 (*IV, 4*). *Christ and the Woman Taken in Adultery.* (*Staatliche Graphische Sammlung, Munich*)

Pen and bistre, red and grey washes added by a later hand: 170 × 202 mm. Inscribed by Rembrandt on an attached strip below: zoo jachtig om Christus in sijn antwoordt te verschalken, kon de schrift(geleerde) antw(oordt) niet afwachten (*so eager to ensnare Christ in his reply, the scribes could not wait for the answer*).

The drawing is on the reverse of a funeral announcement dated 14 May 1659, and was probably made shortly after that date; see 450 (IV, 10b) for another late drawing on the back of a funeral invitation. The composition recalls Rembrandt's etching of Christ Preaching, *the so-called* La Petite Tombe (*Bartsch 67*).

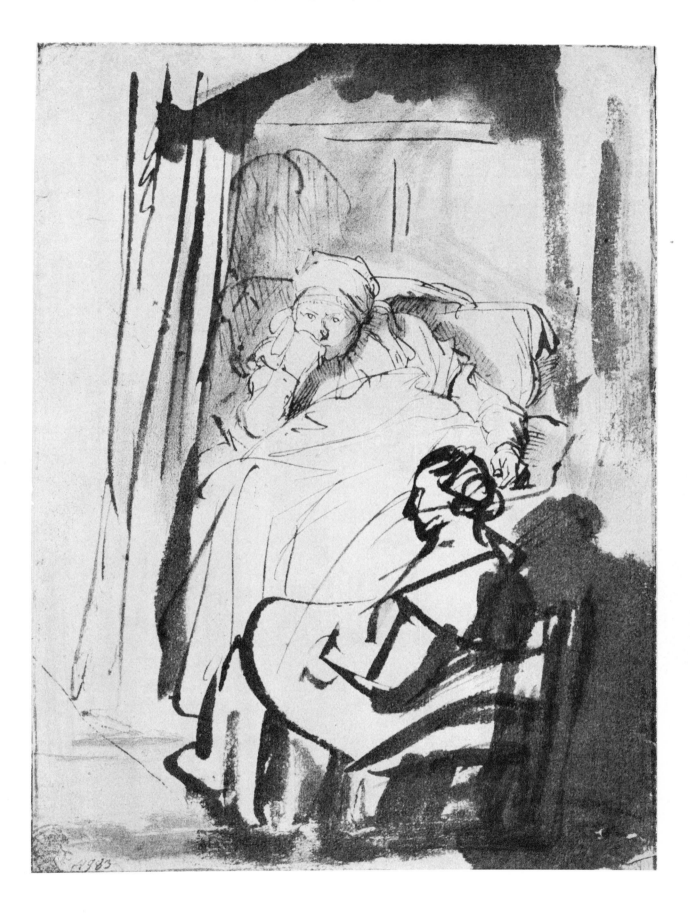

443 (*IV, 5*). *Saskia Lying in Bed, a Woman Sitting at Her Feet.* (*Staatliche Graphische Sammlung, Munich*)
Brush, pen and wash in bistre, and some Indian ink: 228 × 165 mm.
About 1635–38. The suggestion (Neumann, 1919, no. 85) that the dark figure in the foreground and the curtain
were added later can be rejected. There is nothing inconsistent about the powerful brushwork and the pen lines.
The woman in the foreground serves as a repoussoir to establish the front plane, thereby pushing the figure of
Saskia back in space. Rembrandt frequently used this device in his earlier works.

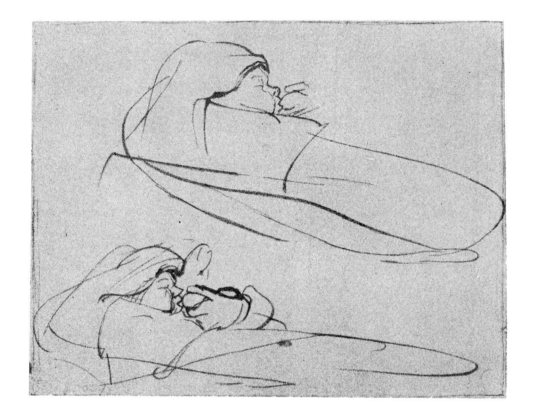

444 (*IV, 6a*). *Two Studies of a Baby with a Bottle.* (*Staatliche Graphische Sammlung, Munich*)
Pen and bistre: 101 × 124 mm.

About 1635. A precious example of Rembrandt's ability to capture the essential aspects of what he observed with a few rapid strokes. The following drawing apparently shows four studies of the same baby, but it is not as striking as this remarkable sheet. The impression has been spoiled in 445 (IV, 6b) by the addition by another hand of diagonal hatchings between the four studies; however, the head of the infant in the bottom study is particularly fine.

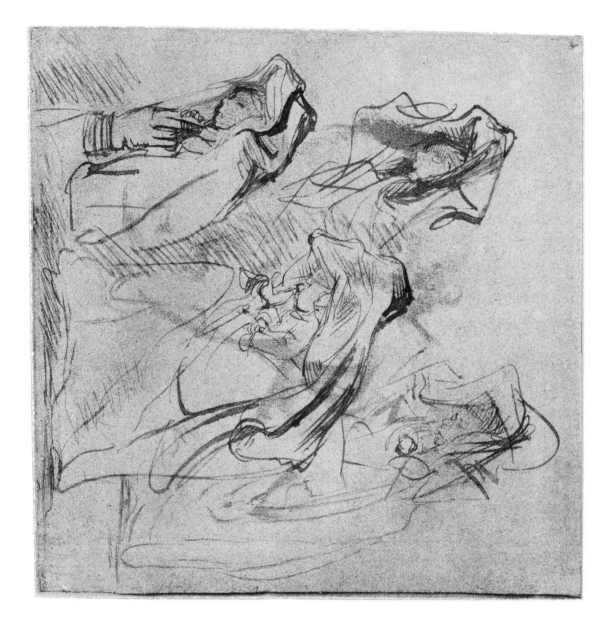

445 (*IV, 6b*). *Four Studies of a Baby.* (*Staatliche Graphische Sammlung, Munich*)
Pen and bistre: 151 × 142 mm.
See the comment to the preceding drawing.

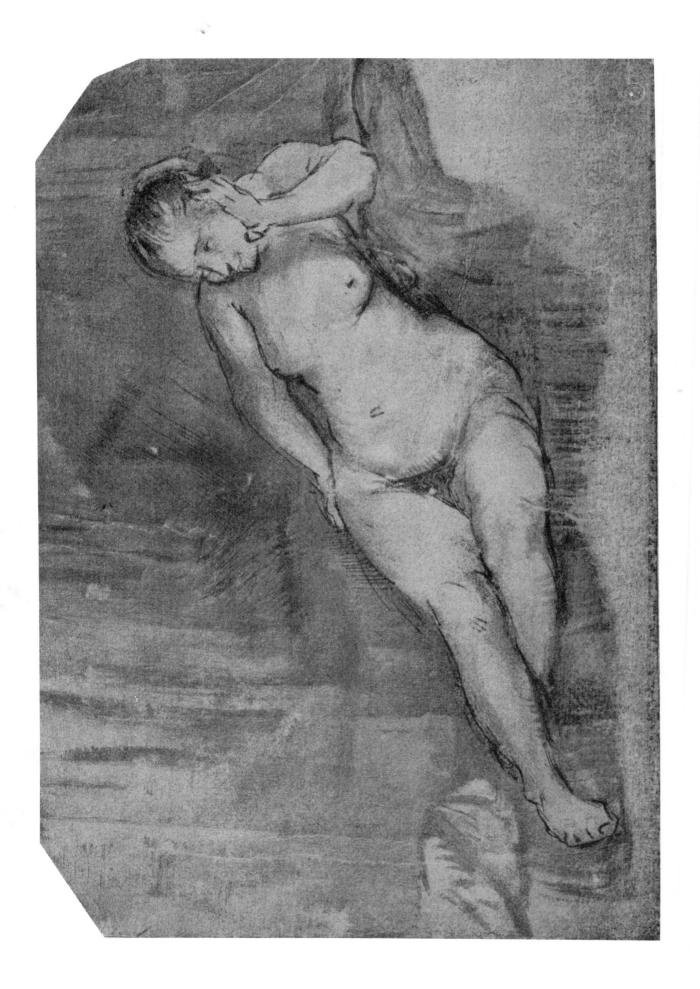

446 (IV, 7). *Reclining Female Nude, Resting Her Head on Her Left Hand. (Staatliche Graphische Sammlung, Munich)*

Pen and brush in bistre: 167 × 246 mm.

Reworked by another hand, and one wonders if the original study was made by Rembrandt himself. The wash on the nude figure fails to model the form or suggest light, and a passage such as the hand supporting the model's head is simply too poor to ascribe to Rembrandt. See the following drawing for an indisputable study of a nude made around 1655—the date suggested by the style of this sheet also.

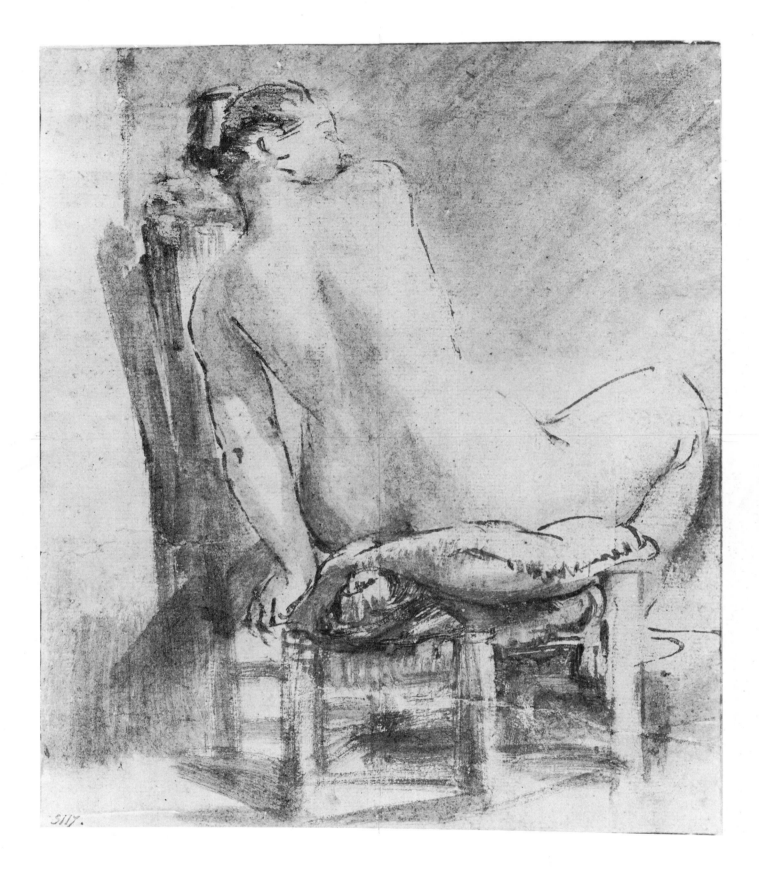

447 (*IV, 8*). *Female Nude Seated on a Chair Seen from Behind.* (*Staatliche Graphische Sammlung, Munich*)
Pen and brush in bistre: 222 × 185 mm.

About 1655. A masterly study which sets the high standard which a drawing of a nude must meet to enter the canon
of Rembrandt's authentic works.

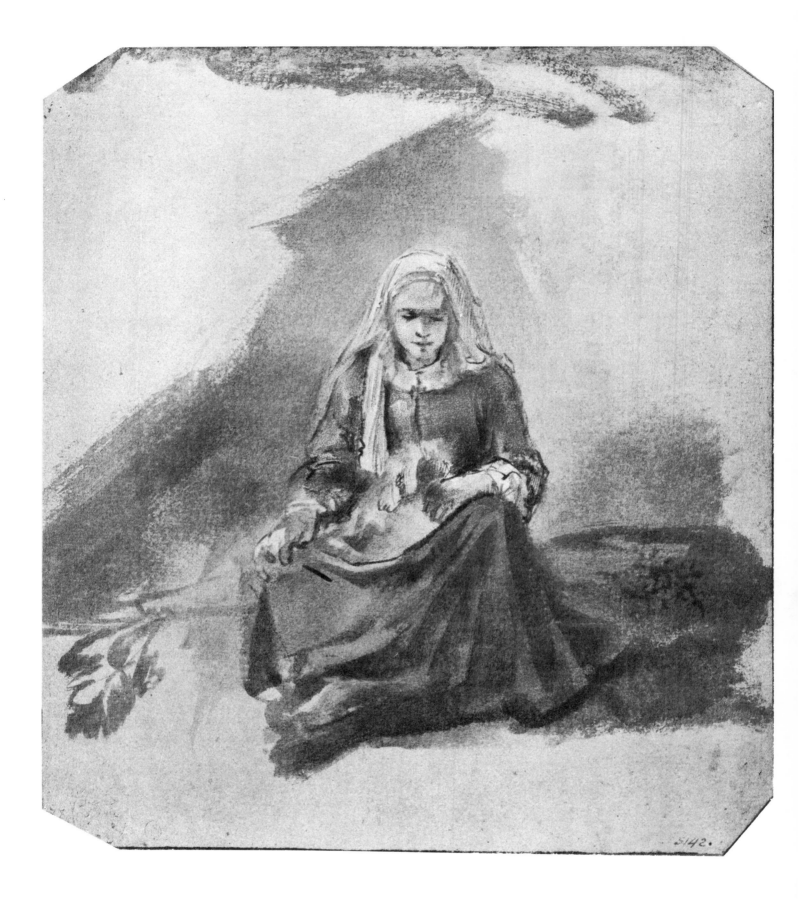

448 (*IV, 9*). *A Young Woman Seated.* (*Staatliche Graphische Sammlung, Munich*)

Pen and wash in bistre, some red wash: 223 × 195 mm.

A copy of a drawing at the Bibliothèque Nationale, Paris, which Lugt (1936, no. 250) dates around 1645 and attributes to Rembrandt, and which Benesch (A47) ascribes to a pupil. The Paris drawing relies more heavily upon the pen than this sheet does. Perhaps the Munich version is by Gerbrand van den Eeckhout.

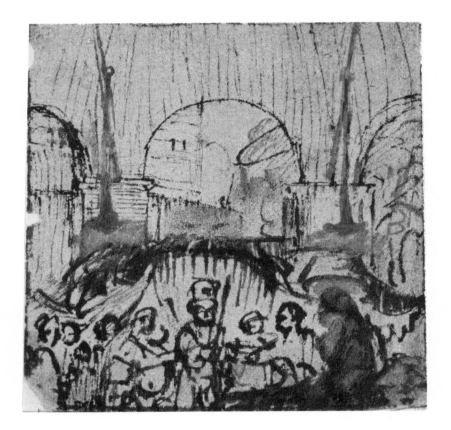

449 (*IV, 10a*). *The Conspiracy of Julius Civilis.* (*Staatliche Graphische Sammlung, Munich*)

Pen and bistre, wash, some reddish ink, white body color: 107 × 105 mm.

A forgery, probably made in the eighteenth century, designed to pass as a preliminary study for Rembrandt's painting of the same subject. See the comment to the following drawing.

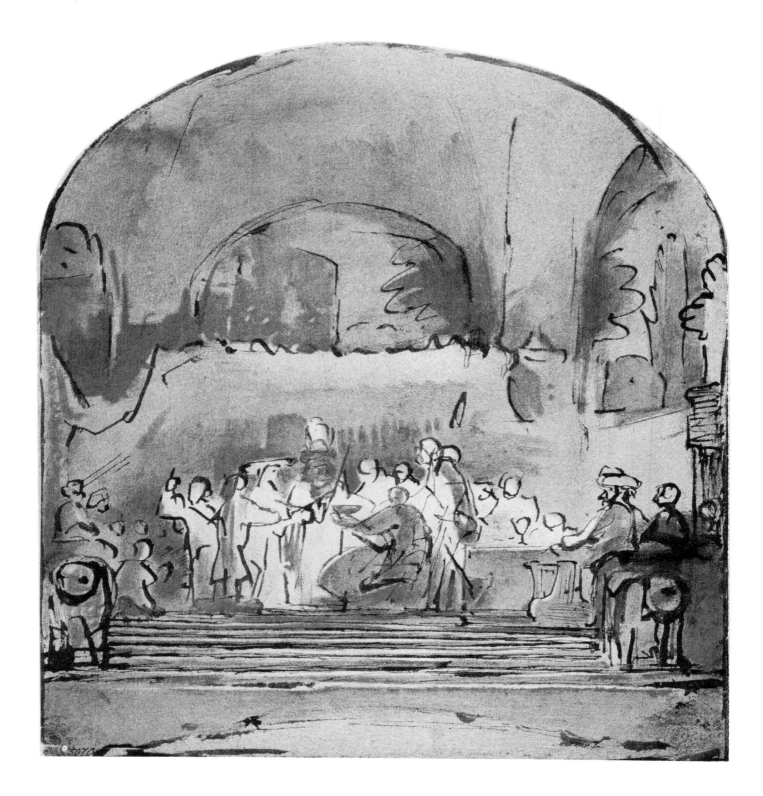

450 (*IV, 10b*). *The Conspiracy of Julius Civilis.* (*Staatliche Graphische Sammlung, Munich*)

Pen and wash in bistre: 196 × 180 mm.

Four drawings, all at Munich, have been related to Rembrandt's monumental painting of The Conspiracy of Julius
Civilis *made for the New Town Hall at Amsterdam. This is the only authentic one. For a close analysis of the
other three, including the one reproduced 449 (IV, 10a), see Cornelius Müller-Hofstede, Konsthistorisk Tidskrift,
XXV (1956), pp. 42 ff. Rembrandt's painting was put in place in July, 1662. For reasons which specialists still
debate the painting was removed from the Town Hall and never returned. After its removal Rembrandt cut down
the gigantic canvas—it measured more than 26 square yards—and only a fragment of the work remains (now at
Stockholm, Bredius 482). Thus, this precious drawing, which was probably made as a preliminary study for the
painting, and not as a record of the composition before it was cut, is the only extant evidence of Rembrandt's
original conception for his most important historical painting. The study is on the back of a funeral invitation dated
25 October 1661. See 442 (IV, 4) for another example of Rembrandt's use of the back of a funeral announcement
for a drawing.*

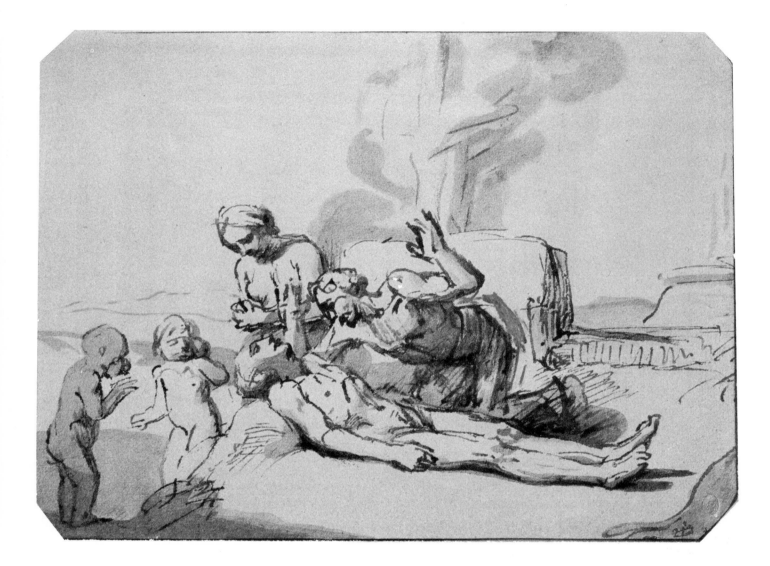

451 (*IV, 11*). *The Lamentation for Abel.* (*Staatliche Graphische Sammlung, Munich*)

Pen and wash in bistre: 137 × 185 mm.

Probably by a pupil or follower who had a good grasp of the mature Rembrandt's method of composing; the execution, however, is weak. Perhaps a copy after a lost original.

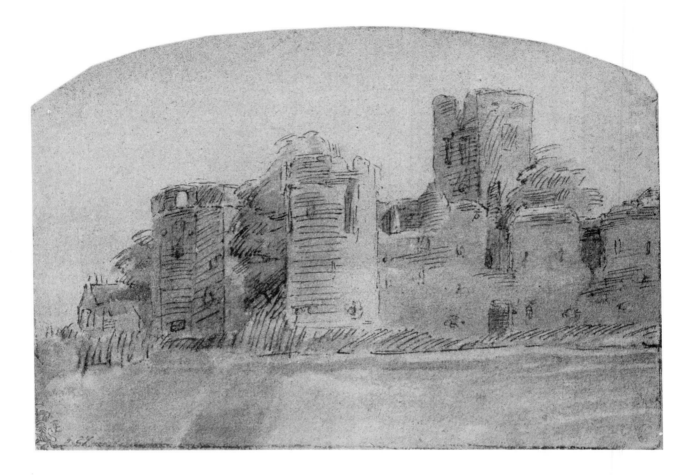

452 (*IV, 12a*). *Ruins of Castle Honingen, near Rotterdam.* (*Staatliche Graphische Sammlung, Munich*)
Pen and wash in bistre: 118 × 170 mm.

The style suggests a date of about 1650, but this sketch and the following one do not have the quality of the monumental studies of medieval architecture Rembrandt made around this time. Both can be assigned to the school or an imitator. Another drawing of this site by a follower is at the Rijksprentenkabinet, Amsterdam (see Henkel, 1943, no. 123).

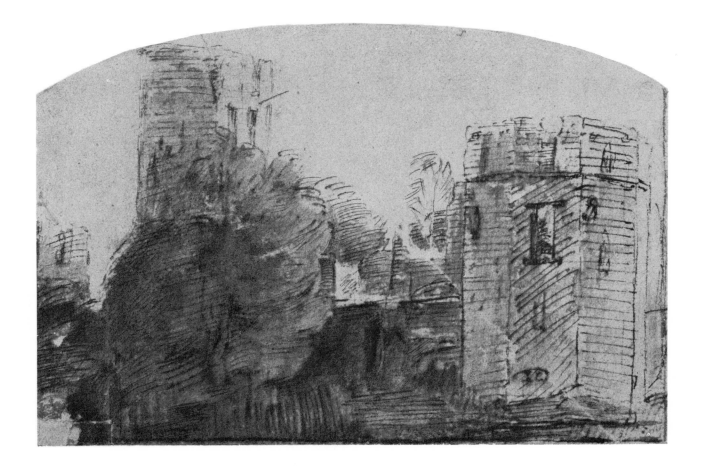

453 (*IV, 12b*). *The Ruins of Castle Honingen.* (*Staatliche Graphische Sammlung, Munich*)

Pen and wash in bistre: 119 × 171 mm.

The same castle as in the preceding sketch, but seen from the other side. See the comment to the preceding drawing.

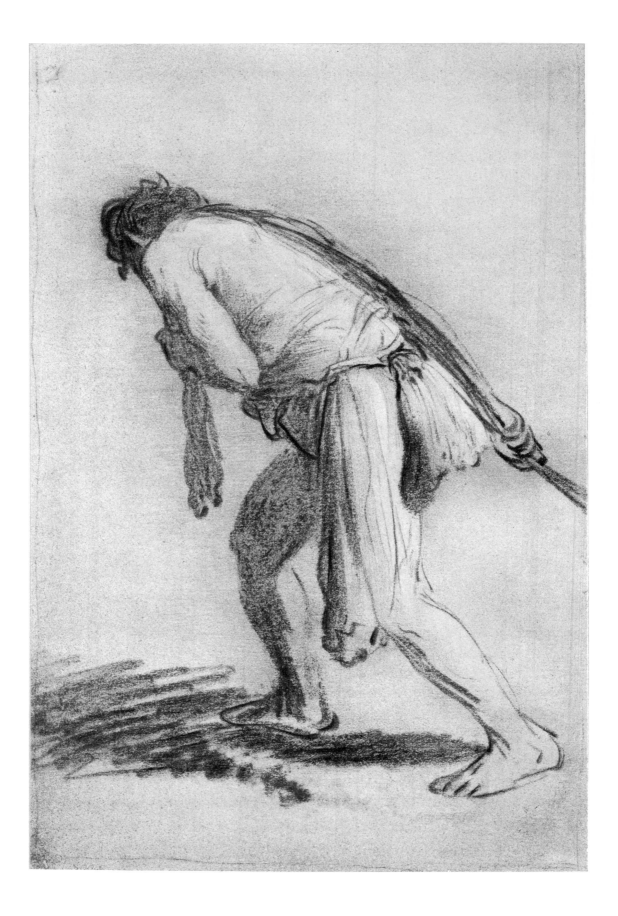

454 (*IV, 13*). *A Man Pulling a Rope.* (*Staatliche Graphische Sammlung, Munich*)
Red chalk: 273 × 176 mm.

About 1627–28. Hofstede de Groot called it a study for the figure of Simon of Cyrene who figures in compositions of The Carrying of the Cross. *The drawing is closely related to 455 (IV, 14) and 456 (IV, 15). All three were probably made from life.*

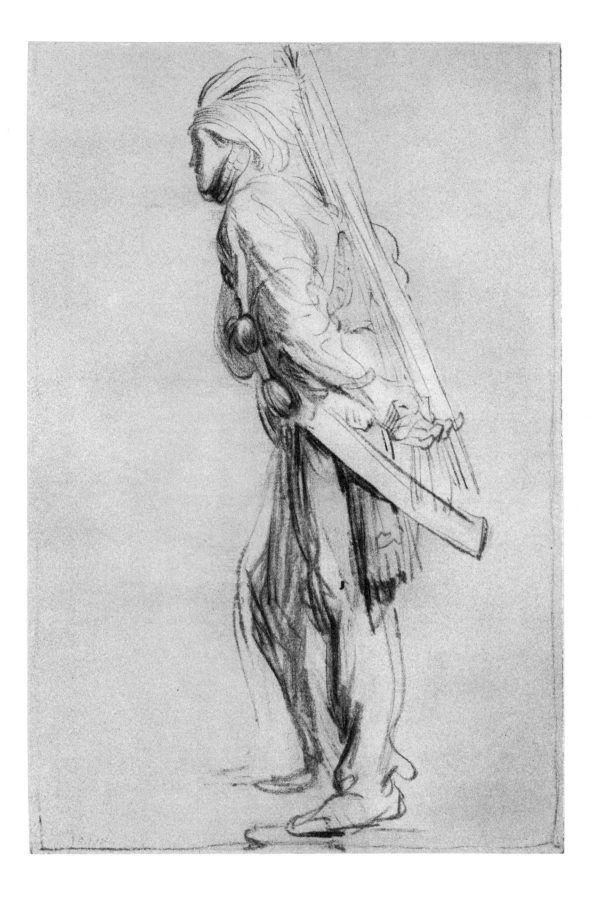

455 (*IV, 14*). *Study of an Archer.* (*Staatliche Graphische Sammlung, Munich*)

Red and white chalk: 277 × 177 mm.

About 1627–28. The same model as 456 (IV, 15). Valentiner (795B) attributed this drawing to Jan Lievens and 456 (IV, 15) to Rembrandt because of the greater power and more naturalistic chiaroscuro effect of the latter. The idea of knowing drawings made by the two young friends as they sat next to each other in a shared studio working from the same model is a very attractive one. Unfortunately, it must be rejected; the handling of the red chalk in both works is unmistakably Rembrandt's.

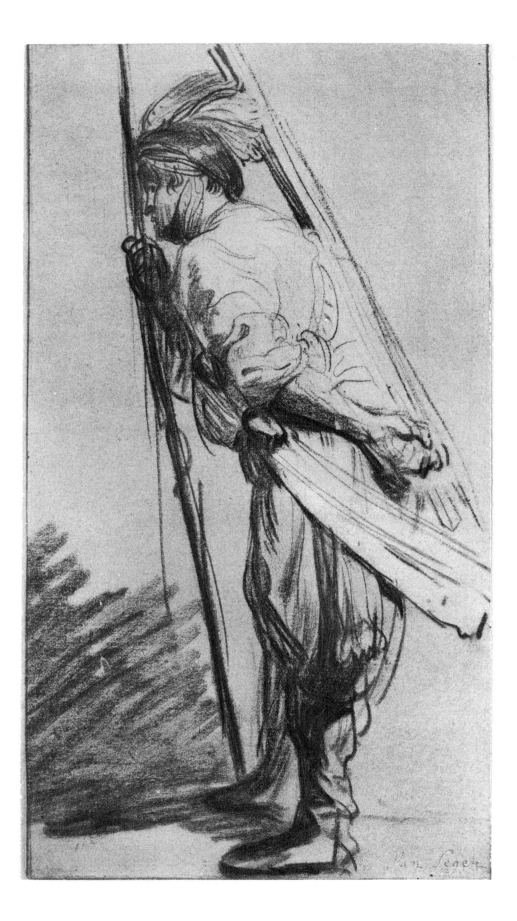

456 (*IV, 15*). *Study of an Archer.* (*Kupferstichkabinett, Dresden*)

Red and white chalk: 306 × 162 mm. Inscribed in the lower right by another hand: Van Segen.

About 1627–28. Benesch (4) notes that this sheet and the preceding are similar to the archer who figures on the right side of Rembrandt's painting, David Presenting the Head of Goliath to Saul, *1627 (?),* Kunstmuseum, Basel (*Bredius 488*).

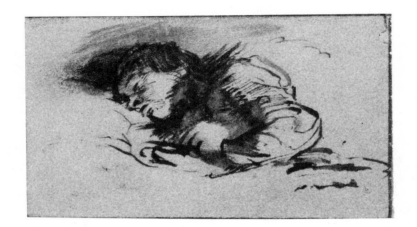

457 (*IV, 16a*). *A Sleeping Child.* (*Kupferstichkabinett, Dresden*)

Pen and brush in bistre: 56 × 97 mm.

This tender sketch is dated at the end of the 1630's in the catalogue of the Dresden drawings (Wichmann, 1925, p. 18, no. 78), but it may have been made about a decade later. In this case the difficulty of finding a firm date should not raise doubts about the drawing's authenticity. Not listed in Benesch.

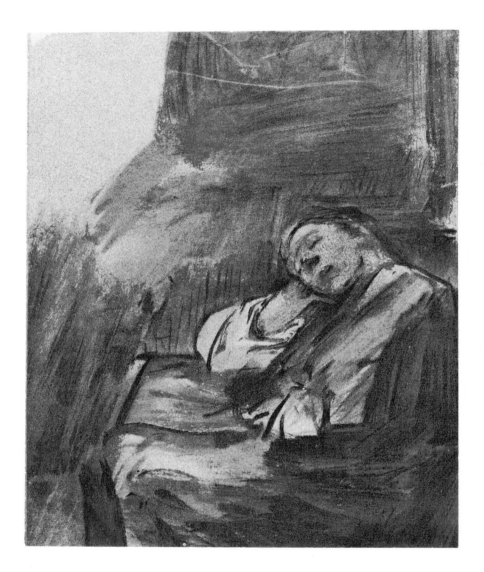

458 (*IV, 16b*). *A Sleeping Woman, Her Head Supported on Her Right Hand.* (*Kupferstichkabinett, Dresden*)
Pen and brush in bistre: 144 × 115 mm.
About 1655–57.

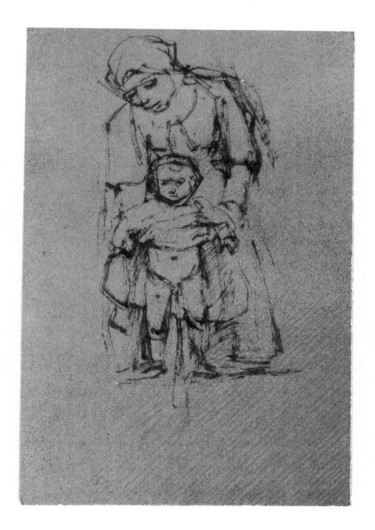

459 (*IV, 17a*). *Woman with a Pissing Child.* (*Kupferstichkabinett, Dresden*)

Pen and bistre: 133 × 90 mm.

About 1657–60. Another study of the same motif, discovered by van Regteren Altena, is now at the Rijksprentenkabinet, Amsterdam (see Benesch Addenda 19, figure 1728).

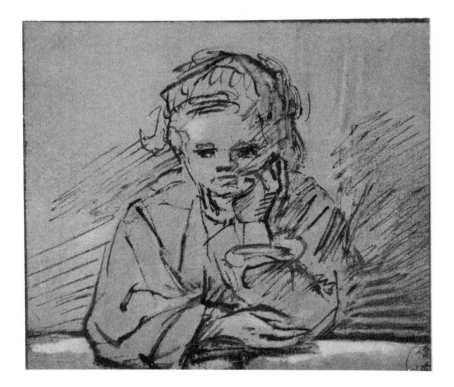

460 (*IV, 17b*). *A Girl Leaning on a Window Frame.* (*Kupferstichkabinett, Dresden*)

Reed pen and bistre, pale blue wash and white body color by another hand: 97 × 107 mm.

Preliminary study for the painting of the same subject, dated 1651, in the Nationalmuseum, Stockholm (Bredius 377).

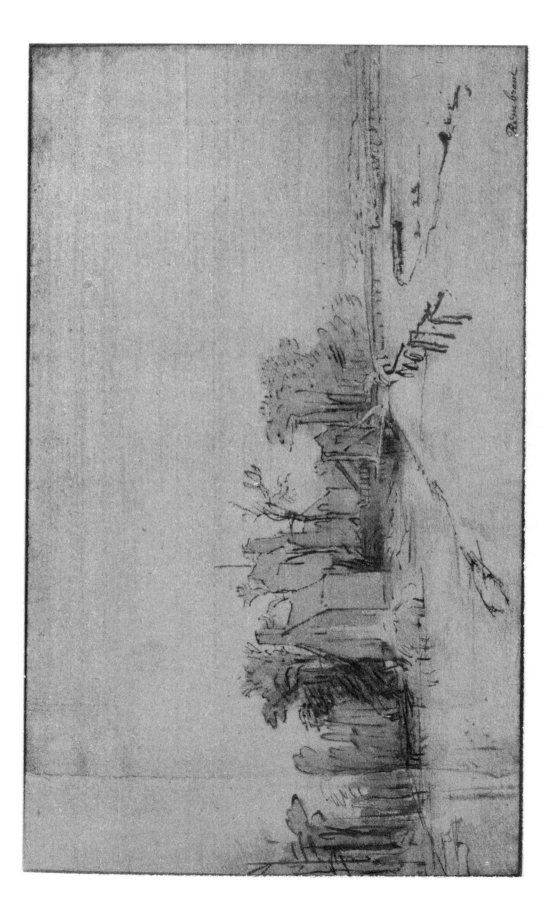

461 (IV, 18). *A View of the Front of the Castle of Kostverloren.* (Kupferstichkabinett, Dresden)

Pen and brush in bistre: 131 × 118 mm. A strip added by the artist on the left. Signed by another hand: Rembrant.

About 1650–52. The castle was identified by Lugt (1920). Not listed in Benesch. Begemann (1961, p. 14) notes that he is reluctant to exclude it from the canon of Rembrandt's original drawings. For other views of this place made around the same time see: 53 (I, 53); 67 (I, 67); 71 (I, 71); 466 (IV, 23).

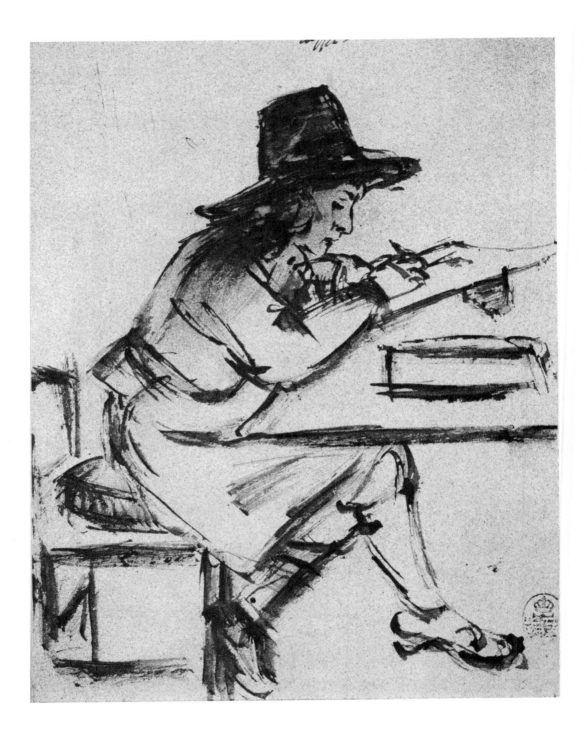

462 (*IV, 19*). *A Boy Drawing at a Desk* (*Titus?*). (*Kupferstichkabinett, Dresden*)

Pen and brush in bistre: 182 × 140 mm.

About 1655–60. A masterful figure study built up almost entirely of vertical, horizontal and diagonal lines.

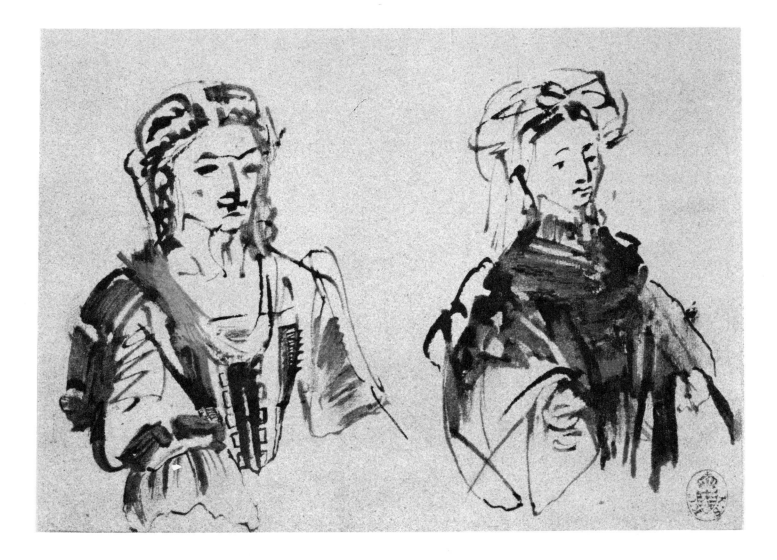

463 (*IV, 20*). *Portrait Studies of Two Women.* (*Kupferstichkabinett, Dresden*)
Pen and bistre, white body color: 137 × 183 mm.
About 1660–65. An example of Rembrandt's most mature portrait style.

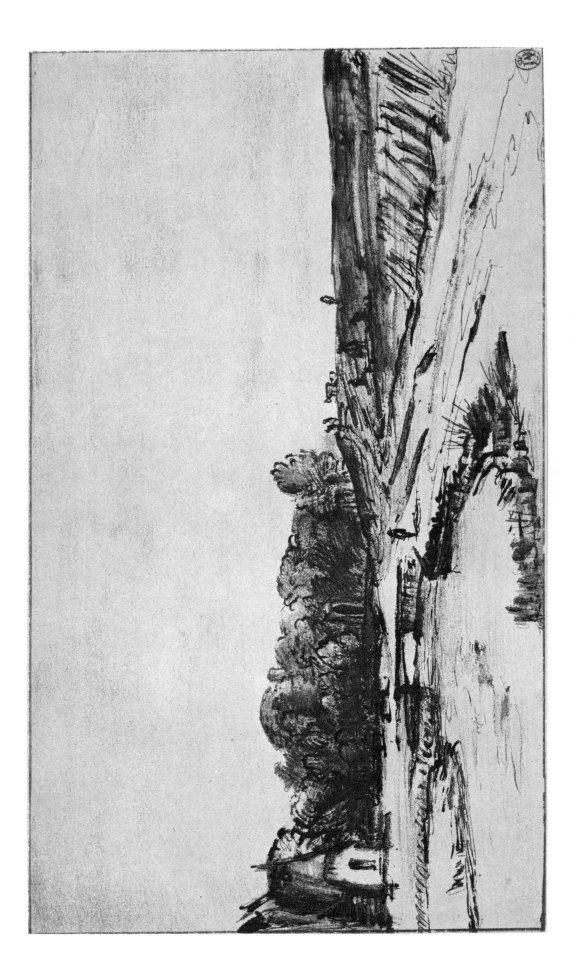

464 (IV, 21). *Farm Buildings at the "Dijk."* (Museum of Art, Rhode Island School of Design, Providence, Rhode Island)

Pen and brush in bistre, wash: 145 × 260 mm.

About 1648. See the comment to 117 (I, 115). On the verso a slight black chalk study of some trees.

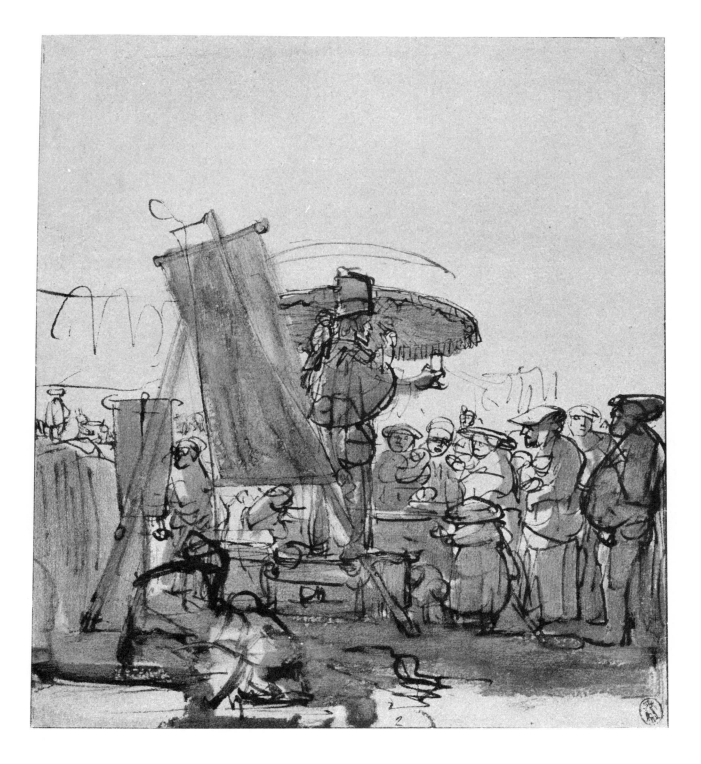

465 (*IV, 22*). *A Quack Addressing a Crowd at a Fair.* (*Count Antoine Seilern Collection, London*)
Pen and wash: 188 × 164 mm.

*Although the figures are only suggested with a few strokes and some wash, the drawing gives the impression of a
work complete in itself. The subject was a popular one with seventeenth-century Dutch artists and Rembrandt made
a few other drawings of a quacksalver at work; however, he did not use the theme for either a painting or an
etching. The author of the Catalogue of the Paintings and Drawings . . . at 56 Princes Gate, London, 1961,
Vol. 3, p. 21, makes the good observation that the tectonic composition and tendency toward angularity suggest a
date of about 1638–42. This is a bit later than the drawing has usually been catalogued.*

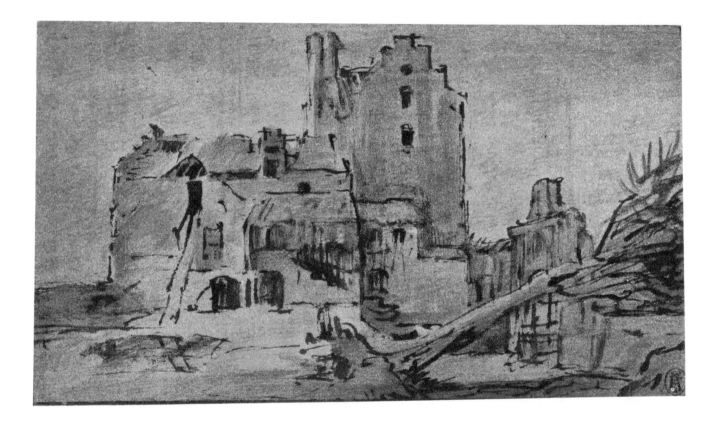

466 (*IV, 23*). *The Ruins of Kostverloren Castle.* (*The Art Institute of Chicago, Chicago, Illinois*)
Pen and bistre, wash, and white body color: 104 × 173 mm.
About 1650–52. The castle was one of the principal sights Rembrandt saw on his favorite walk along the Amstel
River; see 53 (I, 53); 67 (I, 67); 71 (I, 71); 461 (IV, 18).

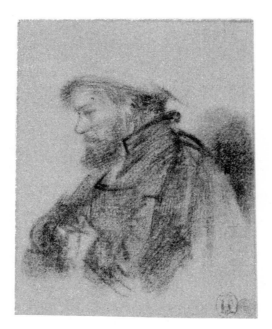

467 (*IV, 24a*). *Bearded Man in Profile.* (*Friedrich August II Collection, Dresden*)
Black chalk: 83 × 65 mm.
About 1645.

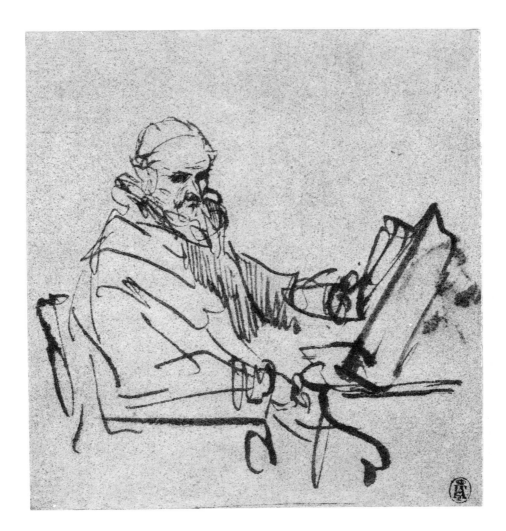

468 (*IV, 24b*). *Portrait of the Preacher Jan Cornelisz Sylvius.* (*Friedrich August II Collection, Dresden*)

Pen and bistre: 133 × 122 mm.

Study for the portrait dated 1644 or 1645 now at the Wallraf-Richartz Museum, Cologne (Bredius 237). The portrait is posthumous; Sylvius died in 1638. For other posthumous portraits of the preacher see 123 (I, 121) and Benesch 762a.

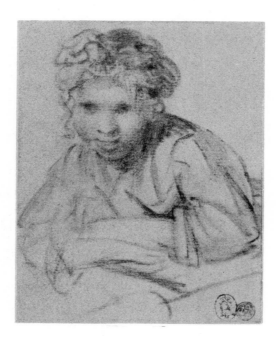

469 (*IV, 25a*). *A Girl Leaning on the Sill of a Window.* (*Count Antoine Seilern Collection, London*)
Black chalk: 83 × 65 mm.

A preliminary study for the picture of the same subject dated 1645 at Dulwich College, London (Bredius 368).
Similar in size and style to 467 (IV, 24a), now in the Friedrich August II Collection, Dresden. This drawing was once in the same collection.

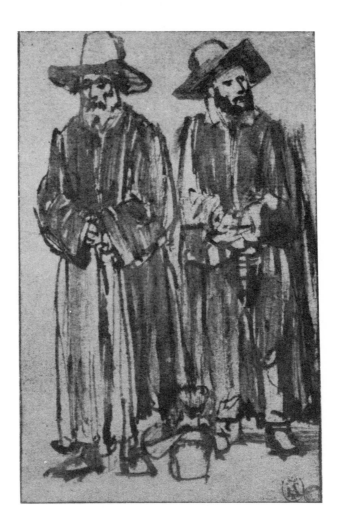

470 (*IV, 25b*). *Two Standing Jews, Between Their Feet the Inverted Head of a Third.* (*Formerly Friedrich August II Collection, Dresden*)

Pen and brush in bistre: 127 × 80 mm.

About 1650–55. Erroneously attributed to Nicolaes Maes by Wichmann (1925, p. 22, no. 119). A comparison of the drawing with Maes' studies of standing figures (see Valentiner, 1924, pp. 56–57, figures 61 and 62) points up the difference between the master's broad, luminous touch which never loses the form of a figure, and the work of a talented pupil, whose figures become wooden or amorphous when he uses Rembrandt's mature style.

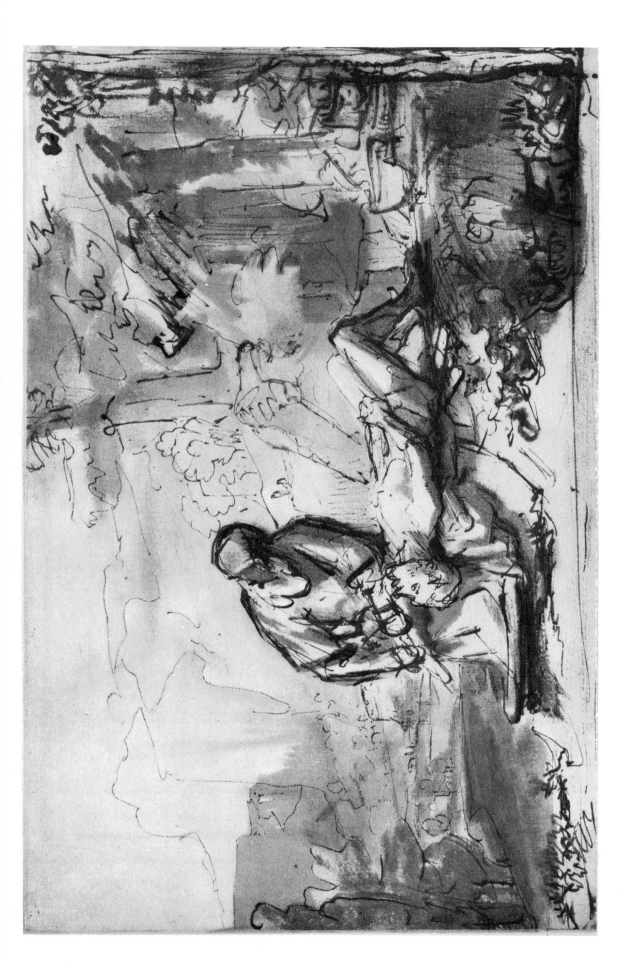

471 (IV, 26). The Sacrifice of Abraham. (Kupferstichkabinett, Berlin)

Pen and wash in bistre: 165 × 262 mm.

Not authentic. There is a superficial resemblance to works of the middle period, but the poor articulation of the forms and the messy scrawls cannot be attributed to Rembrandt.

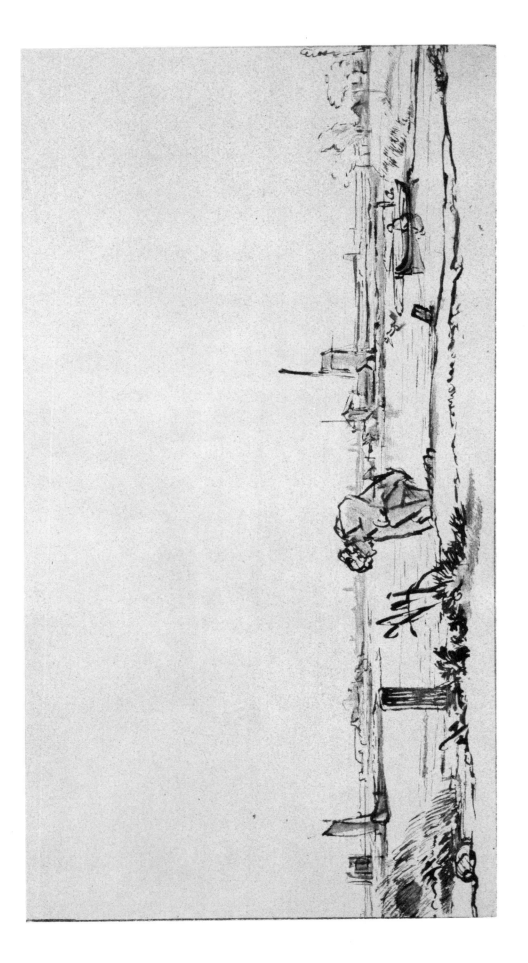

472 (IV, 27). *A View of the Amstel with a Man Bathing; in the Background Amsterdam. (Kupferstichkabinett, Berlin)*
Reed pen and wash in bistre, white body color: 146 × 273 mm.
About 1650–55.

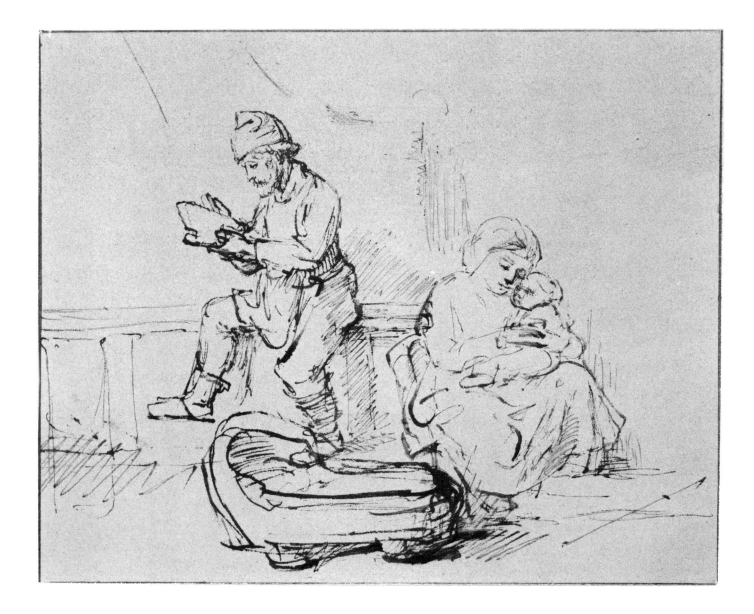

473 (*IV, 28*). *The Holy Family.* (*Kupferstichkabinett, Berlin*)

Reed pen and bistre: 153 × 183 mm.

About 1648–50. Rosenberg (1930, p. 225, no. 4268) rightly compares the Madonna to the painting in Cassel of
1646 (Bredius 572) and to the etching of 1654 (Bartsch 63). The work still has the tender intimacy of the former,
yet some anticipation of the monumentality of the latter.

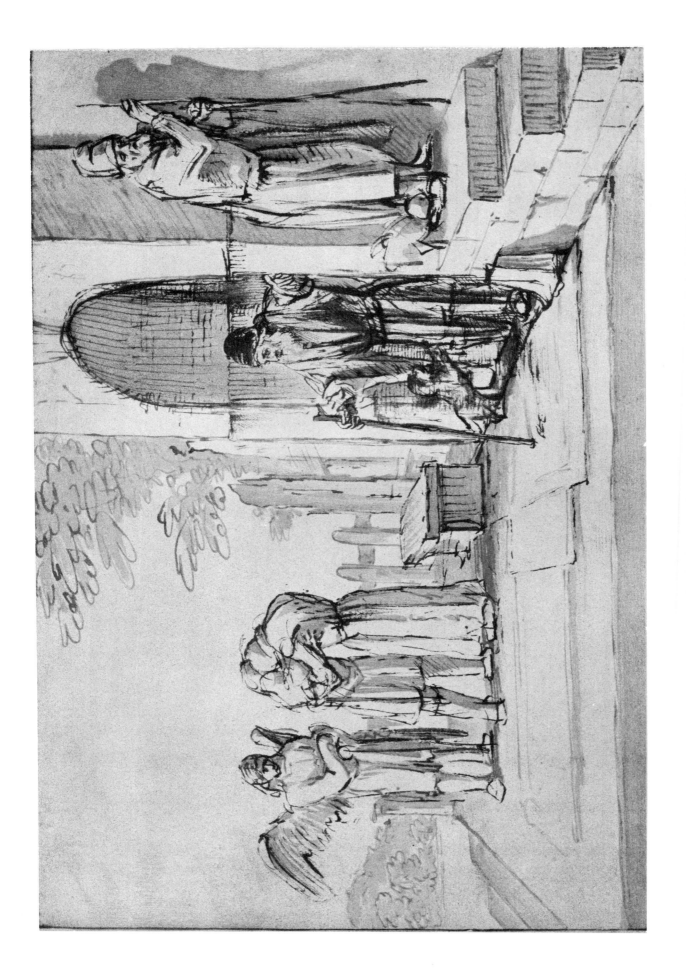

474 (IV, 29). *The Return of Young Tobias.* (Kupferstichkabinett, Berlin)

Reed pen and wash in bistre: 200 × 301 mm.

A sheet of figure studies made by Rembrandt around 1650 with extensive additions by a weak hand (architecture and landscape) to transform it into a more finished whole.

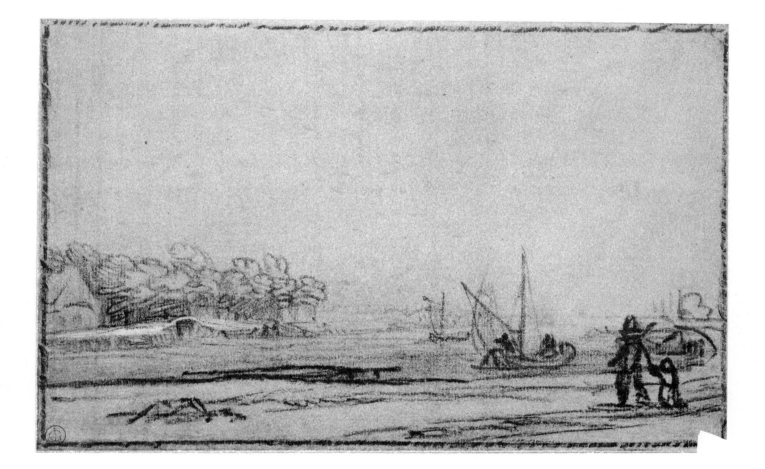

475 (*IV, 30*). *A View of the Amstel.* (*Kupferstichkabinett, Berlin*)
Black chalk with touches of white on the left: 119 × 185 mm.
About 1640–45.

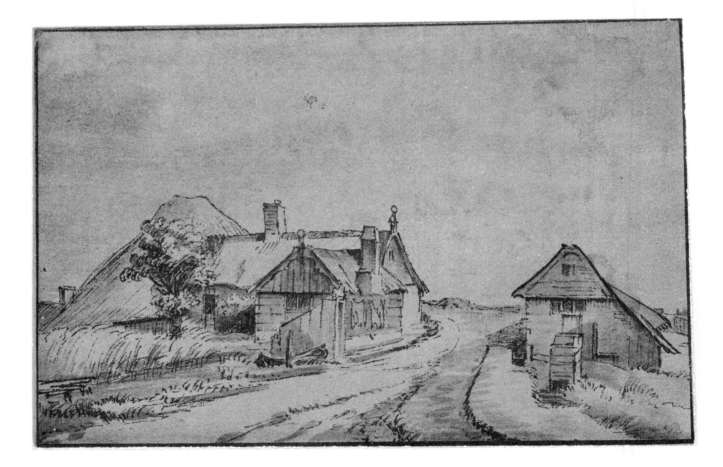

476 (*IV, 31*). *A Road with Houses on Each Side.* (*Kupferstichkabinett, Berlin*)

Pen in bistre on a preliminary pencil drawing, wash: 117 × 174 mm.

The meticulous execution and the preliminary pencil drawing both point to a copy of a work made around 1650.
Lugt (1920) suggests it probably represents houses on the Diemerdijk.

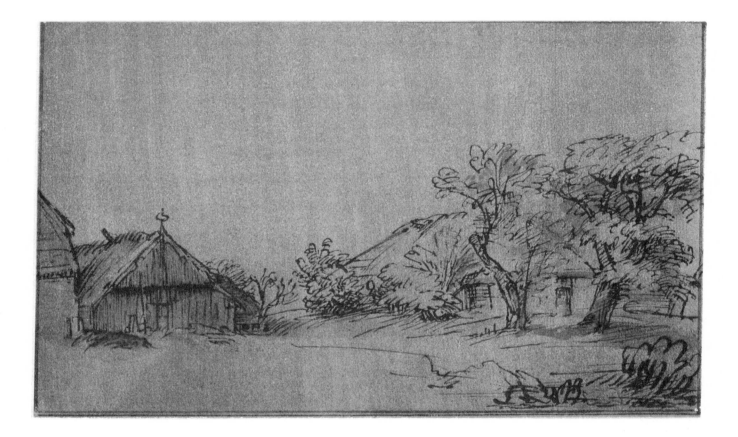

477 (*IV, 32*). *Farmhouses with Trees on the Right.* (*Kupferstichkabinett, Berlin*)
Pen and bistre, washes by a later hand, on brownish paper: 110 × 178 mm.
About 1648–50.

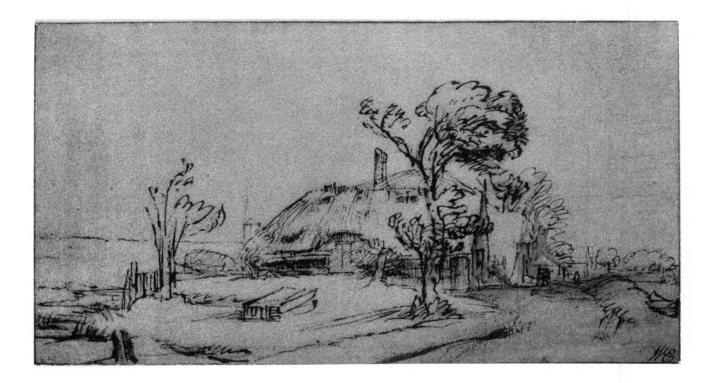

478 (*IV, 33*). *Landscape with Cottages at the Left Side of a Road.* (*Kupferstichkabinett, Berlin*)

Pen and bistre in wash, on brownish paper: 94 × 172 mm.

About 1650. Begemann (1961, no. 865) observed that the motif is the same (in reverse) as the etching of 1650 of
a Landscape with Three Cottages (*Bartsch 217*); *in the etching the artist added trees behind the cottages.*

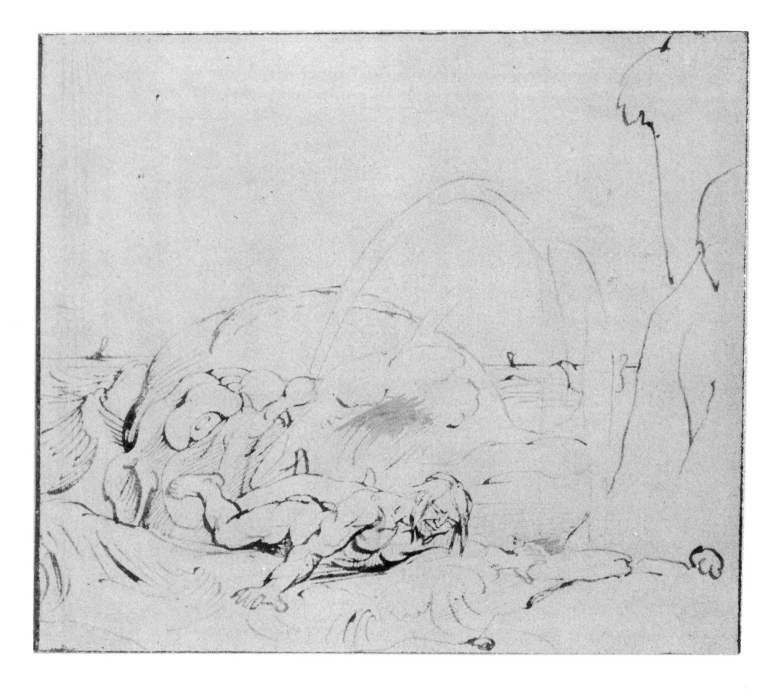

479 (*IV, 34*). *Jonah Ejected by the Whale.* (*Kupferstichkabinett, Berlin*)

Pen and bistre: 181 × 197 mm.

Rosenberg (1930, p. 241, no. 5663) suggests that Samuel van Hoogstraten may have been the author of this rather awkward drawing.

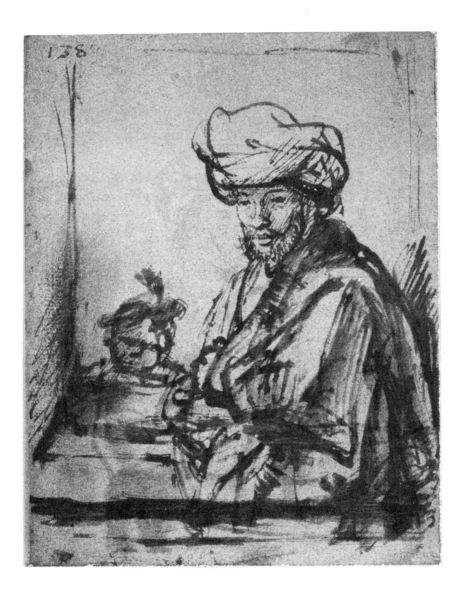

480 (*IV, 35*). *Half-figure of an Oriental Turned to the Left, superimposed upon a compositional study of a Girl at a Window.* (*Kupferstichkabinett, Berlin*)

Pen and wash in bistre: 148 × 110 mm.

About 1638. Hofstede de Groot recognized that the Oriental was drawn upon a compositional study for Rembrandt's painting of A Still Life with Dead Peacocks (*Bredius 456*) *which includes a girl leaning at a window. On the verso a drawing of an Oriental by another hand.*

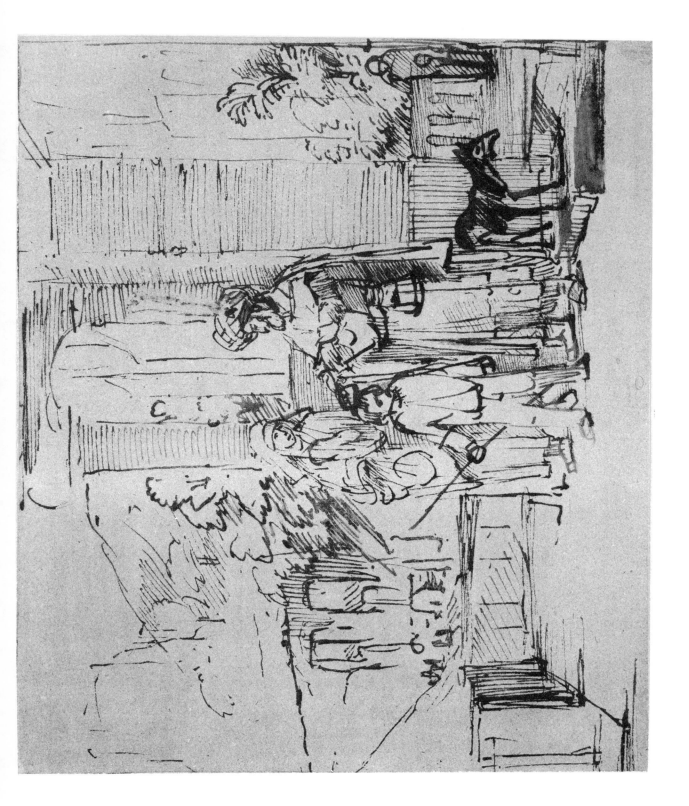

481 (IV, 36). *The Dismissal of Hagar.* (Kupferstichkabinett, Berlin)

Pen and bistre, some white body color: 182 × 220 mm.

The execution does not do justice to the subtle invention. Probably a copy after a lost work of about 1655. Rosenberg sees the same hand that executed an Ecce Homo (sale Prestel, Frankfurt-am-Main, 4–5 October 1917, no. 465; reproduced Benesch, figure 1650).

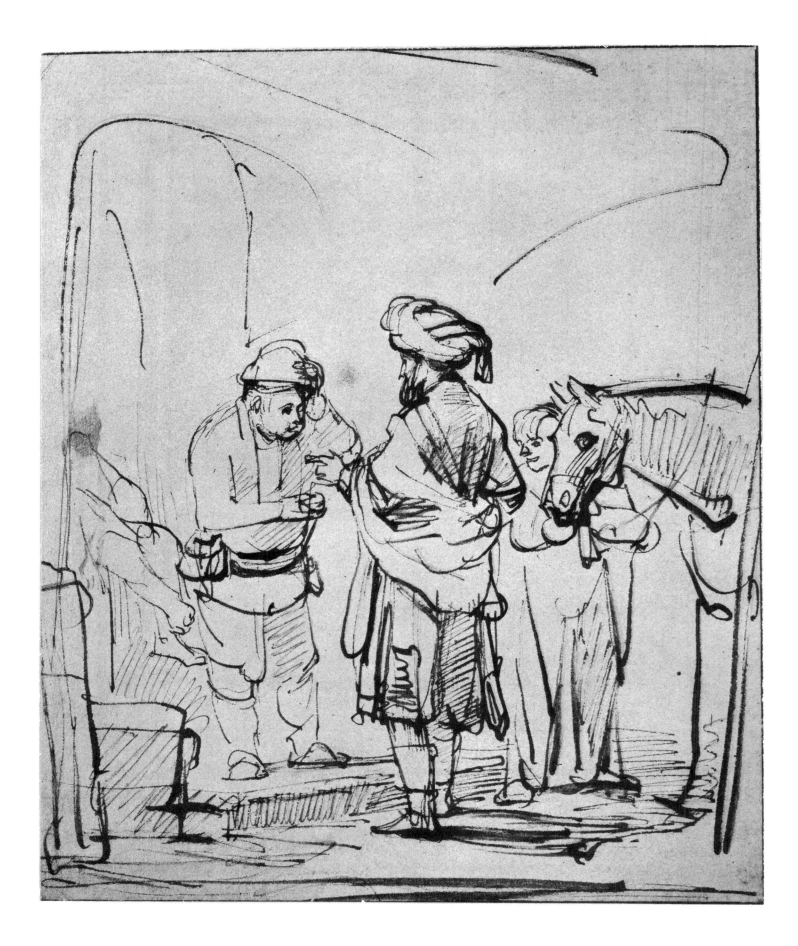

482 (*IV, 37*). *The Good Samaritan Paying the Host.* (*Kupferstichkabinett, Berlin*)

Pen and bistre: 238 × 195 mm.

A characteristic work made around 1640–45. Valentiner (381) writes that it is certainly genuine. Also accepted by Rosenberg (1930, p. 226, no. 5214). Not listed in Benesch.

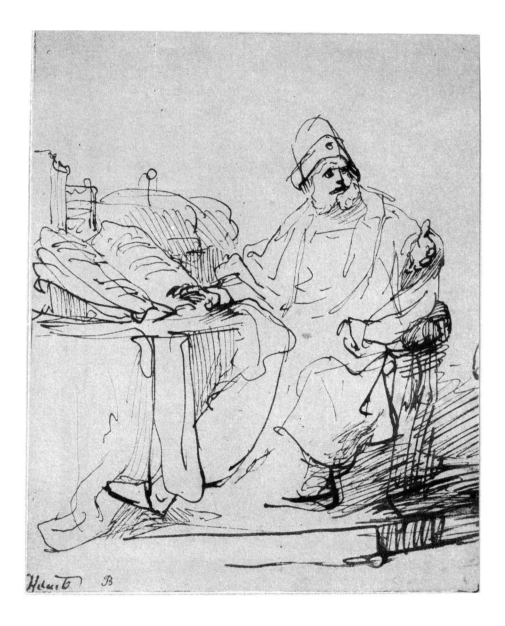

483 *(IV, 38). A Bearded Man Seated at a Desk Covered with Books. (Kupferstichkabinett, Berlin)*
Pen and bistre: 155 × 122 mm. Signed by a later hand: Remb.

Erroneously identified by Hofstede de Groot in the first edition of this work as a preliminary study by Rembrandt for his portrait of Cornelis Claesz Anslo at Berlin (Bredius 409). The relation of this weak school piece to the painting is superficial.

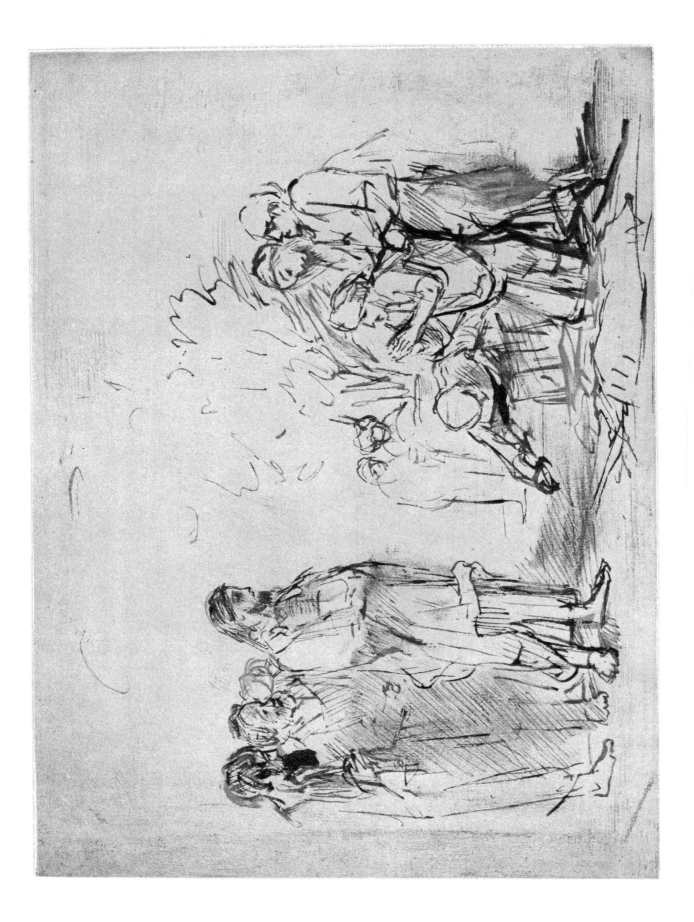

484 (IV, 39). *Christ Healing a Leper. (Kupferstichkabinett, Berlin)*

Pen and wash in bistre, white body color: 180 × 247 mm.

About 1655. An outstanding example of Rembrandt's balanced compositions of the 1650's which remind us that Poussin was making masterworks imbued with a similar spirit around the same time. However, Rembrandt's suggestive line and use of hatching and wash to make shadows vibrant is a hallmark of a personal, not a period, style.

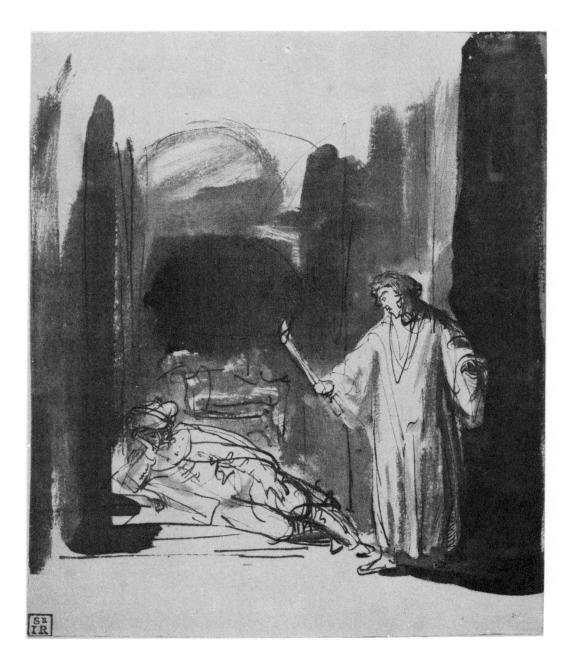

485 (*IV, 40*). *Young Samuel Finds the High Priest Eli Asleep in the Temple.* (*Kupferstichkabinett, Berlin*)
Pen and wash in bistre: 227 × 187 mm.

*About 1635–40. The unusual subject of the drawing has been much discussed. The most convincing interpretation
is that it represents Samuel who hears the voice of God in the Temple during the night. Samuel, who "did not yet
know the Lord, neither was the word of the Lord yet revealed unto him," thought the High Priest Eli called him. He
went to Eli and found him asleep (I Samuel 3, 1–9). This identification of the theme was made by C. Hofstede de
Groot, "Rembrandt's Bijbelsche en Historische Vorstellingen,"* Oud Holland, *41 (1923/24), pp. 58 ff.; Hofstede
de Groot also notes that Samuel wears the linen ephod mentioned in I Samuel 2, 18. Hofstede de Groot's
interpretation of the subject as Eli and Samuel is accepted by Rosenberg (1930, p. 234, no. 5292) and Hans
Martin Rotermund ("Unidentifizierte bzw. missverstandene Zeichnungen Rembrandts zu biblischen Szenen,"*
Wallraf-Richartz-Jahrbuch, *XXI [1959], pp. 182 ff.). K. Lilienfeld (*Rembrandts Handzeichnungen, *Berlin,
1922, p. 22, no. 128) doubts the authenticity of the drawing without justification and suggests it is a study for* The
Liberation of St. Peter. *Valentiner (809) rightly accepts the drawing, but erroneously calls it the Angel Appearing
to Samuel. Hans Kauffmann ("Rembrandt und die Humanisten vom Muiderkring,"* Jahrbuch der preussischen
Kunstsammlungen, *41 [1920], pp. 77 ff.) ventures that it is an illustration of a scene from Jacob Cats' Trouringh.
The ingenious suggestion that it represents an episode from the eleventh-century Persian epic, the* Shāh Nāmah, *is
put forth by Benesch (171). The drawing does indeed correspond with the episode Benesch cites from the life of
Prince Dārāb, and it can be assumed that Rembrandt knew the legend and even a representation of it. However,
since the drawing also perfectly fits the story of Eli and Samuel, and in view of our knowledge of Rembrandt's
proclivities, it seems more reasonable to assume that Rembrandt was depicting a scene from the Old Testament than
an incident from the Persian* Book of Kings.

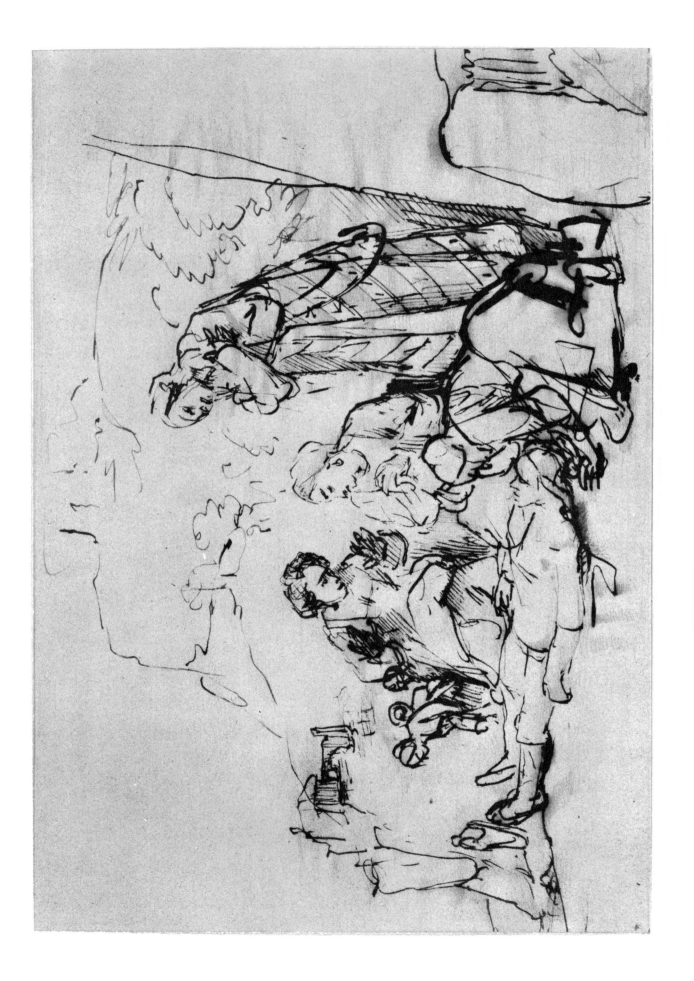

486 (IV, 41). *Four Women Mourning the Death of a Young Man. (Kupferstichkabinett, Berlin)*
Pen and wash in bistre: 188 × 281 mm.

The subject is enigmatic and there are no strong voices in favor of an attribution to Rembrandt. Rosenberg (1930, p. 229, no. 5293) wrote that although it is of good quality and close to the style of the 1650's, it is somewhat strange. Lugt (1931) stated it is not by Rembrandt, but may be a copy. Not listed by Benesch.

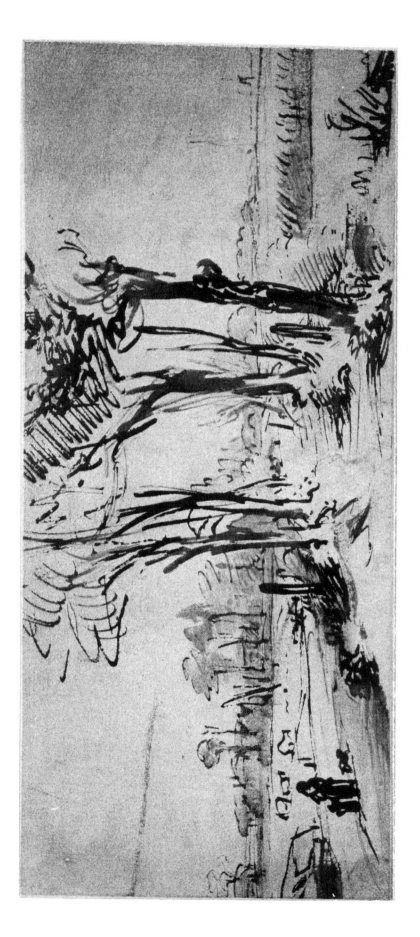

487 (IV, 42). *An Avenue of Trees Leading into the Distance.* (*Kupferstichkabinett, Berlin*)

Reed pen and wash in bistre: 99 × 235 mm.

About 1655. F. Lugt (1930) suggests it represents the road leading to Ouderkerk. On the verso a copy by another hand of a kneeling figure in Lastman's painting of Abraham and the Three Angels at The Hermitage, Leningrad.

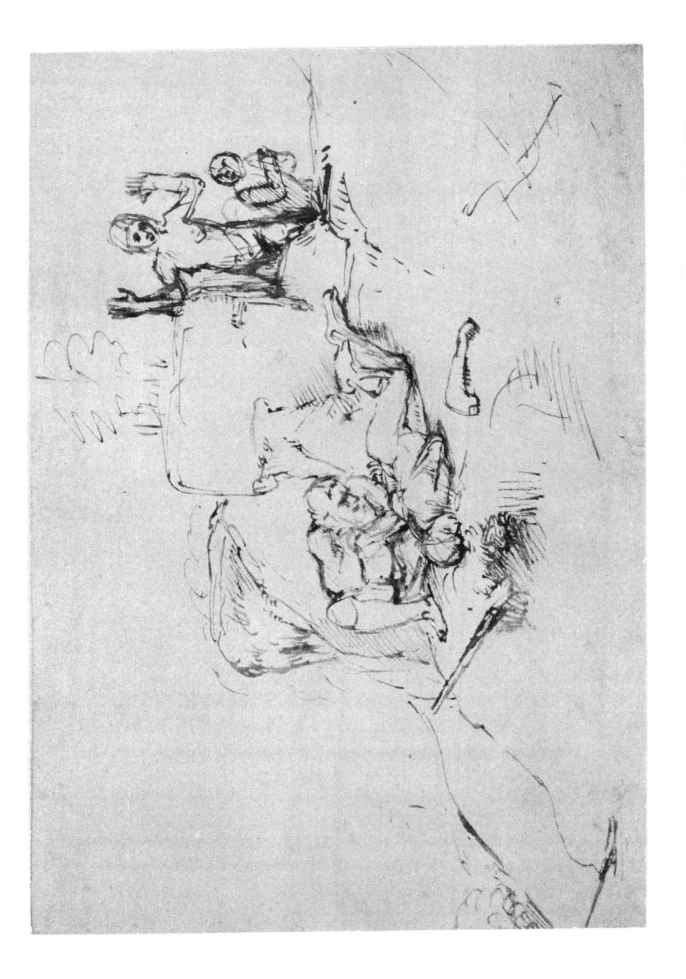

488 (IV, 43). *The Discovery of Abel's Body. (Kupferstichkabinett, Berlin)*
Pen and bistre: 195 × 286 mm.

About 1655. Rosenberg (1930, p. 220, no. 1115) notes that the lines of the terrain in the lower right have been added by another hand.
These few touches detract from the strong concentration upon essentials in this summary, and yet most expressive, study. On the verso,
another pen study by Rembrandt for Abel's body.

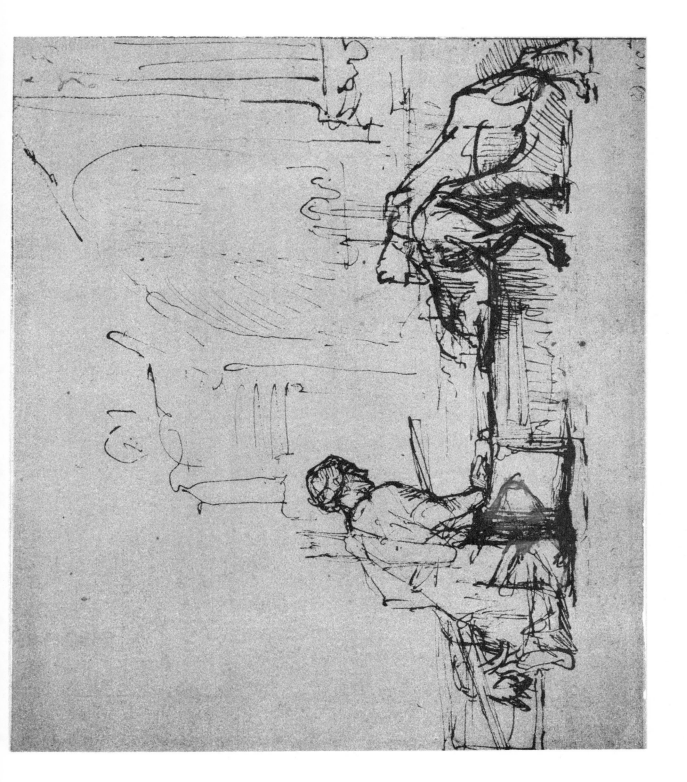

489 (IV, 44). *Esau at the Well(?).* (Formerly F. F. Koenigs Collection, Rotterdam; lost during World War II)

Pen and bistre, white body color: 180 × 210 mm.

About 1645. The drawing is close in style to Esau Selling His Birthright to Jacob (see 424 [III, 87]). For the argument that the drawing represents Narcissus see Valentiner (601).

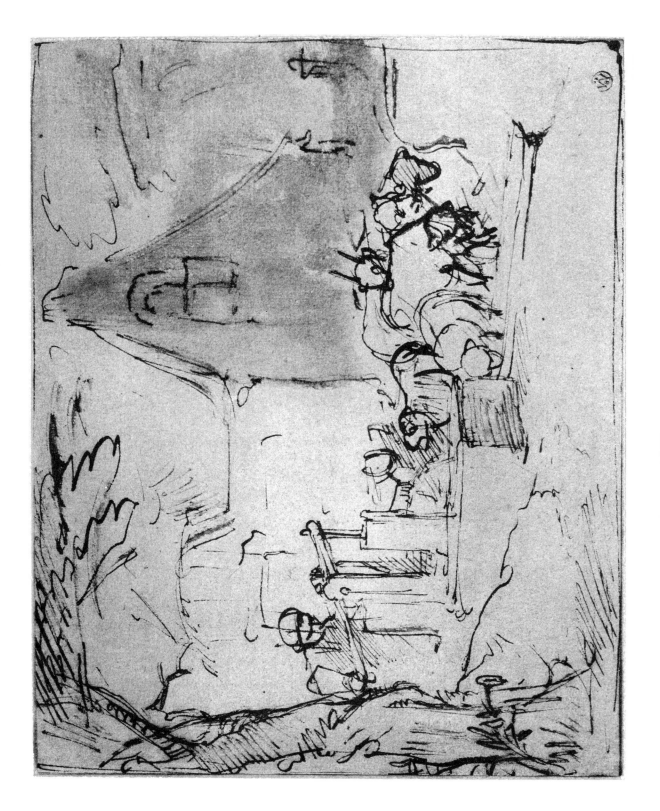

490 (IV, 45). *A Shepherd Watering His Flock.* (Boymans-van Beuningen Museum, Rotterdam)
Pen and bistre, wash: 158 × 204 mm.

About 1655. The wash, which shows little relation to the penwork, is probably a later addition.

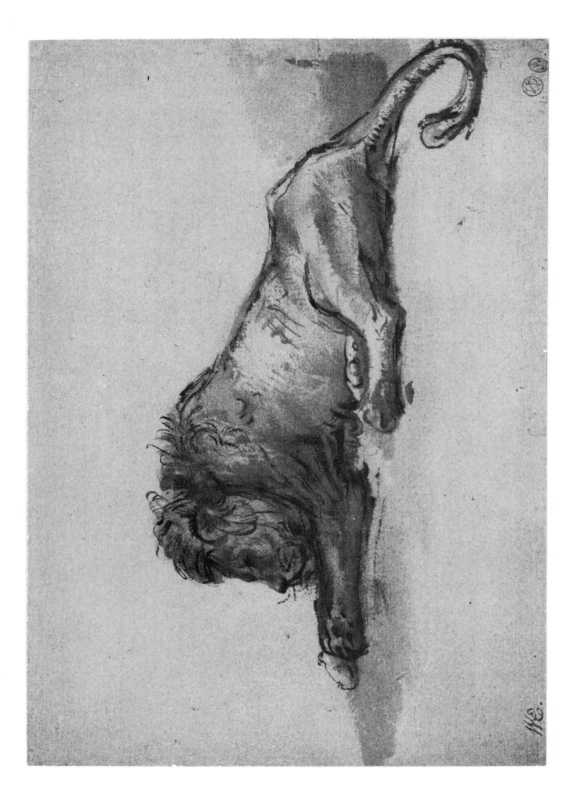

491 (IV, 46). *A Lion Resting, in Profile to the Left.* (Boymans–van Beuningen Museum, Rotterdam)

Pen and brush, wash in bistre, white body color: 140 × 205 mm.

About 1650–52.

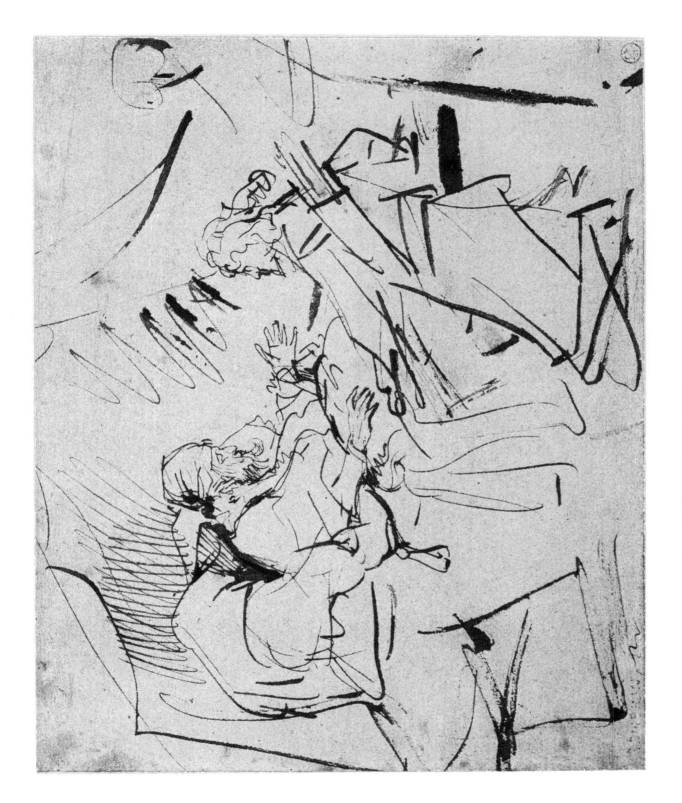

492 (IV, 47). *Isaac Refusing to Bless Esau.* (Formerly E. Wauters Collection, Paris)

Pen and bistre: 160 × 230 mm.

Crudities in the drawing suggest it is probably a copy after a lost original made around 1635. The dramatic scene is Genesis 27, 34: "And when Esau heard the words of his father, he cried with a great and exceeding bitter cry, and said unto his father, Bless me, even me also, O my father."

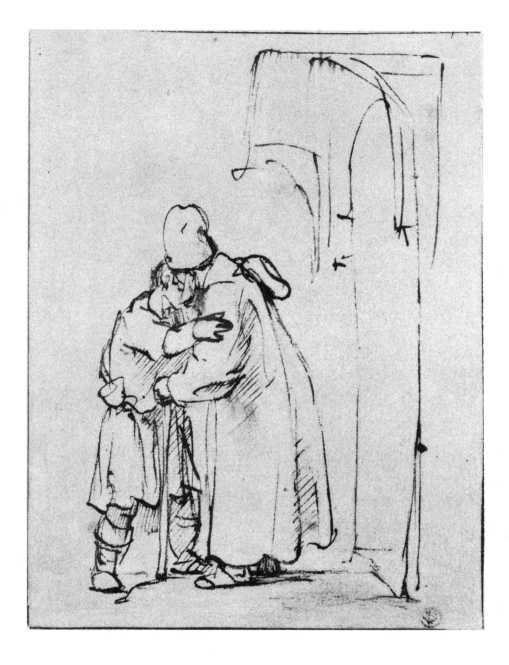

493 (*IV, 48*). *The Departure of Tobias*(?) (*Frits Lugt Collection, Paris*)
Pen and bistre: 165 × 120 mm.
About 1650–55. Benesch (983) suggests it represents the Return of the Prodigal Son because the mother and angel
are not represented.

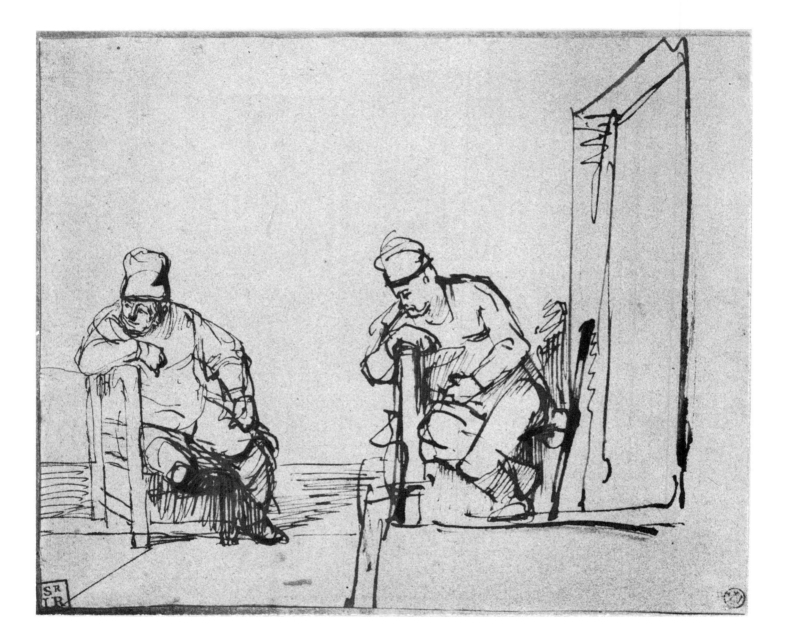

494 (*IV, 49*). *Two Studies of a Man Seated in a Chair.* (*Boymans–van Beuningen Museum, Rotterdam*)
Pen and bistre: 160 × 190 mm.
About 1635–40.

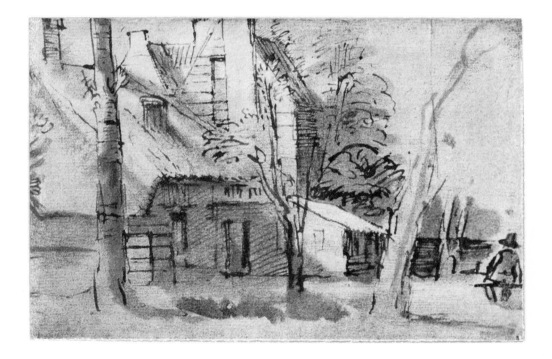

495 (*IV, 50a*). *Farmhouse.* (*Formerly H. Véver Collection, Paris*)

Pen and bistre, wash: 80 × 130 mm.

Traces of the foliage of a tree on the left border suggest the drawing is a small fragment of a larger sheet. This makes it difficult to judge, but it could be an original work made around 1650. Not listed in Benesch.

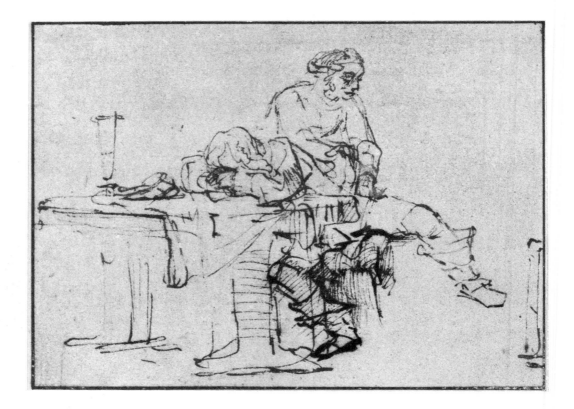

496 (*IV, 50b*). *A Woman Picking the Pocket of a Sleeping Man.* (*Formerly H. Véver Collection, Paris*)
Pen and bistre: 101 × 136 mm.

Although there is a lack of clarity and accent in some passages it is difficult to reject this delicate drawing of a low-life scene without reservation. The style is related to works done around 1650–55. Not listed in Benesch.

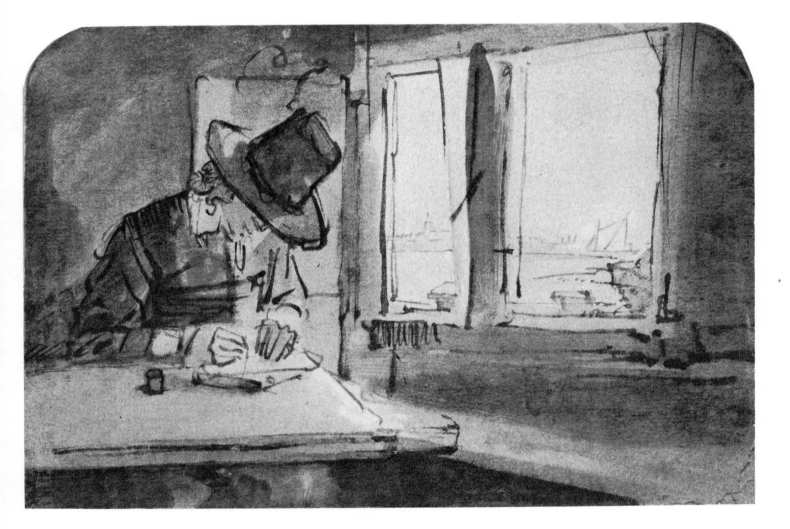

497 *(IV, 51). A Man (Jan Six?) Writing. (Louvre, Paris)*

Pen and wash in bistre, white body color: 135 × 197 mm.

About 1655. Lugt (1933, no. 1152) observed that the scene through the window is the same view of "Het IJ" as 42 (I, 42). Since Jan Six had an estate called "IJmond" at Joaphannes on the Diemerdijk, Lugt's assumption that the drawing was made in Six's house is a reasonable one. Whether the man at the table is Jan Six is moot.

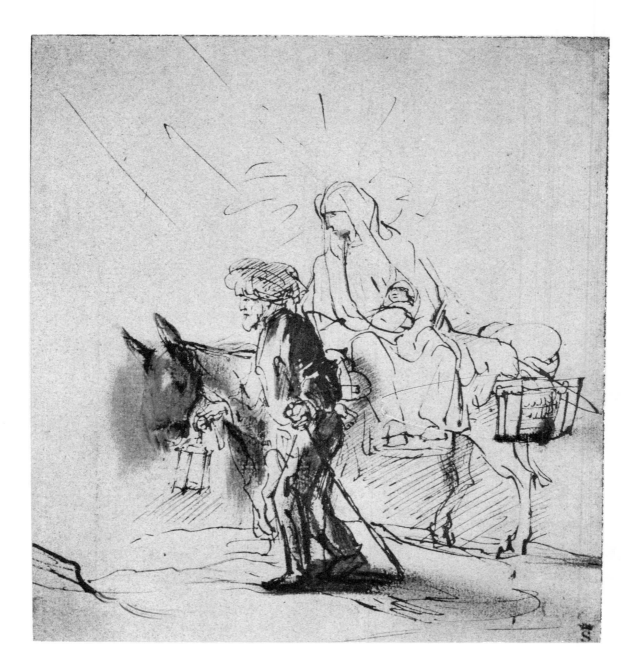

498 (*IV, 52*). *The Flight into Egypt. (Formerly E. Moreau-Nélaton Collection, Paris)*
Pen and bistre, wash: 101 × 92 mm.
Hind (1923, no. 253) called it a study for the etching (Bartsch 53) dated 1651. The drawing, however, is too weak
to attribute to Rembrandt. Münz (1952, no. 220) rightly concluded it is a school piece after the etching. H. M.
Rotermund, "The Motif of Radiance in Rembrandt's Biblical Drawings," Journal of the Warburg and Courtauld
Institutes, 15 (1952), p. 117, notes that the rays coming from the left in the drawing also suggest it is a school
piece. Rembrandt used such rays as a symbol to show a person or group made aware of the Majesty of God and
of His Will; see for example 20 (I, 20); 190 (I, 178); 500 (IV, 54). In a depiction of this moment of the story
of the Flight into Egypt, Rembrandt probably would have included Mary's halo, but not the rays.

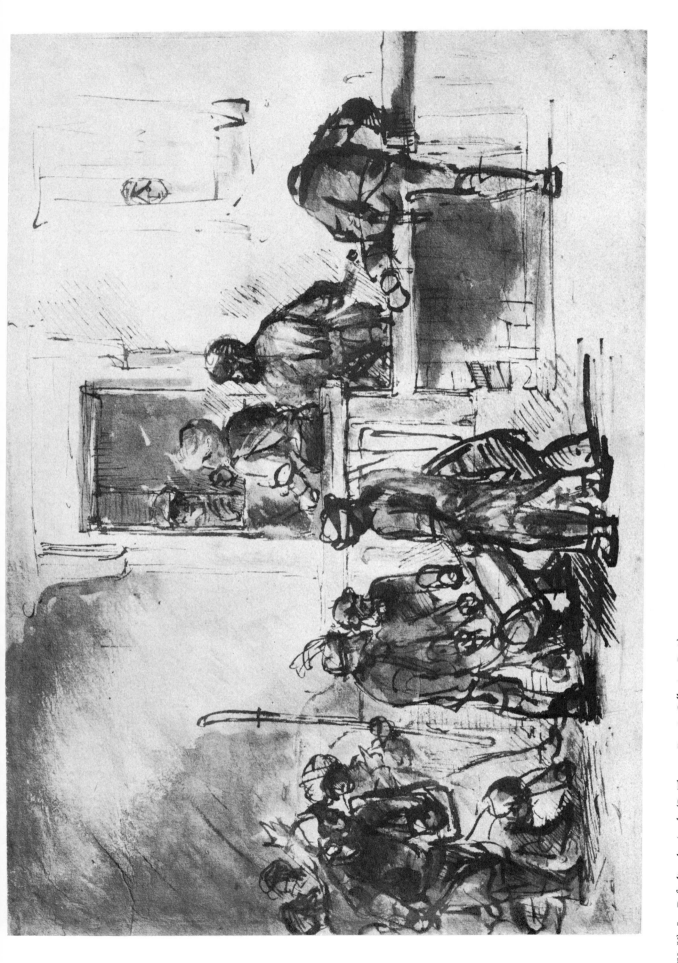

499 (IV, 53). *Lot Defending the Angels.* (P. Thureau-Dangin Collection, Paris)

Pen and brush in bistre, wash.: 184 × 270 mm.

About 1655–60. Valentiner (35) lists it as an original. Benesch (C101) is more critical and calls it an "excellent copy after a powerful original." However, not only the total effect of the agitated scene looks convincing, but the details are vigorous and fresh. It was probably made around the time of The Arrest of Christ, *now in the Count Antoine Seilern Collection, London (271 [II, 47]).*

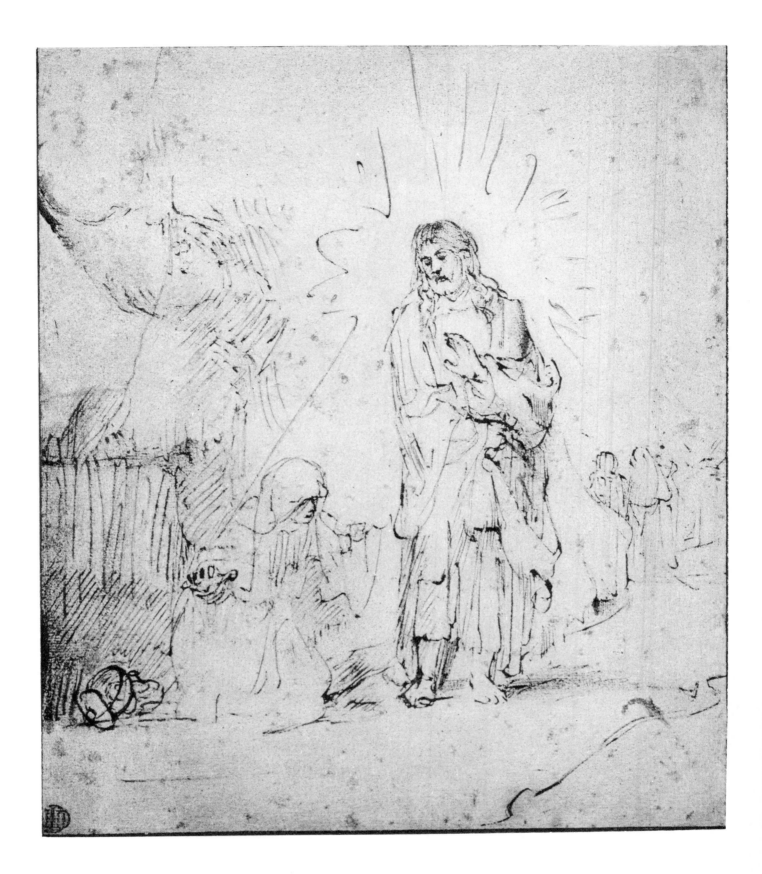

500 (*IV, 54*). *Noli Me Tangere.* (*Van der Waals Collection, Heemstede*)

Pen and bistre: 220 × 185 mm.

About 1650. The supernatural light radiating from the monumental figure of Christ permeates the atmosphere of this drawing of the moment after Mary Magdalen recognizes Him.

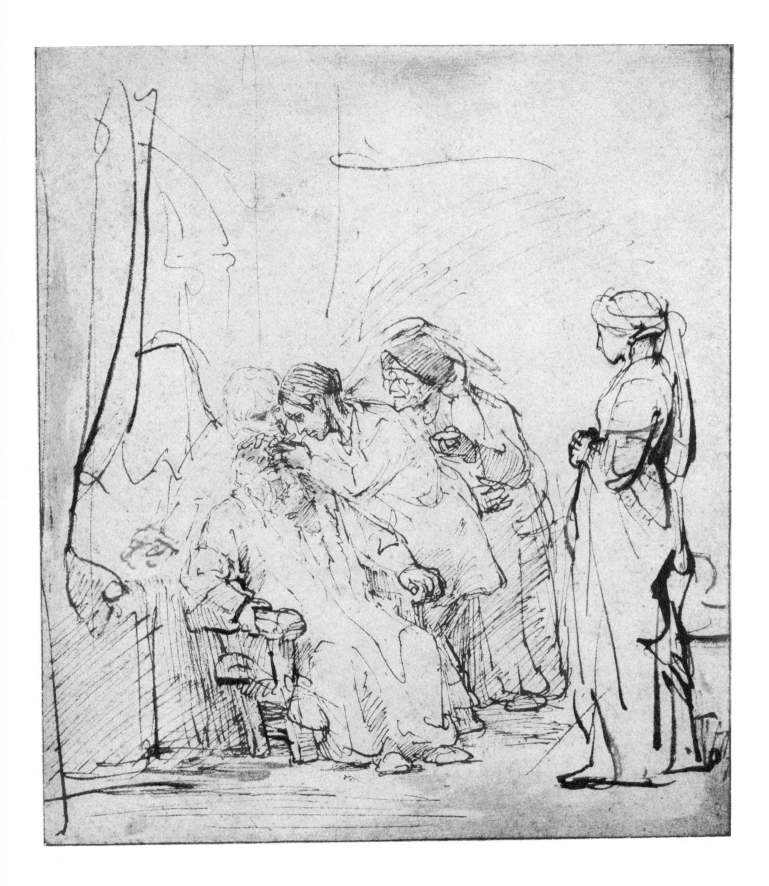

501 (*IV, 55*). *The Healing of Tobit.* (*Mme. Pierre Goujon Collection, Paris*)
Pen and bistre, wash, white body color: 210 × 177 mm.
About 1640–45.

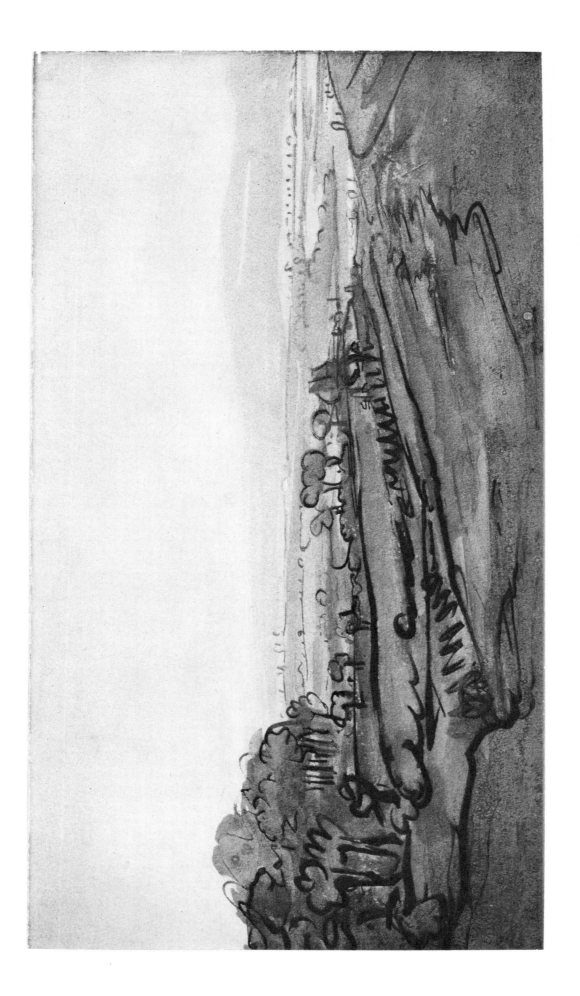

502 (*IV, 56*). *View in Gelderland.* (*Comtesse de Béhague Collection, Paris*)

Pen and brush, wash, in bistre: 145 × 261 mm.

About 1648. Pen and wash cooperate here to give the illusion of intangible light and atmosphere in this panoramic view of a great valley in the hilly region of Gelderland.

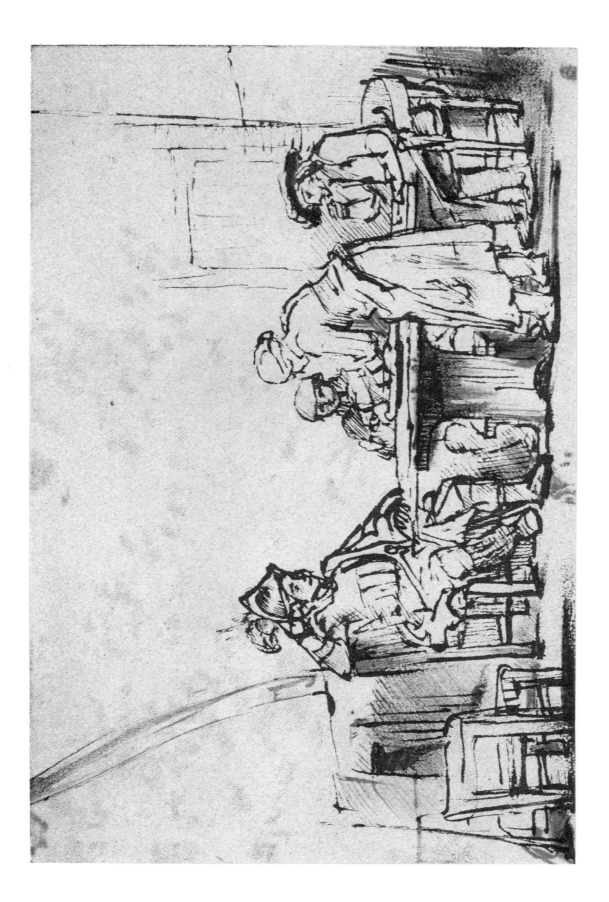

503 (IV, 57). *Saul and His Servants with the Witch of Endor. (Bredius Museum, The Hague)*

Pen and wash in bistre: 114 × 226 mm.

About 1655.

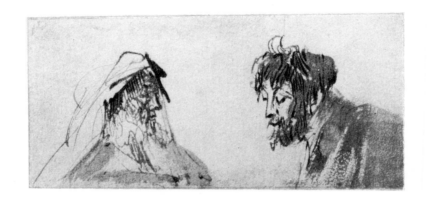

504 (*IV, 58a*). *Two Studies of Old Men Facing Each Other.* (*Comtesse de Béhague Collection, Paris*)
Pen and brush in bistre and Indian ink: 47 × 99 mm.
Benesch's (371) conclusion that the small sketch was made around 1637–38 is more acceptable than the date of about 1630 given by K. Bauch, Die Kunst des jungen Rembrandt, *Heidelberg, 1933, p. 205.*

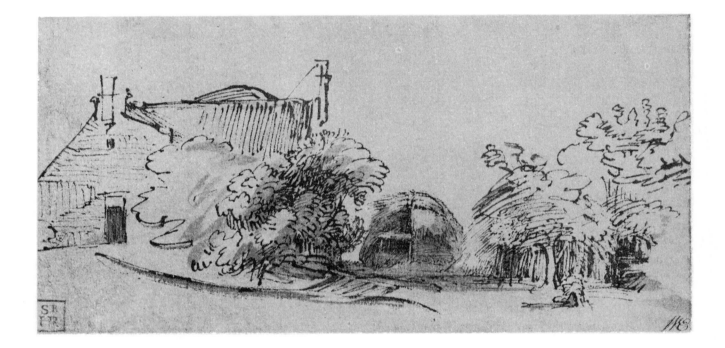

505 (*IV, 58b*). *A Farmhouse with a Haystack Between Trees.* (*Boymans–van Beuningen Museum, Rotterdam*)
Pen and bistre, wash in bistre and sepia: 89 × 179 mm.
About 1650.

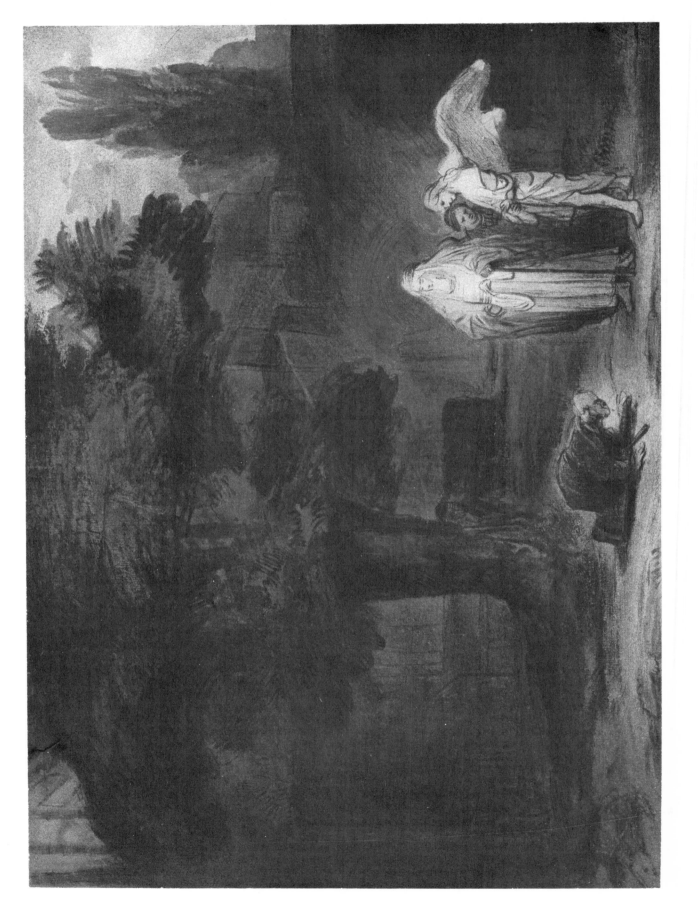

506 (IV, 59). *Abraham Before God and the Two Angels.* (British Museum, London)

Red and black chalk, pen, wash: 232 × 326 mm.

Closely related to the following drawing of the same subject in the British Museum (see Hind, 1915, nos. 116 and 117). Hind rightly inclined to the conclusion that both are by a pupil or follower of about 1640–50. Valentiner (1924, pp. 11 ff.) demonstrated they are works by Nicolaes Maes.

507 (IV, 60). *Abraham Before God and the Two Angels. (British Museum, London)*

Red chalk: 170 × 292 mm.

By Nicolaes Maes. See the comment to the preceding drawing.

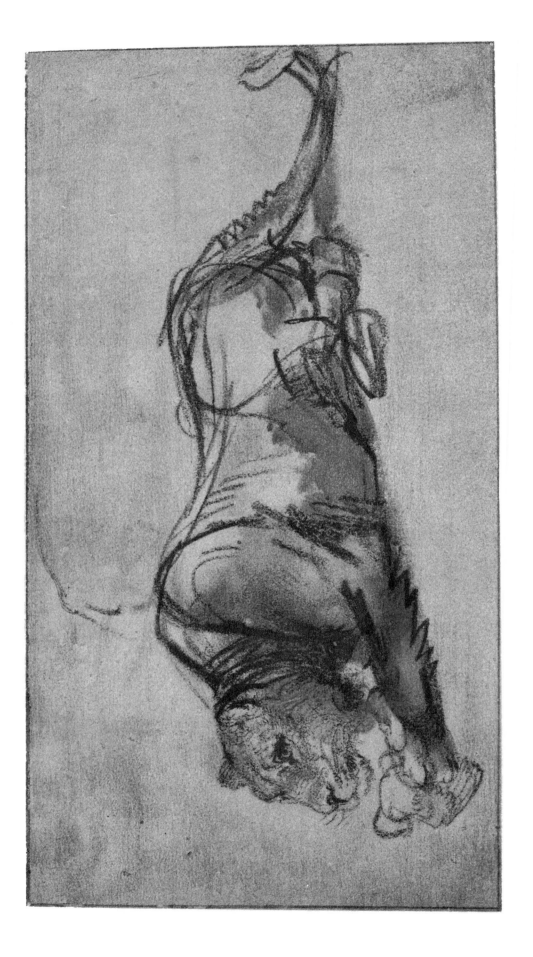

508 *(IV, 61). Lioness Eating a Bird. (British Museum, London)*

Black chalk and Indian ink wash, heightened with white: 127 × 238 mm.

Rembrandt referred to studies such as this and 509 (IV, 62) for his painting The Concord of the State *of 1641, now at the Boymans-van Beuningen Museum, Rotterdam (Bredius 476).*

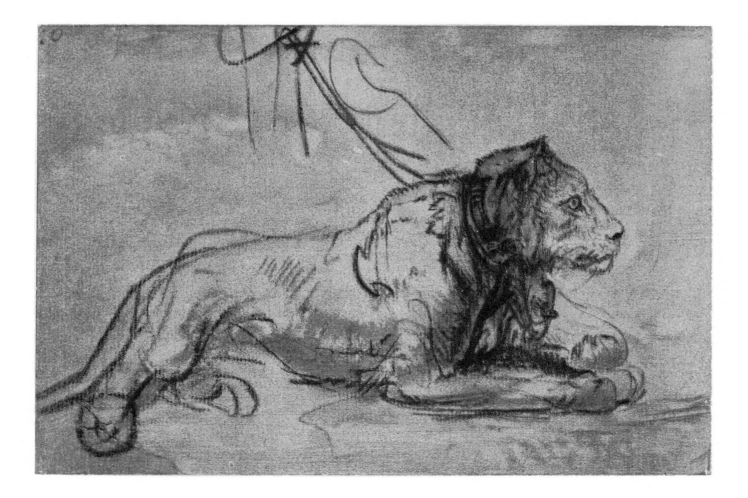

509 (*IV, 62*). *Study of a Chained Lioness Lying Down to the Right.* (British Museum, London)
Black chalk, wash in Indian ink, heightened with white: 126 × 181 mm.
About 1640. See the comment to the preceding drawing. Both are executed in a similar fashion.

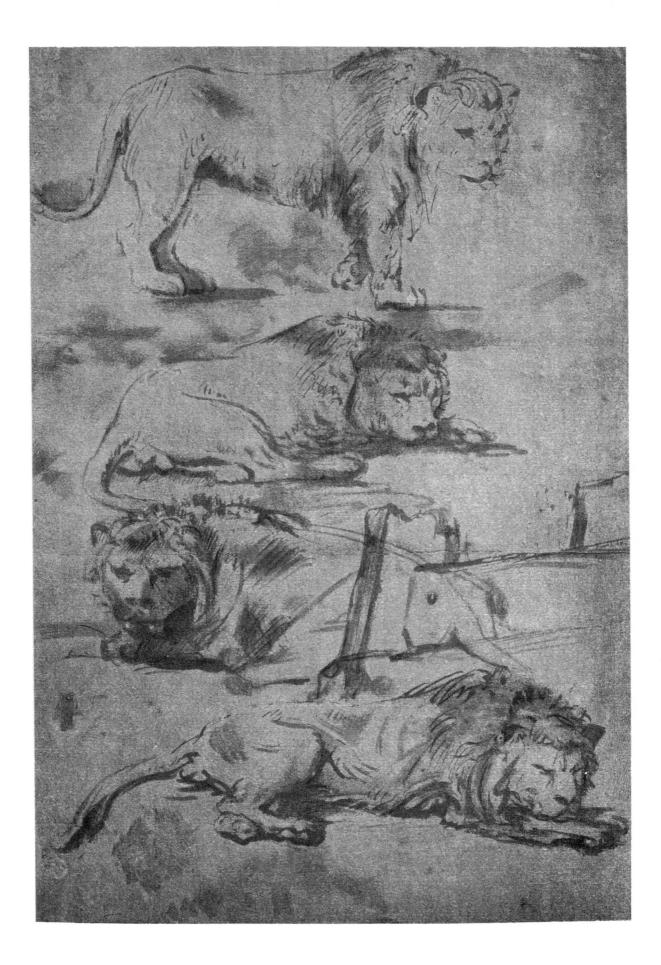

510 *(IV, 63). Four Studies of Lions. (British Museum, London)*

Pen and wash in bistre, traces of white: 294 × 193 mm.

By a pupil or follower. The second lion is seen from virtually the same point of view in a drawing by Rembrandt formerly in the F. Koenigs Collection, Rotterdam (see Benesch 782).

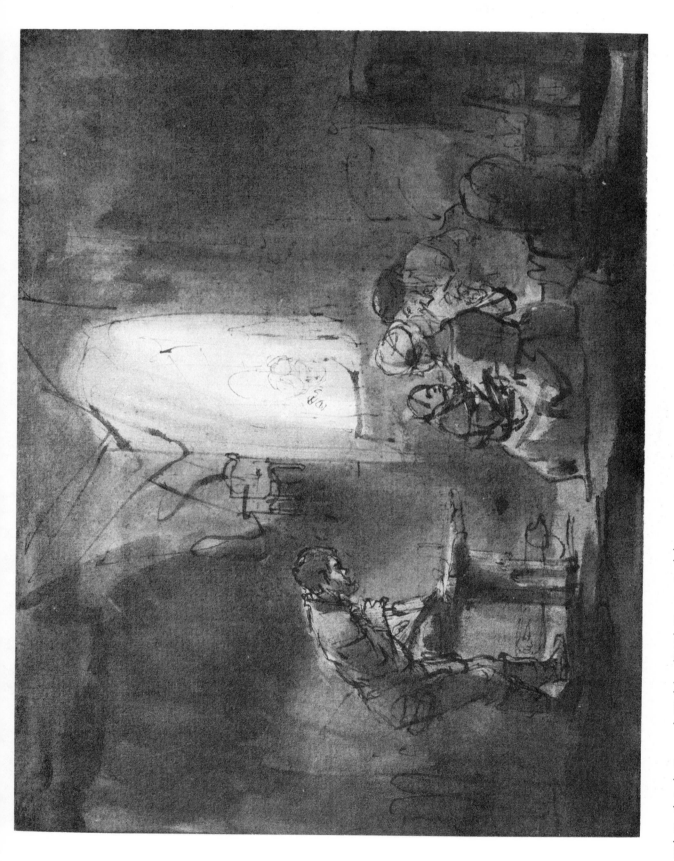

511 (IV, 64). *The Holy Family in the Carpenter's Workshop. (British Museum, London)*
Pen and bistre, washes in bistre and Indian ink: 184 × 246 mm.

About 1640–43. Related to the painting of the same subject of 1640 at the Louvre, Paris (Bredius 563). A free copy is at the Fogg Art Museum, Harvard University, Cambridge, Massachusetts (Agnes Mongan and Paul J. Sachs, Drawings in the Fogg Museum of Art, Cambridge, 1940, Vol. 1, p. 279, no. 531). A similar figure at a window appears again as Joseph in the etching of 1654 (Bartsch 63), and in the Faust etching (Bartsch 270) it is transformed into a supernatural apparition.

512 (IV, 65). *Study after Leonardo's Last Supper. (British Museum, London)*
Red chalk: 124 × 210 mm.

Around 1635. The sheet is a fragment. Traces of Rembrandt's cut-off signature are visible along the lower margin. For Rembrandt's other studies after Leonardo's painting see 24 (I, 24) and 100 (I, 99).

513 (*IV, 66*). *Judith Returning in Triumph with the Head of Holofernes. (British Museum, London)*
Pen and bistre, wash, some white body color: 237 × 190 mm.

*About 1652–55. One of Rembrandt's most impressive mature drawings. Valentiner relates it with good reason to the
etching of* The Three Crosses (*Bartsch 78*) *and the painting of* Quintus Fabius Maximus *of 165(3), (Bredius 477).
Although it was made about a decade after* The Night Watch *it is not difficult to imagine that if a preliminary
study for the composition of Rembrandt's most famous painting is ever discovered it will have a similar spirit. For a
view that the drawing is not authentic see Benesch (A93).*

514 (IV, 67). *Houses Among Trees on the Bank of a River.* (British Museum, London)

Pen and wash in Indian ink: 160 × 233 mm.

About 1650. Such studies of the shimmering effect of light and shadows in the open air had a profound effect upon Rembrandt's late use of chiaroscuro. Hind (1915, no. 103) notes that the drawing corresponds exactly to the following one, in both style and execution.

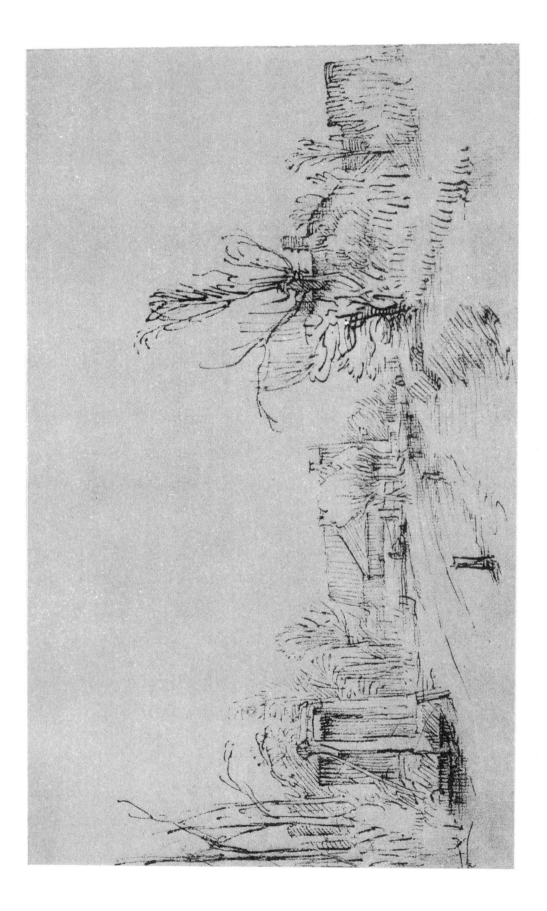

515 (IV, 68). *Village Street Beside a Canal. (British Museum, London)*

Pen and bistre: 130 × 231 mm.

About 1650. The same street is represented in a drawing at Chatsworth (226 [II, 9]).

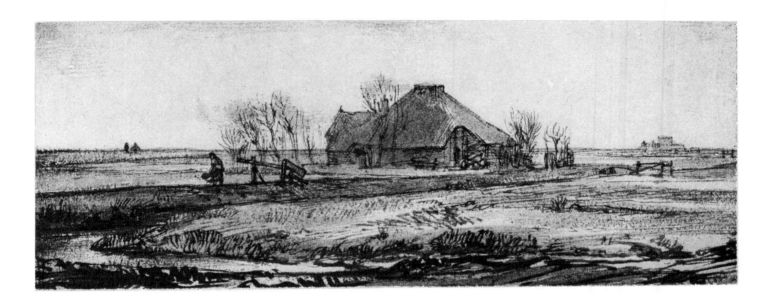

516 (*IV, 69a*). *Landscape with a Thatched Cottage.* (*British Museum, London*)

Pen and wash in bistre, white body color: 76 × 190 mm.

About 1647–50. The exquisitely executed drawing captures the mood of barren fields. It is that aspect of the Dutch countryside which Van Gogh repeatedly studied during his Dutch phase. Benesch (A47) is inclined to see the drawing as the work of a pupil.

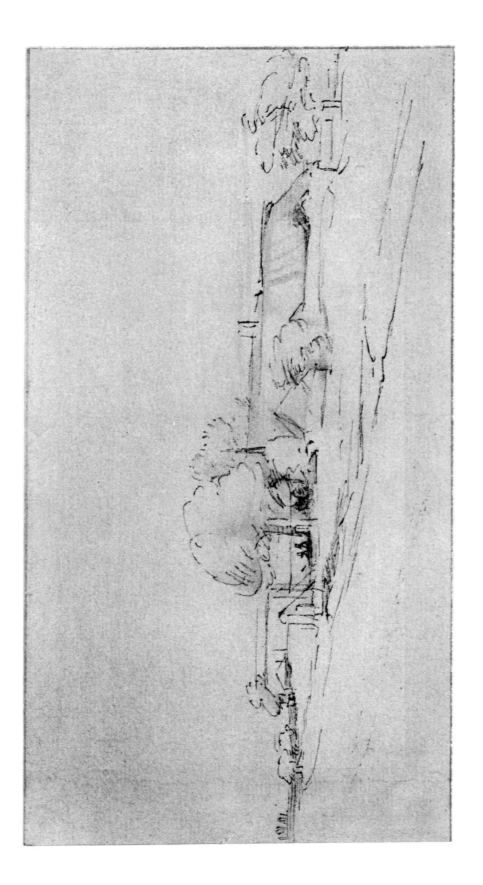

517 (IV, 69b). *Farm Buildings near a Canal. (British Museum, London)*

Pen and wash in bistre: 117 × 222 mm.

About 1647–50. A slight sketch which is virtually impossible to reproduce. The original gives the impression that it was gently blown, not drawn, upon the paper.

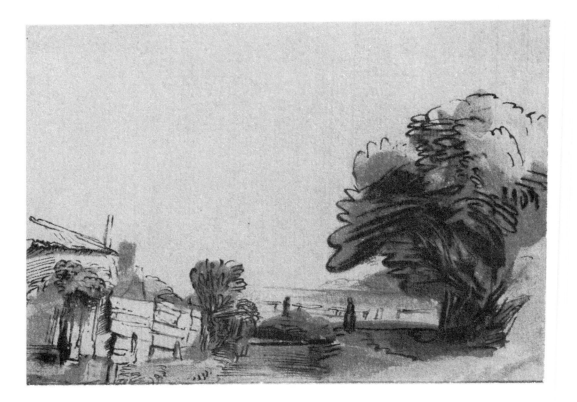

518 (*IV, 70a*). *Landscape with a Cottage, Canal and Trees.* (*British Museum, London*)
Pen and wash in bistre: 102 × 140 mm.
Compares well with drawings made around 1648–50. Rejected as a copy by Benesch (C55).

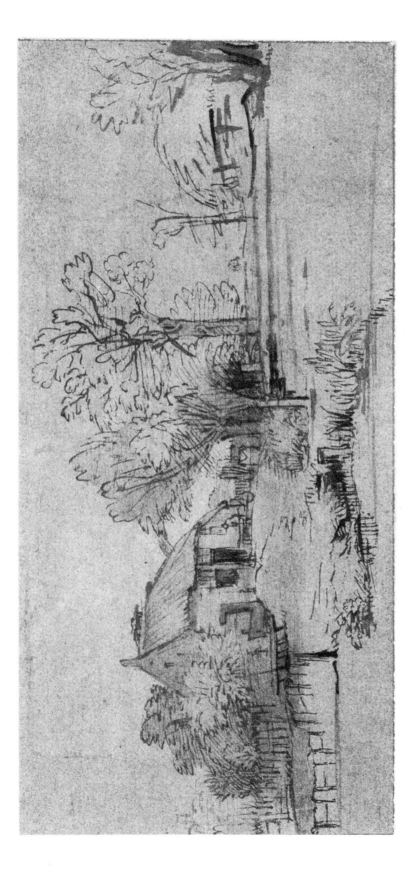

519 *(IV, 70b). Cottages with Trees Beside Water and a Hay Barn. (British Museum, London)*

Pen and bistre, wash: 102 × 223 mm.

About 1650.

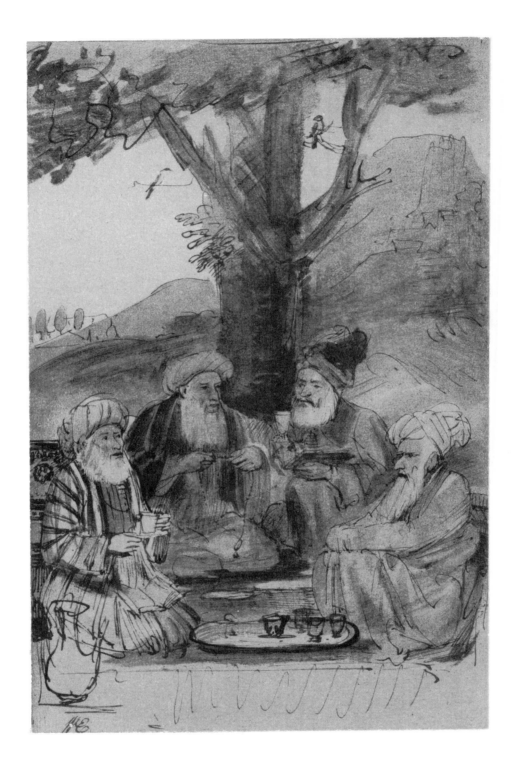

520 (*IV, 71*). *Four Orientals Seated Beneath a Tree.* (*British Museum, London*)

Pen and bistre, wash on Japanese paper: 192 × 125 mm.

About 1655. One of Rembrandt's copies after Indian miniatures (see 167 [I, 159]). The composition was used for his etching of Abraham Entertaining the Angels *of 1656 (Bartsch 29).*

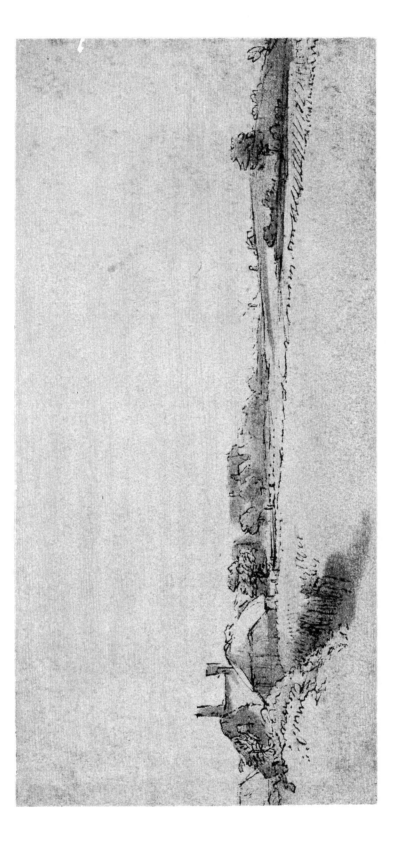

521 (IV, 72). *Landscape with Cottages, Meadows and a Distant Windmill. (British Museum, London)*

Pen and wash in bistre: 99 × 214 mm.

About 1647–50. Accepted by Hofstede de Groot (959) and Hind (1915, no. 100); not listed in Benesch. The great sense of spaciousness achieved with such economical means suggests that the work is authentic. Compare with 517 (IV, 69b).

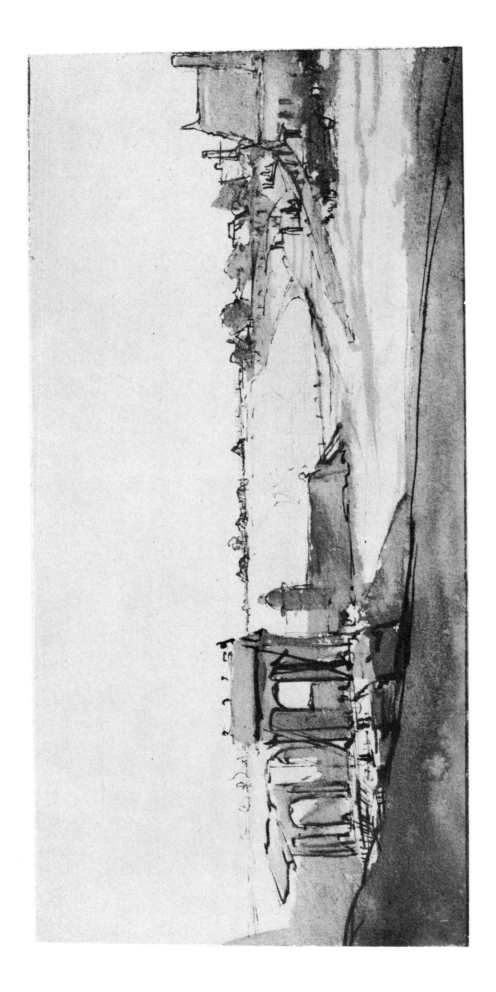

522 (*IV, 73*). *View from near the Anthoniespoort.* (*British Museum, London*)

Pen and wash in bistre: 123 × 261 mm.

About 1650. Lugt (1920) identified the site. Rightly praised for its breadth and clarity by Hind (1915, no. 115), and by Rosenberg (1959) as one of Rembrandt's outstanding landscape drawings. See Benesch A38 for the view that it is not authentic.

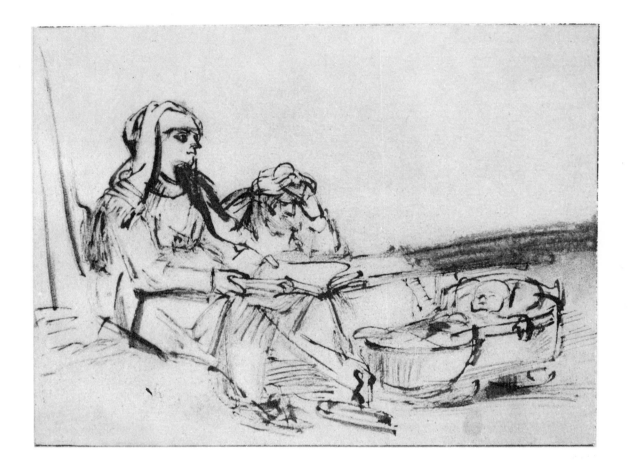

523 (*IV, 74*). *The Holy Family. (British Museum, London)*
Reed pen and bistre, Indian ink washes: 117 × 151 mm.
About 1655.

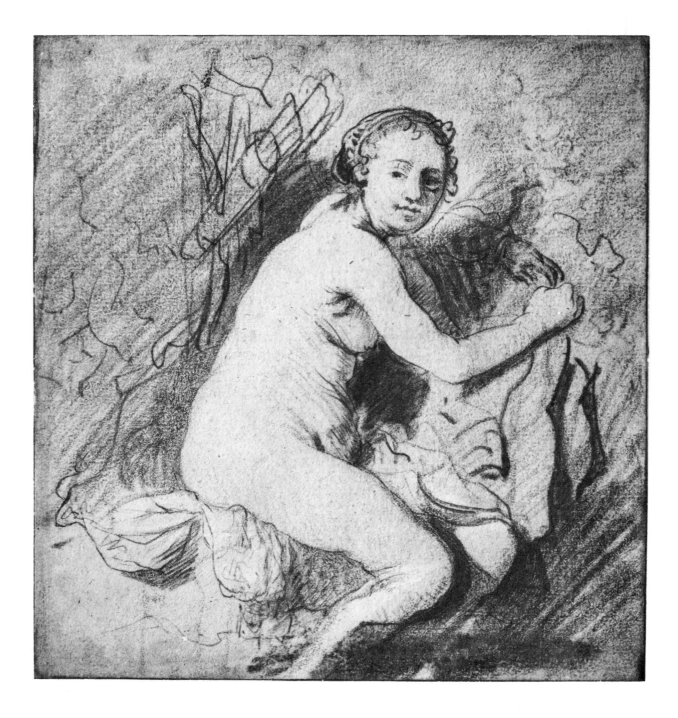

524 (*IV, 75*). *Diana at Her Bath.* (*British Museum, London*)

Black chalk, bistre wash: 181 × 164 mm.

About 1630–31. Preparatory drawing for the etching of the same subject (Bartsch 201); the principal lines of the drawing have been indented with a stylus for transfer to the plate. A painting attributed to Rembrandt (Bredius 461), which has been related to this drawing, is probably a school piece after the etching.

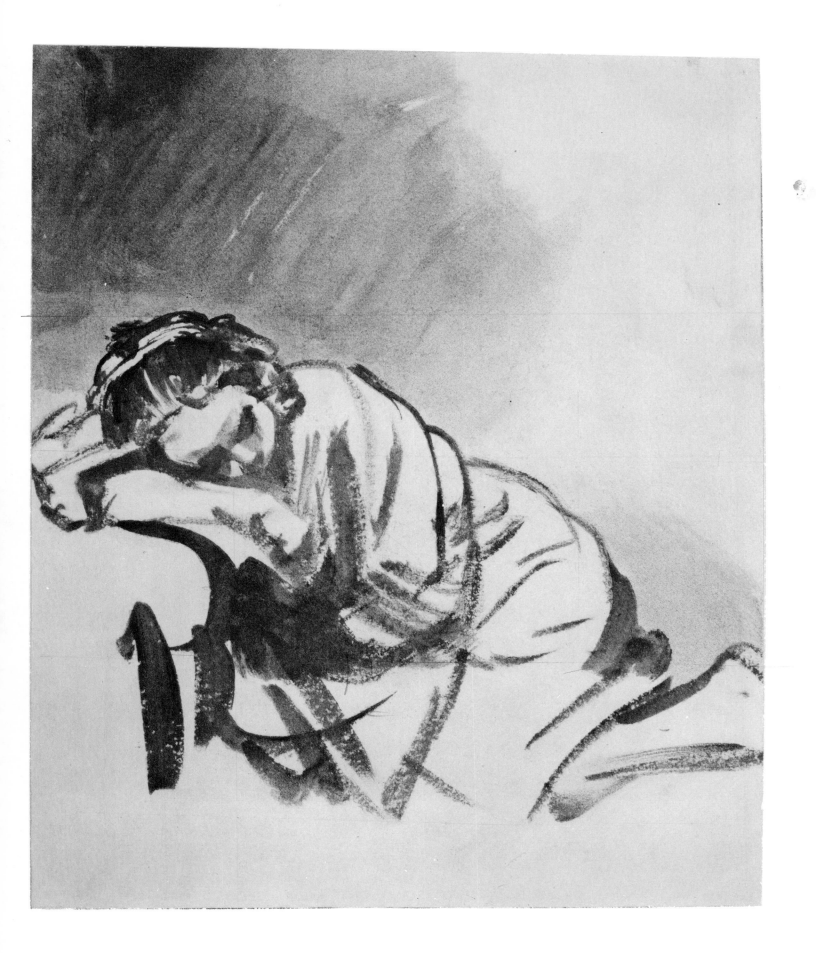

525 (*IV, 76*). *A Woman Sleeping* (*Hendrickje?*). (*British Museum, London*)
Brush and wash in bistre: 245 × 203 mm.

About 1655. Universally praised as one of Rembrandt's finest drawings. With powerful strokes and unequalled economy, his swift brush suggests the model's form, the luminous atmosphere and, in some miraculous way, even the warmth of the young woman's huddled body.

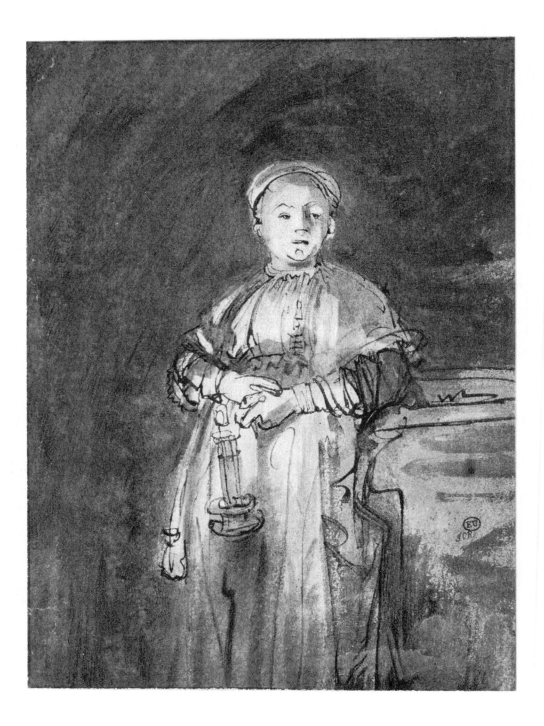

526 (*IV, 77*). *A Woman Standing, with a Candle.* (*British Museum, London*)

Pen, bistre and Indian ink wash, slightly heightened with white: 181 × 132 mm.

About 1637–40. Many of Rembrandt's contemporaries made pictures of people seen by artificial light. Most of them are virtuoso displays of mastery over the difficulties such a subject poses. In Rembrandt's work we never think of the problems; we are only aware of the mood he establishes. The woman would not look out of place if she were cast as the maid who looks upon St. Peter as he sits by the fire and says, " 'This man was also with him.' And he denied him, saying, 'Woman, I know him not' " (Luke 22).

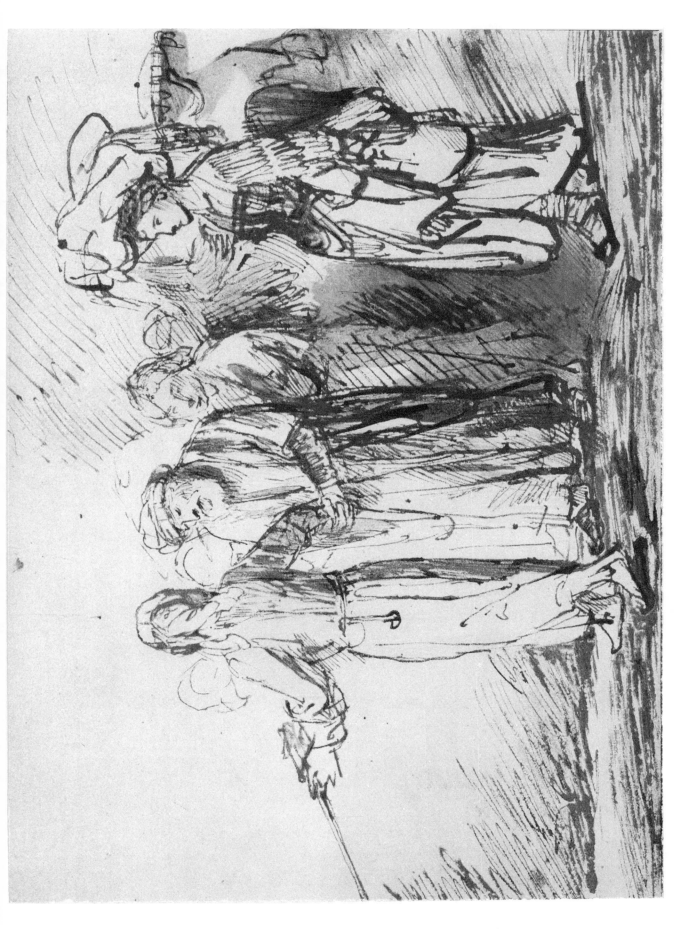

527 (IV, 78). *Angels Leading Lot and His Family Out of Sodom. (British Museum, London)*
Pen and wash in bistre, white body color: 177 × 243 mm.

About 1652–53. An impressive drawing—particularly the woman on the right—which has been disfigured by the addition by another hand of washes and hatching on the ground and to the left.

528 (IV, 79). *Children Dancing and Making Music Before a Street Door. (British Museum, London)*
Pen and bistre: 192 × 224 mm.

About 1640. The center boy is playing a rommel-pot, an instrument frequently used during Shrove Tuesday celebrations. Rembrandt made a group of similar drawings around the same time. The one closest to it in style and subject, formerly in the Paul J. Sachs Collection, Cambridge, Massachusetts, is Benesch 735, figure 876 (note: the Paul J. Sachs drawing is not in the Fogg Art Museum as listed by Benesch; it was stolen in January, 1937).

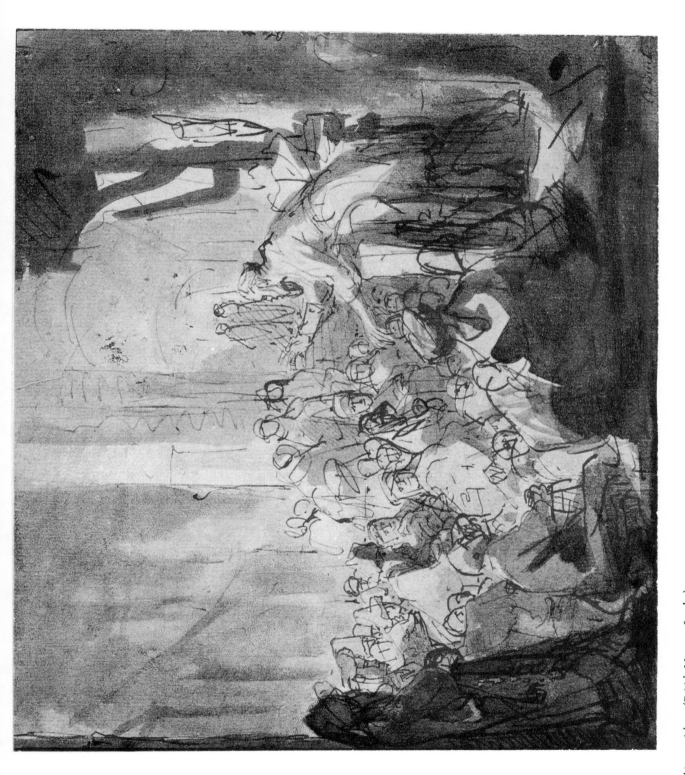

529 (IV, 80). *St. Paul Preaching at Athens.* (British Museum, London)

Pen and bistre, wash: 178 × 204 mm. Inscribed by a later hand: Rembt.

About 1637. The drawing is one of the steps in the evolution of the painting at Berlin–Dahlem of St. John the Baptist Preaching (Bredius 555). Hind (1915, no. 15) notes that the sheet "shows some of the characteristics (the straight lines crossing at right angles for eyebrows and nose, and the circles for eyes), which were carried to an almost excessive mannerism by Philips de Koninck."

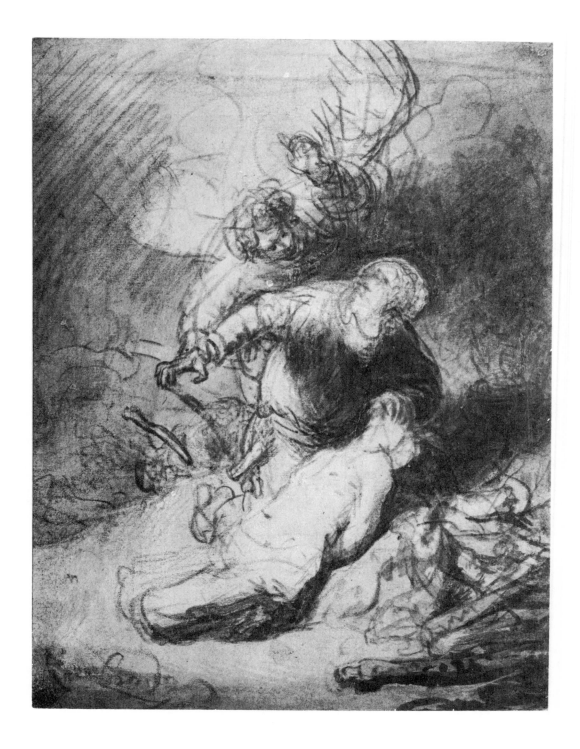

530 (*IV, 81*). *The Sacrifice of Abraham.* (*British Museum, London*)

Red and black chalk, wash in Indian ink, white body color: 194 × 146 mm. Signed: Rembrandt.

Closely related to the painting of the same subject dated 1635 at The Hermitage, Leningrad (Bredius 498) and even more closely to a pupil's version (Flinck?), now at Munich, which was corrected by Rembrandt and signed and dated 1636 by the master. The drawing may have been made after the Leningrad version was finished as a model for the pupil who executed the Munich variant. See Begemann (1961, no. 90) for the suggestion that the drawing is the work of a pupil.

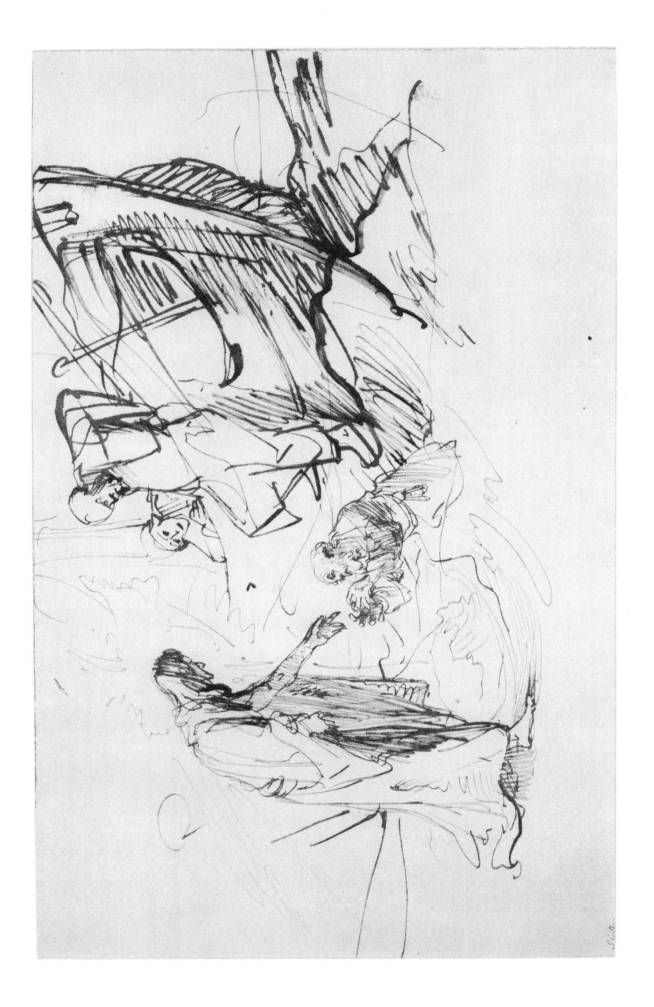

531 (*IV, 82*). *Christ Walking on the Waves.* (*British Museum, London*)
Pen and bistre: 166 × 266 mm.

About 1633. A brilliant example of Rembrandt's early mastery of the quill pen, which is handled with extraordinary flexibility.

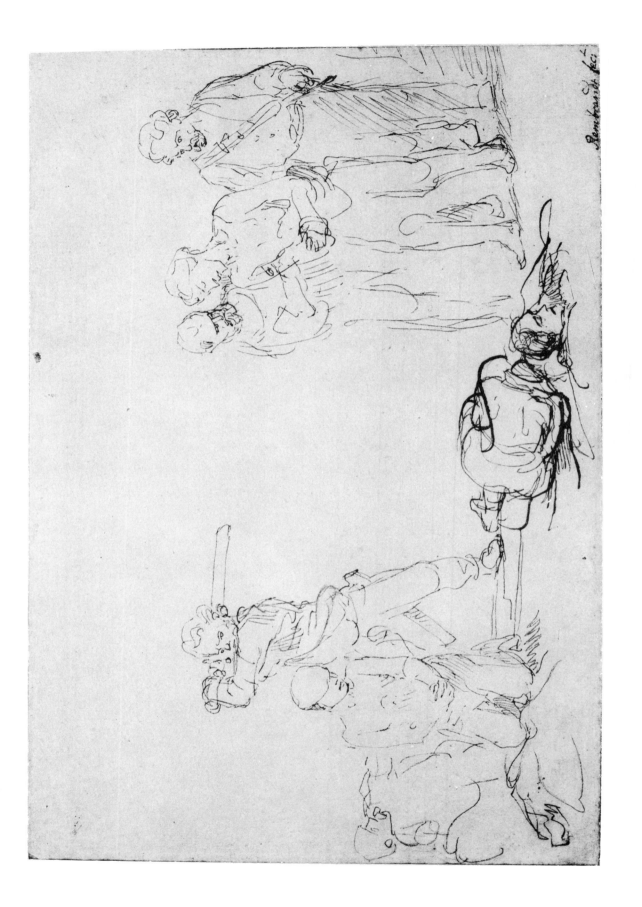

532 (IV, 83). *Studies for a Beheading of St. John the Baptist.* (British Museum, London)

Pen and bistre: 154 × 225 mm. Inscribed by another hand: Rembrandt fect.

About 1640. Interpretation of the drawing as a unified scene depicting more than one person being beheaded leads Valentiner (543) to suggest that it represents The Death of St. James the Great, and Benesch (479) to propose that it shows The Beheading of the Tarquinian Conspirators, Livy, II, 4, 5. The drawing can also be viewed as three separate studies. The close relation of the group on the left to the etching dated 1640 of The Beheading of St. John the Baptist (Bartsch 92) suggests it is a study for that print. The drawing is similar in style and conception to another study for the print now at Amsterdam (reproduced Benesch, figure 603).

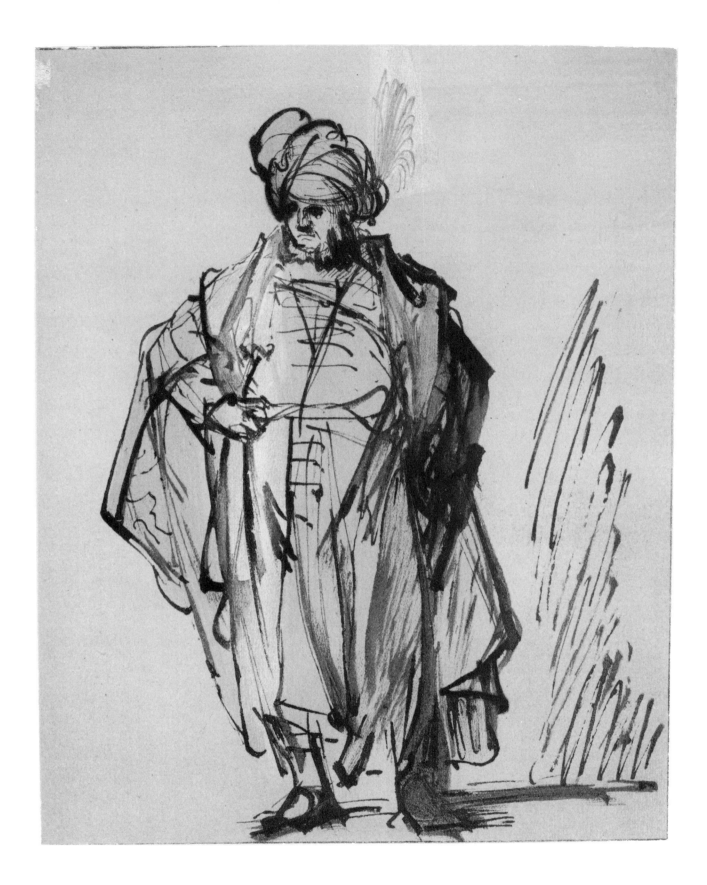

533 (*IV, 84*). *Study of an Oriental Standing.* (British Museum, London)
Pen and bistre, wash, white body color: 221 × 169 mm.
About 1633.

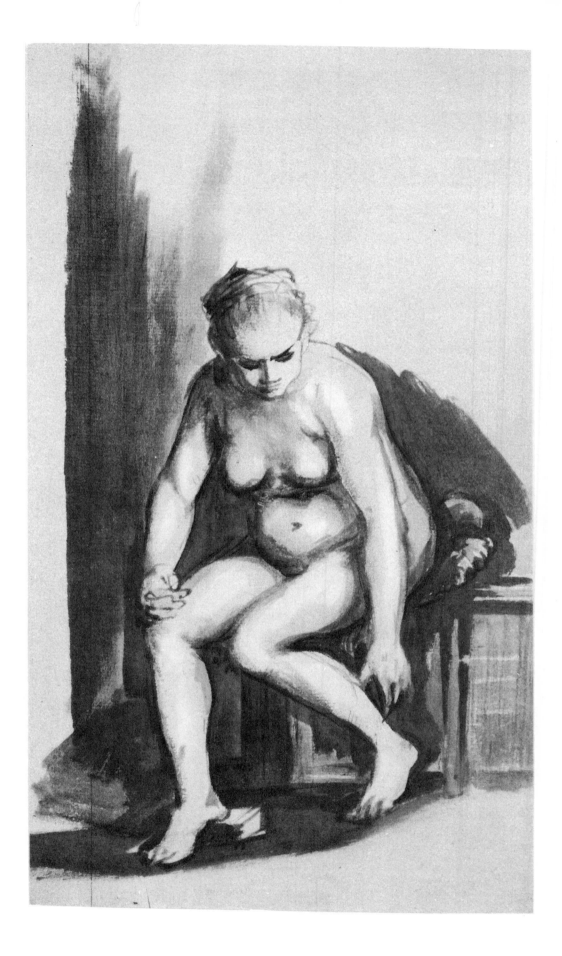

534 (*IV, 85*). *Female Nude Seated and Bending Forward.* (*British Museum, London*)

Pen, brush and wash in bistre and Indian ink: 286 × 160 mm.

About 1660–62. Valentiner (746) noted that Rembrandt used the same paper (with a vertical line on the side) for another drawing of the same model in the same pose (Benesch 1142) and for a magnificent drawing of one of the Syndics (Benesch 1180) in De Staalmeesters of 1662.

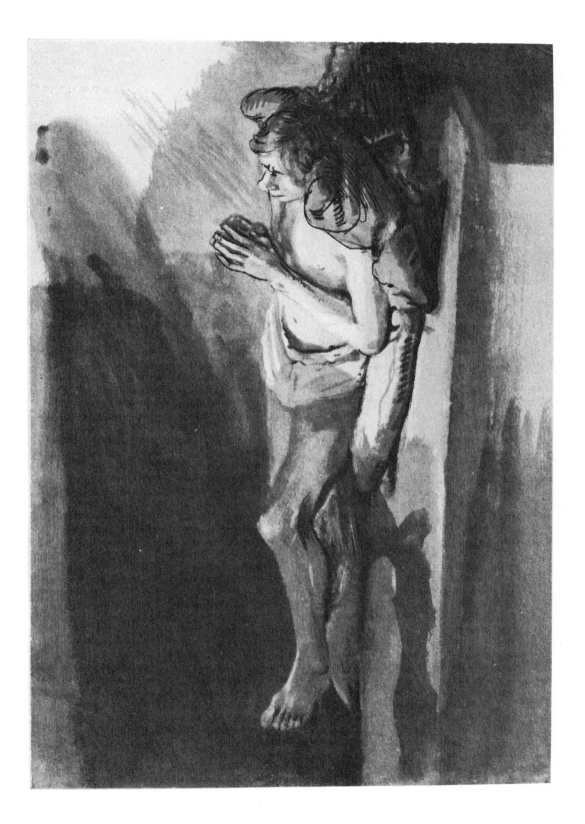

535 (IV, 86). *Life Study of a Man Lying on His Back with His Hands in a Praying Gesture.* (British Museum, London)

Pen and wash, white body color, traces of black and red chalk: 141 × 208 mm.

Attributed by Hind (1915, no. 67) to Rembrandt, but probably by a pupil working with Rembrandt in the 1640's (Eeckhout?). The transition from strong light to the deep shadows suggests this drawing of a model set in the pose of a tomb effigy was made at night.

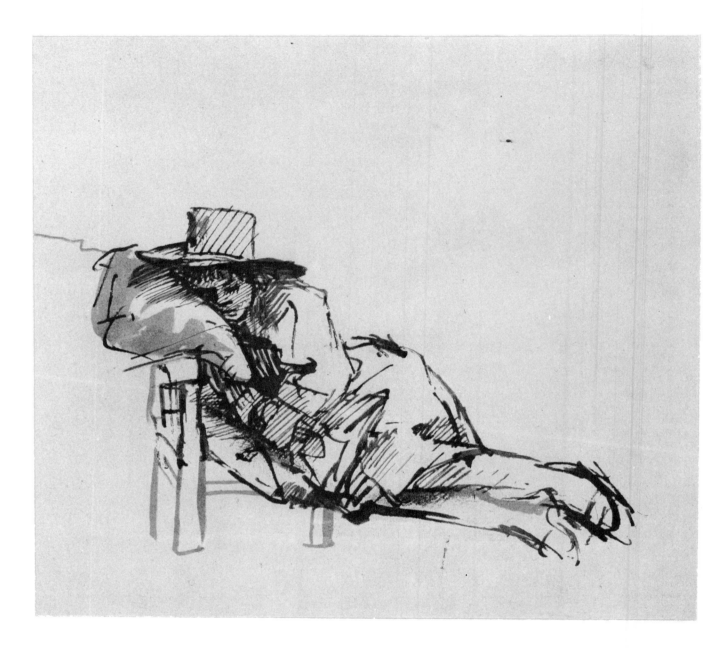

536 (*IV, 87*). *Study of a Young Man Asleep.* (*British Museum, London*)
Pen and wash in bistre: 161 × 178 mm.
About 1655. The brushwork in light brown on the pillow and chair is not by Rembrandt.

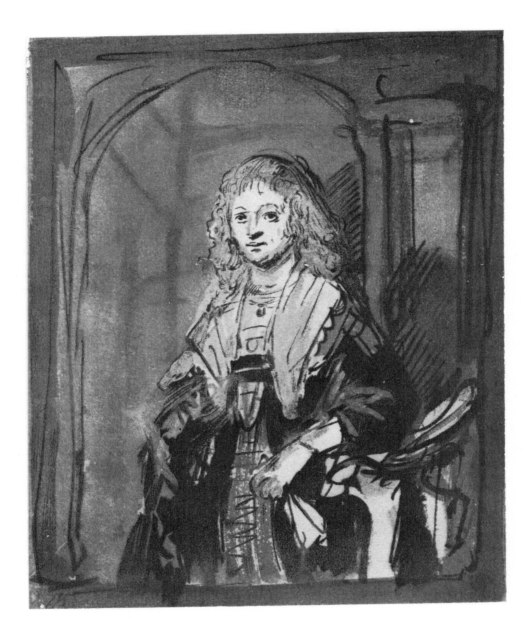

537 (*IV, 88*). *Portrait of a Lady Holding a Fan.* (*British Museum, London*)
Pen and bistre, wash, red chalk, white body color: 160 × 129 mm.
Preparatory study for the portrait dated 1639 on loan from the Van Weede Family Foundation to the Rijksmuseum,
Amsterdam (Bredius 356). The sketch suggests that the painting has been cut on all four sides.

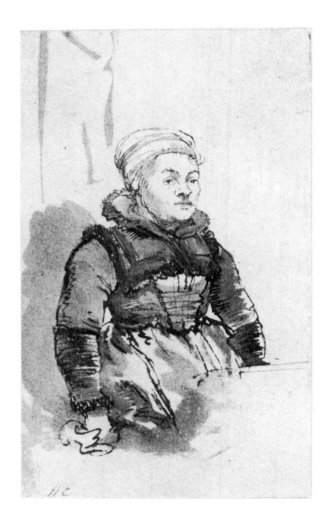

538 (*IV, 89a*). *Woman Wearing a Costume of North Holland.* (*British Museum, London*)
Pen and bistre, wash: 130 × 78 mm.
About 1642. See the comment to 176 (I, 166).

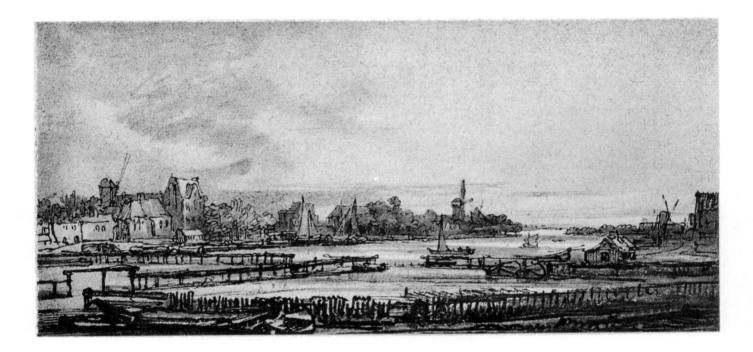

539 (*IV, 89b*). *View Over the Amstel from the Rampart.* (*Rosenwald Collection, National Gallery of Art, Washington, D.C.*)

Pen and wash in bistre: 90 × 186 mm.

About 1647–50. Lugt (1920) identified the site as a view from the bastion near the Amsterdam bridge called the "Blauwbrug." The drawing can be related to other carefully executed landscape drawings done around the same time which show the same keen observation, convincing accents, and soft tonal treatment (see, for example, 516 [IV, 69a]). Not listed in Benesch.

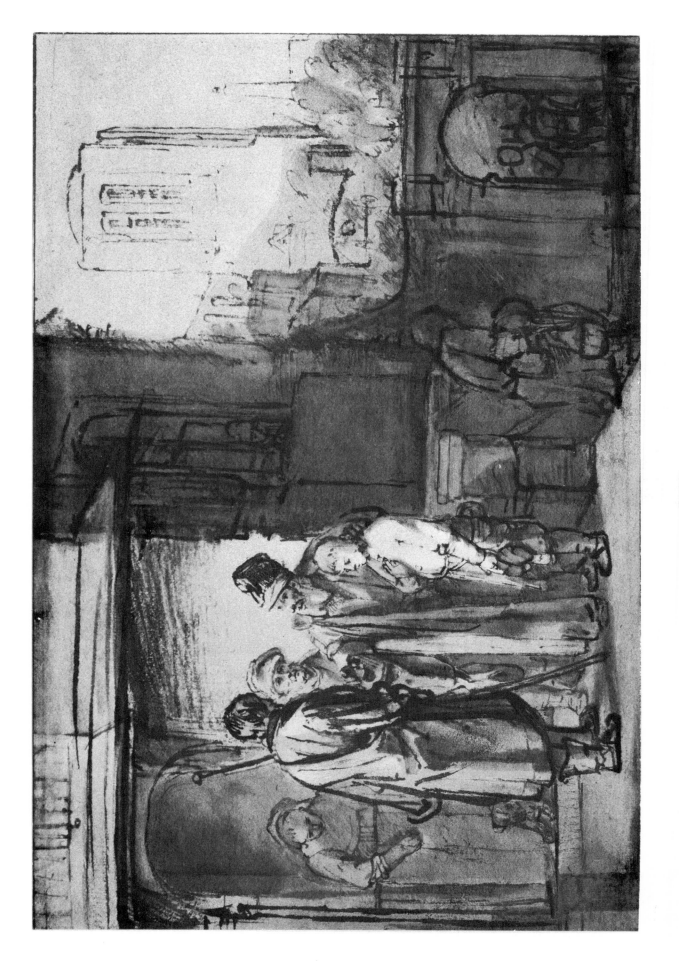

540 (IV, 90). *The Departure of Benjamin for Egypt. (Teyler Museum, Haarlem)*

Pen and bistre, wash, white body color: 190 × 290 mm.

A pupil's drawing with some corrections by Rembrandt which are particularly clear in the architecture in the shadow on the right. The drawing is a study for a painting now in the Mauritshuis, The Hague. Both the drawing and the painting have been attributed to Barent Fabritius (see Valentiner 119 and Benesch 856); D. Pont, Barent Fabritius, Utrecht, 1958, pp. 94 and 129, suggests that Constantijn van Renesse made them. A weak copy of the Haarlem drawing incorporating the corrections is in the Rijksprentenkabinet, Amsterdam.

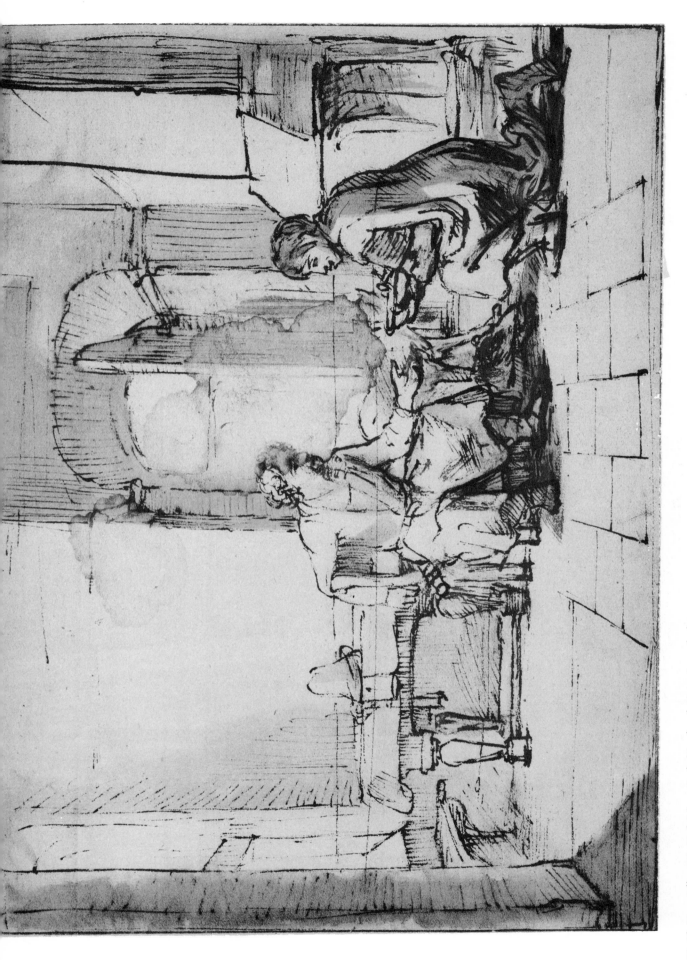

541 (IV, 91). *Esau Selling His Birthright to Jacob.* (Rembrandt Huis, Amsterdam)

Pen and bistre, wash: 190 × 265 mm.

About 1650. Washes, which probably are not by Rembrandt, disturb the effect of the monumental composition. The large water-stain, which formerly disfigured the central portion of the drawing, was removed after the facsimile used for this reproduction was made.

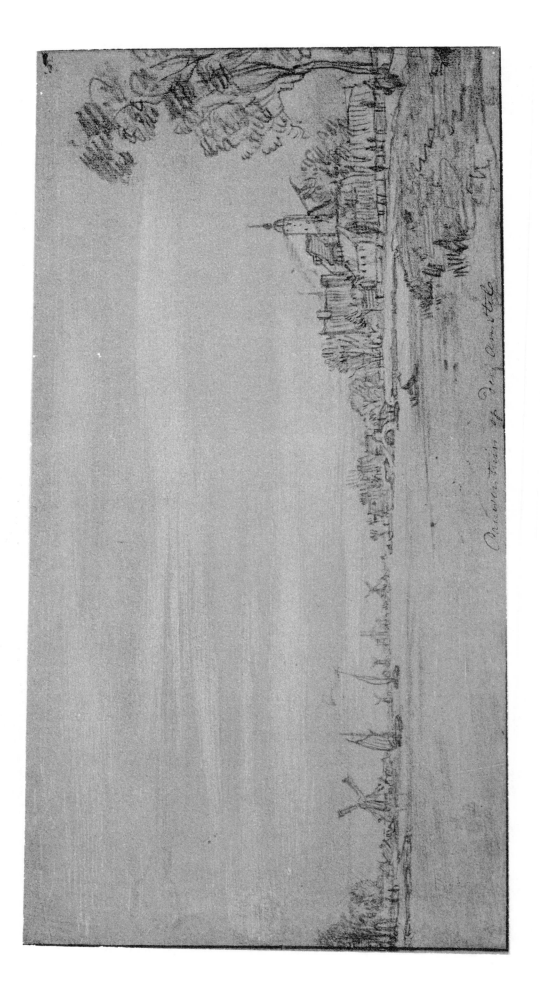

542 (IV, 92). *View of the Gardens of the Pauw Family on the Amstel. (Rijksprentenkabinet, Amsterdam)*
Black chalk on brownish paper: 159 × 316 mm.

The drawing has been frequently questioned; see Henkel (1943, p. 55, no. 112). It lacks the energy, directness and modulation of Rembrandt's stroke; probably a copy after a genuine drawing of the 'forties. The identification of the site is based on the inscription at the bottom of the sheet: Pauwentuin op den Amstel.

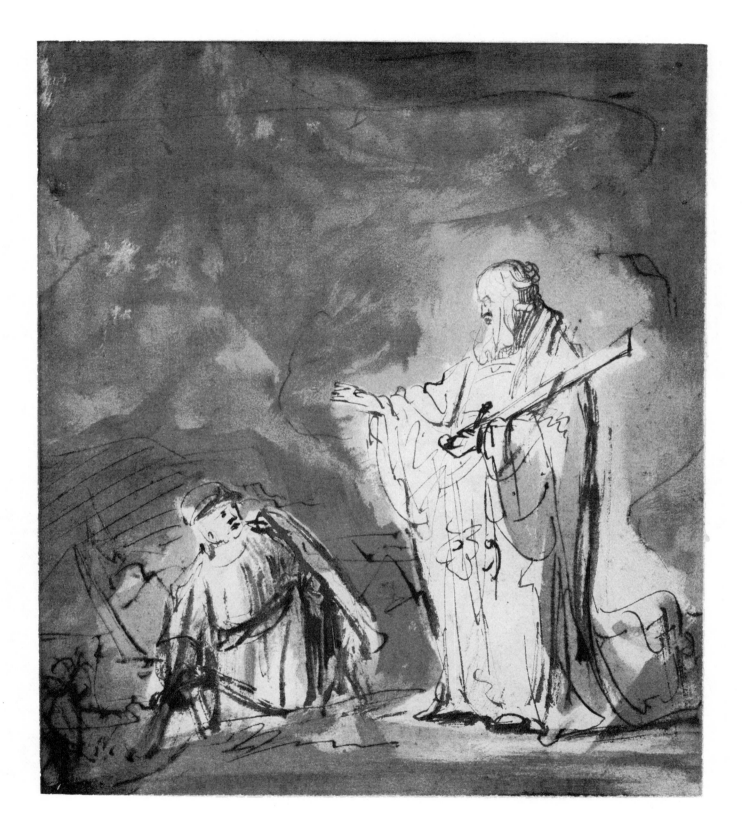

543 (IV, 93). *The Lord Appearing to Joshua* (*Joshua 5, 13*). (*Rijksprentenkabinet, Amsterdam*)
Pen in bistre, wash: 213 × 182 mm.
Attributed by Henkel (1943, p. 64, no. 2) with good reason to Ferdinand Bol.

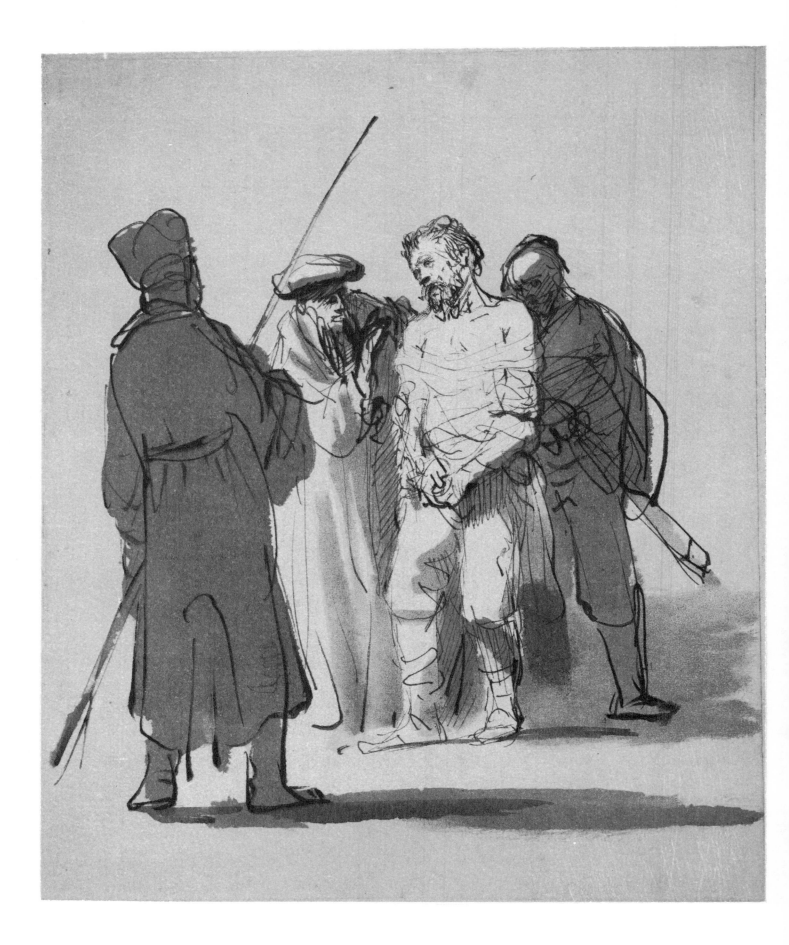

544 (*IV, 94*). *Study for an* Ecce Homo. (*Rijksprentenkabinet, Amsterdam*)

Pen and wash in bistre, white body color: 225 × 176 mm.

A copy by a pupil—Philips Koninck and Ferdinand Bol have both been suggested—of the principal group in the
Ecce Homo *at Dresden* (*141* [*I, 137*]).

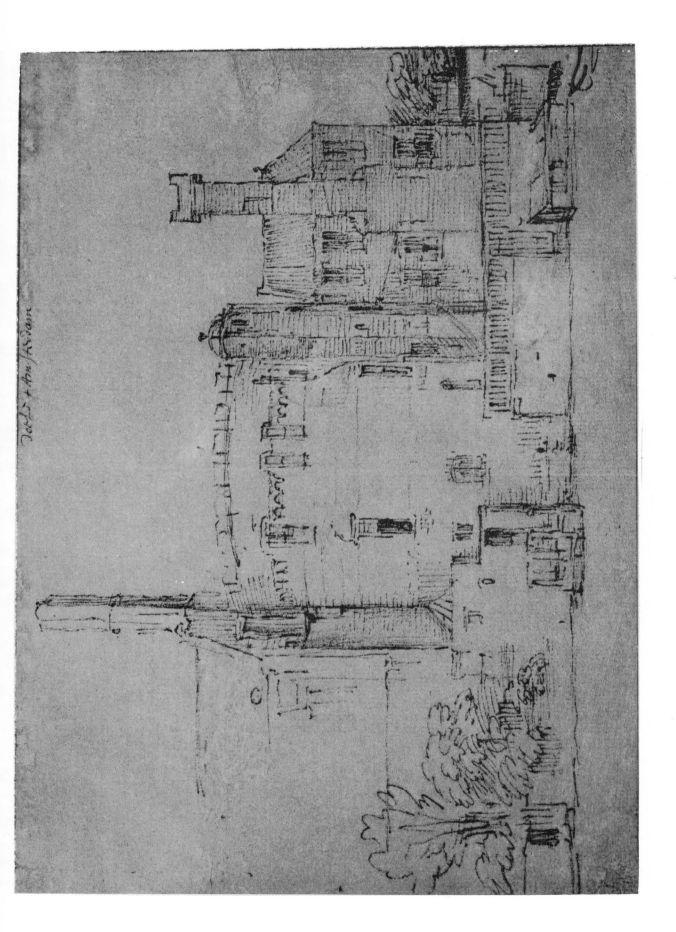

545 (IV, 95). *The "Kloveniersdoelen" and the Tower "Swijght Utrecht" at Amsterdam. (A. Boerlage-Koenigs Collection, Amsterdam)*

Reed pen and bistre: 164 × 235 mm. Inscribed by two different hands: doelen t Amsterdam/Rembrant.

About 1655. It is noteworthy that Rembrandt deleted the new pointed roof which was added to the tower (see the comment to 85 [I, 84]).

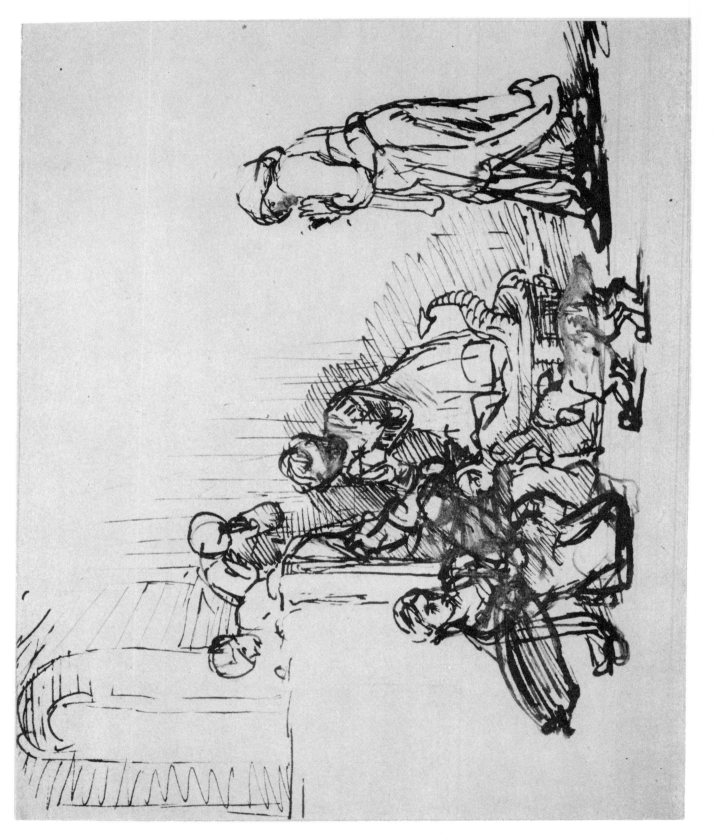

546 (IV, 96). *The Daughters of Cecrops Discover Erichthonius.* (Museum, Groningen)
Pen and bistre, white body color: 177 × 218 mm.

About 1645–48. The lid of the basket containing the little monster was drawn in two different positions; this accounts for the lack of clarity around kneeling Aglauros, the inquisitive daughter who opened the basket.

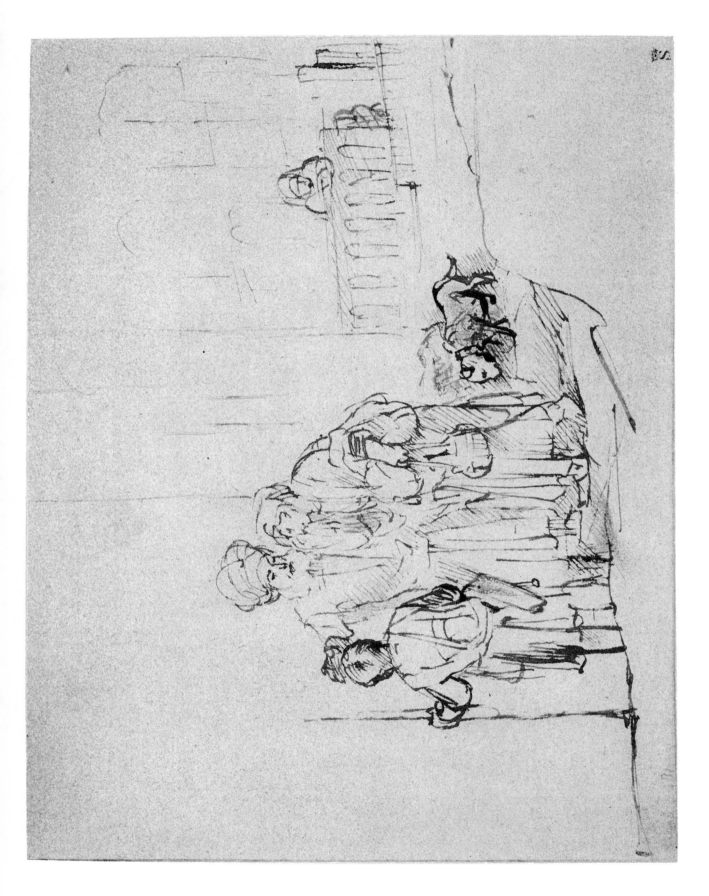

547 (IV, 97). *The Dismissal of Hagar. (Rijksprentenkabinet, Amsterdam)*
Pen and bistre: 172 × 224 mm.
About 1650–52.

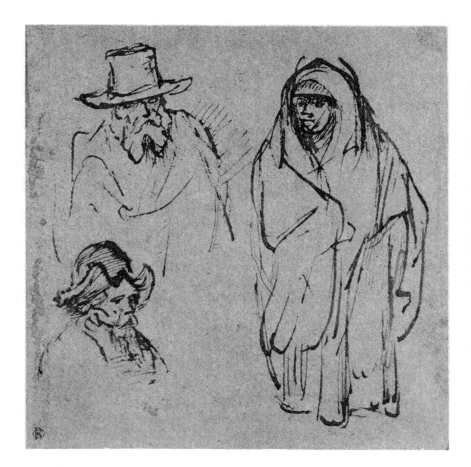

548 (*IV, 98*). *Studies of Three Figures.* (*Museum, Groningen*)
Pen and bistre: 110 × 110 mm.
About 1648–50.

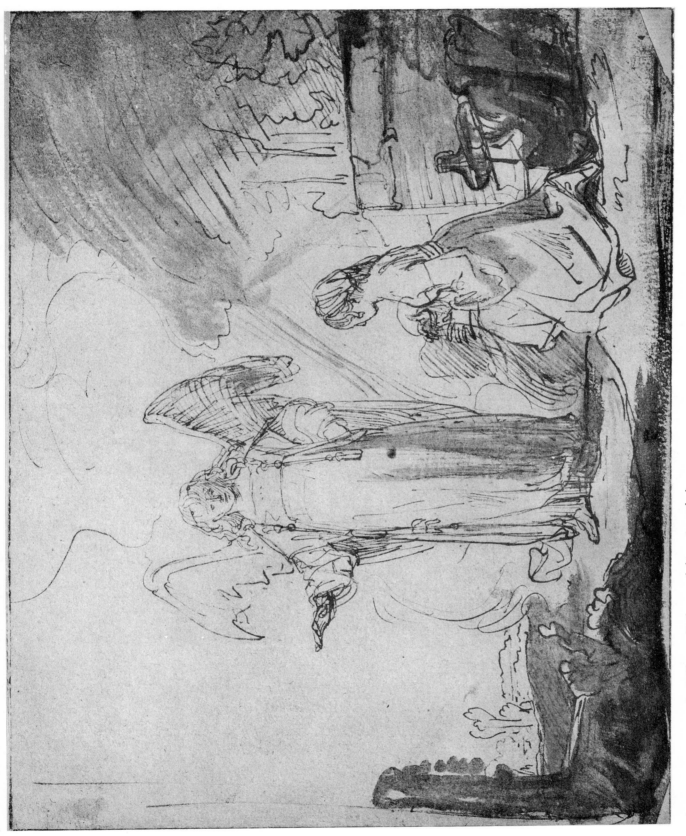

549 (IV, 99). *The Angel Appearing to Hagar in the Wilderness.* (Rijksprentenkabinet, Amsterdam)

Pen and wash in bistre: 182 × 233 mm.

Published as a Rembrandt (representing the Angel at the Tomb of Christ) by Hofstede de Groot. Münz (Belvedere, VI [1924], p. 106) recognized it as a work by Ferdinand Bol; his ascription and correct interpretation of the subject were confirmed by the discovery of a painting by Bol of this theme (see Henkel, 1943, p. 64, no. 1).

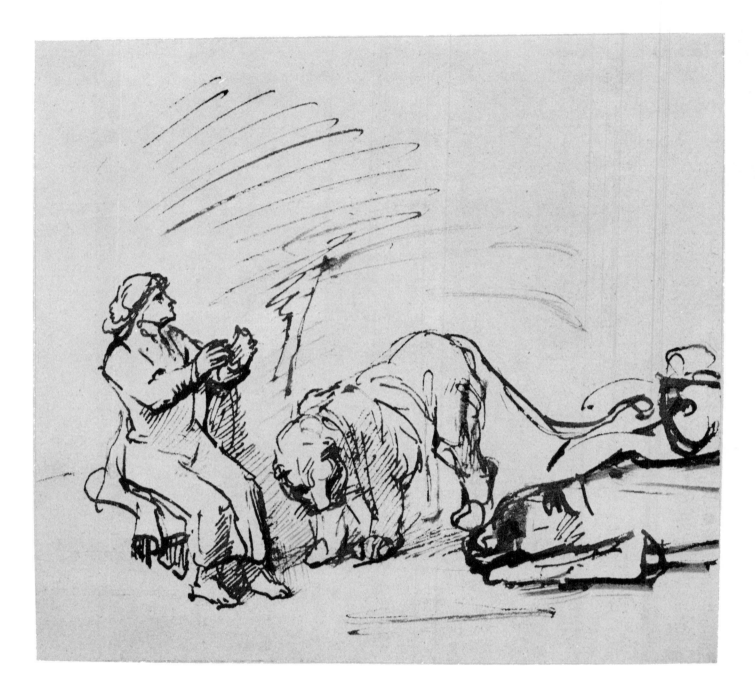

550 (*IV, 100*). *Daniel in the Lions' Den.* (*Museum, Gröningen*)
Pen and bistre: 180 × 190 mm.
About 1655.

Concordance

Between the Numbers of the Present Edition

And Those of the Catalogues of

Benesch, Valentiner, and Hofstede de Groot

To LOCATE a drawing, included in the present edition, in the catalogues of Benesch, Valentiner, and Hofstede de Groot:

Locate, in the consecutive listing in the first column of the Concordance, the number assigned to the drawing in the present edition.

The number assigned to the same drawing in any of the three catalogues will be found on the same line, in the column headed by the name of the editor of that catalogue.

A dash indicates that the drawing is not listed in the catalogue.

For example, if you wish to locate in the Benesch catalogue the drawing which bears the number 441 (IV, 3) in the present edition, find that number in the first column of the Concordance. On the same line, in the column headed "Benesch," you will find that this drawing bears the number 256 in the Benesch catalogue. Similarly, the same drawing is not listed in the Valentiner catalogue, but bears the number 417 in the Hofstede de Groot catalogue.

CONCORDANCE

Present edition	Benesch	Valentiner	Hofstede de Groot	Present edition	Benesch	Valentiner	Hofstede de Groot
1 (I, 1)	432	663	98	31 (I, 31)	989	196	36
2 (I, 2)	218	—	157	32 (I, 32)	465	—	164
3 (I, 3)	188	409	56	33 (I, 33)	940	450	66
4 (I, 4)	788	—	170	34 (I, 34)	—	—	725
5 (I, 5)	922	492	72	35 (I, 35)	804	—	168
6 (I, 6)	427	672	99	36 (I, 36)	1257	—	167
7 (I, 7)	325	—	129	37 (I, 37)	803	—	165
8 (I, 8)	755	—	149	38 (I, 38)	1278	—	1040
9 (I, 9)	401	781	140	39 (I, 39)	—	446	991
10 (I, 10)	41	—	—	40 (I, 40)	1247	—	1055
11 (I, 11)	100	494	75	41 (I, 41)	1335	—	1039
12 (I, 12)	1367	—	171	42 (I, 42)	1358	—	1056
13 (I, 13)	466	—	169	43 (I, 43)	1326	—	1053
14 (I, 14)	466	—	169	44 (I, 44)	—	—	746
15 (I, 15)	97	481	71	45 (I, 45)	345	—	1013
16 (I, 16)	141	274	158	46 (I, 46)	—	—	1019
17 (I, 17)	879	334	52	47 (I, 47)	1065	65	984
18 (I, 18)	219	—	159	48 (I, 48)	341	—	1023
19 (I, 19)	574	308	49	49 (I, 49)	341	—	1043
20 (I, 20)	944	182	81	50 (I, 50)	1338	—	1060
21 (I, 21)	203	—	133	51 (I, 51)	A81	174	830
22 (I, 22)	180	134	31	52 (I, 52)	A82	477	831
23 (I, 23)	223	—	141	53 (I, 53)	1265	—	835
24 (I, 24)	445	625	65	54 (I, 54)	1218	—	836
25 (I, 25)	945	373	62	55 (I, 55)	1253	—	843
26 (I, 26)	1186	630	100	56 (I, 56)	1239	—	844
27 (I, 27)	—	—	26	57 (I, 57)	1263	—	845
28 (I, 28)	A27	604	93	58 (I, 58)	1261	—	846
29 (I, 29)	760	—	102	59 (I, 59)	1232	—	847
30 (I, 30)	960	608	89	60 (I, 60)	847	—	848

Present edition	Benesch	Valentiner	Hofstede de Groot	Present edition	Benesch	Valentiner	Hofstede de Groot
61 (I, 61)	1248	—	849	124 (I, 122)	756	—	966
62 (I, 62)	1314	—	850	125 (I, 123)	1147	—	937
63 (I, 63)	1233	—	851	126 (I, 124a)	1329	—	957
64 (I, 64)	1219	—	837	127 (I, 124b)	1304	—	958
65 (I, 65)	796	—	852	128 (I, 125a)	1093	715	905
66 (I, 66)	1237	—	853	129 (I, 125b)	656	—	922
67 (I, 67)	1266	—	838	130 (I, 126)	—	271	875
68 (I, 68)	1217	—	854	131 (I, 127)	433	719	1063
69 (I, 69)	1294	—	855	132 (I, 128)	975	135	1546
70 (I, 70)	1295	—	856	133 (I, 129)	1154	254	1602
71 (I, 71)	1268	—	839	134 (I, 130)	706	—	1597
72 (I, 72)	1301	—	857	135 (I, 131)	708	—	1596
73 (I, 73)	1252	—	857a	136 (I, 132)	—	—	346
74 (I, 74)	1321	—	840	137 (I, 133)	886	562	345
75 (I, 75)	1228	—	858	138 (I, 134)	899	454	344
76 (I, 76)	891	64	829	139 (I, 135)	904	34	342
77 (I, 77)	A80b	76	828	140 (I, 136)	92	609	241
78 (I, 78)	142	—	833	141 (I, 137)	135	468	221
79 (I, 79)	120	—	832	142 (I, 138)	1003	9	197
80 (I, 80)	1282	—	859	143 (I, 139)	—	—	251
81 (I, 81)	1308	—	860	144 (I, 140a)	724	—	309
82 (I, 82)	1346	—	842	145 (I, 140b)	684	727	306
83 (I, 82a)	1347	—	841	146 (I, 141)	—	465	—
84 (I, 83)	846	—	861	147 (I, 142)	249	—	—
85 (I, 84)	1309	—	1050	148 (I, 143)	1249	—	1037
86 (I, 85)	340	—	1024	149 (I, 144)	948	168	—
87 (I, 86)	1144	—	1033	150 (I, 145)	885	348a	686
88 (I, 87)	1137	—	1032	151 (I, 146)	1064	415	57
89 (I, 88)	—	294	988	152 (I, 147)	910	364	694
90 (I, 89)	—	726	998	153 (I, 148a)	202	—	272
91 (I, 90)	757	720	999	154 (I, 148b)	324	—	—
92 (I, 91)	A54	—	1031	155 (I, 149)	—	—	—
93 (I, 92)	1099	714	1011	156 (I, 150a)	784	—	827
94 (I, 93)	—	706	996	157 (I, 150b)	1215	—	826
95 (I, 94)	1171	665	994	158 (I, 151)	52	—	682
96 (I, 95)	1068	540	229	159 (I, 152)	18	554	615
97 (I, 96)	—	175	—	160 (I, 153)	545	248	600
98 (I, 97)	C97	177	206	161 (I, 154a)	185	—	641
99 (I, 98)	1210	600	240	162 (I, 154b)	A49	366a	604
100 (I, 99)	443	623B	297	163 (I, 155)	557	72	591
101 (I, 100)	118	602	302	164 (I, 156)	652	489	609
102 (I, 101)	524	20	865	165 (I, 157)	824	—	659
103 (I, 102)	17	499	891	166 (I, 158)	15	550	613
104 (I, 103)	154	495	890	167 (I, 159)	1188	636	644
105 (I, 104a)	1345	—	925	168 (I, 160)	C89	39	584
106 (I, 104b)	1316	—	963	169 (I, 161a)	429	684	623
107 (I, 105)	ad979	131	873	170 (I, 161b)	—	—	627
108 (I, 106)	—	—	868	171 (I, 162a)	39	—	624
109 (I, 107)	554	340	881	172 (I, 162b)	995	180	597
110 (I, 108)	1001	109	871	173 (I, 163)	1300	—	656
111 (I, 109)	528	89	923	174 (I, 164)	456	—	757
112 (I, 110)	423	800	939	175 (I, 165)	89	363	1319
113 (I, 111)	327	—	919	176 (I, 166)	315	704	1327
114 (I, 112)	—	394	884	177 (I, 167)	519	388	1318
115 (I, 113)	1337	—	949	178 (I, 168)	40	—	1322
116 (I, 114)	113	320	877	179 (I, 169)	1208	29	—
117 (I, 115)	832	—	950	180 (I, 170)	79	396	1320
118 (I, 116)	1205	653	929	181 (I, 171)	—	—	—
119 (I, 117)	365	792	924	182 (I, 172a)	969	277	687
120 (I, 118)	459	—	948	183 (I, 172b)	949	541	704
121 (I, 119)	1207	621B	894	184 (I, 173a)	360	678	710
122 (I, 120)	758	724	896	185 (I, 173b)	360	789	710
123 (I, 121)	763	730	898	186 (I, 174)	542	118	670

Present edition	Benesch	Valentiner	Hofstede de Groot	Present edition	Benesch	Valentiner	Hofstede de Groot
187 (I, 175)	552	155	693	250 (II, 30b)	1324	—	1046
188 (I, 176)	901	211	677	251 (II, 31)	—	709	1000
189 (I, 177)	812	—	766	252 (II, 32a)	1291	—	1045
190 (I, 178)	560	16	666	253 (II, 32b)	1272	—	1052
191 (I, 179)	761	723	709	254 (II, 33)	951	125	985
192 (I, 180a)	880	71	722	255 (II, 34)	919	603	91
193 (I, 180b)	777	—	748	256 (II, 35a)	723	—	146
194 (I, 181)	—	344	684	257 (II, 35b)	43	—	108
195 (I, 182)	—	346	685	258 (II, 36)	941	449	990
196 (I, 183)	908	232	679	259 (II, 37)	—	385	60
197 (I, 184)	589	—	989	260 (II, 38a)	1104	—	1007
198 (I, 185)	250	676	1016	261 (II, 38b)	317	—	130
199 (I, 186)	815	—	1049	262 (II, 39)	939	497	74
200 (I, 187a)	—	—	1008	263 (II, 40)	877	560	117
201 (I, 187b)	37	—	997	264 (II, 41a)	1090	—	904
202 (I, 188a)	114	324	987	265 (II, 41b)	1091	—	902
203 (I, 188b)	570	—	1012	266 (II, 42)	A77	—	92
204 (I, 189a)	814	—	1044	267 (II, 43)	367	791	901
205 (I, 189b)	1325	—	1048	268 (II, 44)	1190	638	930
206 (I, 190)	518a	379	885	269 (II, 45)	53	657	895
207 (I, 191)	301	—	533	270 (II, 46)	710	—	933
208 (I, 192a)	1000	—	532	271 (II, 47)	1022	455	298
209 (I, 192b)	128	45	528	272 (II, 48a)	358	—	142
210 (I, 193)	1209	504	76	273 (II, 48b)	373	—	316
211 (I, 194)	947	167	34	274 (II, 49)	A35	14	288
212 (I, 195)	140	275	85	275 (II, 50)	12	530	233
213 (I, 196)	1178	744	101	276 (II, 51)	—	90	1242
214 (I, 197)	590	261	46	277 (II, 52)	825	—	1245
215 (I, 198)	—	—	70	278 (II, 53)	767	732	1235
216 (I, 199)	587	491	73	279 (II, 54)	914	737	1237
217 (I, 200)	—	361	55	280 (II, 55)	892	63	1337
218 (II, 1)	A18a	659	708	281 (II, 56)	1175	741	1238
219 (II, 2)	1214	—	751	282 (II, 57a)	722	—	—
220 (II, 3)	711	—	747	283 (II, 57b)	10	—	105
221 (II, 4)	—	—	759	284 (II, 58a)	133	146	35
222 (II, 5)	1181	739	1236	285 (II, 58b)	60	500	77
223 (II, 6)	913	566	1234	286 (II, 59)	878	213	18
224 (II, 7)	527	87	1231	287 (II, 60)	858	2	16
225 (II, 8)	826	—	1334	288 (II, 61a)	—	—	965
226 (II, 9)	1243	—	834	289 (II, 61b)	818	—	166
227 (II, 10)	440	—	1592	290 (II, 61c)	—	—	170A
228 (II, 11)	1379	207	1548	291 (II, 62)	857	—	945
229 (II, 12)	1038	406	1554	292 (II, 63)	1351	—	763
230 (II, 13)	1044	456	1556	293 (II, 64)	—	—	770; 1051
231 (II, 14)	795	—	1612	294 (II, 65)	281	691	995
232 (II, 15)	441	703	1567	295 (II, 66)	—	—	1026
233 (II, 16)	—	717	1573	296 (II, 67)	769	—	1006
234 (II, 17)	707	—	1595	297 (II, 68)	—	—	1028
235 (II, 18)	292	572	1569	298 (II, 69a)	385	—	1009
236 (II, 19)	936	347	1551	299 (II, 69b)	834	—	1207
237 (II, 20)	448	632B	45	300 (II, 70)	541	117	1160
238 (II, 21)	931	444	1173	301 (II, 71)	—	—	1188
239 (II, 22)	829	—	1205	302 (II, 72)	30	—	1184
240 (II, 23)	912	110	1159	303 (II, 73)	31	—	1185
241 (II, 24)	—	—	1178	304 (II, 74)	1221	—	1206
242 (II, 25)	407	779	1194	305 (II, 75)	869	513	1175
243 (II, 26)	1179	745	1180	306 (II, 76a)	59	556	1176
244 (II, 27)	1216	—	1202	307 (II, 76b)	896	—	1191
245 (II, 28a)	222	—	1193	308 (II, 77)	634	197	1179
246 (II, 28b)	—	354b	1174	309 (II, 78)	—	367	1172
247 (II, 29a)	389	—	1183	310 (II, 79)	828	—	1211
248 (II, 29b)	379	686A	1190	311 (II, 80a)	—	—	1182
249 (II, 30a)	1259	—	1038	312 (II, 80b)	—	—	1189

Present edition	Benesch	Valentiner	Hofstede de Groot	Present edition	Benesch	Valentiner	Hofstede de Groot
313 (II, 81)	870	224	1163	376 (III, 43)	302	—	1298
314 (II, 82)	C45	225	1164	377 (III, 44)	A3	—	1297
315 (II, 83)	412	—	1195	378 (III, 45)	999	290	1266
316 (II, 84)	A63	—	1196	379 (III, 46)	887	210	1262
317 (II, 85)	844	—	1208	380 (III, 47)	—	—	1360
318 (II, 86)	409	760	1198	381 (III, 48)	—	—	1358
319 (II, 87)	1118	—	1199	382 (III, 49)	C93	11	1345
320 (II, 88)	871	227	1263	383 (III, 50)	518b	378	1350
321 (II, 89)	1023	291	1267	384 (III, 51)	—	286a	777
322 (II, 90)	837	—	1309	385 (III, 52)	—	—	783
323 (II, 91)	—	—	1272	386 (III, 53)	1040	615	780
324 (II, 92)	115	302	1268	387 (III, 54)	1331	—	785
325 (II, 93)	—	—	1291	388 (III, 55)	—	593	781
326 (II, 94)	—	8	1246	389 (III, 56)	212	—	—
327 (II, 95)	915	333	1269	390 (III, 57)	—	—	779
328 (II, 96)	404	697	1299	391 (III, 58)	ad907	186	782
329 (II, 97)	—	—	1302	392 (III, 59)	953	80	820
330 (II, 98)	1026	412	1270	393 (III, 60a)	199	—	784
331 (II, 99)	537	507	1275	394 (III, 60b)	48	—	—
332 (II, 100)	506	199	1260	395 (III, 61)	1016	575	—
333 (III, 1)	1182	743	632	396 (III, 62)	797	—	786
334 (III, 2)	1182	743	632	397 (III, 63)	930	422	778
335 (III, 3)	1007	272	601	398 (III, 64)	602	22	—
336 (III, 4)	1125	—	652	399 (III, 65)	—	—	621
337 (III, 5)	197	—	647	400 (III, 66)	—	441	608
338 (III, 6)	869a	509	611	401 (III, 67)	1296	—	776
339 (III, 7)	—	—	664	402 (III, 68)	1012	143	672
340 (III, 8)	—	—	657	403 (III, 69)	A113	103	789
341 (III, 9)	A110	443	607	404 (III, 70)	745	787	1095A
342 (III, 10)	1184	718	634	405 (III, 71)	1043	426	1120
343 (III, 11)	C54	—	662	406 (III, 72)	659	—	1126
344 (III, 12)	213	—	629	407 (III, 73)	A12	—	1123
345 (III, 13)	—	380	605	408 (III, 74a)	422	—	1125
346 (III, 14)	176	215	599	409 (III, 74b)	421	—	1127
347 (III, 15)	—	762	643	410 (III, 75)	1366	—	1517
348 (III, 16)	—	176	595	411 (III, 76)	620	328	1347
349 (III, 17)	759	725	816	412 (III, 77)	—	458	1353
350 (III, 18)	A25a	—	769	413 (III, 78)	518	421	1352
351 (III, 19)	406	780	739	414 (III, 79)	—	740	1357
352 (III, 20)	567	326	683	415 (III, 80a)	151	788	1355
353 (III, 21)	1024	475	697	416 (III, 80b)	285	694	1359
354 (III, 22)	—	—	723	417 (III, 81)	753	—	1324
355 (III, 23)	827	—	761	418 (III, 82)	540	568	1219
356 (III, 24)	549	15	665	419 (III, 83)	548	247	1215
357 (III, 25)	—	—	749	420 (III, 84)	486	313	1216
358 (III, 26)	—	—	680	421 (III, 85a)	—	—	1226
359 (III, 27)	A7	681	803	422 (III, 85b)	—	359	1217
360 (III, 28)	392	—	812	423 (III, 86)	A62	—	1230
361 (III, 29)	974	136	791	424 (III, 87)	564	55	1213
362 (III, 30a)	ad1105	—	804	425 (III, 88)	6	483	1362
363 (III, 30b)	1106	—	805	426 (III, 89)	339	—	1363
364 (III, 31)	—	—	794	427 (III, 90)	823	—	1315
365 (III, 32)	—	—	800	428 (III, 91a)	838	—	1314
366 (III, 33)	386	—	806	429 (III, 91b)	1222	—	1307
367 (III, 34)	1025	158	1256	430 (III, 92)	311	480	1280
368 (III, 35)	—	797	807	431 (III, 93)	643	149	1254
369 (III, 36)	650	393	799	432 (III, 94)	890	163	1255
370 (III, 37)	—	241	1265	433 (III, 95)	1146	—	1303
371 (III, 38)	C99	92	1249	434 (III, 96)	85	—	1284
372 (III, 39)	—	546	1277	435 (III, 97)	C57	—	1304
373 (III, 40)	475	123	1251	436 (III, 98)	393	—	1305
374 (III, 41)	436	673	1279	437 (III, 99)	1042	129	1253
375 (III, 42)	—	170	1257	438 (III, 100)	932	193	1243

Present edition	Benesch	Valentiner	Hofstede de Groot	Present edition	Benesch	Valentiner	Hofstede de Groot
439 (IV, 1)	1173	735	419	495 (IV, 50a)	—	—	—
440 (IV, 2)	1039	542	396	496 (IV, 50b)	—	—	—
441 (IV, 3)	256	—	417	497 (IV, 51)	1172	738	—
442 (IV, 4)	1047	408	383	498 (IV, 52)	—	336	—
443 (IV, 5)	405	699	418	499 (IV, 53)	C101	35	—
444 (IV, 6a)	259	—	489	500 (IV, 54)	993	511	—
445 (IV, 6b)	258	—	490	501 (IV, 55)	547	252	815
446 (IV, 7)	1124	—	504	502 (IV, 56)	830	—	—
447 (IV, 8)	1107	—	502	503 (IV, 57)	1028	812	—
448 (IV, 9)	—	—	465	504 (IV, 58a)	371	—	—
449 (IV, 10a)	1060	—	412	505 (IV, 58b)	1223	—	—
450 (IV, 10b)	1061	588	409	506 (IV, 59)	—	—	863
451 (IV, 11)	—	5	359	507 (IV, 60)	—	—	—
452 (IV, 12a)	—	—	511	508 (IV, 61)	775	—	946
453 (IV, 12b)	—	—	512	509 (IV, 62)	774	—	940
454 (IV, 13)	5	796	389	510 (IV, 63)	—	—	947
455 (IV, 14)	4	795B	424	511 (IV, 64)	516	325a	—
456 (IV, 15)	3	795A	—	512 (IV, 65)	444	624	888
457 (IV, 16a)	—	—	271	513 (IV, 66)	A93	216	—
458 (IV, 16b)	1100	710	256	514 (IV, 67)	1244	—	960
459 (IV, 17a)	1140	—	270	515 (IV, 68)	1242	—	—
460 (IV, 17b)	1170	708	253	516 (IV, 69a)	A37	—	962
461 (IV, 18)	—	—	—	517 (IV, 69b)	836	—	961
462 (IV, 19)	1095	716	244	518 (IV, 70a)	C55	—	951
463 (IV, 20)	1185	747	266	519 (IV, 70b)	1240	—	956
464 (IV, 21)	831	—	322	520 (IV, 71)	1187	654	926
465 (IV, 22)	417	479	318	521 (IV, 72)	—	—	959
466 (IV, 23)	1270	—	320	522 (IV, 73)	A38	—	955
467 (IV, 24a)	701	—	307	523 (IV, 74)	903	331	878
468 (IV, 24b)	762	729	304	524 (IV, 75)	21	598	893
469 (IV, 25a)	700	707	308	525 (IV, 76)	1103	713	914
470 (IV, 25b)	—	—	311	526 (IV, 77)	263a	—	913
471 (IV, 26)	—	49	22	527 (IV, 78)	A36	40	864
472 (IV, 27)	1352	—	175	528 (IV, 79)	733	785	—
473 (IV, 28)	873	330	—	529 (IV, 80)	138	551	876
474 (IV, 29)	881	244	41	530 (IV, 81)	90	48	866
475 (IV, 30)	1279	—	180	531 (IV, 82)	70	425	882
476 (IV, 31)	—	—	172	532 (IV, 83)	479	543	862
477 (IV, 32)	833	—	185	533 (IV, 84)	207	—	912
478 (IV, 33)	835	—	183	534 (IV, 85)	1143	—	936
479 (IV, 34)	—	—	—	535 (IV, 86)	—	—	932
480 (IV, 35)	353	—	147	536 (IV, 87)	1092	—	903
481 (IV, 36)	A73	28	20	537 (IV, 88)	442	722	900
482 (IV, 37)	—	381	63	538 (IV, 89a)	314	705	899
483 (IV, 38)	—	—	—	539 (IV, 89b)	—	—	—
484 (IV, 39)	900	410	58	540 (IV, 90)	856	119	1317
485 (IV, 40)	171	809	139	541 (IV, 91)	607	59	1312
486 (IV, 41)	—	—	—	542 (IV, 92)	—	—	1306
487 (IV, 42)	1341	—	177	543 (IV, 93)	—	—	1252
488 (IV, 43)	955	4	17	544 (IV, 94)	—	—	1271
489 (IV, 44)	565	601	—	545 (IV, 95)	1334	—	—
490 (IV, 45)	1157	—	—	546 (IV, 96)	622	597	—
491 (IV, 46)	1211	—	1070	547 (IV, 97)	916	27	1247
492 (IV, 47)	—	68	—	548 (IV, 98)	731	—	—
493 (IV, 48)	983	228	—	549 (IV, 99)	—	—	1273
494 (IV, 49)	291	—	—	550 (IV, 100)	1021	209	—

General Concordance

Between the Numbers of the Catalogues of

Benesch, Valentiner, and Hofstede de Groot

And Those of the Present Edition

To LOCATE in the present edition any drawing when you know its number in the catalogue of Benesch, Valentiner, or Hofstede de Groot:

Locate, in the consecutive listing in the first column of the General Concordance, the number you have from any of the three catalogues.

The number assigned to the same drawing in the present edition will be found on the same line, in the column headed by the name of the editor of the catalogue from which the number is known.

A dash indicates that the number is not applicable to the catalogue in question.

For example, if you know that a certain drawing bears the number 256 in the Benesch catalogue, and you wish to find it in the present edition, locate the number 256 in the consecutive listing in the first column of the General Concordance. On the same line, in the column headed "Benesch," you will find that the drawing bears the number 441 (IV, 3) in the present edition.

GENERAL CONCORDANCE

	Benesch	Valentiner	Hofstede de Groot		Benesch	Valentiner	Hofstede de Groot
2	—	287 (II, 60)	—	49	—	471 (IV, 26)	19 (I, 19)
3	456 (IV, 15)	—	—	52	158 (I, 151)	—	17 (I, 17)
4	455 (IV, 14)	488 (IV, 43)	—	53	269 (II, 45)	—	—
5	454 (IV, 13)	451 (IV, 11)	—	55	—	424 (III, 87)	217 (I, 200)
6	425 (III, 88)	—	—	56	—	—	3 (I, 3)
8	—	326 (II, 94)	—	57	—	—	151 (I, 146)
9	—	142 (I, 138)	—	58	—	—	484 (IV, 39)
10	283 (II, 57b)	—	—	59	306 (II, 76a)	541 (IV, 91)	—
11	—	382 (III, 49)	—	60	285 (II, 58b)	—	259 (II, 37)
12	275 (II, 50)	—	—	62	—	—	25 (I, 25)
14	—	274 (II, 49)	—	63	—	280 (II, 55)	482 (IV, 37)
15	166 (I, 158)	356 (III, 24)	—	64	—	76 (I, 76)	—
16	—	190 (I, 178)	287 (II, 60)	65	—	47 (I, 47)	24 (I, 24)
17	103 (I, 102)	—	488 (IV, 43)	66	—	—	33 (I, 33)
18	159 (I, 152)	—	286 (II, 59)	68	—	492 (IV, 47)	—
20	—	102 (I, 101)	481 (IV, 36)	70	531 (IV, 82)	—	215 (I, 198)
21	524 (IV, 75)	—	—	71	—	192 (I, 180a)	15 (I, 15)
22	—	398 (III, 64)	471 (IV, 26)	72	—	163 (I, 155)	5 (I, 5)
26	—	—	27 (I, 27)	73	—	—	216 (I, 199)
27	—	547 (IV, 97)	—	74	—	—	262 (II, 39)
28	—	481 (IV, 36)	—	75	—	—	11 (I, 11)
29	—	179 (I, 169)	—	76	—	77 (I, 77)	210 (I, 193)
30	302 (II, 72)	—	—	77	—	—	285 (II, 58b)
31	303 (II, 73)	—	22 (I, 22)	79	180 (I, 170)	—	—
34	—	139 (I, 135)	211 (I, 194)	80	—	392 (III, 59)	—
35	—	499 (IV, 53)	284 (II, 58a)	81	—	—	20 (I, 20)
36	—	—	31 (I, 31)	85	434 (III, 96)	—	212 (I, 195)
37	201 (I, 187b)	—	—	87	—	224 (II, 7)	—
39	169 (I, 162a)	168 (I, 160)	—	89	175 (I, 165)	111 (I, 109)	30 (I, 30)
40	178 (I, 168)	527 (IV, 78)	—	90	530 (IV, 81)	276 (II, 51)	—
41	10 (I, 10)	—	474 (IV, 29)	91	—	—	255 (II, 34)
43	257 (II, 35b)	—	—	92	140 (I, 136)	371 (III, 38)	266 (II, 42)
45	—	209 (I, 192b)	237 (II, 20)	93	—	—	28 (I, 28)
46	—	—	214 (I, 197)	97	15 (I, 15)	—	—
48	394 (III, 60b)	530 (IV, 81)	—	98	—	—	1 (I, 1)

	Benesch	Valentiner	Hofstede de Groot		Benesch	Valentiner	Hofstede de Groot
99	—	—	6 (I, 6)	193	—	438 (III, 100)	—
100	11 (I, 11)	—	26 (I, 26)	196	—	31 (I, 31)	—
101	—	—	213 (I, 196)	197	337 (III, 5)	308 (II, 77)	142 (I, 138)
102	—	—	29 (I, 29)	199	393 (III, 60a)	332 (II, 100)	—
103	—	403 (III, 69)	—	202	153 (I, 148a)	—	—
105	—	—	283 (II, 57b)	203	21 (I, 21)	—	—
108	—	—	257 (II, 35b)	206	—	—	98 (I, 97)
109	—	110 (I, 108)	—	207	533 (IV, 84)	228 (II, 11)	—
110	—	240 (II, 23)	—	209	—	550 (IV, 100)	—
113	116 (I, 114)	—	—	210	—	379 (III, 46)	—
114	202 (I, 188a)	—	—	211	—	188 (I, 176)	—
115	324 (II, 92)	—	—	212	389 (III, 56)	—	—
117	—	300 (II, 70)	263 (II, 40)	213	344 (III, 12)	286 (II, 59)	—
118	101 (I, 100)	186 (I, 174)	—	215	—	346 (III, 14)	—
119	—	540 (IV, 90)	—	216	—	513 (IV, 66)	—
120	79 (I, 79)	—	—	218	2 (I, 2)	—	—
123	—	373 (III, 40)	—	219	18 (I, 18)	—	—
125	—	254 (II, 33)	—	221	—	—	141 (I, 137)
128	209 (I, 192b)	—	—	222	245 (II, 28a)	—	—
129	—	437 (III, 99)	7 (I, 7)	223	23 (I, 23)	—	—
130	—	—	261 (II, 38b)	224	—	313 (II, 81)	—
131	—	107 (I, 105)	—	225	—	314 (II, 82)	—
133	284 (II, 58a)	—	21 (I, 21)	227	—	320 (II, 88)	—
134	—	22 (I, 22)	—	228	—	493 (IV, 48)	—
135	141 (I, 137)	132 (I, 128)	—	229	—	—	96 (I, 95)
136	—	361 (III, 29)	—	232	—	196 (I, 183)	—
138	529 (IV, 80)	—	—	233	—	—	275 (II, 50)
139	—	—	485 (IV, 40)	240	—	—	99 (I, 98)
140	212 (I, 195)	—	9 (I, 9)	241	—	370 (III, 37)	140 (I, 136)
141	16 (I, 16)	—	23 (I, 23)	244	—	474 (IV, 29)	462 (IV, 19)
142	78 (I, 78)	—	272 (II, 48a)	247	—	419 (III, 83)	—
143	—	402 (III, 68)	—	248	—	160 (I, 153)	—
146	—	284 (II, 58a)	256 (II, 35a)	249	147 (I, 142)	—	—
147	—	—	480 (IV, 35)	250	198 (I, 185)	—	—
149	—	431 (III, 93)	8 (I, 8)	251	—	—	143 (I, 139)
151	415 (III, 80a)	—	—	252	—	501 (IV, 55)	—
154	104 (I, 103)	—	—	253	—	—	460 (IV, 17b)
155	—	187 (I, 175)	—	254	—	133 (I, 129)	—
158	—	367 (III, 34)	16 (I, 16)	256	441 (IV, 3)	—	458 (IV, 16b)
159	—	—	18 (I, 18)	258	445 (IV, 6b)	—	—
163	—	432 (III, 94)	—	259	444 (IV, 6a)	—	—
164	—	—	32 (I, 32)	261	—	214 (I, 197)	—
165	—	—	37 (I, 37)	263a	526 (IV, 77)	—	—
166	—	—	289 (II, 61b)	266	—	—	463 (IV, 20)
167	—	211 (I, 194)	36 (I, 36)	270	—	—	459 (IV, 17a)
168	—	149 (I, 144)	35 (I, 35)	271	—	130 (I, 126)	457 (IV, 16a)
169	—	—	13 (I, 13);	272	—	335 (III, 3)	153 (I, 148a)
			14 (I, 14)	274	—	16 (I, 16)	—
170	—	375 (III, 42)	4 (I, 4)	275	—	212 (I, 195)	—
170A	—	—	290 (II, 61c)	277	—	182 (I, 172a)	—
171	485 (IV, 40)	—	12 (I, 12)	281	294 (II, 65)	—	—
172	—	—	476 (IV, 31)	285	312 (II, 80b)	—	—
174	—	51 (I, 51)	—	286a	—	384 (III, 51)	—
175	—	97 (I, 96)	472 (IV, 27)	288	—	—	274 (II, 49)
176	346 (III, 14)	348 (III, 16)	—	290	—	378 (III, 45)	—
177	—	98 (I, 97)	487 (IV, 42)	291	494 (IV, 49)	321 (II, 89)	—
180	22 (I, 22)	172 (I, 162b)	475 (IV, 30)	292	235 (II, 18)	—	—
182	—	20 (I, 20)	—	294	—	89 (I, 88)	—
183	—	—	478 (IV, 33)	297	—	—	100 (I, 99)
185	161 (I, 154a)	—	303 (II, 73);	298	—	—	271 (II, 47)
			477 (IV, 32)	301	207 (I, 191)	—	—
186	—	391 (III, 58)	—	302	376 (III, 43)	324 (II, 92)	101 (I, 100)
188	3 (I, 3)	—	—	304	—	—	468 (IV, 24b)

	Benesch	Valentiner	Hofstede de Groot		Benesch	Valentiner	Hofstede de Groot
306	—	—	145 (I, 140b)	406	351 (III, 19)	229 (II, 12)	—
307	—	—	467 (IV, 24a)	407	242 (II, 25)	—	—
308	—	19 (I, 19)	469 (IV, 25a)	408	—	442 (IV, 4)	—
309	—	—	144 (I, 140a)	409	318 (II, 86)	3 (I, 3)	450 (IV, 10b)
311	430 (III, 92)	—	470 (IV, 25b)	410	—	484 (IV, 39)	—
313	—	420 (III, 84)	—	412	315 (II, 83)	330 (II, 98)	449 (IV, 10a)
314	538 (IV, 89a)	—	—	415	—	151 (I, 146)	—
315	176 (I, 166)	—	—	417	465 (IV, 22)	—	441 (IV, 3)
316	—	—	273 (II, 48b)	418	—	—	443 (IV, 5)
317	261 (II, 38b)	—	—	419	—	—	439 (IV, 1)
318	—	—	465 (IV, 22)	421	409 (III, 74b)	413 (III, 78)	—
320	—	116 (I, 114)	466 (IV, 23)	422	408 (III, 74a)	397 (III, 63)	—
322	—	—	464 (IV, 21)	423	112 (I, 110)	—	—
324	154 (I, 148b)	202 (I, 188a)	—	424	—	—	455 (IV, 14)
325	7 (I, 7)	—	—	425	—	531 (IV, 82)	—
325a	—	511 (IV, 64)	—	426	—	405 (III, 71)	—
326	—	352 (III, 20)	—	427	6 (I, 6)	—	—
327	113 (I, 111)	—	—	429	169 (I, 161a)	—	—
328	—	411 (III, 76)	—	432	1 (I, 1)	—	—
330	—	473 (IV, 28)	—	433	131 (I, 127)	—	—
331	—	523 (IV, 74)	—	436	374 (III, 41)	—	—
333	—	327 (II, 95)	—	440	227 (II, 10)	—	—
334	—	17 (I, 17)	—	441	232 (II, 15)	400 (III, 66)	—
336	—	498 (IV, 52)	—	442	537 (IV, 88)	—	—
339	426 (III, 89)	—	—	443	100 (I, 99)	341 (III, 9)	—
340	86 (I, 85)	109 (I, 107)	—	444	512 (IV, 65)	238 (II, 21)	—
341	48 (I, 48); 49 (I, 49)	—	—	445	24 (I, 24)	—	—
342	—	—	139 (I, 135)	446	—	39 (I, 39)	—
344	—	194 (I, 181)	138 (I, 134)	448	237 (II, 20)	—	—
345	45 (I, 45)	—	137 (I, 133)	449	—	258 (II, 36)	—
346	—	195 (I, 182)	136 (I, 132)	450	—	33 (I, 33)	—
347	—	236 (II, 19)	—	454	—	138 (I, 134)	—
348a	—	150 (I, 145)	—	455	—	271 (II, 47)	—
353	480 (IV, 35)	—	—	456	174 (I, 164)	230 (II, 13)	—
354b	—	246 (II, 28b)	—	458	—	412 (III, 77)	—
359	—	422 (III, 85b)	451 (IV, 11)	459	120 (I, 118)	—	—
360	184 (I, 173a); 185 (I, 173b)	—	—	465	32 (I, 32)	146 (I, 141)	448 (IV, 9)
361	—	217 (I, 200)	—	466	13 (I, 13); 14 (I, 14)	—	—
363	—	175 (I, 165)	—	468	—	141 (I, 137)	—
364	—	152 (I, 147)	—	475	373 (III, 40)	353 (III, 21)	—
365	119 (I, 117)	—	—	477	—	52 (I, 52)	—
366a	—	162 (I, 154b)	—	479	532 (IV, 83)	465 (IV, 22)	—
367	267 (II, 43)	309 (II, 78)	—	480	—	430 (III, 92)	—
371	504 (IV, 58a)	—	—	481	—	15 (I, 15)	—
373	—	25 (I, 25)	—	483	—	425 (III, 88)	—
378	—	383 (III, 50)	—	486	420 (III, 84)	—	—
379	248 (II, 29b)	206 (I, 190)	—	489	—	164 (I, 156)	444 (IV, 6a)
380	—	345 (III, 13)	—	490	—	—	445 (IV, 6b)
381	—	482 (IV, 37)	—	491	—	216 (I, 199)	—
383	—	—	442 (IV, 4)	492	—	5 (I, 5)	—
385	298 (II, 69a)	259 (II, 37)	—	494	—	11 (I, 11)	—
386	366 (III, 33)	—	—	495	—	104 (I, 103)	—
388	—	177 (I, 167)	—	497	—	262 (II, 39)	—
389	247 (II, 29a)	—	454 (IV, 13)	499	—	103 (I, 102)	—
392	360 (III, 28)	—	—	500	—	285 (II, 58b)	—
393	436 (III, 98)	369 (III, 36)	—	502	—	—	447 (IV, 8)
394	—	114 (I, 112)	—	504	—	210 (I, 193)	446 (IV, 7)
396	—	180 (I, 170)	440 (IV, 2)	506	332 (II, 100)	—	—
401	9 (I, 9)	—	—	507	—	331 (II, 99)	—
404	328 (II, 96)	—	—	509	—	338 (III, 6)	—
405	443 (IV, 5)	—	—	511	—	500 (IV, 54)	452 (IV, 12a)
				512	—	—	453 (IV, 12b)

	Benesch	Valentiner	Hofstede de Groot		Benesch	Valentiner	Hofstede de Groot
513	—	305 (II, 75)	—	621	—	—	399 (III, 65)
516	511 (IV, 64)	—	—	621B	—	121 (I, 119)	—
517	413 (III, 78)	—	—	622	546 (IV, 96)	—	—
518a	206 (I, 190)	—	—	623	—	—	169 (I, 161a)
518b	383 (III, 50)	—	—	623B	—	100 (I, 99)	—
519	177 (I, 167)	—	—	624	—	512 (IV, 65)	171 (I, 162a)
524	102 (I, 101)	—	—	625	—	24 (I, 24)	—
527	224 (II, 7)	—	—	627	—	—	170 (I, 161b)
528	111 (I, 109)	—	209 (I, 192b)	629	—	—	344 (III, 12)
530	—	275 (II, 50)	—	630	—	26 (I, 26)	—
532	—	—	208 (I, 192a)	632	—	—	333 (III, 1);
533	—	—	207 (I, 191)				334 (III, 2)
537	331 (II, 99)	—	—	632B	—	237 (II, 20)	—
540	418 (III, 82)	96 (I, 95)	—	634	308 (II, 77)	—	342 (III, 10)
541	300 (II, 70)	183 (I, 172b)	—	636	—	167 (I, 159)	—
542	186 (I, 174)	440 (IV, 2)	—	638	—	268 (II, 44)	—
543	—	532 (IV, 83)	—	641	—	—	161 (I, 154a)
545	160 (I, 153)	—	—	643	431 (III, 93)	—	347 (III, 15)
546	—	372 (III, 39)	—	644	—	—	167 (I, 159)
547	501 (IV, 55)	—	—	647	—	—	337 (III, 5)
548	419 (III, 83)	—	—	650	369 (III, 36)	—	—
549	356 (III, 24)	—	—	652	164 (I, 156)	—	336 (III, 4)
550	—	166 (I, 158)	—	653	—	118 (I, 116)	—
551	—	529 (IV, 80)	—	654	—	520 (IV, 71)	—
552	187 (I, 175)	—	—	656	129 (I, 125b)	—	173 (I, 163)
554	109 (I, 107)	159 (I, 152)	—	657	—	269 (II, 45)	340 (III, 8)
556	—	306 (II, 76a)	—	659	406 (III, 72)	218 (II, 1)	165 (I, 157)
557	163 (I, 155)	—	—	662	—	—	343 (III, 11)
560	190 (I, 178)	263 (II, 40)	—	663	—	1 (I, 1)	—
562	—	137 (I, 133)	—	664	—	—	339 (III, 7)
564	424 (III, 87)	—	—	665	—	95 (I, 94)	356 (III, 24)
565	489 (IV, 44)	—	—	666	—	—	190 (I, 178)
566	—	223 (II, 6)	—	670	—	—	186 (I, 174)
567	352 (III, 20)	—	—	672	—	6 (I, 6)	402 (III, 68)
568	—	418 (III, 82)	—	673	—	374 (III, 41)	—
570	203 (I, 188b)	—	—	676	—	198 (I, 185)	—
572	—	235 (II, 18)	—	677	—	—	188 (I, 176)
574	19 (I, 19)	—	—	678	—	184 (I, 173a)	—
575	—	395 (III, 61)	—	679	—	—	196 (I, 183)
584	—	—	168 (I, 160)	680	—	—	358 (III, 26)
587	216 (I, 199)	—	—	681	—	359 (III, 27)	—
588	—	450 (IV, 10b)	—	682	—	—	158 (I, 151)
589	197 (I, 184)	—	—	683	—	—	352 (III, 20)
590	214 (I, 197)	—	—	684	145 (I, 140b)	169 (I, 161a)	194 (I, 181)
591	—	—	163 (I, 155)	685	—	—	195 (I, 182)
593	—	388 (III, 55)	—	686	—	—	150 (I, 145)
595	—	—	348 (III, 16)	686A	—	248 (II, 29b)	—
597	—	546 (IV, 96)	172 (I, 162b)	687	—	—	182 (I, 172a)
598	—	524 (IV, 75)	—	691	—	294 (II, 65)	—
599	—	—	346 (III, 14)	693	—	—	187 (I, 175)
600	—	99 (I, 98)	160 (I, 153)	694	—	416 (III, 80b)	152 (I, 147)
601	—	489 (IV, 44)	335 (III, 3)	697	—	328 (II, 96)	353 (III, 21)
602	398 (III, 64)	101 (I, 100)	—	699	—	443 (IV, 5)	—
603	—	255 (II, 34)	—	700	469 (IV, 25a)	—	—
604	—	28 (I, 28)	162 (I, 154b)	701	467 (IV, 24a)	—	—
605	—	—	345 (III, 13)	703	—	232 (II, 15)	—
607	541 (IV, 91)	—	341 (III, 9)	704	—	176 (I, 166)	183 (I, 172b)
608	—	30 (I, 30)	400 (III, 66)	705	—	538 (IV, 89a)	—
609	—	140 (I, 136)	164 (I, 156)	706	134 (I, 130)	94 (I, 93)	—
611	—	—	338 (III, 6)	707	234 (II, 17)	469 (IV, 25a)	—
613	—	—	166 (I, 158)	708	135 (I, 131)	460 (IV, 17b)	218 (II, 1)
615	—	386 (III, 53)	159 (I, 152)	709	—	251 (II, 31)	191 (I, 179)
620	411 (III, 76)	—	—	710	270 (II, 46)	458 (IV, 16b)	184 (I, 173a); 185 (I, 173b)

	Benesch	Valentiner	Hofstede de Groot		Benesch	Valentiner	Hofstede de Groot
711	220 (II, 3)	—	—	788	4 (I, 4)	415 (III, 80a)	—
713	—	525 (IV, 76)	—	789	—	185 (I, 173b)	403 (III, 69)
714	—	93 (I, 92)	—	791	—	267 (II, 43)	361 (III, 29)
715	—	128 (I, 125a)	—	792	—	119 (I, 117)	—
716	—	462 (IV, 19)	—	794	—	—	364 (III, 31)
717	—	233 (II, 16)	—	795	231 (II, 14)	—	—
718	—	342 (III, 10)	—	795A	—	456 (IV, 15)	—
719	—	131 (I, 127)	—	795B	—	455 (IV, 14)	—
720	—	91 (I, 90)	—	796	65 (I, 65)	454 (IV, 13)	—
722	282 (II, 57a)	537 (IV, 88)	192 (I, 180a)	797	396 (III, 62)	368 (III, 35)	—
723	256 (II, 35a)	191 (I, 179)	354 (III, 22)	799	—	—	369 (III, 36)
724	144 (I, 140a)	122 (I, 120)	—	800	—	112 (I, 110)	365 (III, 32)
725	—	349 (III, 17)	34 (I, 34)	803	37 (I, 37)	359 (III, 27)	—
726	—	90 (I, 89)	—	804	35 (I, 35)	—	362 (III, 30a)
727	—	145 (I, 140b)	—	805	—	—	363 (III, 30b)
729	—	468 (IV, 24b)	—	806	—	—	366 (III, 33)
730	—	123 (I, 121)	—	807	—	—	368 (III, 35)
731	548 (IV, 98)	—	—	809	—	485 (IV, 40)	—
732	—	278 (II, 53)	—	812	189 (I, 177)	503 (IV, 57)	360 (III, 28)
733	528 (IV, 79)	—	—	814	204 (I, 189a)	—	—
735	—	439 (IV, 1)	—	815	199 (I, 186)	—	501 (IV, 55)
737	—	279 (II, 54)	—	816	—	—	349 (III, 17)
738	—	497 (IV, 51)	—	818	289 (II, 61b)	—	—
739	—	222 (II, 5)	351 (III, 19)	820	—	—	392 (III, 59)
740	—	414 (III, 79)	—	823	427 (III, 90)	—	—
741	—	281 (II, 56)	—	824	165 (I, 157)	—	—
743	—	333 (III, 1); 334 (III, 2)	—	825	277 (II, 52)	—	—
744	—	213 (I, 196)	—	826	225 (II, 8)	—	157 (I, 150b)
745	404 (III, 70)	243 (II, 26)	—	827	355 (III, 23)	—	156 (I, 150a)
746	—	—	44 (I, 44)	828	310 (II, 79)	—	77 (I, 77)
747	—	463 (IV, 20)	220 (II, 3)	829	239 (II, 22)	—	76 (I, 76)
748	—	—	193 (I, 180b)	830	481 (IV, 36)	—	51 (I, 51)
749	—	—	357 (III, 25)	831	464 (IV, 21)	—	52 (I, 52)
751	—	—	219 (II, 2)	832	117 (I, 115)	—	79 (I, 79)
753	417 (III, 81)	—	—	833	477 (IV, 32)	—	78 (I, 78)
755	8 (I, 8)	—	—	834	299 (II, 69b)	—	226 (II, 9)
756	124 (I, 122)	—	—	835	478 (IV, 33)	—	53 (I, 53)
757	91 (I, 90)	—	174 (I, 164)	836	299 (IV, 69b)	—	54 (I, 54)
758	122 (I, 120)	—	—	837	322 (II, 90)	—	64 (I, 64)
759	349 (III, 17)	—	221 (II, 4)	838	428 (III, 91a)	—	67 (I, 67)
760	29 (I, 29)	318 (II, 86)	—	839	—	—	71 (I, 71)
761	191 (I, 179)	—	355 (III, 23)	840	—	—	74 (I, 74)
762	468 (IV, 24b)	347 (III, 15)	—	841	—	—	83 (I, 82a)
763	123 (I, 121)	—	292 (II, 63)	842	—	—	82 (I, 82)
766	—	—	189 (I, 177)	843	—	—	55 (I, 55)
767	278 (II, 53)	—	—	844	317 (II, 85)	—	56 (I, 56)
769	296 (II, 67)	—	350 (III, 18)	845	—	—	57 (I, 57)
770	—	—	293 (II, 64)	846	84 (I, 83)	—	58 (I, 58)
774	509 (IV, 62)	—	—	847	60 (I, 60)	—	59 (I, 59)
775	508 (IV, 61)	—	—	848	—	—	60 (I, 60)
776	—	—	401 (III, 67)	849	—	—	61 (I, 61)
777	193 (I, 180b)	—	384 (III, 51)	850	—	—	62 (I, 62)
778	—	—	397 (III, 63)	851	—	—	63 (I, 63)
779	—	242 (II, 25)	390 (III, 57)	852	—	—	65 (I, 65)
780	—	351 (III, 19)	386 (III, 53)	853	—	—	66 (I, 66)
781	—	9 (I, 9)	388 (III, 55)	854	—	—	68 (I, 68)
782	—	—	391 (III, 58)	855	—	—	69 (I, 69)
783	—	—	385 (III, 52)	856	540 (IV, 90)	—	70 (I, 70)
784	156 (I, 150a)	—	393 (III, 60a)	857	291 (II, 62)	—	72 (I, 72)
785	—	528 (IV, 79)	387 (III, 54)	857a	—	—	73 (I, 73)
786	—	—	396 (III, 62)	858	287 (II, 60)	—	75 (I, 75)
787	—	404 (III, 70)	—	859	—	—	80 (I, 80)
				860	—	—	81 (I, 81)

	Benesch	Valentiner	Hofstede de Groot		Benesch	Valentiner	Hofstede de Groot
861	—	—	84 (I, 83)	941	258 (II, 36)	—	—
862	—	—	532 (IV, 83)	944	20 (I, 20)	—	—
863	—	—	506 (IV, 59)	945	25 (I, 25)	—	291 (II, 62)
864	—	—	527 (IV, 78)	946	—	—	508 (IV, 61)
865	—	—	102 (I, 101)	947	211 (I, 194)	—	510 (IV, 63)
866	—	—	530 (IV, 81)	948	149 (I, 144)	—	120 (I, 118)
868	—	—	108 (I, 106)	949	183 (I, 172b)	—	115 (I, 113)
869	305 (II, 75)	—	—	950	—	—	117 (I, 115)
869a	338 (III, 6)	—	—	951	254 (II, 33)	—	518 (IV, 70a)
870	313 (II, 81)	—	—	953	392 (III, 59)	—	—
871	320 (II, 88)	—	110 (I, 108)	955	488 (IV, 43)	—	522 (IV, 73)
873	473 (IV, 28)	—	107 (I, 105)	956	—	—	519 (IV, 70b)
875	—	—	130 (I, 126)	957	—	—	126 (I, 124a)
876	—	—	529 (IV, 80)	958	—	—	127 (I, 124b)
877	263 (II, 40)	—	116 (I, 114)	959	—	—	521 (IV, 72)
878	286 (II, 59)	—	523 (IV, 74)	960	30 (I, 30)	—	514 (IV, 67)
879	17 (I, 17)	—	—	961	—	—	517 (IV, 69b)
880	192 (I, 180a)	—	—	962	—	—	516 (IV, 69a)
881	474 (IV, 29)	—	109 (I, 107)	963	—	—	106 (I, 104b)
882	—	—	531 (IV, 82)	965	—	—	288 (II, 61a)
884	—	—	114 (I, 112)	966	—	—	124 (I, 122)
885	150 (I, 145)	—	206 (I, 190)	969	182 (I, 172a)	—	—
886	137 (I, 133)	—	—	974	361 (III, 29)	—	—
887	379 (III, 46)	—	—	975	132 (I, 128)	—	—
888	—	—	512 (IV, 65)	ad979	107 (I, 105)	—	—
890	432 (III, 94)	—	104 (I, 103)	983	493 (IV, 48)	—	—
891	76 (I, 76)	—	103 (I, 102)	984	—	—	47 (I, 47)
892	280 (II, 55)	—	—	985	—	—	254 (II, 33)
893	—	—	524 (IV, 75)	987	—	—	202 (I, 188a)
894	—	—	121 (I, 119)	988	—	—	89 (I, 88)
895	—	—	269 (II, 45)	989	31 (I, 31)	—	197 (I, 184)
896	307 (II, 76b)	—	122 (I, 120)	990	—	—	258 (II, 36)
898	—	—	123 (I, 121)	991	—	—	39 (I, 39)
899	138 (I, 134)	—	538 (IV, 89a)	993	500 (IV, 54)	—	—
900	484 (IV, 39)	—	537 (IV, 88)	994	—	—	95 (I, 94)
901	188 (I, 176)	—	267 (II, 43)	995	172 (I, 162b)	—	294 (II, 65)
902	—	—	265 (II, 41b)	996	—	—	94 (I, 93)
903	523 (IV, 74)	—	536 (IV, 87)	997	—	—	201 (I, 187b)
904	139 (I, 135)	—	264 (II, 41a)	998	—	—	90 (I, 89)
905	—	—	128 (I, 125a)	999	378 (III, 45)	—	91 (I, 90)
ad907	391 (III, 58)	—	—	1000	208 (I, 192a)	—	251 (II, 31)
908	196 (I, 183)	—	—	1001	110 (I, 108)	—	—
910	152 (I, 147)	—	—	1003	142 (I, 138)	—	—
912	240 (II, 23)	—	533 (IV, 84)	1006	—	—	296 (II, 67)
913	223 (II, 6)	—	526 (IV, 77)	1007	335 (III, 3)	—	260 (II, 38a)
914	279 (II, 54)	—	525 (IV, 76)	1008	—	—	200 (I, 187a)
915	327 (II, 95)	—	—	1009	—	—	298 (II, 69a)
916	547 (IV, 97)	—	—	1011	—	—	93 (I, 92)
919	255 (II, 34)	—	113 (I, 111)	1012	402 (III, 68)	—	203 (I, 188b)
922	5 (I, 5)	—	129 (I, 125b)	1013	—	—	45 (I, 45)
923	—	—	111 (I, 109)	1016	395 (III, 61)	—	198 (I, 185)
924	—	—	119 (I, 117)	1019	—	—	46 (I, 46)
925	—	—	105 (I, 104a)	1021	550 (IV, 100)	—	—
926	—	—	520 (IV, 71)	1022	271 (II, 47)	—	—
929	—	—	118 (I, 116)	1023	321 (II, 89)	—	48 (I, 48)
930	397 (III, 63)	—	268 (II, 44)	1024	353 (III, 21)	—	86 (I, 85)
931	238 (II, 21)	—	—	1025	367 (III, 34)	—	—
932	438 (III, 100)	—	535 (IV, 86)	1026	330 (II, 98)	—	295 (II, 66)
933	—	—	270 (II, 46)	1028	503 (IV, 57)	—	297 (II, 68)
936	236 (II, 19)	—	534 (IV, 85)	1031	—	—	92 (I, 91)
937	—	—	125 (I, 123)	1032	—	—	88 (I, 87)
939	262 (II, 39)	—	112 (I, 110)	1033	—	—	87 (I, 86)
940	33 (I, 33)	—	509 (IV, 62)	1037	—	—	148 (I, 143)

	Benesch	Valentiner	Hofstede de Groot
1038	229 (II, 12)	—	249 (II, 30a)
1039	440 (IV, 2)	—	41 (I, 41)
1040	386 (III, 53)	—	38 (I, 38)
1042	437 (III, 99)	—	—
1043	405 (III, 71)	—	49 (I, 49)
1044	230 (II, 13)	—	204 (I, 189a)
1045	—	—	252 (II, 32a)
1046	—	—	250 (II, 30b)
1047	442 (IV, 4)	—	—
1048	—	—	205 (I, 189b)
1049	—	—	199 (I, 186)
1050	—	—	85 (I, 84)
1051	—	—	293 (II, 64)
1052	—	—	253 (II, 32b)
1053	—	—	43 (I, 43)
1055	—	—	40 (I, 40)
1056	—	—	42 (I, 42)
1060	449 (IV, 10a)	—	50 (I, 50)
1061	450 (IV, 10b)	—	—
1063	—	—	131 (I, 127)
1064	151 (I, 146)	—	—
1065	47 (I, 47)	—	—
1068	96 (I, 95)	—	—
1070	—	—	491 (IV, 46)
1090	264 (II, 41a)	—	—
1091	265 (II, 41b)	—	—
1092	536 (IV, 87)	—	—
1093	128 (I, 125a)	—	—
1095	462 (IV, 19)	—	—
1095A	—	—	404 (III, 70)
1099	93 (I, 92)	—	—
1100	458 (IV, 16b)	—	—
1103	525 (IV, 76)	—	—
1104	260 (II, 38a)	—	—
ad1105	362 (III, 30a)	—	—
1106	363 (III, 30b)	—	—
1107	447 (IV, 8)	—	—
1118	319 (II, 87)	—	—
1120	—	—	405 (III, 71)
1123	—	—	407 (III, 73)
1124	446 (IV, 7)	—	—
1125	336 (III, 4)	—	408 (III, 74a)
1126	—	—	406 (III, 72)
1127	—	—	409 (III, 74b)
1137	88 (I, 87)	—	—
1140	459 (IV, 17a)	—	—
1143	534 (IV, 85)	—	—
1144	87 (I, 86)	—	—
1146	433 (III, 95)	—	—
1147	125 (I, 123)	—	—
1154	133 (I, 129)	—	—
1157	490 (IV, 45)	—	—
1159	—	—	240 (II, 23)
1160	—	—	300 (II, 70)
1163	—	—	313 (II, 81)
1164	—	—	314 (II, 82)
1170	460 (IV, 17b)	—	—
1171	95 (I, 94)	—	—
1172	497 (IV, 51)	—	309 (II, 78)
1173	439 (IV, 1)	—	239 (II, 21)
1174	—	—	246 (II, 28b)
1175	281 (II, 56)	—	309 (II, 75)
1176	—	—	306 (II, 76a)

	Benesch	Valentiner	Hofstede de Groot
1178	213 (I, 196)	—	241 (II, 24)
1179	243 (II, 26)	—	308 (II, 77)
1180	—	—	243 (II, 26)
1181	222 (II, 5)	—	—
1182	333 (III, 1);		
	334 (III, 2)	—	311 (II, 80a)
1183	—	—	247 (II, 29a)
1184	342 (III, 10)	—	302 (II, 72)
1185	463 (IV, 20)	—	303 (II, 73)
1186	26 (I, 26)	—	—
1187	520 (IV, 71)	—	—
1188	167 (I, 159)	—	301 (II, 71)
1189	—	—	312 (II, 80b)
1190	268 (II, 44)	—	248 (II, 29b)
1191	—	—	307 (II, 76b)
1193	—	—	245 (II, 28a)
1194	—	—	242 (II, 25)
1195	—	—	315 (II, 83)
1196	—	—	316 (II, 84)
1198	—	—	318 (II, 86)
1199	—	—	319 (II, 87)
1202	—	—	244 (II, 27)
1205	118 (I, 116)	—	239 (II, 22)
1206	—	—	304 (II, 74)
1207	121 (I, 119)	—	299 (II, 69b)
1208	179 (I, 169)	—	317 (II, 85)
1209	210 (I, 193)	—	—
1210	99 (I, 98)	—	—
1211	491 (IV, 46)	—	310 (II, 79)
1213	—	—	424 (III, 87)
1214	219 (II, 2)	—	—
1215	157 (I, 150b)	—	419 (III, 83)
1216	244 (II, 27)	—	420 (III, 84)
1217	68 (I, 68)	—	422 (III, 85b)
1218	54 (I, 54)	—	—
1219	64 (I, 64)	—	418 (III, 82)
1221	304 (II, 74)	—	—
1222	429 (III, 91b)	—	—
1223	505 (IV, 58b)	—	—
1226	—	—	421 (III, 85a)
1228	75 (I, 75)	—	—
1230	—	—	423 (III, 86)
1231	—	—	224 (II, 7)
1232	59 (I, 59)	—	—
1233	63 (I, 63)	—	—
1234	—	—	223 (II, 6)
1235	—	—	278 (II, 53)
1236	—	—	222 (II, 5)
1237	66 (I, 66)	—	279 (II, 54)
1238	—	—	281 (II, 56)
1239	56 (I, 56)	—	—
1240	519 (IV, 70b)	—	—
1242	515 (IV, 68)	—	276 (II, 51)
1243	226 (II, 9)	—	438 (III, 100)
1244	514 (IV, 67)	—	—
1245	—	—	277 (II, 52)
1246	—	—	326 (II, 94)
1247	40 (I, 40)	—	547 (IV, 97)
1248	61 (I, 61)	—	—
1249	148 (I, 143)	—	371 (III, 38)
1251	—	—	373 (III, 40)
1252	73 (I, 73)	—	543 (IV, 93)
1253	55 (I, 55)	—	437 (III, 99)

	Benesch	Valentiner	Hofstede de Groot		Benesch	Valentiner	Hofstede de Groot
1254	—	—	431 (III, 93)	1319	—	—	175 (I, 165)
1255	—	—	432 (III, 94)	1320	—	—	180 (I, 170)
1256	—	—	367 (III, 34)	1321	74 (I, 74)	—	—
1257	36 (I, 36)	—	375 (III, 42)	1322	—	—	178 (I, 168)
1259	249 (II, 30a)	—	—	1324	250 (II, 30b)	—	417 (III, 81)
1260	—	—	332 (II, 100)	1325	205 (I, 189b)	—	—
1261	58 (I, 58)	—	—	1326	43 (I, 43)	—	—
1262	—	—	379 (III, 46)	1327	—	—	176 (I, 166)
1263	57 (I, 57)	—	320 (II, 88)	1329	126 (I, 124a)	—	—
1265	53 (I, 53)	—	370 (III, 37)	1331	387 (III, 54)	—	—
1266	67 (I, 67)	—	378 (III, 45)	1334	545 (IV, 95)	—	225 (II, 8)
1267	—	—	321 (II, 89)	1335	41 (I, 41)	—	—
1268	71 (I, 71)	—	324 (II, 92)	1337	115 (I, 113)	—	280 (II, 55)
1269	—	—	327 (II, 95)	1338	50 (I, 50)	—	—
1270	466 (IV, 23)	—	330 (II, 98)	1341	487 (IV, 42)	—	—
1271	—	—	544 (IV, 94)	1345	105 (I, 104a)	—	382 (III, 49)
1272	253 (II, 32b)	—	323 (II, 91)	1346	82 (I, 82)	—	—
1273	—	—	549 (IV, 99)	1347	83 (I, 82a)	—	411 (III, 76)
1275	—	—	331 (II, 99)	1350	—	—	383 (III, 50)
1277	—	—	372 (III, 39)	1351	292 (II, 63)	—	—
1278	38 (I, 38)	—	—	1352	472 (IV, 27)	—	413 (III, 78)
1279	475 (IV, 30)	—	374 (III, 41)	1353	—	—	412 (III, 77)
1280	—	—	430 (III, 92)	1355	—	—	415 (III, 80a)
1282	80 (I, 80)	—	—	1357	—	—	414 (III, 79)
1284	—	—	434 (III, 96)	1358	42 (I, 42)	—	381 (III, 48)
1291	252 (II, 32a)	—	325 (II, 93)	1359	—	—	416 (III, 80b)
1294	69 (I, 69)	—	—	1360	—	—	380 (III, 47)
1295	70 (I, 70)	—	—	1362	—	—	425 (III, 88)
1296	401 (III, 67)	—	—	1363	—	—	426 (III, 89)
1297	—	—	377 (III, 44)	1366	410 (III, 75)	—	—
1298	—	—	376 (III, 43)	1367	12 (I, 12)	—	—
1299	—	—	328 (II, 96)	1379	228 (II, 11)	—	—
1300	173 (I, 163)	—	—	1517	—	—	410 (III, 75)
1301	72 (I, 72)	—	—	1546	—	—	132 (I, 128)
1302	—	—	329 (II, 97)	1548	—	—	228 (II, 11)
1303	—	—	433 (III, 95)	1551	—	—	236 (II, 19)
1304	127 (I, 124b)	—	435 (III, 97)	1554	—	—	229 (II, 12)
1305	—	—	436 (III, 98)	1556	—	—	230 (II, 13)
1306	—	—	542 (IV, 92)	1567	—	—	232 (II, 15)
1307	—	—	429 (III, 91b)	1569	—	—	235 (II, 18)
1308	81 (I, 81)	—	—	1573	—	—	233 (II, 16)
1309	85 (I, 84)	—	322 (II, 90)	1592	—	—	227 (II, 10)
1312	—	—	541 (IV, 91)	1595	—	—	234 (II, 17)
1314	62 (I, 62)	—	428 (III, 91a)	1596	—	—	135 (I, 131)
1315	—	—	427 (III, 90)	1597	—	—	134 (I, 130)
1316	106 (I, 104b)	—	—	1602	—	—	133 (I, 129)
1317	—	—	540 (IV, 90)	1612	—	—	231 (II, 14)
1318	—	—	177 (I, 167)				

BENESCH ONLY

A3	377 (III, 44)	A49	162 (I, 154b)	A113	403 (III, 69)		
A7	359 (III, 27)	A54	92 (I, 91)	C45	314 (II, 82)		
A12	407 (III, 73)	A62	423 (III, 86)	C54	343 (III, 11)		
A18a	218 (II, 1)	A63	316 (II, 84)	C55	518 (IV, 70a)		
A25a	350 (III, 18)	A73	481 (IV, 36)	C57	435 (III, 97)		
A27	28 (I, 28)	A77	266 (II, 42)	C89	168 (I, 160)		
A35	274 (II, 49)	A80b	77 (I, 77)	C93	382 (III, 49)		
A36	527 (IV, 78)	A81	51 (I, 51)	C97	98 (I, 97)		
A37	516 (IV, 69a)	A82	52 (I, 52)	C99	371 (III, 38)		
A38	522 (IV, 73)	A93	513 (IV, 66)	C101	499 (IV, 53)		
		A110	341 (III, 9)				

Indexes

INDEX OF COLLECTIONS

AMSTERDAM

Rijksprentenkabinet

Female Nude Asleep, 88 (I, 87)

A Lion Resting, 157 (I, 150b)

Christ Washing the Feet of the Disciples, 238 (II, 21)

View in Gelderland, 239 (II, 22)

Joseph Interpreting the Prisoners' Dreams, 240 (II, 23)

Jupiter and Mercury with Philemon and Baucis, 241 (II, 24)

Three Women and a Child at the Entrance of a House, 242 (II, 25)

Study of a Syndic, 243 (II, 26)

A Recumbent Lion, 244 (II, 27)

An Old Woman Giving Drink to a Child, 245 (II, 28a)

Study for a Figure of Christ, 246 (II, 28b)

A Beggar with a Leather Bag, 247 (II, 29a)

A Sleeping Child, 248 (II, 29b)

The Anatomy Lesson of Dr. Deyman, 281 (II, 56)

A Farm Amidst Trees, 299 (II, 69b)

Joseph's Brothers Requesting Benjamin from Their Father, 300 (II, 70)

A Boy Lighting His Pipe at a Candle, 301 (II, 71)

Standing Beggar, 302 (II, 72)

Standing Beggar with a Leather Bag, 303 (II, 73)

Landscape with an Inn and a Sailboat, 304 (II, 74)

The Incredulity of St. Thomas, 305 (II, 75)

St. Jerome Praying, 306 (II, 76a)

Two Old Men, 307 (II, 76b)

Esther Fainting before Ahasuerus, 308 (II, 77)

The Unmerciful Servant, 309 (II, 78)

A City Gate (perhaps Rhenen), 310 (II, 79)

Old Man Standing, 311 (II, 80a)

Young Woman with a Large Hat and a Walking Stick, 312 (II, 80b)

The Angel in the House of Tobit, 313 (II, 81)

Departure of The Young Tobias, 314 (II, 82)

Two Women with a Child Learning to Walk, 315 (II, 83)

Woman Holding a Child, 316 (II, 84)

View over the Amstel from the Blauwbrug, 317 (II, 85)

The Pancake Woman, 318 (II, 86)

Standing Female Nude, 319 (II, 87)

Raguel Welcomes Tobias, 320 (II, 88)

The Annunciation to the Shepherds, 321 (II, 89)

Winter Landscape with a Farm, 322 (II, 90)

A Woman in a Faint, Supported by Two Figures, 323 (II, 91)

The Virgin Showing the Infant Christ to One of the Magi, 324 (II, 92)

Standing Man with His Right Hand Raised, 325 (II, 93)

God Appearing to Abraham, 326 (II, 94)

The Angel Appearing to Joseph in a Dream, 327 (II, 95)

Saskia's Lying-in Room, 328 (II, 96)

Job and His Friends(?), 329 (II, 97)

Christ Healing a Leper, 330 (II, 98)

Christ Appearing as a Gardener to Mary Magdalen, 331 (II, 99)

The Messenger with the Crown of Saul Before David, 332 (II, 100)

David Taking Leave of Jonathan, 367 (III, 34)

Tobias Cleaning the Fish, 370 (III, 37)

Joseph Divested of His Multicolored Coat, 371 (III, 38)

The Liberation of St. Peter from Prison, 372 (III, 39)

The Finding of Moses, 373 (III, 40)

Portrait of a Young Lady, 374 (III, 41)

David Taking Leave of Jonathan, 375 (III, 42)

Studies of a Woman with a Baby, 376 (III, 43)

Young Woman Seated by a Window, 377 (III, 44)

The Annunciation to the Shepherds, 378 (III, 45)

Daniel in the Lions' Den, 379 (III, 46)

Landscape with a Farmer's House and a Hayrick, 429 (III, 91b)

Youth Pulling at a Rope, 430 (III, 92)

Boaz Pours Barley into Ruth's Veil, 431 (III, 93)

David Receiving the News of Uriah's Death, 432 (III, 94)

Seated Female Nude with a Sling, 433 (III, 95)

Ahasuerus at a Table, 434 (III, 96)

Recumbent Lion Scratching his Muzzle, 435 (III, 97)

Cow Standing in a Shed, 436 (III, 98)

Jael Driving a Nail into the Head of Sisera, 437 (III, 99)

View of the Gardens of the Pauw Family on the Amstel, 542 (IV, 92)
The Lord Appearing to Joshua, 543 (IV, 93)
Ecce Homo, 544 (IV, 94)
The Dismissal of Hagar, 547 (IV, 97)
The Angel Appearing to Hagar, 549 (IV, 99)

Fodor Museum

Mars and Venus with Vulcan and the Assembled Gods, 418 (III, 82)
The Healing of Tobit, 419 (III, 83)
The Presentation in the Temple, 420 (III, 84)
Nine People in a Synagogue(?), 421 (III, 85a)
Christ Surrounded by a Group of Figures, 422 (III, 85b)
The Tower of the Westerkerk at Amsterdam, 423 (III, 86)
Esau Selling His Birthright, 424 (III, 87)

Rembrandt Huis

The Old Town Hall at Amsterdam, 38 (I, 38)
The "Montelbaanstoren" in Amsterdam, 85 (I, 84)
Self-portrait in Studio Attire, 95 (I, 94)
Portrait of a Woman, 200 (I, 187a)
Sleeping Girl, 260 (II, 38a)
Sheet of Studies of Women, 273 (II, 48b)
Esau Selling His Birthright, 541 (IV, 91)

A. Boerlage-Koenigs Collection

The "Kloveniersdoelen" and the Tower "Swijght Utrecht" at Amsterdam, 545 (IV, 95)

Paul Cassirer Collection

Dog with a Collar, 156 (I, 150a)

Chr. P. van Eeghen Collection

The Street Musician, 404 (III, 70)

Six Collection

Portrait of a Young Man, 222 (II, 5)
Homer Reciting Verses, 223 (II, 6)
Jan Six with a Dog, Standing by an Open Window, 278 (II, 53)
Minerva in Her Study, 279 (II, 54)

BAYONNE

Musée

Study of a Group of Figures, 158 (I, 151)
St. Peter's Prayer Before the Raising of Tabitha, 183 (I, 172b)
House Amidst Trees, 189 (I, 177)
Portrait Bust of a Lady in a Cap, 191 (I, 179)
Seated Male Nude, 220 (II, 3)
A Pollard Willow at the Waterside, 350 (III, 18)
The Holy Family, 352 (III, 20)
Standing Boy in a Long Robe, 354 (III, 22)
The Eastern Gate at Rhenen, 355 (III, 23)

Sarah Complaining of Hagar to Abraham, 356 (III, 24)
Three Pigs, 357 (III, 25)
The Adoration of the Shepherds, 358 (III, 26)
Delilah Calls the Philistines, 402 (III, 68)

BERLIN

Kupferstichkabinett

Self-portrait, 1 (I, 1)
Study of Seven Figures, 2 (I, 2)
Study for *The Hundred Guilder Print*, 3 (I, 3)
View of London with Old St. Paul's, 4 (I, 4)
Descent from the Cross, 5 (I, 5)
Saskia van Uylenburch, 6 (I, 6)
Woman Seated, in an Oriental Costume, 7 (I, 7)
Man Approached by a Beggar, 8 (I, 8)
Screaming Boy, 9 (I, 9)
Old Man Seated in an Armchair, 10 (I, 10)
The Lamentation Over Christ, 11 (I, 11)
Cottages Amongst High Trees, 12 (I, 12)
Landscape with Two Cottages, 13 (I, 13)
Landscape with a Man by a Road, 14 (I, 14)
Christ Carrying the Cross, 15 (I, 15)
Studies of Groups and Figures, 16 (I, 16)
The Angel Appearing to Joseph in His Dream, 17 (I, 17)
Studies of Nine Figures, 18 (I, 18)
The Circumcision of Christ, 19 (I, 19)
The Prophet Elijah by the Brook Cherith, 20 (I, 20)
Reading Woman Seated, 21 (I, 21)
The Angel Leaving Manoah and His Wife, 22 (I, 22)
Study of Three Figures, 23 (I, 23)
Study after Leonardo's *Last Supper*, 24 (I, 24)
The Good Samaritan, 25 (I, 25)
Andrea Doria, 26 (I, 26)
Jacob's Dream, 27 (I, 27)
Thisbe Killing Herself Beside the Corpse of Pyramus, 28 (I, 28)
Elderly Man Walking, 29 (I, 29)
Jupiter with Philemon and Baucis, 30 (I, 30)
Joseph Kneeling Before Pharaoh, 31 (I, 31)
Milkmaids, 32 (I, 32)
Christ Finding His Disciples Asleep on the Mount of Olives, 33 (I, 33)
Old Woman Reading, 34 (I, 34)
Canal with a Bridge, 35 (I, 35)
Canal with a Boat, 36 (I, 36)
Canal with a Town, 37 (I, 37)
The Raising of the Daughter of Jairus, 151 (I, 146)
The Entombment, 210 (I, 193)
Nathan Admonishing David, 211 (I, 194)
Sheet of Studies of Listeners, 212 (I, 195)
Study for *The Syndics of the Clothmakers' Guild*, 213 (I, 196)

Study for the Figure of Susanna, 214 (I, 197)
Oriental Noble with His Retinue, 215 (I, 198)
The Deposition, 216 (I, 199)
Christ Among the Disciples, 217 (I, 200)
Susanna and the Elders, 220 (II, 20)
Thisbe Lamenting Pyramus, 255 (II, 34)
Oriental Seen from Behind, 256 (II, 35a)
Standing Beggar, 257 (II, 35b)
Departure of the Prodigal Son, 259 (II, 37)
Figure in a Rich Costume, 261 (II, 38b)
The Lamentation, 262 (II, 39)
Man Reading on His Knees, 263 (II, 40)
Thisbe Weeping Over Pyramus, 266 (II, 42)
Studies of Walking Figures, 272 (II, 48a)
Three Jews Conversing, 282 (II, 57a)
An Oriental Leaning on a Stick, 283 (II, 57b)
Boaz and Ruth, 284 (II, 58a)
The Entombment, 285 (II, 58b)
Judith and Her Servant, 286 (II, 59)
The Offerings of Cain and Abel, 287 (II, 60)
View of Cottages, 289 (II, 61b)
Village Street Along a Canal, 290 (II, 61c)
The Sacrifice of Abraham, 471 (IV, 26)
The Amstel with a Man Bathing, 472 (IV, 27)
The Holy Family, 473 (IV, 28)
The Return of Young Tobias, 474 (IV, 29)
View of the Amstel, 475 (IV, 30)
Road with Houses, 476 (IV, 31)
Farm Houses with Trees, 477 (IV, 32)
Landscape with Cottages by a Road, 478 (IV, 33)
Jonah Ejected by the Whale, 479 (IV, 34)
An Oriental, and a Girl at a Window, 480 (IV, 35)
The Dismissal of Hagar, 481 (IV, 36)
The Good Samaritan Paying the Host, 482 (IV, 37)
A Bearded Man Seated, 483 (IV, 38)
Christ Healing a Leper, 484 (IV, 39)
Young Samuel Finds Eli Asleep, 485 (IV, 40)
Four Women Mourning a Young Man, 486 (IV, 41)
Avenue of Trees, 487 (IV, 42)
The Discovery of Abel's Body, 488 (IV, 43)

BIRMINGHAM, ENGLAND

Barber Institute of Arts

Male Nude Seated on a Box, 44 (I, 44)
Studies of Heads and Figures, 86 (I, 85)

BRUSSELS

Musée des Beaux-Arts

A Woman Putting on an Earring, 359 (III, 27)

CAMBRIDGE, MASSACHUSETTS

Fogg Art Museum, Harvard University

A Woman Hanging on a Gibbet, 362 (III, 30a)

CHATSWORTH

Chatsworth Settlement (formerly the Duke of Devonshire Collection)

David Appoints Solomon His Successor, 51 (I, 51)

The Mocking of Christ, 52 (I, 52)

The Bend in the Amstel River, with Kostverloren Castle, 53 (I, 53)

The Amsteldijk near the Trompenburg Estate, 54 (I, 54)

Road Through a Wood, 55 (I, 55)

View Over "Het IJ" from the Diemerdijk, 56 (I, 56)

The Bulwark "De Rose" and the Windmill "De Smeerpot," 57 (I, 57)

View of Houtewaal, 58 (I, 58)

Farmhouse Beside a Canal, 59 (I, 59)

View of a Lake with a Sailboat, 60 (I, 60)

Trees and Huts near a High Road, 61 (I, 61)

Inn Beside a Road, 62 (I, 62)

Hayrick near a Farm, 63 (I, 63)

The Amsteldijk near the Trompenburg Estate, 64 (I, 64)

Two Thatched Huts by a Road, 65 (I, 65)

View of Sloten, 66 (I, 66)

The Bend in the Amstel River, with Kostverloren Castle, 67 (I, 67)

The Rampart near the Bulwark Beside the St. Anthoniespoort, 68 (I, 68)

Farmstead with a Hayrick Beside a Stream, 69 (I, 69)

Farmstead Beside a Stream, 70 (I, 70)

The Bend of the Amstel River near Kostverloren Castle, 71 (I, 71)

The Rijnpoort at Rhenen, 72 (I, 72)

Canal near a Road, 73 (I, 73)

The Omval at the River Amstel, 74 (I, 74)

Farmstead at the Diemerdijk, 75 (I, 75)

Isaac Blessing Jacob, 76 (I, 76)

Laban Guiding Leah or Rachel, 77 (I, 77)

Three Men in Discussion and the Bust of a Woman, 78 (I, 78)

Man Seated at a Table Covered with Books, 79 (I, 79)

Cottage by a Tree, 80 (I, 80)

Windmill with Houses, 81 (I, 81)

Amstelveen, 82 (I, 82)

View Over the Amstel near the Omval, 83 (I, 82a)

Flat Landscape with a Farmstead, 84 (I, 83)

Village Street Beside a Canal, 226 (II, 9)

CHICAGO

The Art Institute of Chicago

Ruins of Kostverloren Castle, 466 (IV, 23)

COPENHAGEN

Kobberstiksamling

Windmills on the West Side of Amsterdam, 41 (I, 41)

The Widower, 45 (I, 45)

Interior with a Winding Staircase, 360 (III, 28)

Jacob and Laban, 392 (III, 59)

DRESDEN

Kupferstichkabinett

St. Peter at the Deathbed of Tabitha, 96 (I, 95)

The Judgment of Solomon, 97 (I, 96)

Departure of the Disobedient Prophet, 98 (I, 97)

Diana and Actaeon, 99 (I, 98)

Ganymede Carried Away by the Eagle, 140 (I, 136)

Ecce Homo, 141 (I, 137)

God Announces His Covenant to Abraham, 142 (I, 138)

The Geographer, 143 (I, 139)

Old Man and a Young Lady Walking, 153 (I, 148a)

Study for St. Peter, 275 (II, 50)

The Angel Disappearing Before Manoah and His Wife, 361 (III, 29)

Study of an Archer, 456 (IV, 15)

Sleeping Child, 457 (IV, 16a)

Sleeping Woman, 458 (IV, 16b)

Woman with a Pissing Child, 459 (IV, 17a)

Girl Leaning on a Window Frame, 460 (IV, 17b)

Castle of Kostverloren, 461 (IV, 18)

Boy Drawing at a Desk, 462 (IV, 19)

Portrait Studies of Two Women, 463 (IV, 20)

Friedrich August II Collection

Pyramus and Thisbe, 101 (I, 100)

Old Man with a Walking Stick, 144 (I, 140a)

Sarah Presenting Hagar to Abraham, 274 (II, 49)

Bearded Man in Profile, 467 (IV, 24a)

Portrait of Sylvius, 468 (IV, 24b)

Two Standing Jews, 470 (IV, 25b)

FRANCE

Private collection

Three Women at an Open Door, 351 (III, 19)

GRONINGEN

Museum

Farmhouses with a Water Mill Amidst Trees, 40 (I, 40)

Cottages by the Water, 252 (II, 32a)

Daughters of Cecrops Discover Erichthonius, 546 (IV, 96)

Studies of Three Figures, 548 (IV, 98)

Daniel in the Lions' Den, 550 (IV, 100)

HAARLEM

Teyler Museum

Christ and His Disciples, 175 (I, 165)

Woman Wearing a Costume of North Holland, Seen from the Back, 176 (I, 166)

The Return of the Prodigal Son, 177 (I, 167)

Bearded Old Man Seated in an Armchair, 178 (I, 168)

The Entombment, 179 (I, 169)

Christ in the House of Mary and Martha, 180 (I, 170)

The "Westpoort" Gate at Rhenen, 225 (II, 8)

Two Jews and Some Dutch People on a Street, 417 (III, 81)

The Departure of Benjamin for Egypt, 540 (IV, 90)

THE HAGUE

Bredius Museum

Joseph Telling His Dreams(?), 276 (II, 51)

View of Rhenen, 277 (II, 52)

Elisha Making a Piece of Iron Float on Water, 438 (III, 100)

Saul and His Servants with the Witch of Endor, 503 (IV, 57)

V. de Stuers Collection

Ruins of the Church of Muiderberg, 427 (III, 90)

View of Diemen, 428 (III, 91a)

HAMBURG

Kunsthalle

St. Jerome Praying in the Desert, 136 (I, 132)

St. Jerome Reading, 137 (I, 133)

Christ Consoled by the Angel, 138 (I, 134)

The Angel Appearing to Hagar, 139 (I, 135)

HEEMSTEDE

Van der Waals Collection

Noli Me Tangere, 500 (IV, 54)

LONDON

British Museum

Abraham Dismissing Hagar and Ishmael, 102 (I, 101)

The Entombment of Christ, 103 (I, 102)

The Lamentation, 104 (I, 103)

View of a Camp, 105 (I, 104a)

A Farmstead, 106 (I, 104b)

The Sacrifice of Iphigenia, 107 (I, 105)

Esau Selling his Birthright, 108 (I, 106)

A Man of Gibeah Offers Hospitality to the Levite and His Concubine, 109 (I, 107)

Joseph Waiting on His Fellow Prisoners, 110 (I, 108)

Jacob and Rachel Listening to an Account of Joseph's Dreams, 111 (I, 109)

An Artist Drawing from a Model, 112 (I, 110)

Studies of an Old Man on Crutches, and of a Woman Seen in Half-length, 113 (I, 111)

The Widow's Mite(?), 114 (I, 112)

Riverside Landscape, 115 (I, 113)

The Virgin and Child Seated near a Window, 116 (I, 114)

Farm Buildings at the "Dijk," 117 (I, 115)

Copy after an Indian Miniature, 118 (I, 116)

Two Negro Drummers on Mules, 119 (I, 117)

An Elephant and Spectators, 120 (I, 118)

Copy after Mantegna's *Calumny of Apelles*, 121 (I, 119)

Portrait of Cornelis Claesz Anslo, 122 (I, 120)

Portrait of Jan Cornelisz Sylvius, 123 (I, 121)

A Coach, 124 (I, 122)

Female Nude Grasping a Sling, 125 (I, 123)

Landscape with a Road, 126 (I, 124a)

An Old City Gate, 127 (I, 124b)

Boy in a Wide-brimmed Hat, 128 (I, 125a)

Standing Woman and Other Figures, 129 (I, 125b)

Gabriel Appearing to Zacharias, 130 (I, 126)

The Good Samaritan Bringing the Wounded Man into the Inn, 206 (I, 190)

Child's Head, 264 (II, 41a)

A Youth Drawing, 265 (II, 41b)

Mounted Officer, 267 (II, 43)

Emperor Jahangir, 268 (II, 44)

Self-portrait, 269 (II, 45)

Standing Male Nude, 270 (II, 46)

Two Sailing Boats, 288 (II, 61a)

Sleeping Lion, 291 (II, 62)

Christ Walking on the Waves, 405 (III, 71)

Studies of a Child Pulling Off the Cap of an Old Man, and Other Sketches, 406 (III, 72)

Woman Seated in an Armchair, 407 (III, 73)

Woman Teaching a Child to Stand, 408 (III, 74a)

Two Women Teaching a Child to Walk, 409 (III, 74b)

Abraham Before God and the Two Angels, 506 (IV, 59)

Abraham Before God and the Two Angels, 507 (IV, 60)

Lioness Eating a Bird, 508 (IV, 61)

Chained Lioness Lying Down to the Right, 509 (IV, 62)

Four Studies of Lions, 510 (IV, 63)

The Holy Family, 511 (IV, 64)

Study after Leonardo's *Last Supper*, 512 (IV, 65)

Judith Returning in Triumph, 513 (IV, 66)

Houses Among Trees by a River, 514 (IV, 67)

Village Street Beside a Canal, 515 (IV, 68)

Landscape with a Cottage, 516 (IV, 69a)

Farm Buildings near a Canal, 517 (IV, 69b)

Landscape with a Cottage, Canal and Trees, 518 (IV, 70a)

Cottages with Trees Beside Water and a Hay Barn, 519 (IV, 70b)

Four Orientals Seated Beneath a Tree, 520 (IV, 71)

Landscape with Cottages and a Windmill, 521 (IV, 72)

View from near the Anthoniespoort, 522 (IV, 73)

The Holy Family, 523 (IV, 74)

Diana at Her Bath, 524 (IV, 75)

Woman Sleeping, 525 (IV, 76)

Woman with a Candle, 526 (IV, 77)

Angels Leading Lot and His Family Out of Sodom, 527 (IV, 78)

Children Before a Street Door, 528 (IV, 79)

St. Paul Preaching at Athens, 529 (IV, 80)

The Sacrifice of Abraham, 530 (IV, 81)

Christ Walking on the Waves, 531 (IV, 82)

Studies for a Beheading of St. John the Baptist, 532 (IV, 83)

Oriental Standing, 533 (IV, 84)

Female Nude Seated and Bending Forward, 534 (IV, 85)

Man Lying on his Back, 535 (IV, 86)

Young Man Asleep, 536 (IV, 87)

Portrait of a Lady Holding a Fan, 537 (IV, 88)

Woman Wearing a Costume of North Holland, 538 (IV, 89a)

Sir Max J. Bonn Collection

Moses and the Burning Bush, 254 (II, 33)

Formerly D. Y. Cameron Collection

Christ and the Disciples in Gethsemane, 39 (I, 39)

Colnaghi's

Sheet of Studies with Four Heads of Men, 426 (III, 89)

O. Gutekunst Collection

The Holy Family Seated by a Window, 202 (I, 188a)

Baron Paul Hatvany Collection

Joseph Telling His Dreams, 224 (II, 7)

Formerly J. P. Heseltine Collection

Cottages Amidst Trees, 43 (I, 43)

Tobit(?) Having His Feet Bathed, 46 (I, 46)

Man in Oriental Attire at a Table, 90 (I, 89)

Sleeping Woman at a Window, 251 (II, 31)

Christ Finding the Apostles Asleep, 258 (II, 36)

Saskia Asleep in Bed, 294 (II, 65)

Male Nude Seated on a Low Bench, 295 (II, 66)

Male Nude Standing on a Cushion, 297 (II, 68)

Lady Melchett Collection

Isaac Blessing Jacob, 280 (II, 55)

Formerly Henry Oppenheimer Collection

Adoration of the Shepherds, 89 (I, 88)

Sleeping Woman, 94 (I, 93)

River Landscape with a Cottage, 293 (II, 64)

The Angel Appearing to Elijah, 391 (III, 58)

Study of Two Men, 394 (III, 60b)

Heirs of Henry Oppenheimer

Baby Sleeping in a Cradle, 203 (I, 188b)

Count Antoine Seilern Collection

Seated Old Woman, 145 (I, 140b)

The Arrest of Christ, 271 (II, 47)

Scene from the Old Testament(?), 369 (III, 36)

Quack at a Fair, 465 (IV, 22)

Girl Leaning on the Sill of a Window, 469 (IV, 25a)

MUNICH

Staatliche Graphische Sammlung

Man Seated by a Window, 439 (IV, 1)

The Vision of St. Peter, 440 (IV, 2)

Saskia Sitting Up in Bed, 441 (IV, 3)

Christ and the Woman Taken in Adultery, 442 (IV, 4)

Saskia Lying in Bed, a Woman Sitting at Her Feet, 443 (IV, 5)

Two Studies of a Baby with a Bottle, 444 (IV, 6a)

Studies of a Baby, 445 (IV, 6b)

Reclining Female Nude, 446 (IV, 7)

Female Nude Seated, Seen from Behind, 447 (IV, 8)

Young Woman Seated, 448 (IV, 9)

The Conspiracy of Julius Civilis, 449 (IV, 10a)

The Conspiracy of Julius Civilis, 450 (IV, 10b)

Lamentation for Abel, 451 (IV, 11)

Ruins of Castle Honingen, near Rotterdam, 452 (IV, 12a)

Ruins of Castle Honingen, 453 (IV, 12b)

Man Pulling a Rope, 454 (IV, 13)

Study of an Archer, 455 (IV, 14)

NEW YORK

Metropolitan Museum of Art

Studies of a Woman Reading, 147 (I, 142)

Thatched Cottage Among Trees, 148 (I, 143)

Nathan Admonishing David, 149 (I, 144)

Man in a Flat Cap Seated on a Step, 154 (I, 148b)
Seated Woman Reading, 298 (II, 69a)

Frick Collection
Isaac Blessing Jacob, 47 (I, 47)
Farm Amidst Trees, 205 (I, 189b)

Robert Lehman Collection
Study after Leonardo's *Last Supper*, 100 (I, 99)
Cottage near a Wood, 199 (I, 186)
A Woman Hanging on a Gibbet, 363 (III, 30b)
Standing Man with a Sword, 365 (III, 32)

Mr. and Mrs. Charles S. Payson Collection
Portrait of a Man, Seen Through a Frame, 131 (I, 127)

PARIS

Louvre
Trees on the Edge of a Pond, 50 (I, 50)
Seated Female Nude, 92 (I, 91)
Woman Looking Out of a Window, 93 (I, 92)
Christ Disputing with the Doctors, 150 (I, 145)
The Parable of the Talents, 152 (I, 147)
St. Jerome, 159 (I, 152)
The Healing of Tobit, 160 (I, 153)
Studies of Blind Man and a Head in Profile, 161 (I, 154a)
The Wicked Servant Begs for Pardon, 162 (I, 154b)
Jacob's Dream, 163 (I, 155)
The Crucifixion, 164 (I, 156)
The Singel in Amersfoort, 165 (I, 157)
St. Paul, 166 (I, 158)
Emperor Tamerlane Enthroned, 167 (I, 159)
Saskia Seated in an Armchair, 169 (I, 161a)
Man in a Broad Hat, Seated, 170 (I, 161b)
Bust of a Bearded Old Man, 171 (I, 162a)
The Lion by the Body of the Disobedient Prophet, 172 (I, 162b)
The Rijnpoort at Rhenen, 173 (I, 163)
Two Studies of a Bird of Paradise, 174 (I, 164)
View of a Wide Plain, with Windmills, 181 (I, 171)
St. John the Baptist Preaching, 182 (I, 172a)
Joseph's Brothers Requesting Benjamin from Their Father, 186 (I, 174)
David Taking Leave of Jonathan, 187 (I, 175)
The Vision of Daniel, 188 (I, 176)
Hagar by the Fountain, 190 (I, 178)
Study of a Man Asleep, 192 (I, 180a)
Study of Two Pigs, 193 (I, 180b)
Rest on the Flight to Egypt, 194 (I, 181)
Christ Among the Doctors, 195 (I, 182)
Tobias and the Angel, 196 (I, 183)
The Presentation in the Temple, 197 (I, 184)

Self-portrait, 218 (II, 1)
Lion Resting, 219 (II, 2)
Landscape with Cottages and Trees, 221 (II, 4)
River with Trees, 292 (II, 63)
Bearded Man Seated, 296 (II, 67)
Portrait of a Man, 333 (III, 1)
Portrait of a Man, 334 (III, 2)
The Naming of St. John the Baptist, 335 (III, 3)
Female Nude Seated on a Stool, 336 (III, 4)
Two Studies of a Begging Woman Seated with Two Children, 337 (III, 5)
Christ Appearing to Mary Magdalen, 338 (III, 6)
Houses Amidst Trees and Shrubs, 339 (III, 7)
An Avenue Lined with Trees, 340 (III, 8)
Christ Washing the Disciples' Feet, 341 (III, 9)
Young Man Holding a Flower, 342 (III, 10)
Landscape with a Pond, 343 (III, 11)
Head of an Oriental, 344 (III, 12)
The Good Samaritan Arriving at the Inn with the Wounded Man, 345 (III, 13)
Judith's Servant with Holofernes' Head, 346 (III, 14)
The Pancake Woman, 347 (III, 15)
The Judgment of Solomon, 348 (III, 16)
Portrait of Cornelis Claesz Anslo, 349 (III, 17)
The Annunciation, 384 (III, 51)
Man Seated in a Study, 385 (III, 52)
Jupiter and Antiope, 386 (III, 53)
Large Tree on a Dike, 387 (III, 54)
Mercury and Argus in a Landscape, 388 (III, 55)
Two Standing Orientals, 389 (III, 56)
Study of Two Men and Two Children, 393 (III, 60a)
Four Figures in an Interior Around a Woman on the Floor, 395 (III, 61)
Cottages Beside a Road, 396 (III, 62)
The Miraculous Draught of Fishes, 397 (III, 63)
The Dismissal of Hagar, 398 (III, 64)
Mucius Scaevola Before King Porsenna, 399 (III, 65)
The Last Supper, 400 (III, 66)
Man Writing, 497 (IV, 51)

Bibliothèque Nationale
Lot and His Family Led by the Angel Out of Sodom, 168 (I, 160)

École des Beaux-Arts
Peter Denying Christ, 146 (I, 141)

Comtesse de Béhague Collection
View in Gelderland, 502 (IV, 56)
Two Studies of Old Men, 504 (IV, 58a)

Formerly Léon Bonnat Collection
The Mocking of Christ, 353 (III, 21)

Formerly Walter Gay Collection
Supper at Emmaus, 390 (III, 57)

Mme. Pierre Goujon Collection
The Healing of Tobit, 501 (IV, 55)

Frits Lugt Collection
Young Man Standing, 155 (I, 149)
Farmstead, 401 (III, 67)
House Beside a Road, 410 (III, 75)
The Departure of Tobias(?), 493 (IV, 48)

Formerly Paul Mathey Collection
The Presentation in the Temple, 364 (III, 31)
Painter Before His Easel, 368 (III, 35)

Formerly E. Moreau-Nélaton Collection
The Flight into Egypt, 498 (IV, 52)

P. Thureau-Dangin Collection
Lot Defending the Angels, 499 (IV, 53)

Formerly H. Véver Collection
Farmhouse, 495 (IV, 50a)
Woman Picking the Pocket of a Sleeping Man, 496 (IV, 50b)

Formerly E. Wauters Collection
Sheet of Studies, 366 (III, 33)
Isaac Refusing to Bless Esau, 492 (IV, 47)

PROVIDENCE, RHODE ISLAND

Museum of Art, Rhode Island School of Design
Farm Buildings at the "Dijk," 464 (IV, 21)

ROTTERDAM

Boymans-van Beuningen Museum
View over "Het IJ," 42 (I, 42)
Sketches of Five Heads, 48 (I, 48)
Two Cottages, 49 (I, 49)
Female Nude, 87 (I, 86)
Seated Old Woman with an Open Book on Her Knees, 91 (I, 90)
Four Studies of Saskia, 184 (I, 173a)
Studies of Men on Horseback, 185 (I, 173b)
Saskia Looking Out of a Window, 198 (I, 185)
Landscape with an Inn, 204 (I, 189a)
View of Haarlem, 249 (II, 30a)
Farm Amidst Trees, 250 (II, 30b)
Cottage and Barn with Trees, 253 (II, 32b)
Old Woman with a Baby, 380 (III, 47)
Old Man Asleep in His Chair, 381 (III, 48)
Abraham Kneeling Before God and Two Angels, 382 (III, 49)
The Good Samaritan Bringing the Wounded Man into the Inn, 383 (III, 50)
Judah and Tamar, 403 (III, 69)
The Holy Family, 411 (III, 76)
The Kiss of Judas, 412 (III, 77)
The Raising of Lazarus, 413 (III, 78)
Man Seated at a Table, 414 (III, 79)

Compositional Sketch of Horsemen, 415
 (III, 80a)
Woman Asleep in a Landscape, 416
 (III, 80b)
The Elevation of the Cross, 425 (III, 88)
Shepherd Watering His Flock, 490 (IV, 45)
Lion Resting, in Profile to the Left, 491
 (IV, 46)
Two Studies of a Man in a Chair, 494
 (IV, 49)
Farmhouse with Haystack and Trees, 505
 (IV, 58b)

Formerly F. Koenigs Collection
Esau at the Well(?), 489 (IV, 44)

STOCKHOLM

Nationalmuseum
The Angel Disappearing Before Manoah

and His Wife, 132 (I, 128)
The Eye Operation(?), 133 (I, 129)
Old Woman Holding a Child in Leading
 Strings, 134 (I, 130)
Study of Two Women, 135 (I, 131)
Portrait of a Boy, 227 (II, 10)
Job Visited by His Wife and Friends, 228
 (II, 11)
Christ and the Woman Taken in Adultery,
 229 (II, 12)
The Arrest of Christ, 230 (II, 13)
Three Cottages, 231 (II, 14)
Portrait of Titia van Uylenburch, 232
 (II, 15)
Seated Youth, 233 (II, 16)
Woman Suckling a Child, 234 (II, 17)
Study for the Etching called *The Great
 Jewish Bride*, 235 (II, 18)

Christ Among the Doctors, 236 (II, 19)

WASHINGTON, D.C.

**Rosenwald Collection, National
Gallery of Art**

Seated Old Man, 201 (I, 187b)
View Over the Amstel, 539 (IV, 89b)

WEIMAR

Goethe National Museum

Sheet of Studies, 207 (I, 191)
Sheet of Studies, 208 (I, 192a)
Lot and His Daughters, 209 (I, 192b)

INDEX OF SUBJECTS

OLD TESTAMENT

Genesis

The Offerings of Cain and Abel, 287 (II, 60)

The Discovery of Abel's Body, 488 (IV, 43)

The Lamentation for Abel, 451 (IV, 11)

God Appearing to Abraham, 142 (I, 138); 326 (II, 94); 382 (III, 49); 506 (IV, 59); 507 (IV, 60)

Sarah Presenting Hagar to Abraham, 274 (II, 49)

Sarah Complaining of Hagar to Abraham, 356 (III, 24)

Hagar by the Fountain on the Way to Shur, 190 (I, 178)

The Dismissal of Hagar, 102 (I, 101); 398 (III, 64); 481 (IV, 36); 547 (IV, 97)

The Angel Appearing to Hagar in the Desert, 139 (I, 135); 549 (IV, 99)

Lot Defending the Angels, 499 (IV, 53)

Lot and His Family Led by the Angels Out of Sodom, 168 (I, 160); 527 (IV, 78)

Lot and His Daughters, 209 (I, 192b)

The Sacrifice of Abraham, 471 (IV, 26); 530 (IV, 81)

Esau Selling His Birthright to Jacob, 108 (I, 106); 424 (III, 87); 541 (IV, 91)

Esau at the Well(?), 489 (IV, 44)

Isaac Blessing Jacob, 47 (I, 47); 76 (I, 76); 280 (II, 55)

Isaac Refusing to Bless Esau, 492 (IV, 47)

Jacob's Dream, 27 (I, 27); 163 (I, 155)

The Meeting of Jacob and Laban, 392 (III, 59)

Laban Guiding Leah or Rachel, 77 (I, 77)

Joseph Telling His Dreams, 224 (II, 7); 276 (II, 51)

Jacob and Rachel Listening to an Account of Joseph's Dreams, 111 (I, 109)

Joseph Divested of His Multicolored Coat, 371 (III, 38)

Judah and Tamar, 403 (III, 69)

Joseph Waiting on His Two Fellow Prisoners, 110 (I, 108)

Joseph Interpreting the Prisoners' Dreams, 240 (II, 23)

Joseph Before Pharaoh, 31 (I, 31)

Joseph's Brothers Requesting Benjamin from Their Father, 186 (I, 174); 300 (II, 70)

The Departure of Benjamin for Egypt, 540 (IV, 90)

Exodus

The Finding of Moses, 373 (III, 40)

Moses and the Burning Bush, 254 (II, 33)

Joshua

The Lord Appearing to Joshua, 543 (IV, 93)

Judges

Jael and Sisera, 437 (III, 99)

The Angel Disappearing Before Manoah, 22 (I, 22); 132 (I, 128); 361 (III, 29)

Delilah Calls the Philistines, 402 (III, 68)

A Man of Gibeah Offers Hospitality to the Levite and His Concubine, 109 (I, 107)

Ruth

Boaz and Ruth, 284 (II, 58a); 431 (III, 93)

I Samuel

Young Samuel Finds the High Priest Eli Asleep, 485 (IV, 40)

David Taking Leave of Jonathan, 187 (I, 175); 367 (III, 34); 375 (III, 42)

Saul and His Servants with the Witch of Endor, 503 (IV, 57)

II Samuel

The Messenger with the Crown of Saul Before David, 332 (II, 100)

David Receiving the News of Uriah's Death, 432 (III, 94)

I Kings

Nathan Admonishing David, 149 (I, 144); 211 (I, 194)

David Appoints Solomon His Successor, 51 (I, 51)

The Judgment of Solomon, 97 (I, 96); 348 (III, 16)

The Departure of the Disobedient Prophet, 98 (I, 97)

The Lion by the Body of the Disobedient Prophet, 172 (I, 162b)

The Prophet Elijah by the Brook Cherith, 20 (I, 20)

The Angel Appearing to Elijah in the Desert, 391 (III, 58)

II Kings

Elisha Making a Piece of Iron Float on Water, 438 (III, 100)

Esther

Ahasuerus Seated at a Table, 434 (III, 96)

Esther Fainting Before Ahasuerus, 308 (II, 77)

Job

Job Visited by His Friends, 228 (II, 11); 329 (II, 97)

Daniel

Daniel in the Lions' Den, 379 (III, 46); 550 (IV, 100)

The Vision of Daniel, 188 (I, 176)

Jonah

Jonah Ejected by the Whale, 479 (IV, 34)

Unidentified Scene

Scene from the Old Testament(?), 369 (III, 36)

APOCRYPHA

Tobit

The Angel in the House of Tobit, 313 (II, 81)

Departure of the Young Tobias, 314 (II, 82); 493 (IV, 48)

Tobias and the Angel, 196 (I, 183)

Tobias Cleaning the Fish, 370 (III, 37)

Raguel Welcomes Tobias, 320 (II, 88)

The Return of Tobias, 474 (IV, 29)

The Healing of Tobit, 133 (I, 129); 160 (I, 153); 419 (III, 83); 501 (IV, 55)

Tobit(?) Having His Feet Bathed, 46 (I, 46)

Judith

Judith and Her Servant Before the Tent of Holofernes, 286 (II, 59)

Judith's Servant Puts Holofernes' Head into a Sack, 346 (III, 14)

Judith Returning in Triumph with the Head of Holofernes, 513 (IV, 66)

The History of Susanna

Study for the Figure of Susanna, 214 (I, 197)

Susanna and the Elders, 237 (II, 20)

NEW TESTAMENT

The Life of St. John the Baptist

Gabriel Appearing to Zacharias in the Temple, 130 (I, 126)

The Naming of St. John the Baptist, 335 (III, 3)

St. John the Baptist Preaching (design for a frame), 182 (I, 172a)

Studies for *St. John the Baptist Preaching*, 16 (I, 16); 78 (I, 78); 212 (I, 195)

The Beheading of St. John the Baptist, 532 (IV, 83)

The Life of Christ

The Annunciation to the Virgin, 384 (III, 51)

The Annunciation to the Shepherds, 321 (II, 89); 378 (III, 45)

The Adoration of the Shepherds, 89 (I, 88); 358 (III, 26)

The Virgin Showing the Infant to One of the Magi, 324 (II, 92)

The Presentation in the Temple, 197 (I, 184); 364 (III, 31); 420 (III, 84)

The Circumcision of Christ, 19 (I, 19)

The Angel Appearing to Joseph in a Dream, 17 (I, 17); 327 (II, 95)

The Flight into Egypt, 498 (IV, 52)

Rest on the Flight, 194 (I, 181)

The Holy Family, 202 (I, 188a); 473 (IV, 28); 523 (IV, 74)

The Holy Family in the Carpenter's Workshop, 352 (III, 20); 398 (III, 64); 411 (III, 76)

The Virgin and Child, 116 (I, 114)

Christ in the Temple Disputing with the Doctors, 150 (I, 145); 195 (I, 182); 236 (II, 19)

Satan Tempting Christ to Change Stones into Bread, 246 (II, 28b)

The Teaching of Christ

Christ and His Disciples, 175 (I, 165); 217 (I, 200)

Christ Surrounded by a Group of Figures, 422 (III, 85b)

The Preaching of Christ, a Study for *The Hundred Guilder Print*, 3 (I, 3)

Blind Man Guided by a Woman, a Study for *The Hundred Guilder Print*, 161 (I, 154a)

Christ and the Woman Taken in Adultery, 229 (II, 12); 442 (IV, 4)

Christ in the House of Mary and Martha, 180 (I, 170)

Parables

The Wicked Servant Begs for Pardon, 162 (I, 154b)

The Unmerciful Servant, 309 (II, 78)

The Good Samaritan, 25 (I, 25)

The Good Samaritan Bringing the Wounded Man into the Inn, 206 (I, 190); 345 (III, 13); 383 (III, 50)

The Good Samaritan Paying the Host, 482 (IV, 37)

The Parable of the Talents, 152 (I, 147)

The Departure of the Prodigal Son, 259 (II, 37)

The Return of the Prodigal Son, 177 (I, 167)

The Widow's Mite(?), 114 (I, 112)

Miracles

The Miraculous Draught of Fishes, 397 (III, 63)

Christ Healing a Leper, 330 (II, 98); 484 (IV, 39)

The Raising of the Daughter of Jairus, 151 (I, 146)

Christ Walking on the Waves, 405 (III, 71); 531 (IV, 82)

The Raising of Lazarus, 413 (III, 78)

The Passion of Christ

Christ Washing the Feet of His Disciples, 238 (II, 21); 341 (III, 9)

The Last Supper, 24 (I, 24); 100 (I, 99); 400 (III, 66); 512 (IV, 65)

Christ Consoled by the Angel on the Mount of Olives, 39 (I, 39); 138 (I, 134)

Christ Finding the Apostles Asleep in Gethsemane, 258 (II, 36)

Christ Pleading for Aid from His Disciples, 33 (I, 33)

The Kiss of Judas, 412 (III, 77)

The Arrest of Christ, 230 (II, 13); 271 (II, 47)

St. Peter Denying Christ, 146 (I, 141)

The Mocking of Christ, 52 (I, 52); 353 (III, 21)

Ecce Homo, 141 (I, 137); 544 (IV, 94)

Christ Carrying the Cross, 15 (I, 15)

The Elevation of the Cross, 425 (III, 88)

The Crucifixion, 164 (I, 156)

The Descent from the Cross, 5 (I, 5); 216 (I, 199)

The Lamentation, 11 (I, 11); 104 (I, 103); 262 (II, 39)

The Entombment, 103 (I, 102); 179 (I, 169); 210 (I, 193); 285 (II, 58b)

Christ Appearing as a Gardener to Mary Magdalen, 331 (II, 99); 338 (III, 6)

Noli Me Tangere, 500 (IV, 54)

The Supper at Emmaus, 390 (III, 57)

The Incredulity of St. Thomas, 305 (II, 75)

Acts of the Apostles

St. Peter at the Deathbed of Tabitha, 96 (I, 95)

St. Peter's Prayer Before the Raising of Tabitha, 183 (I, 172b)

The Vision of St. Peter, 440 (IV, 2)

The Liberation of St. Peter, 372 (III, 39)

St. Paul Preaching at Athens, 529 (IV, 80)

Saints and Religious Figures

St. Jerome Praying, 136 (I, 132); 159 (I, 152); 306 (II, 76a)

St. Jerome Reading, 137 (I, 133); 263 (II, 40)

St. Paul, 166 (I, 158)

Study for St. Peter, 275 (II, 50)

ALLEGORY, MYTHOLOGY AND PROFANE HISTORY

The Calumny of Apelles, 121 (I, 119)

The Daughters of Cecrops Discover Erichthonius, 546 (IV, 96)

Diana and Actaeon, 99 (I, 98)

Diana at Her Bath, 524 (IV, 75)

Ganymede Carried Away by the Eagle of Zeus, 140 (I, 136)

Homer Reciting Verses, 223 (II, 6)

The Sacrifice of Iphigenia, 107 (I, 105)

The Conspiracy of Julius Civilis, 449 (IV, 10a); 450 (IV, 10b)

Jupiter and Antiope, 386 (III, 53)

Mars and Venus Caught in a Net and Exposed by Vulcan to the Assembled Gods, 418 (III, 82)

Mercury and Argus in a Landscape, 388 (III, 55)

Minerva in Her Study, 279 (II, 54)

Mucius Scaevola Holding His Hand in Fire Before King Porsenna, 399 (III, 65)

Odysseus(?) Having His Feet Bathed by His Old Nurse, 46 (I, 46)

Philemon and Baucis, 30 (I, 30); 241 (II, 24)

Pyramus and Thisbe, 28 (I, 28); 101 (I, 100); 255 (II, 34); 266 (II, 42)

The Emperor Tamerlane Enthroned, 167 (I, 159)

FIGURE STUDIES

Single Figures, Male

Old Man Seated in an Armchair, Full-length, 10 (I, 10)

Elderly Man in a Wide-brimmed Hat Walking with a Stick, 29 (I, 29)

Man Seated at a Table Covered with Books, 79 (I, 79)

Man in Oriental Attire Seated at a Table Covered with Books, 90 (I, 89)

Boy in a Wide-brimmed Hat, Resting His Chin on His Right Hand, 128 (I, 125a)

The Geographer, 143 (I, 139)

Old Man in a Fur Cap, Walking with a Stick, Turned to the Left, 144 (I, 140a)

Man in a Flat Cap Seated on a Step, 154 (I, 148b)

Young Man Standing, 155 (I, 149)

Man in a Broad Hat, Seated, Reading a Book, 170 (I, 161b)

Bust of a Bearded Old Man, 171 (I, 162a)

Bearded Old Man Seated in an Armchair, Turned to the Right, Full-length, 178 (I, 168)

Study of a Man Asleep, Seated on the Ground, 192 (I, 180a)

Seated Old Man, 201 (I, 187b)

Seated Youth, 233 (II, 16)

Beggar with a Leather Bag, Turned Toward the Left, 247 (II, 29a)

Oriental Seen from Behind, Another Head Above on the Right, 256 (II, 35a)

Standing Beggar in a High Cap, 257 (II, 35b)

Man Reading on His Knees (St. Jerome?), 263 (II, 40)

Child's Head, 264 (II, 41a)

Youth Drawing, 265 (II, 41b)

Mounted Officer, 267 (II, 43)

An Oriental Leaning on a Stick, 283 (II, 57b)

Bearded Man Seated in an Armchair, 296 (II, 67)

Standing Beggar Turned to the Right, 302 (II, 72)

Standing Beggar with a Leather Bag, 303 (II, 73)

Old Man Standing, 311 (II, 80a)

Standing Man with His Right Hand Raised and a Whip(?) in His Left, 325 (II, 93)

Head of an Oriental in a Turban, Turned to the Right, 344 (III, 12)

Standing Boy in a Long Robe, 354 (III, 22)

Standing Man, with a Two-handed Sword in His Right Hand, 365 (III, 32)

Man Seated in a Study, 385 (III, 52)

Study of a Man Seated at a Table, 414 (III, 79)

Life Study of a Youth Pulling at a Rope, 430 (III, 92)

Man Seated by a Window, Reading, 439 (IV, 1)

Man Pulling a Rope, 454 (IV, 13)

Study of an Archer, 455 (IV, 14); 456 (IV, 15)

Boy Drawing at a Desk (Titus?), 462 (IV, 19)

Bearded Man in Profile, 467 (IV, 24a)

Half Figure of an Oriental Turned to the Left, Superimposed upon a Compositional Study of a Girl at a Window, 480 (IV, 35)

Bearded Man Seated at a Desk Covered with Books, 483 (IV, 38)

Study of an Oriental Standing, 533 (IV, 84)

Study of a Young Man Asleep, 536 (IV, 87)

Single Figures, Female

Woman Seated, in an Oriental Costume, 7 (I, 7)

Reading Woman Seated in an Armchair, 21 (I, 21)

Old Woman Reading, Wearing Glasses, 34 (I, 34)

Woman Looking Out of a Window, 93 (I, 92)

Sleeping Woman with Her Hands Folded on a Book She Is Holding, 94 (I, 93)

Seated Old Woman, in a Large Head-dress, Half-length, Turned to the Right, 145 (I, 140b)

Woman Wearing a Costume of North Holland, Seen from the Back, 176 (I, 166)

Study for the Etching called *The Great Jewish Bride*, 235 (II, 18)

Sleeping Woman at a Window, 251 (II, 31)

Sleeping Girl, 260 (II, 38a)

Figure in a Rich Costume, 261 (II, 38b)

Seated Woman Reading, 298 (II, 69a)

Young Woman with a Large Hat and a Walking Stick, 312 (II, 80b)

Woman Hanging on a Gibbet Seen from the Front, 362 (III, 30a)

Woman Hanging on a Gibbet in Three-quarter Profile to the Left, 363 (III, 30b)

Young Woman Seated by a Window, 377 (III, 44)

Woman Seated in an Armchair with Her Head Resting on Her Left Hand, 407 (III, 73)

Woman Lying Asleep in a Landscape, 416 (III, 80b)

Young Woman Seated, 448 (IV, 9)

Sleeping Woman, Her Head Supported on Her Right Hand, 458 (IV, 16b)

Girl Leaning on a Window Frame, 460 (IV, 17b)

Girl Leaning on the Sill of a Window, 469 (IV, 25a)

Woman Sleeping (Hendrickje?), 525 (IV, 76)

Woman Standing, with a Candle, 526 (IV, 77)

Woman Wearing a Costume of North Holland, 538 (IV, 89a)

Groups

The Widower, 45 (I, 45)

Two Negro Drummers Mounted on Mules, 119 (I, 117)

Old Man and Young Lady Walking, 153 (I, 148a)

Study of a Group of Figures, 158 (I, 151)

Oriental Noble, with his Retinue, 215 (I, 198)

Three Jews Conversing, 282 (II, 57a)

Woman in a Faint, Supported by Two Figures, 323 (II, 91)

Two Standing Orientals, 389 (III, 56)

Four Figures in an Interior Around a Woman Lying on the Floor, 395 (III, 61)

Compositional Sketch of Horsemen, 415 (III, 80a)

Two Jews and Some Dutch People on a Street, 417 (III, 81)

Nine People in a Synagogue(?) Behind a Low Wall, 421 (III, 85a)

Two Standing Jews, Between Their Feet the Inverted Head of a Third, 470 (IV, 25b)

Four Women Mourning the Death of a Young Man, 486 (IV, 41)

Sheets of Studies

Study of Seven Figures, 2 (I, 2)

Studies of Groups and Figures, 16 (I, 16)

Studies of Nine Figures, 18 (I, 18)

Study of Three Figures, 23 (I, 23)

Sketches of Five Heads, 48 (I, 48)

Three Men in Discussion and the Bust of a Woman, 78 (I, 78)

Studies of Heads and Figures, 86 (I, 85)

Three Full-length Studies of an Old Man on Crutches, and of a Woman Seen in Half-length, 113 (I, 111)

Standing Woman with Folded Hands; Figures in the Background, 129 (I, 125b)

Two Studies of a Woman Reading, 147 (I, 142)

Blind Man Guided by a Woman and a Study of a Head in Profile on the Left, 161 (I, 154a)

Studies of Men on Horseback, 185 (I, 173b)

Sheet of Studies of an Old Woman and of Two Women with a Child, 207 (I, 191)

Sheet of Studies Including Two Figures Supporting an Old Man and a Mourning Woman, 208 (I, 192a)

Sheet of Studies of Listeners, 212 (I, 195)

Studies of Walking Figures, 272 (II, 48a)

Sheet of Studies of Women, 273 (II, 48b)

Two Old Men, One Seated in an Armchair, the Other with a Globe, 307 (II, 76b)

Two Studies of a Begging Woman Seated with Two Children, 337 (III, 5)

Study of a Woman Seated and of a Man Standing in Front of Her, and Four Studies of the Head of a Young Woman, 366 (III, 33)

Two Studies of a Woman with a Baby in Her Arms, 376 (III, 43)

Study of Two Men and Two Children (One of the Latter in a Little Chair), 393 (III, 60a)

Old Man with His Hands Leaning on a Book and a Study of a Man Wearing a Turban, 394 (III, 60b)

Two Studies of a Child Pulling Off the Cap of an Old Man, and Other Sketches of the Same Group, 406 (III, 72)

Sheet of Studies with Four Heads of Men, 426 (III, 89)

Two Studies of a Baby with a Bottle, 444 (IV, 6a)

Four Studies of a Baby, 445 (IV, 6b)

Two Studies of a Man Seated in a Chair, 494 (IV, 49)

Two Studies of Old Men Facing Each Other, 504 (IV, 58a)

Studies of Three Figures, 548 (IV, 98)

Male Nudes

Male Nude Seated on a Box, His Hands Clasped, 44 (I, 44)

Seated Male Nude, 220 (II, 3)

Standing Male Nude, 270 (II, 46)

Male Nude Seated on a Low Bench, 295 (II, 66)

Male Nude Standing on a Cushion, 297 (II, 68)

Life Study of a Man Lying on His Back, 535 (IV, 86)

Female Nudes

Female Nude, Seated on a Chair Before a Curtain, 87 (I, 86)

Female Nude Asleep, 88 (I, 87)

Seated Female Nude Turned to the Left, 92 (I, 91)

Female Nude with Her Left Hand Grasping a Sling, 125 (I, 123)

Study for the Figure of Susanna, 214 (I, 197)

Standing Female Nude, 319 (II, 87)

Female Nude Seated on a Stool, Turned to the Left, 336 (III, 4)

Seated Female Nude with Her Arms Raised, Supported by a Sling, 433 (III, 95)

Reclining Female Nude, Resting Her Head on Her Left Hand, 446 (IV, 7)

Female Nude Seated on a Chair Seen from Behind, 447 (IV, 8)

Female Nude Seated and Bending Forward, 534 (IV, 85)

GENRE SCENES, INTERIORS AND OBJECTS

A Man Approached by a Beggar, 8 (I, 8)

Milkmaids, 32 (I, 32)

The Eye Operation(?), 133 (I, 129)

Artist Drawing from a Model, 112 (I, 110)

Boy Lighting His Pipe, 301 (II, 71)

Painter Before His Easel, on the Right a Visitor, 368 (III, 35)

Street Musician, 404 (III, 70)

Quack Addressing a Crowd, 465 (IV, 22)

Shepherd Watering His Flock, 490 (IV, 45)

Woman Picking the Pocket of a Sleeping Man, 496 (IV, 50b)

Interior with a Winding Staircase, 360 (III, 28)

A Coach, 124 (I, 122)

The Life of Women and Children

Saskia's Lying-in Room, 328 (II, 96)

Baby Sleeping in a Wicker Cradle, 203 (I, 188b)

Sleeping Child, 248 (II, 29b); 457 (IV, 16a)

Woman with a Child in Her Lap, and Another Nursing a Baby, 135 (I, 131)

Woman Suckling a Child, 234 (II, 17)

Woman Holding a Child, 316 (II, 84)

Old Woman Giving Drink to a Child, 245 (II, 28a)

Woman Teaching a Child to Stand, 408 (III, 74a)

Two Women with a Child Learning to Walk, 315 (II, 83); 409 (III, 74b)

An Old Woman Holding a Child in Leading Strings, 134 (I, 130)

The Widower, 45 (I, 45)

The Screaming Boy, 9 (I, 9)

Woman with a Pissing Child, 459 (IV, 17a)

Three Women and a Child at the Entrance of a House, 242 (II, 25)

Three Women Looking Out from an Open Door, 351 (III, 19)

Woman Putting on an Earring, 359 (III, 27)

Old Woman with a Baby, 380 (III, 47)

The Pancake Woman, 318 (II, 86); 347 (III, 15)

Children Dancing and Making Music Before a Street Door, 528 (IV, 79)

PORTRAITS

Self-portraits

Self-portrait, 1 (I, 1); 218 (II, 1); 269 (II, 45)

Self-portrait in Studio Attire, Full-length, 95 (I, 94)

Known Male Portraits

Cornelius Claesz Anslo, 122 (I, 120); 349 (III, 17)

The Anatomy Lesson of Dr. Deyman, 281 (II, 56)

Andrea Doria, 26 (I, 26)

Jan Six with a Dog, Standing by an Open Window, 278 (II, 53)

Jan Six(?), 222 (II, 5); 497 (IV, 51)

Jan Cornelisz Sylvius, 123 (I, 121); 468 (IV, 24b)

Titus(?), 128 (I, 125a); 155 (I, 149); 222 (II, 5); 233 (II, 16); 342 (III, 10); 462 (IV, 19)

Known Female Portraits

Saskia van Uylenburch (Three Days After Her Betrothal), 6 (I, 6)

Sketch of Saskia, 48 (I, 48)

Saskia Seated in an Armchair, 169 (I, 161a)

Four Studies of Saskia, 184 (I, 173a)

Saskia Looking Out of a Window, 198 (I, 185)

Saskia Asleep in Bed, 294 (II, 65)

Portrait Study of Saskia(?), 374 (III, 41)

Saskia(?) Asleep, 416 (III, 80b)

Saskia Sitting Up in Bed, 441 (IV, 3)

Saskia Lying in Bed, a Woman Sitting at Her Feet, 443 (IV, 5)

A Woman Looking Out of a Window (Hendrickje Stoffels?), 93 (I, 92)

A Sleeping Woman at a Window (Hendrickje Stoffels?), 251 (II, 31)

A Woman Sleeping (Hendrickje Stoffels?), 525 (IV, 76)

Geertje Dircx(?), 176 (I, 166); 538 (IV, 89a)

Margaretha de Geer(?), 91 (I, 90)

Titia van Uylenburch, 232 (II, 15)

Anna Wijmer (see 279 [II, 54])

Unknown Male Portraits

Portrait of a Man in an Armchair Seen Through a Frame, 131 (I, 127)

Study for *The Syndics*, 213 (I, 196); 243 (II, 26)

Portrait of a Young Man, 222 (II, 5)

Portrait of a Boy, 227 (II, 10)

Portrait of a Man, 333 (III, 1); 334 (III, 2)

Portrait of a Young Man Holding a Flower (Titus?), 342 (III, 10)

Man Writing (Jan Six?), 497 (IV, 51)

Unknown Female Portraits

Portrait of a Seated Old Woman with an Open Book on Her Knees (Margaretha de Geer?), 91 (I, 90)

Portrait Bust of a Lady in a Cap Plumed with an Ostrich Feather, 191 (I, 179)

Portrait of a Woman, 200 (I, 187a)

Portrait Study of a Young Lady, 374 (III, 41)

Portrait Studies of Two Women, 463 (IV, 20)

Portrait of a Lady Holding a Fan, 537 (IV, 88)

COPIES

Copies After Dutch and Italian Originals

After Lastman's *Susanna and the Elders*, 237 (II, 20)

After Leonardo's *Last Supper*, 24 (I, 24); 100 (I, 99); 512 (IV, 65)

After Mantegna's *Calumny of Apelles*, 121 (I, 119)

After a Raphael school drawing of *The Entombment of Christ*, 179 (I, 169); 210 (I, 193)

After Jan Pynas, 204 (I, 189a)

After a Medal of Andrea Doria, 26 (I, 26)

Copies After Indian Miniatures

Horseman, 118 (I, 116)

The Emperor Tamerlane Enthroned, 167 (I, 159)

The Emperor Jahangir Receiving an Address, 268 (II, 44)

Four Orientals Seated Beneath a Tree, 520 (IV, 71)

ANIMALS

Studies of a Bird of Paradise, 174 (I, 164)

Cow Standing in a Shed, 436 (III, 98)

Milkmaids and Cows, 32 (I, 32)

Dog with a Collar, 156 (I, 150a)

Elephant, 120 (I, 118)

Lion Resting Turned to the Left, 157 (I, 150b); 219 (II, 2); 491 (IV, 46)

Recumbent Lion, Turned to the Right, 244 (II, 27)

Sleeping Lion Chained, 291 (II, 62)

Recumbent Lion Scratching His Muzzle, 435 (III, 97)

Four Studies of Lions, 510 (IV, 63)

Lioness Eating a Bird, 508 (IV, 61)

Chained Lioness, 509 (IV, 62)

Three Pigs Outside Their Sty, 357 (III, 25)

Two Pigs, 193 (I, 180b)

Shepherd Watering His Flock, 490 (IV, 45)

LANDSCAPES AND VIEWS

Identified Motifs

The Singel in Amersfoort, 165 (I, 157)

View of the Amstel, 475 (IV, 30)

View of the Amstel with a Man Bathing, 472 (IV, 27)

Bend in the Amstel with Kostverloren Castle, 53 (I, 53); 67 (I, 67); 71 (I, 71)

The Omval at the River Amstel, 74 (I, 74); 83 (I, 82a)

View of the Gardens of the Pauw Family on the Amstel, 542 (IV, 92)

View Over the Amstel from the Rampart, 539 (IV, 89b)

The Amsteldijk near the Trompenburg Estate, 54 (I, 54); 64 (I, 64)

Amstelveen, 82 (I, 82)

Houses Along the Amstelveensche Weg(?), 189 (I, 177)

Windmills on the West Side of Amsterdam, 41 (I, 41)

View Over the Amstel from the Blauwbrug in Amsterdam, 317 (II, 85)

View from near the St. Anthoniespoort in Amsterdam, 522 (IV, 73)

The Rampart near the Bulwark Beside the St. Anthoniespoort at Amsterdam, 68 (I, 68)

The St. Anthoniessluis seen from Uilenburgh(?) at Amsterdam, 36 (I, 36)

The "Kloveniersdoelen" and the Tower "Swijght Utrecht" at Amsterdam, 545 (IV, 95)

The "Montelbaanstoren" in Amsterdam, 85 (I, 84)

A View of the Oude Schans(?) in Amsterdam, 35 (I, 35)

The Bulwark "De Rose" and the Windmill "De Smeerpot" near Amsterdam, 57 (I, 57)

The Old Town Hall at Amsterdam After its Destruction by Fire in 1652, 38 (I, 38)

Tower of the Westerkerk at Amsterdam, 423 (III, 86)

View of Diemen, 428 (III, 91a)

View of "Het IJ" from the Diemerdijk, 42 (I, 42); 56 (I, 56); 497 (IV, 51)

Tree near the Diemerdijk(?), 387 (III, 54)

Farmstead at the Diemerdijk, 75 (I, 75)

An Avenue Lined with Trees, Diemermeer(?), 340 (III, 8)

Farm Buildings at the "Dijk," 117 (I, 115); 464 (IV, 21)

View of Gelderland, 239 (II, 22); 502 (IV, 56)

View of Haarlem Seen from Overveen, 249 (II, 30a)

Ruins of Castle Honingen, near Rotterdam, 452 (IV, 12a); 453 (IV, 12b)

View of Houtewaal, 58 (I, 58)

Kostverloren Castle, 53 (I, 53); 67 (I, 67); 71 (I, 71); 461 (IV, 18); 466 (IV, 23)

View of London, with Old St. Paul's, 4 (I, 4)

Ruins of the Church of Muiderberg, 427 (III, 90)

View of the Nieuwe Meer(?) with a Sailboat, 60 (I, 60)

View of Rhenen, 277 (II, 52)

The Oostpoort at Rhenen, 355 (III, 23)

The Rijnpoort at Rhenen, 72 (I, 72); 173 (I, 163)

The Westpoort at Rhenen, 225 (II, 8)

A City Gate, perhaps Rhenen, 310 (II, 79)

View of Sloten, 66 (I, 66)

Unidentified Motifs

Cottages Amongst High Trees, 12 (I, 12)

Landscape with Two Cottages, 13 (I, 13)

Landscape with a Man Standing by a Road, 14 (I, 14)

Canal with a Bridge in the Distance, 35 (I, 35)

View of a Canal with a Boat in the Right Foreground, 36 (I, 36)

Landscape with a Canal Leading Towards a Town in the Distance, 37 (I, 37)

Farmhouses with a Water Mill Amidst Trees, 40 (I, 40)

Cottages Among a Clump of Large Trees, 43 (I, 43)

Two Cottages, 49 (I, 49)

Group of Large Trees on the Edge of a Pond, 50 (I, 50)

Road Through a Wood, 55 (I, 55)

Farmhouse Among Trees Beside a Canal with a Man in a Rowboat, 59 (I, 59)

View of a Lake with a Sailboat on the Right and High Reeds on the Left, 60 (I, 60)

Group of Trees and Huts near a High Road, 61 (I, 61)

Inn Beside a Road, 62 (I, 62)

Hayrick near a Farm, 63 (I, 63)

Two Thatched Huts by a Road, 65 (I, 65)

A Farmstead with a Hayrick and Weirs Beside a Stream, 69 (I, 69)

Farmstead Beside a Stream, 70 (I, 70)

Canal near a Road with a Group of Trees in the Background, 73 (I, 73)

Thatched Cottage by a Tree, 80 (I, 80)

Windmill with a Group of Houses, 81 (I, 81)

Flat Landscape with a Farmstead in the Middle Distance, 84 (I, 83)

View of a Camp, 105 (I, 104a)

Farmstead, 106 (I, 104b)

Riverside Landscape, a Cottage and High Hayrick to the Right, 115 (I, 113)

Landscape with a Road, 126 (I, 124a)

Old City Gate, 127 (I, 124b)

Thatched Cottage Among Trees, 148 (I, 143)

View of a Wide Plain, with Windmills in the Distance on the Right, 181 (I, 171)

Houses Amidst Trees, 189 (I, 177)

Cottage Near the Entrance to a Wood, 199 (I, 186)

Landscape with an Inn Beside a Road, 204 (I, 189a)

Farm Amidst Trees, 205 (I, 189b)

Landscape with Peasant Cottages and Trees, 221 (II, 4)

Village Street Beside a Canal, 226 (II, 9)

Three Cottages, 231 (II, 14)

Farm Amidst Trees, 249 (II, 30b)

Cottages by the Water, 252 (II, 32a)

Cottage and Barn Surrounded by Trees, 253 (II, 32b)

Two Sailing Boats in a Gale, 288 (II, 61a)

View of Cottages, 289 (II, 61b)

Village Street Along a Canal, 290 (II, 61c)

River with Trees on its Embankment at Dusk, 292 (II, 63)

River Landscape with a Cottage, 293 (II, 64)

Farm Amidst Trees, 299 (II, 69b)

Landscape with an Inn, and a Sailboat on the Right, 304 (II, 74)

Winter Landscape with a Farm, 322 (II, 90)

Houses Amidst Trees and Shrubs, 339 (III, 7)

Avenue Lined with Trees (Diemermeer?), 340 (III, 8)

Landscape with a Pond, 343 (III, 11)

Pollard Willow at the Waterside, 350 (III, 18)

Cottages Beside a Road, 396 (III, 62)

Farmstead with a Hayrick and Weirs, 401 (III, 67)

House Beside a Road Lined with Trees, 410 (III, 75)

Landscape with a Farmer's House and a Hayrick, 429 (III, 91b)

Road with Houses on Each Side, 476 (IV, 31)

Farmhouses with Trees on the Right, 477 (IV, 32)

Landscape with Cottages at the Left Side of a Road, 478 (IV, 33)

Avenue of Trees Leading into the Distance, 487 (IV, 42)

Farmhouse, 495 (IV, 50a)

Farmhouse with a Haystack Between Trees, 505 (IV, 58b)

Houses Among Trees on the Bank of a River, 514 (IV, 67)

Village Street Beside a Canal, 515 (IV, 68)

Landscape with a Thatched Cottage, 516 (IV, 69a)

Farm Buildings near a Canal, 517 (IV, 69b)

Landscape with a Cottage, Canal and Trees, 518 (IV, 70a)

Cottages with Trees Beside Water and a Hay Barn, 519 (IV, 70b)

Landscape with Cottages, Meadows and a Distant Windmill, 521 (IV, 72)

INDEX OF REMBRANDT'S
PUPILS AND FOLLOWERS

Beyeren, Leendert Cornelisz van, 237 (II, 20)

Bol, Ferdinand, 237 (II, 20); 274 (II, 49); 373 (III, 40); 375 (III, 42); 543 (IV, 93); 544 (IV, 94); 549 (IV, 99)

Borssom, Anthonie van, 221 (II, 4); 293 (II, 64)

Dijck, Abraham van, 145 (I, 140b)

Drost, Willem, 246 (II, 28b)

Eeckhout, Gerbrand van den, 112 (I, 110); 217 (I, 200); 354 (III, 22); 448 (IV, 9); 535 (IV, 86)

Fabritius, Barent, 309 (II, 78); 540 (IV, 90)

Fabritius, Carel, 309 (II, 78)

Flinck, Govert, 51 (I, 51); 370 (III, 37); 530 (IV, 81)

Gelder, Arent de, 51 (I, 51); 329 (II, 97); 404 (III, 70)

Hoogstraten, Samuel van, 241 (II, 24); 266 (II, 42); 440 (IV, 2); 479 (IV, 34)

Horst, Gerrit Willemsz, 375 (III, 42)

Koninck, Jacob, 339 (III, 7)

Koninck, Philips, 39 (I, 39); 97 (I, 96); 181 (I, 171); 311 (II, 80a); 339 (III, 7); 370 (III, 37); 375 (III, 42); 529 (IV, 80); 544 (IV, 94)

Koninck, Salomon, 90 (I, 89); 215 (I, 198)

Leupenius, Jan, 340 (III, 8)

Lievens, Jan, 103 (I, 102); 455 (IV, 14)

Maes, Nicolaes, 29 (I, 29); 92 (I, 91); 241 (II, 24); 305 (II, 75); 354 (III, 22); 358 (III, 26); 364 (III, 31); 390 (III, 57); 470 (IV, 25b); 506 (IV, 59); 507 (IV, 60)

Mair, Johann Ulrich, 414 (III, 79)

Renesse, Constantijn van, 228 (II, 11); 540 (IV, 90)

Victors, Jan, 241 (II, 24)

With, Peter de, 290 (II, 61c)